Modernity, Sexuality, and Ideology in Iran

Modern Intellectual and Political History of the Middle East

Mehrzad Boroujerdi, *Series Editor*

Other titles in Modern Intellectual and Political History of the Middle East

Britain and the Iranian Constitutional Revolution of 1906–1911: Foreign Policy, Imperialism, and Dissent
 Mansour Bonakdarian

Class and Labor in Iran: Did the Revolution Matter?
 Farhad Nomani and Sohrab Behdad

Democracy and Civil Society in Arab Political Thought: Transcultural Possibilities
 Michaelle L. Browers

Factional Politics in Post-Khomeini Iran
 Mehdi Moslem

Globalization and the Muslim World: Culture, Religion, and Modernity
 Birgit Schaebler and Leif Stenberg, eds.

God and Juggernaut: Iran's Intellectual Encounter with Modernity
 Farzin Vahdat

A Guerrilla Odyssey: Modernization, Secularism, Democracy, and the Fadai Period of National Liberation in Iran, 1971–1979
 Peyman Vahabzadeh

In the Path of Hizbullah
 Ahmad Nizar Hamzeh

The Kurdish Quasi-State: Development and Dependency in Post–Gulf War Iraq
 Denise Natali

The Urban Social History of the Middle East, 1750–1950
 Peter Sluglett, ed.

Modernity, Sexuality, and Ideology in Iran

The Life and Legacy of a Popular Female Artist

Kamran Talattof

SYRACUSE UNIVERSITY PRESS

∞ The paper used in this publication meets the minimum requirements of the American National
Standard for Information Sciences—Permanence of Paper for Printed Library Materials, ANSI
Z39.48-1992.

For a listing of books published and distributed by Syracuse University Press, visit our Web site at
SyracuseUniversityPress.syr.edu.

ISBN: 978-0-8156-3224-5

Library of Congress Cataloging-in-Publication Data
Talattof, Kamran.
 Modernity, sexuality, and ideology in Iran : the life and legacy of a popular female artist /
Kamran Talattof. — 1st ed.
 p. cm. — (Modern intellectual and political history of the Middle East)
 Includes bibliographical references and index.
 ISBN 978-0-8156-3224-5
 1. Sa'idi, Kubra. 2. Women authors, Iranian—Biography. 3. Women artists—Iran—
Biography. 4. Women dancers—Iran—Biography. 5. Iran—Intellectual life—20th century.
6. Iran—Social conditions—20th century. 7. Women in popular culture—Iran—History—20th
century. 8. Sex—Social aspects—Iran—History—20th century. 9. Social change—Iran—
History—20th century. 10. Ideology—Iran—History—20th century. I. Title.
 PK6561.S274Z73 2011
 700.82'0955—dc22 2011007694

For Arjang and Hayden Hooshang

Kamran Talattof is professor of Persian literature and Iranian culture at the University of Arizona and the author, co-author, or co-editor of *The Politics of Writing in Iran: A History of Modern Persian Literature; Modern Persian: Spoken and Written,* with Donald Stilo and Jerome Clinton; *Essays on Nima Yushij: Animating Modernism in Persian Poetry,* with Ahmad Karimi-Hakkak; *The Poetry of Nizami Ganjavi: Knowledge, Love, and Rhetoric,* with Jerome Clinton; and *Contemporary Debates in Islam: An Anthology of Modernist and Fundamentalist Thought,* with Mansoor Moaddel. He is the co-translator of *Women without Men* by Shahrnush Parsipur, with Jocelyn Sharlet; and *Touba: The Meaning of the Night* by Parsipur, with Havva Houshmand. His scholarly articles often focus on such issues as gender, ideology, culture, and language.

Contents

Illustrations

Preface, Acknowledgments, Translation, and Transliteration

SINCE I FINISHED the writing of this project and after I submitted the manuscript for publication a few years ago, Iran and its political atmosphere have gone through significant changes. Iran is indeed on the threshold of a postideological era, which I mention at the end of the book. When it was pointed out to me that it seemed I had predicted these recent events, my first thought was that we in our academic writing tend not to make predictions. If there are any, they might simply be the logical inference derived from a set of arguments. After all, the bulk of this book is about one woman, Shahrzad. The rest is about the lessons we learn from the study of her works and the explanations of how ideologies have affected her life as a representative of the lives of prerevolutionary dancers and popular artists. And yes, there is perhaps some reflection on the future of the struggle for modernity that will have to include debates on gender and sexuality and how the younger generation has been ready since the 1990s to sensibly think and act upon these issues.

The recent events have become known as the Green Movement. After the contested presidential election in 2009, Iran witnessed the largest popular uprisings since the 1979 Islamic Revolution; nearly three million people marched in the streets of Tehran alone. Out of these protests, which in a sense were the continuation of the earlier struggles for reform, the Green Movement of Iran was born. Since then, many more political activists or ordinary youth have died, have been imprisoned, or have been executed, and clashes in the streets through the country have continued. The pictures and video clips of the resistance have been watched by millions all over the world. Iranians once again have exhibited their desire and hope for modernity and, yes, by moving in the direction that the final chapter of the book had envisioned and aspired.

In these pictures, what we see is not only a struggle for democracy and freedom. The mutual participation of women and men in elegant outfits, well groomed and well made up, sometimes holding hands, also indicates their desire to express their sexual agency, their self, their identity. The grassroots nature of the movement has provided a forum, particularly on the Internet, in which the desire to give individuality and personal freedom a priority has become as pressing as the usual aspiration for broader social issues such as freedom and justice. Moreover, the courageous people who risk their lives when they go to the streets exhibit tolerance, practice nonviolence, and advocate rationality as well as a non-ideological approach to the country's politics and problems. Of all the men and women who have died in the process to this point, Neda Agha Sultan, a young woman and a nonpolitical demonstrator, has become the symbol of this new condition. All this means that the questions raised in that final chapter about the ideological approach to sexuality are still as pertinent and urgent as the questions about the future of the ongoing movement, its direction, and its leadership.

ᵔᴗ

I am thankful to many for assisting me to complete this project. It would not have been possible without the cooperation of Ms. Kobra Saidi (Shahrzad), who provided hundreds of pages of writing about her experiences and thoughts on many social issues. I am thankful to my college friend Parviz Nazari, a philanthropist and supporter of cultural improvement, for helping both Ms. Saidi and me and for making all sorts of contributions. I am thankful to my sister Shekooh Talattof and to Ruzbeti Kamali for their assistance with archival research, and to my nieces Pantea and Pamela Karimi for providing the cover artwork and a number of useful sources. I am grateful to colleagues, students, and editors who provided me with critical comments and suggestions during the process of my research and the publication of this book. Finally, I am thankful for the grants I received in support of this project from the Princeton University Committee on Research in the Humanities and Social Sciences and from the Provost's Author Support Fund, University of Arizona, Tucson.

All translations in this book are mine unless mentioned and credited otherwise. These include translations of scholarly statements, poetry, interviews, and other pertinent information. The transliteration of Persian words and names is based upon the way they actually sound in the Persian language unless it was necessary to use other systems to facilitate access to bibliographical information.

Modernity, Sexuality, and Ideology in Iran

1

Academic Writing and Writing about Lives

An Introduction

> Have you ever craved a glass of red wine in a dry town or longed
> to shout in a deaf country?
>
> —Shahrzad

ON MARCH 8, 1979 (International Women's Day), less than a month after the victory of the Islamic Revolution, my friend Azar and I were standing near the front gate of the University of Tehran, which was filled with outraged women. They were preparing to protest the mandatory public veiling of all women. Two days earlier, this demand had been voiced by Ayatollah Khomeini in a speech he delivered in the city of Qom.

We were joined by another woman who told us the crowd at and around the University of Tehran was about to move to the prime minister's office, where another rally was in progress. We all walked down the street and the newcomer, who like the two of us was young and secular, but somewhat more leftist, pointed out famous people who were marching. One woman was a former political prisoner, another was an author, and she laughed when she identified an actress whom I did not recognize at that time.

This rally and others that took place over the next few days were covered at length by the press. One newspaper reported the events in a supportive tone. Others attributed the demonstrations to supporters of the old regime and so-called antirevolutionary forces.[1] One published a photo of the demonstration that featured several women wearing makeup and mocked them as "the kind of women" who have been rallying against the revolutionary government. In the

center of the photo was a woman with large glasses, a rare color photo in that newspaper in those days. I realized this was the actress whom we had seen on the day of the demonstration: Shahrzad, the dancer.[2] I also learned from these reports that she was one of a few women who were arrested.

More than a decade later, in 1991, in a section of the Graduate Library at the University of Michigan known as "the Cage," where they stored publications that lacked sufficient cataloging information, I was combing through Persian materials when I came across a book that aroused my curiosity. It was a short book of poetry entitled *Salam, Aqa* (Hello, sir), written by Shahrzad, whose picture appeared on the cover.

I sat in a corner of the dusty Cage and read it from cover to cover. Many of the poems were grammatically and thematically distorted and were filled with ambiguous references to deserts, horses, seas, and other natural elements. Yet, I believe that it was the book's highly unusual imagery that made me read it through in one sitting. Later, I found and read two other books she wrote before the 1979 Revolution. I also gave some thought to her metaphors and her symbolic, surrealistic language.

Scholarly Views

In the late 1990s, I returned to Shahrzad's books and tried to gather more information about her literary works, films, and life. My contemplation of her career and imprisonment was now an academic (pre)occupation. It was also relevant to my new enthrallment with what Nancy K. Miller describes as the "feminist theory's original emphasis on the study of the personal."[3] "The personal," especially when related to ordinary people, was an unknown theme in the leftist materials I read with eagerness in those revolutionary days. I grew suspicious of the sufficiency of the study of high culture and its elite producers and was interested in "what had become forgotten," to use Susanna Scarparo's words.[4] Yet other issues related to writing biographies can be taken into consideration. Elspeth Probyn, for example, encourages a move beyond the problems of representation, where no one can speak for another, by questioning the dichotomy of "moving selves and stationary others."[5] Perhaps Virginia Woolf could provide a lesson here. Her interest in biographical writing stems from her work on "the lives of the obscure," which often translates to the lives of women and her reflection on the balance that should exist between fact and fiction in

works of biography.[6] Scholars such as Susanna Scarparo have been successful in overcoming the frustration biographers experience in locating the subject of their biographical works through an interdisciplinary and cross-cultural study. Scarparo writes, "I revisit the canonical separations between genres by placing biography at the centre of debates about the boundaries between genres and disciplines."[7]

I participated in those demonstrations, and later I wrote on women's literature, but then I began to see the margins, from a farther breadth, in terms of both time and space.

I tried to track down Shahrzad in Iran to ask questions about her books and her careers. A prominent woman publisher was adamant when she told me that Shahrzad had been ill and disoriented and that she was in a psychiatric hospital. Others thought she was dead. But it turned out that Shahrzad was living in the streets of Tehran at that time and usually could be found near a place called the Cinema House. She would not talk to anyone.

An Enigma

If true, then Kobra Saidi, known as Shahrzad, who played in a great number of theatrical productions, danced in skimpy costumes in cabarets and films in the 1970s, acted in about sixteen movies (some of which were considered risqué for that time), worked as a journalist writing commentaries on cinema and culture and also as a published poet, had surely been the most famous homeless person in Iran!

To be sure, she received a number of cinematic awards, and one of her roles in a movie titled *Dash Akol* (based on a story by Sadeq Hedayat) was highly acclaimed. By many accounts, she was also a screenplay writer and a film director. At the height of her dancing and acting career in the seventies, she gave it all up to devote herself entirely to her writing. In other words, in a relatively short time, a woman who, perhaps due to the Shah's modernization projects, was able to excel in several areas of artistic and professional activities, also languished in prison, was confined in a hospital, and was left homeless in the streets of Tehran.

～

How is it possible?
Why did it happen?
Why Shahrzad?

We could dismiss Shahrzad's case as irrelevant, arguing that the revolution had a more horrifying impact on many others. Indeed, so many reports indicate that many were executed, imprisoned for long periods, or exiled. However, Shahrzad had no political affiliation with leftist or revolutionary organizations, nor was she known to have participated in feminist activities.

The reason for discussing Shahrzad is not then solely related to the events of the 1980s. Moreover, one may ask why Shahrzad is selected for discussion when there are so many other famous women, such as Forugh Farrokhzad and Simin Behbahani, or famous entertainers, such as Googoosh, to choose from. In chapter 6, I show how Shahrzad symbolizes and, if you will, epitomizes other women artists. Shahrzad's life story provides intimate information, relevant context, and insightful commentary as to why her sexuality held a curious charm and an abject antipathy in the public. It also represents some of the most original research in the book. Her multiple identities, her multiple names, and her multiple talents represent some of the characteristics of a contemporary Iranian woman artist.

Moreover, I argue that in order to explain Iranian society, it is not enough (as it has been practiced thus far) to focus only on elites and the elite culture; it is necessary to look at popular culture, for which Shahrzad is a good example as she belongs to three areas of cultural activity. I have studied the works of Farrokhzad, Behbahani, and Parsipur elsewhere, and I have referred to them in this book. I have also referred to Googoosh in this work. Still, I believe that Shahrzad is in some ways different; Googoosh did not write poetry and was not known as a dancer. Forugh Farrokhzad and Simin Behbahani were not known as actors and did not dance. Googoosh and Parsipur moved to the United States to pursue their careers, and Farrokhzad did not live to see the revolution. None of them became homeless. Shahrzad, as an artist and writer, represents the women artists and entertainers of the 1970s for the study of the impact of the ideological discourses on the lives of women artists.

Why did all this happen to her?

I do not believe it was what Shahrzad *did* that changed her fate; it was instead what she *symbolized*.

Shahrzad represented the culture of the Pahlavi era, a sign of women's expression of sexuality.

Her life reflects the conflict between two cultures and modes of expression in their most extreme and repressive states. Her fate was impacted by the revolution and the events that followed, giving rise to a new mode of expression in art and

literature and a different perception of women. In fact, Shahrzad's case leads us to several more complex questions about the struggles between modernity and religious fundamentalism in Iran. A prominent, deadly, and highly bloody point of contestation between the two has, since the mid–nineteenth century, been the question of women, gender, and more broadly, sexuality.

The Iranian proponents of modernity often do not have an expressed understanding or interest in the issues related to sexuality. Their paradigm has not included a serious, secular, and scientific discourse about sexuality. At best, they have simply proclaimed the necessity of gender equality in its most abstract sense. The traditionalists and religious fundamentalists have long offered a somewhat well-formulated albeit archaic notion of sexuality, a notion that in many ways underpins societal practices.

Sex and sexuality (which in addition to sex includes such broad areas as sexual orientation, sexual education, women's health, passion, love, identity, etc.) have been points of contention, and the battles over women's bodies in political conflicts have resulted from that essential divergence. In this cultural situation, discussion of menstruation and body hygiene, female sexual desire, and sensuality transgress the limits of normative gendered roles. Discussion of these topics has never been a common or acceptable practice.

A Pivotal Question

In Iran, since the mid–nineteenth century, one issue has been a common concern: How can Iran become modern, or should it?

More than a century of struggle for or against modernity has constituted much of the social, political, and cultural history of the country. In the decades since the 1979 Revolution, the question of Iran's modernity has become even more critical. Often political players in Iran are characterized as reformists or conservatives based upon their stance on modernity. Taking a public position on issues related to modernity can guarantee someone a position in the state echelon or, conversely, can lead someone to prison.

Many intellectuals view themselves through what they understand to be a modern lens.[8] After all, since automobiles or earlier technologies arrived in the country, the intellectuals or social commentators have felt the need for new mores that can address the new social realities created by these imports. Obviously, the traditional culture of their society alone could not provide those mores.

Nonetheless, the ideals of modernity (such as rationalism, individual sovereignty, political equality, sexual equality, and sexual preferences as one's prerogative) remain rather remote.

So what is the problem?

It is not convincing to attribute the failure of modernist authors, intellectuals, students, and ordinary people to colonialism or to conservative forces alone. Other more successful societies have faced similar obstacles in their histories. It is not possible to attribute the failure to some intrinsic cultural flaws because this nation and its members have accomplished so much throughout its long history at home and abroad. Iran's natural resources, infrastructure, and economy have had much potential. The failure, I believe, is related, among other variables, to an absence of a modern notion of sexuality. This absence is evident in the discourse of the liberals, reformists, Marxists, leftist revolutionaries, and particularly in the discourse of fundamentalists and their archaic notion of sexuality. These tendencies have not only silenced or stigmatized an open conversation about sex, sexual health, and modern notion of sexuality in general but have resulted in a radical, ideological dichotomization of nudity and poetry, sexuality and intellectuality, sex and art. We are left with a distorted picture of sexuality that separates mind and spirit. Deliberating on these superfluous dichotomies can help launch our analyses of the context of the rise and fall of Shahrzad. This means that even though we are moving away from a binary understanding of sexual difference (or, as queer theory suggests, from any grouping of identities), by considering many perspectives and identities, we still have to deal with the reality of the existence of many dichotomies that social players have imposed on life in that society.

This book seeks to illustrate the root of the problem of Iranian modernity and shed light on the reasons for excluding modern views of sexuality from the official discourses and implementation of gender equality in official practices. It examines the presence of the prevailing traditional, fundamentalist, religious discourse on sexuality and the absence of a meaningful discourse about gender and sexuality in national discourse and links them to the failure of Iran to fully embrace modernity.

Semi-intellectual flirtations with some domains of sexuality were conducted in the 1970s, but only in the arenas of Iranian popular arts and culture—and then only dismissively and absurdly. The limited, vulgar portrayals of sex and nudity in cinema and their near absence in literature could neither help open public

dialogue about gender and gender roles nor help the gender equality movement. In fact, the (mis)treatment of sexuality within popular culture and the lack of any serious discourse contributed to the rise of the antimodern revolutionary movement of 1976–79.

Repulsed religious populace, bazaar merchants, sexually dissatisfied youth, disoriented boys, and even the revolutionary men and women provided the moral fuel that powered the anti-Shah and anti-Western movement by offering an alternative discourse on sexuality, which defined the precise role of women in society vis-à-vis men.

Prominent People and the Profit Motive

The rise to power of religious and puritan speakers resulted in the utter suppression of any manifestation of sexuality in the 1980s and in the creation of new forms of gender segregation and the reappearance of more defined gendered spaces in Iranian society.[9]

Even the recent rise and politicization of some aspects of sexuality as a result of technological advancements since the 1990s, such as the Internet and satellite television, resulting in a definite battleground between the youth and the hardliners, has not directly helped the cause of modernity.

Nevertheless, the changes in the young generation's attitudes toward sex, which some refer to as a sexual revolution, provide further reasons to discuss the relationship between the discourses of modernity and sexuality in this highly ideological society.

The absence of a modern discourse on sexuality or a documented history of sexuality in Iran was not due solely to resistance from revolutionary forces or the traditionalist segments of society, that is, those upholding religious dogma, opposing modern culture, and resisting social change.[10] It was also because producers of popular culture manipulated aspects of sexuality and sex in unsavory ways for profit. This manipulation created in Iran a history not of modernity but of *response* to modernity comprised of stories upholding the dominant ideologies, offering only a quasi, spurious, and at best uneven ideal of modernization without any fundamental, irreversible, and systematic transformation.[11]

Products in the areas of economy, industry, culture, art, and lifestyle as well as in academia and intelligentsia have frequently been produced in the contemporary period when contact between Iran and the West occurred.

How Can Shahrzad Help?

To help explicate these arguments, this book views the life story and works of Shahrzad (b. 1946) and references stories of other famous female artists of Iran in the 1970s. These stories serve as windows through which to explore the question of and the quest for modernity in Iran.

Shahrzad's work in particular spans at least three distinct fields of popular culture and modern art.[12] In contextualizing her narrative, we see how her works were consumed in the Iran of the 1970s and especially consumed by the younger generation that was dealing with issues of Westernization, nudity, and sex. And of course, Shahrzad's life before the revolution was affected by the lack of a discourse of sexuality and by the intellectual ideologues' aversion to such matters.

In the absence of any major historiography of mass popular culture and the way it was consumed, personal narratives and popular journals may best shed light on such issues.[13] In this case, it is particularly important to know how the Iranian intellectuals in the 1970s perceived artists such as Shahrzad and how they responded to the message these artists wittingly, or unwittingly, conveyed. Further, the fundamentalist and traditionalist notion of sexuality affected even more radically the life and the fate of such artists as Shahrzad after the revolution. The result is a window through which to view a segment of Iran's cultural history during the fateful 1970s. This period delivered the ingredients for a unique revolution in 1979, which toppled the rule of Mohammad Reza Pahlavi (the king of Iran from 1941 to 1979, known as the Shah) on February 11, 1979, and initiated decades of cultural turmoil.

This book pursues an interdisciplinary and multigenre exploration of the question of modernity in Iran and the way it was represented and perceived in the period before (and after) the 1979 Revolution.

As the next chapter discusses, many scholars have written about the modernization process, its limits and achievements, during this era and throughout the reign of the Pahlavis (1925–79).[14] The general consensus is that Iran achieved a certain degree of modernity, variously conceptualized as modernization of segments of society, industrialization, or Westernization.[15] It has been perceived as a positive accomplishment but largely one for which the country was not ready.

What Is It All About? Arguments and Chapters

Taking into consideration the case of Shahrzad and other popular Iranian female artists, I argue that modernity never truly unfolded in that period and that any attempt to promote the discourse of modernity was hampered by numerous obstacles.

I further argue that the reason for the absence of a successful modernization process and a pervasive discourse of modernity in Iran, particularly in the seventies, was that any public and theoretical discussion of modern ideas and philosophies lacked the necessary academic, intellectual, and national debate over the seminal subjects of gender and sexuality. Even if some erratic statements were made within the realm of popular culture about sexuality, their meanings were limited to sex instead of covering all that which makes a person sexual, regardless of their sexual identity. Yet religious fundamentalists found such statements erotic enough to embark on a moral campaign to repackage and present their view of sexuality as more virtuous and even as revolutionary ideas.[16]

In chapter 2, assessing why Iranian society has failed to achieve modernity and why, as a result, its culture has become unstable, changing constantly in a chaotic fashion yet always lacking a modern conceptualization of sexuality, I argue that another approach is needed to describe it, perhaps something I call *modernoid,* or resembling modernity. In such modernoid society, for example, pious religious men in power can use advanced technology to impose a medieval notion of sexuality on society and in particular on women.[17]

I acknowledge that sexuality is not universally understood in the same way; "It is in large part culturally constructed and is invested with particular meaning in various societies."[18] Even in the West one might find an approach similar to what might be found in some sectors of Iranian society. For example, many conservatives in the United States are apparently concerned about the corruption of society and emphasize the intimate relationship between a man and woman as an important aspect of sexuality. For them, sexuality and sex are limited to a function of procreation and the core biological, psychological, and social function of the union of opposing sexes in durable family structures. In that regard, the concerns of Muslim forces in Iran in the 1970s were similar. But, because they feared that discussing such topics could lead to social and cultural problems, they

simply imposed their own ideological views on the whole nation, first as revolutionary ideas and then by force, making sex clearly connected with issues of power, very much the same way Foucault explained medieval sexuality.[19]

I find Foucault's historiography of sexuality, in which he explains how a modern attitude toward sexuality has developed, very illuminating. According to Foucault, in societies where modernity has been achieved, sexuality has become the subject of daily conversations; it is written about extensively and formal sex education prevails.

Whether or not these developments lead to new methods of control, as Foucault wants us to believe, is not the point. The point is that in the absence of any serious, useful, modern discussion about gender, sexuality, and sexual identity, Iran's population continues to be treated as subjects, not as individuals, not as free citizens.

Chapter 2 also points out research and academic work that focuses on gender and women's struggle in Iran within the frameworks of egalitarianism, women's rights, and women's autonomy.[20] These works have been framed mainly within a national discourse.

In the seventies, when many believed that Iran was moving toward modernization, ideological and political discourses dealt only with an "unsexed" social identity. Popular arts such as movies and popular magazines in Iran considered sexuality in a limited and simplistic fashion constructing rather than deconstructing obstacles to modernization. Popular culture alone proved an inadequate vehicle for promoting modernity, but it has to be taken into analysis to explain what happened to female artists and their lives after the revolution.

Ironically, starting with a theoretical examination of the problems of modernity and sexuality, this book ponders, although in microcosmic and somewhat tacit senses, the very same questions posed by Muslim and secular intellectuals since the nineteenth century.

Ask Yourself

What happened to Iranian society?

Why has it fallen behind the West?

Did Iran regress toward the end of the seventies?

Is there anything modern about Iran now?

Why have women, despite all their achievements, suffered so much?

To shed light on the answers, I will demonstrate how, in the seventies, reactions to the sexual "excess," the "representation" of "sexuality" as perverse, and the absence of aesthetic and literary notions of sexuality contributed to a nihilistic, revolutionary, and moralist discourse. This chaste notion of sexuality led the revolutionary movement to nullify many achievements of women during the Pahlavi era.

Many fascinating scholarly works have been written about the 1979 Iranian Revolution, the seventies, Iranian women, and about modernization and Westernization projects, and numerous long endnotes in this book review or refer to them.

The conflict constituted a subliminal and central point of contention among all revolutionary players: Marxists, leftist intellectuals, and committed literature authors. All oppositional forces capitalized on this conflict, and they did so successfully and rather unexpectedly, just as women like Shahrzad were finally entering the public arena due to top-down social changes.

The questions above will be better understood if the discussion focuses not only on abstract notions but also on historical nuances about the lives of participants at the time: dancers, singers, and marginal female poets.

I analyze Iranian modernity and its relation to sexuality, popular culture, and popular arts through the study of a number of artistic and ideological narratives. Using a multidisciplinary approach, I examine different aspects of women's social and artistic activities in areas such as cinema, music, dance, and literature in the decades prior to the revolution. In addition, I contemplate the origins and functions of the powerful ideologies that affected their lives and caused social change through the analytical model I have developed as *paradigmatic response*.

My hope is that this book will not only contribute to existing research on the question of Iranian modernity but will also contribute to the emerging scholarship on Iranian popular culture and sexuality.[21] I believe that studies of women's artistic activities in popular culture can shed light on how Iranian intellectual discourses such as Marxism, nationalism, and Islamic fundamentalism approached sexuality.

Furthermore, to understand the current situation of Iranian women and their place in the ongoing debate on modernity and sexuality, we must also study the obstacles placed in their way that prevented self-realization and full participation in literature and other popular forms such as dance, music, and cinema.

It is also necessary to explain more about the reason for this attempt at academic writing about lives and to justify—beyond my personal involvement in the early events of those postrevolutionary days as a young student—the selection of the works of Shahrzad to reflect on the cultural context of the 1970s. Later, where I deliberate on what is known as FilmFarsi type (plain, commercial movies) of that time, it becomes clear why Shahrzad represents a prime case. Hushang Kavusi, who first coined the term FilmFarsi, states that he had in mind the movies that included nightclub and cabaret fighting and that held no artistic value. He did not separate the words Film and Farsi because he intended a new meaning independent of the two words. FilmFarsi movies might also be compared to Bollywood films, some Elvis-style movies, and American soap operas.[22]

I contend that FilmFarsi and other popular art forms that dealt deplorably with sexuality in that decade were not perhaps the best genres and media for the task of conveying messages about modernization because their producers showed lack of necessary knowledge. Messengers, who have been rendered irrelevant under the postrevolutionary regimes, continue to represent the nostalgic memory of the past, the veteran of that cultural turmoil, and the victims of the assault on sexuality.

Modernity and Paradigmatic Response

My deliberations and inquiries about issues of gender and modernity have not occurred in an academic vacuum. Before reading Shahrzad's works, I researched and wrote about the rise of a feminist literary movement in postrevolutionary Iran. My work offers an analytical model to describe women's literature and gender relations and argues that literary works produced by Iranian women writers after the 1979 Revolution, "despite their diversity in artistic value and quality of narrative, commonly manifest a remarkable sensitivity towards women's issues and gender relations."[23] These works belong to a new literary movement that can be conceptualized as the first feminist literary discourse in Iran.

I also developed an analytical model (*episodic literary movement*) to explain the changes in themes, forms, and use of metaphor throughout the history of modern Persian literature, arguing that "modern Persian literature emerged during the nineteenth and early twentieth centuries as a secular activity and has since included texts that demonstrate close affinity to such diverse ideological paradigms as modernism, Marxism, feminism, and Islam."[24]

How can Shahrzad's works be placed in these periodic movements? Based on the concept of the episodic literary movements, those whose works do not resonate with or contribute to the dominant discourse remain marginal, at least temporally. Shahrzad perfectly illustrates this principle. Her poetry, as well as her life story, constitutes a prime example of ideological and social marginalization. She was ignored because of her "deviation" from the dominant discourse.

Context is the key word here, the context in which a literary movement gains dominance and the context in which marginalization occurs. It is possible to view a number of cultural products or texts against a common context, against a temporal context, for example, to find their common characteristics. However, in explaining the process of literary or ideological production, one often comes across the influence of another or broader universal context. Sadeq Hedayat, for example, wrote in the context of feverish desire and indeed within a movement to modernize the Persian language. I termed that literary movement Persianism. But his writings are also comprehensible if analyzed against the pre-Islamic Iranian utopia longed for by Persian intellectuals in the early twentieth century (the Persianists) and against the background of the rise of the concept of modernity with which he became intimately familiar when he resided in France.

Conversely, a single context might also shape different, ideologically conflicting texts. During the 1970s, a time of rapid Westernization of Iranian society, committed literature dominated. It comprised most of the resistance literature and the writings in support of the leftist intellectual activities of that time. It too lacked a modern concept of sexuality. How should we further understand the marginal literary works of that era which were more personal, romantic, and journalistic, highly nonpolitical, truly belonging to the popular, lowbrow, culture?

We cannot argue against the contextualization of any work based on its immediate lack of social impact. Moreover, popular culture did in fact impact social life over the years. It strived to entertain, to address ordinary people's needs, and to imitate Western genres in the vain hope of attending to elitist causes. Popular culture is manifested in religious festivities and in music, cinema, journalism, and radio television productions. They all directly or unintentionally contributed to the political changes affecting every single life in one way or another over the decades prior to the revolution. In this sense, writing about personal lives of popular artists also entails writing about public social-political-poetic change.

Other scholars have also written about the significance of the contextualization of Persian literature in order to grasp its elements and functions.[25] And contextualization inevitably implies some sort of discontinuity. Furthermore, continuity in culture and literature is the result of common cohesion, purposefulness, values, and stances over time. But all these elements do not remain the same throughout a nation's history. Only some aspects of Persian literary tradition persist but even then, the very same elements may convey radically different meanings. With such instability, great poets can also be marginalized if they are not in synchronicity with their times.

Poets and Poetry

A prominent example is Ahmad Shamlu, and, for that matter, many other giants of modern poetry dominant in Iran's literary scene before the revolution. These artists lost their leading roles in the 1980s.[26] They fell from prominence when, according to all major literary analysts, their genre of poetry "faced a crisis" or "lost its leadership" after the revolution.[27]

Actually, the Marxist notion of hegemony best explains the relationship between Persian poetry and its social context in the time of the revolution. In the 1970s, the poets, secular or religious, preferred poetic form to express their revolutionary idealism. Those who did not fancy that kind of idealism remained peripheral and played no role in the country's political landscape.

But all lives, whether in the center or on the periphery, were affected by the change of regimes. Then, in the religious context of the postrevolutionary period, the main drive for many prerevolutionary poets was not idealism; it was political and even physical survival. Others succumbed to the new exigencies, including the acknowledgment of the significance of prose and the centrality of the novel. So, if finding the right social and discursive context is so important in understanding the meaning and the message of a literary work, what is the place and explanation of the works of Shahrzad? She neither wrote in support of the prerevolutionary committed literary movement nor had the chance to explore the new condition.

The answer can be found in placing her life and literary fate within multiple contexts of the popular and elite cultures of her time and in the context of the Iranian struggle over modernity and against sexuality.

But why does writing Shahrzad's story require a chapter on the problematics of modernity and sexuality? Many seemingly basic concepts can be the subject

of contention in this so-called postmodern era. But I intend to demonstrate that modernization theory is still most relevant and that dealing with it requires modesty and candor.

What is modern literature?

Can we consider twentieth-century Persian poetry modern merely based on the change in its themes and forms?

What happens to the similarity of motives in both classical and modern poetry that supposedly represent a strong continuity?

Did Persian literature produce a body of work that had the same social effects as Western modern literary products, thereby deserving to be called *modern* Persian literature?

One may immediately point to the pioneering works of Sadeq Hedayat or M. A. Jamalzadeh as examples of truly modern works. But did they leave a lasting modern impression on society?

These issues involve not just one or two authors whose works and achievements may be explained by their familiarity with Western societies. To understand the implications of the question, we may contemplate a broader question: To what extent has Iranian society achieved modernity at all?

In chapter 2, I explore this question. I reiterate my findings that regardless of the creative innovation and individual improvement present in modern literary works, they for the most part poorly reflect a broader social ideological shift. No matter whether religious or secular, this literature does not fully embrace modernity. This brings us back to our discussion of the life and legacy of artists such as Shahrzad. Is Shahrzad an anomaly? Perhaps in some regards. Was she ignored for the sheer fact that she was not part of the dominant discourse and that her work thus did not reflect the dominant ideology?

As we will see, it was not only officials who suppressed her. By all indications, she has constantly been mistreated by many, including members of the media and advocates of committed literature. Three chapters devoted to the study of Shahrzad's life story and her work in cinema and literature will bring all these to the fore.

In this book, I also elaborate on the analytical model of *paradigmatic response*. Using this model throughout, I explain contemporary products of artistic, cultural, individual, and ideological paradigms as responses to other stronger and often foreign paradigms. I contend that in Iran when a *paradigm* (an

admittedly problematic concept I explore below) comes into contact with other ideological or political paradigms, especially stronger and more advanced ones, it responds in a predictable manner. It produces an ideology similar to the one it has come into contact with—similar in terms of sociopolitical agendas, rituals, and figurative language.

One of the basic relevant definitions of the word paradigm is "a philosophical or theoretical framework of any kind."[28]

I use paradigm to mean an ideology in action (including thoughts, rituals, values, and metaphorical elocutions) or a body of beliefs that perpetually acts to influence the functions of society by providing or imposing a model for seeing and perceiving the world.

Paradigm is an active ideology that makes structured sense of how society works and how best to provide programs to make it work in certain ways. A paradigm is essentially a set of suppositions about the world. It includes thoughts, rituals, and values that form a particular frame for perceiving any number of constructs, whether "real" or "divine." Marxism, Islam, and feminism are, for example, transnational ideological paradigms that have exerted significant influence on literary production in Iran.

I use *response* in place of a more mimetic term such as *emulation* in order to stress the dynamic nature of the contact. In the twentieth century, as explained elsewhere, these responses included Islamic modernism (also referred to by some scholars as "Islamic liberalism" or "liberal Islam") as a response to Western influence and Islamic fundamentalism (otherwise known as "militant Islam," "Islamism," or "radical Islam") as a response to Soviet-Marxist influence.[29]

I have also come to the conclusion that like ideological and discursive developments, personal behavior and individuality in Iran, whether political or apolitical, religious or secular, seem to have been shaped through the responses people offered when in contact with the representation of stronger paradigms such as Western culture or Marxist ideology. These responses included areas such as hairstyle, dress, treatment of the opposite sex, and even one's notion of sexuality. True, the youth in the 1970s could never become exactly like Westerners, but their responses showed similarities such as an affinity for Western styles. Likewise, even if they never fully embraced traditional or Marxist ideologies, they adopted many of their tenets. These aspects will be demonstrated in the discussion of the consumption of FilmFarsi and Western cinematic products. This model therefore

not only explains the dichotomy between liberal and fundamentalist Islamic discourses, but also the changes in literary discourses, women's participation in FilmFarsi, Shahrzad's poetic constructions, the young generation's behavior in the 1970s, and again the rise of leftist and revolutionary discourses.

Chapters 3, 4, and 5 are all about Shahrzad. They provide information about how she was affected by the ideological discourses of 1970s that ignored the issues related to sexuality or women all together. In chapter 3, I tell her life story, present her ideas and aspirations as a young artist, and discuss her journalistic works that touch upon the questions of gender, equality, and women's cinematic endeavors. By all indications, Shahrzad aspired to be perceived as an intellectual. The committed literary communities in the years prior to the revolution, however, harshly rejected her for her "failure" to act "decently." Additional factors that rendered her marginal, or subaltern, were related to her chosen arts of dancing and acting. This biography is based on a survey of journals, movies, archival documents, interviews, and hundreds of pages of letters she wrote in response to a number of basic questions I posed about the meaning of her metaphors.

In chapter 4, I discuss Shahrzad's cinematic works in the context of the Film-Farsi of the late 1960s and 1970s to illustrate how the filmmakers, consciously or not, used female roles and nudity to inhibit cultural and political processes. Shahrzad's cinematic roles, her dancing, and her lip-synched pop or risqué songs in those movies along with her ideas about cinema in general prove her an incredibly talented artist who had developed a unique style in all these genres.

Through a brief historiography of Iranian dance and cinema, drawing upon the definition of Western concepts of dance and film and comparing such Iranian genres with Western film production and the burlesque form of the 1940s through 1960s, I arrive at the same conclusion about the tension between Iranian modernity and traditional sexuality. Based on this historiography, I argue that on a deeper level, FilmFarsi filmmakers utilized bold dance scenes and nudity as cinematic elements to fulfill men's need for voyeurism and to validate their controlling role in society by providing simplistic moral conclusions. Film-Farsi—and Iranian cinema as a whole—responded to some issues related to the sociopolitical changes occurring in society in relation to women's presence in many areas of social life, but it also played a role in effecting these changes, both before and after the revolution.

In chapter 5, I explore Shahrzad's literary and autobiographical works, including her three books—*Salam, Aqa* (Hello, sir), *Ba Teshnegi Pir Mishavim* (Thirsty, we age), and *Tuba* (Tuba) as well as her letters—to illustrate the way issues of modernity and gender were approached in popular culture and how they affected her life and art. In Iran, through certain social processes and constructions, women were identified as the site of Westernization, resulting in the formulation of a moral resistance against Western culture that became widespread across ideological divisions. (Women were later used as the site of Islamization resulting in a new set of complex social conflicts.) In her poetry, Shahrzad resists the social construction of women's bodies by the prevailing ideologies and by the agents and consumers of the dismal show business of her time. Her poetry, while occasionally incomprehensible, stands in contrast to the highly realist literary discourse of the prerevolutionary period. It is original, picturesque, and autobiographical. The analysis of these poems clearly reveals Shahrzad's talents, ideas, and aspirations.

In chapter 6, I review the traditionalist religious discourse of sexuality and how it affected the postrevolutionary lives of a number of other popular Iranian female artists who, like Shahrzad, had been active and accomplished in the 1970s music and entertainment industry. That discourse and these women again represent the conflict this book strives to show from all angles, an absence of a modern notion of sexuality and the quest for modernity.

I conclude that the circumstances of women during and after the revolution were related to cultural and discursive developments in the 1970s. That is, gender segregation and the decision to enforce the veiling code after the revolution are both rooted in cultural debates within popular and religious cultures of the 1970s. Another underlying notion for the somewhat prosopographic juxtaposition of the story of Shahrzad with the life stories (albeit epigrammatically) of such artists as Ruhangiz Saminejad, Parvin Ghafari, Delkash, Marzieh, Foruzan, Googoosh, Susan, and several others is an attempt to show that without these women, the flickering notion of modernity upheld by women activists in the 1970s and the excuses used for the regression of the postrevolutionary women's condition would have not been possible.

Finally, in chapter 7, I revisit the concepts of modernity and sexuality and argue that political and religious ideologies affecting lives in Iran during the last century or more continue to impede a healthy discourse about sexuality, a move

toward modernity, and even greater women's accomplishments. I try to explain why and how the state has created an ideological safeguard to control women's aspirations and advancement.

Fear Abounds

I refer to the regime's defense mechanism and control as "veiling terrorism": women are constantly fearful because they do not know how to respond to the vague codes embedded in Iran's official ideology and current veiling laws, a condition that limits physical mobility and mental serenity. This fear may last a long time even after a woman is situated in a free society. In a sense, the veil is the most essential symbol of the current Iranian religious state, in a society where symbolism has always played an essential role. Without it, I argue, the state would cease to exist in its current form. The women's veil is closely tied to the state's ability to exert power, to maintain its ideological posture in the face of universal exigencies of a global economy and rapidly changing population. I offer some examples of the effects of ideologies on certain aspects of sexuality in recent years as responses to Western models, now more accessible through technological advances, all resulting in the creation of a situation that can at best be described as chaotic.

Through these chapters, I refer to "modernity" as any serious theoretical adaptation and manifestation of the Western discourse of modernity, enlightenment, reformism, and reason in different areas of life beyond industry and economy. It is not used to signify up-to-date, contemporary, or technologically advanced practices in industry and economy. I do not argue against cultural diversity. Neither do I dismiss the myriad problems that liberal capitalism faces. I also suggest that this theoretical adaptation along with the practice of modernization should be viewed as a grand social project.

My arguments on behalf of modernity are rooted rather in the fact that modernity and its related concepts of civil society and democracy have been the obsession and muse of Iranian society and its intellectuals for more than a century even though they have not always been candid about it. The publication of hundreds of books and articles in recent years in Iran shows that interest in the topic is rising and attitudes about it are changing. The Iranian case may illustrate that modernity, a deeply and inherently Western phenomenon in my understanding, cannot be fully successful without a progressive, scientific, and just and lawful discourse of sexuality that can even be rooted in the indigenous culture.[30]

Finally, in the absence of an open treatment of sexuality by the advocates of modernity, the religious fundamentalists have at times used their notion of sexuality as a means to provoke the populace against modernization attempts. As a result, modernity and freedom of sexual representation that should theoretically be inseparable have been distortedly used against each other, in public and in private.

The writings of Michel Foucault, Jacques Derrida, Julia Kristeva, and Hélène Cixous have led to the renegotiation of the notion of the unified and integrated self among Western literary critics and analysts. They believe the dichotomy of male-female, that is, the dominant sexual binary, may be an unreliable and limited concept in women's literary studies. Such social or biological binary concepts, however, continue to underpin daily life in Iran where walls, curtains, rules, power, and intimidation facilitate gender segregation and sexual suppression.

In addition, such an archaic practice as gender segregation influences identity and art production and weakens the challenge against the dominant state discourse. Similarly, highly refuted or contested dichotomies such as the public versus the private, the secular versus the religious, and, in brief, the modern versus the traditional have constituted much of the basis of the social tensions and daily stresses of life. Only through these theoretical clarifications and kaleidoscopic lenses can we explain how Iranian cultural engineers first encouraged Shahrzad to enter the popular culture arena of dance and FilmFarsi cinema and then punished her for that participation. In the end they refused to allow her to explore filmmaking and the high culture of poetry on behalf of which she had long before decided to abandon her acting and dancing works. It is in these contexts that we can truly understand why Shahrzad faced numerous political, mental, and financial problems throughout her career to become eventually the most prominent homeless person in Tehran.

2

Modernity, Sexuality, and Popular Culture

Iran's Social Agony

Have you ever tried to prove your innocence to a wall?

Shahrzad

IN THIS CHAPTER, I expand my argument that since the beginning of the debate on modernity in Iran, the question of sexuality has mainly been absent from the debates. Instead, only traditionalists and religious fundamentalists have offered their archaic and well-formulated notion of sexuality, often wrapped in anticolonial packaging. Because of this awkward bifurcation, and in the absence of certain modern values and practices, culture and cultural debates have become unstable, constantly changing in a disorderly fashion. This partially explains why despite all its struggles and desires for modernity, Iran, through a series of paradigmatic responses, has become what I term *modernoid;* a society that resembles a modern one in some areas but lacks other essential modern structures.[1]

To illustrate this notion of modernoid in Iran, a theoretical and comparative look at the concept of modernity is valuable. American modernism presents a good example of what has been achieved through adaptation and creative modernity and not through paradigmatic response to it.

The American Approach

In explaining the expatriation of the modern authors Henry James and William James, Mark Bauerlein believes that to realize one's Americanness, one must search out "forms of civilization *not our own*" and "fuse" and "synthesize" them into a vision of future "achievement." He continues, "Rather than rebelling

against the (European) past by casting it as some obsolete feudal mistake or preserving one's innocence or ignorance through some illusory commitment to nature, Americans embrace those from other cultures, incorporating them and using them as an opportunity for growth." He exemplifies this process in his book using the Hegelian language of "'fusion and synthesis,' a language that does away with simple oppositions of nature and culture, past and future, East and West."[2]

In contrast, Iran fails to do this and consequently does not fall into any of the definitions of modernity as differentiated by Mike Featherstone. These include "'modernity' proper as an epochal or historical category; 'modernité' as a state of mind and being or a human experience; 'modernisation' as material development; industrialisation, or development in technology and economic relationships; and 'modernism' as a realm of cultural and aesthetic values and practices."[3]

Three decades after the 1979 Revolution, thinkers and academics, in Iran and abroad, are still debating voluminously Iran's modernization. They ponder the tensions among religion, tradition, and modernity—the same set of concepts that were the preoccupation of their predecessors in the late nineteenth century.

A new generation of political activists, such as Akbar Ganji, Abbas Abdi, and Said Hajjarian, and religious reformers, such as Abdolkarim Soroush, Mohsen Kadivar, Mostafa Malekian, and Mohammad Mojtahed Shabestari, began to reinterpret the tenets of Islam to highlight religious tolerance. Soroush, who broke away from the mainstream Islamic revolutionaries soon after the 1979 revolution, particularly shook the theological foundation of the state discourse when he argued for a liberal interpretation of the faith in numerous published works and lectures.

Worthy of Special Note

There are two key questions in their writing: Are modernity and Islam compatible? How can Iran and Islam achieve democracy and a civil society, and is this even possible?

A number of scholars have been concerned with modernity in trying to introduce, define, and redefine the concepts related to and the connection between the issues of modernity, tradition, and in some cases the 1979 Revolution.[4] Others look at these issues from a historical point of view. For example, Afsaneh Najmabadi notes that Qajar backwardness was "an internally generated

problem" rooted in the "unwillingness of the wealthy classes to diversify from commerce and land to industrial ventures."[5]

She further notes that intellectuals' answers to the question "why is Iran backward?" changed constantly. Initially, intellectuals sought answers in the structures of government; then in the mid–twentieth century they shifted toward the "economic structure of international capitalism" as a factor; and by the end of the 1970s they shifted internally to see the erosion of traditional Iranian and Islamic values as the cause.[6] These scholars provide critical studies of the pioneering modernist thinkers and present Eastern society as the "other," the nonmodern.[7] Some believe that, according to the existing definition of modernity, Iran can be understood as a modern state. Others, however, like a number of scholars of Western modernity, imply that a final answer about Iran's modernity is elusive because there is no common or widely accepted understanding of the meaning of modernity.[8]

There are some scholars, whether or not they believe in an indigenous or local modernity and multiple forms of modernity, who maintain that Iran achieved modernity in certain technological and material areas but not in other areas, such as social and political participation.

Postcolonial and postmodern researches on modernity in third world societies, however, have been especially influenced by the works of Elsa Chaney, Marianne Schmink, Ester Boserup, Frances Vavrus, Lisa Ann Richey, Eleanor Burke Leacock, Caroline Brettell, and Carolyn Fishel Sargent (to name a few).[9] Overemphasizing certain undeniable negative aspects of capitalism and globalization, these analyses have concluded that the "Western model" of modernity has negatively affected lives in third world countries, including Iran. These approaches include the postmodern notion of diverse modernities, the notion of the "indigenous modernity," "authoritarian modernity," "multiple modernities," or "creative modernity." A number of scholars of Iranian and Middle Eastern studies have pursued these views as well.[10]

I believe this angst over the problematization of the concept of modernity is unwarranted.

Reinhart Kössler, a German sociologist, writes, "The modern nation state forms one of the central achievements of the grand process of rationalization on which modernity in an encompassing sense resides. In its region of origin in northwestern Europe, this form of the state is the outcome of a long series of

societal and political transformations that have led to a number of interrelated structural relationships and institutional arrangements."[11] Furthermore, Allan Pred and Michael Watts describe a "multiplicity of experienced modernities" and assert that there is not just one way to express and experience modernity.[12]

The journal *Public Culture* has included contributions by some who advocate the notion of alternative or creative modernities. According to the authors, these modernities, however, are neither mere imitations of Western modernity nor the forceful imposition of an outside mode of modernity by Western authorities; they are, rather, adaptations.

Adaptation or imitation of modern ideas in Iran occurred with the translation of works from European sources and with the contact of some Iranians with European societies in the nineteenth century or earlier. It is important to ask whether those ideas ever materialized or were institutionalized or whether they were greeted with animosity by the ruling elite.[13] Adaptation and imitation can be positive approaches only if there is a positive and informed attitude toward European modernity among the majority. Even if there was some merit in the Western criticism of modernity, it does not mean its basic principles and values should be dismissed in the case of Iran.

I propose to perceive Western modernity as a series of universal guidelines for social, cultural, political, and economic projects; a series of grand ideas, decisions, and actions that made a difference in Western societies.[14]

Indeed, based on these projects, the core of modernity has come to lie in its recognition of the individual in all aspects of life—in epistemology, in the principle that economics presumes sovereign consumers, in the equality of all political voices, and in the equality of sexes—and in its recognition that sex, sexuality, and sexual preferences are one's prerogative.

Rationalism

Through rationalism, modernity has resolved the tensions between religion and state, which is key to making democracy possible. Through rationalism also, modernity has made the grand processes of negotiation and compromise possible. It has helped develop a respect for all that was achieved in the West over six centuries through the Renaissance, Reformation, Enlightenment, and Industrial Revolution—perhaps also the American sexual revolution of the 1960s, which though to some extent a failed experiment did in the end empower cultural

desires for individuality and peace.[15] As a result, modernity as it developed in the West combined and created structural and institutional aspects of life as, for example, the possibilities created by the French Revolution to empower people versus political arrangement.

This is common in all "modernities" and in all definitions offered by Durkheim, Weber, and even Marx.[16] Therefore, the belief that Western modernity is unsuitable to Iran's particular historical situation cannot explain Iran's numerous social contradictions.[17] Such theorization facilitates a *disconnect* between Iran's historical achievements and Western progress in creative literature, science, natural philosophy, medicine, politics, and in virtually all human faculties.[18]

This disconnect has contributed to the creation of a modernoid Iran, where the essential components of the "blueprint" for modernity, such as a rational state system, an individual's right to control his or her own body, and a dialogue about sexuality, are missing.[19]

Nothing New

The problems, resulting from these contrasting attitudes to Western modernity, already have a long history.

For example, in 1868, Jalal Al-Din Mirza, a Qajar prince, referred to Europeans as "the sages of the Earth."[20] Sayed Hasan Taqizadeh, who was very familiar with Western societies and in the early twentieth century helped introduce several Western-style institutions into Persian society, once wrote, "Iran must become westernized outwardly, inwardly, in flesh, and in spirit, and that is that."[21] Taqizadeh's approach, which resembles somewhat the views of political leaders in the region in the early twentieth century, stands in contrast to those of theorists such as Marshall Berman and his Iranian followers. Berman radically opposes a blueprint of modernity, although time and world experiences have not been in favor of Berman's approach.[22]

Taqizadeh, his colleagues, and their like in subsequent periods knew that debate, strong advocacy, and adamant adaptation of ideas of modernity were essential to the actual process of modernization. In his treatise on the need for reform entitled *Daftar-i Tanzimat* (The book of reforms, 1858–59), Mirza Malkum Khan also argued that over the centuries, the Europeans had evolved a system that Iranians should adapt as "unquestioningly" as they did the telegraph.[23] Gender equality was also part of this modernist discourse. Yet none paid

attention to the nuances of modern sexuality and the need for a modern discourse to further the broader need for the adaptation of the ideas and guidelines of modernity. None could overcome the power of traditionalist and religious thinking about women.

In his book on Iranian women, Kasravi mentions that H. Adalat, a writer who once defended women's limited social participation in an article in the year after the Constitutional Revolution, was forced to leave his city.[24] It is interesting to notice that despite his halfhearted defense of women's unveiling and education in his book, Kasravi himself concludes that women should not wear makeup outside the house, should not associate with strange men, and should be accompanied by their husbands when they go to parties. Perhaps the most injurious assertion in his work is, as he supports polygamy in some cases, his incorrect portrayal of European women as a means of enjoyment for their men.[25]

A generation or so later, Jalal Al-e Ahmad, Ali Shariati, S. F. Shadman, S. H. Fardid, S. H. Nasr, D. Shaygan, and many other Marxist and Muslim thinkers criticized Western modernity based on its notions of sexuality and always in unsubstantiated nebulous writings and speculations. They challenged modernity as an approach incongruous with the Iranian condition, an idea that, soon, along with the suppression of sexuality and the disregard for gender equality, became the core thinking of the postrevolutionary ruling conservatives. Al-e Ahmad (1923–69) believed that consumerism and women's emancipation were the result of the subversive Western influence on pure, indigenous Iranian-Islamic culture.[26]

A similar notion was also promoted in the works of his life-long companion, Simin Daneshavar (b. 1921), a pioneer and highly acclaimed fiction writer. I refer to the short story "Tasadof" (The accident, 1961).[27]

Women's struggles and newer education on home economics could not change the outcome of the existence of the stigmatized religious discourse of sexuality or create a modern discourse on gender identity, relationships, sexual violence, sexual orientation, and other issues related to sexuality. In the mid-twentieth century, the goals of women's organizations and other social activists could hardly exceed simple forms of women's social participation and limited gender equality; they made no call for sexual parity.[28]

In the decades immediately prior to the 1979 Revolution, a great number of Iranian women's activities were influenced by oppositional ideologies. These

were in place to undermine the Shah's rule. Issues related to women's rights were not as important as the broader national concerns.[29]

Women who attached themselves to leftist political groups believed that true women's liberation would materialize only in a socialist or Islamic society.[30] Because most intellectuals thought of feminism as a bourgeois ideology, feminism remained an obscure concept.

In the end, Ayatollah Khomeini was able to bring thousands of women to street demonstrations to support an ideological movement that was about to gain power and limit their social role even further.

In the West, negotiations about meanings, bodies, and sexualities had occurred from antiquity through the Middle Ages and continued to the modern time with only short-lived extreme regressions such as the Nazi's subjugations and suppressions.[31] Through this negotiation, gender and sexuality have been progressively reworked and re-represented, leading to a modern discourse in which members are able to express sexual drives and intimate issues and even express their identity through sex or in relation to sex. This preoccupation with sex, despite historical and religious transformations, is wittily or frankly reflected in literary works of different eras, areas, and genres, from *Genesis, Sappho's Poems, Pericles, Paradise Lost, Pretty Little Games,* to *The Penis Poem.* This process also signified a shift from marriage as procreation to marriage as love. Mythology, history, and arts have all helped the understanding of sexual desire. Aphrodite, the beautiful goddess of love and sexual rapture, has been constantly present in cultural manifestations. Even pornographic writings have historically used or misused cultural heritage. One can even see documented similarities between today's culture (perhaps more so in Europe) and that of the ancient world. For example, from two different feminist approaches to pornography, contributors to Amy Richlin's edited volume analyze a wealth of ancient sources and genres. They, however, do not challenge Foucault's assertion about the history of sexuality because he simply attempted to challenge the notion that sexuality has been repressed since the seventeenth century.[32]

To be fair, the West at one time may have held a liberal notion about sexuality while at another time a religious understanding of sexuality as sinful may have prevailed. But these negotiations and the resulting progressions laid the groundwork for thinkers such as Alfred Kinsey, Herbert Marcuse, and Simone de Beauvoir, who in turn paved the road for the sexual revolution of the 1960s.[33]

The psychoanalyst Wilhelm Reich (1897–1957), Freud's colleague, suggested that to conserve one's mental health one needed to liberate one's sexual energy.[34] Hugh Hefner and Larry Flynt developed "products" that encouraged this liberation. And before all of them, Eadweard Muybridge had introduced the picture of naked men and women in what was cinema in 1884. Then, in the 1970s, Foucault amply showed that the West's fixation on sexuality, its ubiquitous representation, and its perception as something quite natural were part of a discourse that led to a conception of "sexuality" that exuded constructive power.

Some of Foucault's readers have understood this assertion differently and argue that historical facts do not support Foucault's theories on sexuality.[35] Ann Stoler tries to implicate Foucault in this *reading* of the relationship between the West and the third world countries. In Hannah Tavares's words, "Stoler recovers the fact of colonialism" within Foucault's story of a nineteenth-century European bourgeois sexual order. She takes issue with Foucault's four strategic unities that formed "specific mechanisms of knowledge and power centering on sex," which include "the hysterization of women's bodies, the pedagogization of children's sex, the socialization of procreative behavior, and the psychiatrization of perverse pleasure."[36]

I believe the big picture in Foucault's history of sexuality was omitted. Foucault's point is that the existence of historical discourses on sexuality (including the way it has been explored and controlled) is an intrinsic characteristic of the bourgeois society.

In a most optimistic way, one may say that Foucault's critique of modernity through his deliberation on discourse and power makes a critique of the Enlightenment through the deliberation on the equation of reason, emancipation, and progress. That is, he might be understood as a thinker who forcefully argued that modern forms of power and knowledge had created new forms of domination. This argument about modernity is as irrelevant to Iran's situation as Foucault's comments on the 1979 Revolution.

Iran lacks that historical characteristic. In the West, drawing upon Foucault's work, Daniel Juan Gil argues, "In sixteenth-century culture emotional limit experiences open the door to a bond that is sexual and not social."[37] Gil also points out that according to Jonathan Goldberg sexuality was not a separate domain in that same period.[38] At any rate, by the time Foucault wrote, the sexual revolution (which made all the above Western theorization possible) was already

a reality; he simply provided historical and theoretical support for what was an integral component of the modernity he was pondering.[39]

The Canvas Shouts!

Western art very vividly portrays such connections made in Foucault's work. (For understanding the intersection of creative and scientific knowledge about sexuality, it is important to understand what Foucault describes as ors erotica and scientia.)

To give a simple example, the painting *La Liberté guidant le peuple* (Liberty leading the people) by Eugène Delacroix has personified and symbolized the Paris Revolt of 1830, which toppled Charles X. A woman showing her breasts, holding the French flag and a rifle, and leading the people over the bodies of fallen revolutionaries, links the representation of sexuality with women's social participation very potently.

And, There's More

To be sure, Julia Kristeva links feminine writing with female pleasure, with motherhood.

Hélène Cixous conceives a fundamental connection between the woman's body, sexual pleasure, and sexual expression within women's writing.[40]

Luce Irigaray believes that masculine language cannot express women's sexual pleasure (jouissance).

Walton, drawing on the Jacques Lacan's psychoanalysis, conceptualizes desire as the "marker of subjectivity."[41] His model might be more related to the problematics of racial dichotomies; however, I find it illuminating in explaining dichotomies related to sexuality as well. That is, the model consists of two binary oppositions: Lacan's distinction between male or female as they relate to the phallus and the distinction between being black or white. This can also be explained by Lévi-Strauss's endogamy and exogamy.

Barbara K. Gold, Paul Allen Miller, and Charles Platter shed light on the connections of the representations of the feminine and the female body in Renaissance texts (and in the Latin tradition).[42]

Albrecht Classen, a scholar of medieval studies, has contextualized the middle ages' notion of love and sexuality to further show such connections.[43] All this indicates that even the sexual revolution was well rooted in a medieval Western

notion of sexuality. Classen further points to the extensive scholarly writings about Luther's viewpoints on sexuality and his call to women to abandon "the cloisters and nunneries and embark on a new life outside the monastic walls."[44]

Finally, Matfre Ermengaud's *Breviari d'Amor* (1288–90), a sort of encyclopedia of love, presents as acceptable courtly love, extramarital love, and adulterous love. Through its different sections, it tries to be reconciliatory between religion and types of erotic love.[45]

Yet, centuries after Luther, and decades after the Constitutional Revolution in Iran, even a reformist, secular, and political activist such as Kasravi, in a book that he pioneered in defense of women, considers housekeeping and childbearing the most natural work for women.[46] The Islamic radical fundamentalist group Fadaian-e Islam (The devotees of Islam) assassinated him for his "blasphemies." These two different histories of approach to sexualities in the West and Iran have resulted in two essential differences between modern and modernoid societies.

Crimes and Punishments

In the Western legal system, polygamy and marrying (or having sex with) minors are crimes punishable by imprisonment, but sex between two consenting adults is not a crime.

It might be considered a transient regression, but in today's Iran, the law permits polygamy and marrying very young girls. However, sex between two consenting adults who are not married is against the law and can be punished by hanging or stoning.[47]

Homosexuality and fornication may be punished as severely as murder. Moreover, the punishment for impermissible sexual acts in Iran stands in contrast to Western and modern societies. Imprisonment and punishments such as stoning are philosophically, legally, and rationally very different concepts and represent two different eras of human history in general. Such contrasts are observable in all areas of sexuality, including sex education, women's health, passion, and love.

In any society, where restraint extends to even eye contact or handshakes, the notion of "female restraint" has a radically different meaning than, say, in Euro-American culture. In those societies, women historically and universally are cautioned not to provoke male sexuality because it is "uncontrollable" or "urgent," whereas in Western cultures that notion is challenged.

Even at the beginning of the twenty-first century, IRI continued to justify its implementation of veiling codes by arguing that they ensure "the protection" of women from harassment and unwanted advances. This absolutely ignores the fact (widely accepted in the West) that such crimes might more effectively and equitably be prevented by controlling the attitudes and behavior of the perpetrator rather than the victim. Such laws normalize a man's "savage" sexual behavior toward women: if the woman is not in her designated space, she may "naturally" face the consequences.

The Nazis' subjugation of women, suppression of homosexuals, and mistreatment of prostitutes were an "attempt to harness popular liberalizing impulses and growing preoccupation with sex to a racist, elitist, and homophobic agenda."[48]

A modernoid society may find it easier to imitate or adopt Western commercial, medical, industrial, and administrative models than to embrace the rationalization, regularization, and validation of issues related to gender, sex, and sexuality. In Iran, for example, during the height of "modernization" in the 1970s, very limited preoccupation with the most basic issues related to the female body and its representation led to a sociopolitical backlash.[49] The female body never freed itself from politics (and traditional constraints). This factor fed the "revolutionary" culture of the next decades, in which the complete control of women by men (relatives and statesmen) became the aim of state ideology. In the 1970s, women kept silent about their sexuality. So did men, who warily observed the results of "Westernization" through their ideological prism. A decade later, men in power began to suppress women socially, culturally, and legally. In both the pre- and postrevolutionary periods, intellectuals in Iran ceded questions of desire and the body to the political elite, who then suppressed them, with their now politicized archaic discourse.

There are other daunting contradictions in modernoid Iran regarding gender and sexuality. The country's economic need to be a part of globalization strategically contradicts its ideological expediencies that resist integration and promote segregation.[50]

Florence Babb notes that in the process of globalization, "like gender a couple of decades ago, sexuality now figures both as a subject of study in itself and as a sort of barometer for the vast changes taking place within and across societies."[51]

These tensions are observed in all levels of social life in Iran. Women's behavior in northern Tehran's cozy coffee shops, where they can sometimes cunningly

hold hands with their boyfriends, contradicts the forced behavior in other areas of the same city where they have to cover entirely and control all their mannerisms in order to avoid attention or any unwelcome sexual advances. Women must work in public, especially in the service industry, yet they must adopt a rough tone, avoid references to sentimental issues, and avoid looking directly into men's eyes in order not to arouse men's sexual curiosity.

An Infuriating World of Contradictions

It is a world of contradiction where a clergyman, sitting in a comfortable chair behind an imported desk and computer in a judiciary office decorated with the photos of the leaders, decrees that a certain woman must be stoned because she had unlawful sexual relations with a man, who gets a much lighter sentence.

For the judge, the reason for the sexual encounter is irrelevant; there is no distinction between having sex out of love or for prostitution. Prostitution is perceived as the product of the woman for her own benefit with men having nothing to do with it.

These inhibitions lead to contradictions between looking pious outside and committing "sins" inside; between public life, where people use religious references to get by, and in private life, where they curse the religious ruling elite; between a desire to be honest and the necessity to be crafty, cunning, and shrewd; and between assumptions and expectations.

The responses and factors that foster resistance to modernity or facilitate the repression of sexuality have begun to affect other aspects of life. Whether women can ride bikes on the streets, ski in the resorts, participate in other sports, or attend men's sporting events can have a major effect on urban and architectural designs. Perceptions about women's space needs influence the shape and use of buildings.[52]

After the revolution, the old notion of the domestic space in which houses were divided into the interior and exterior zones to be occupied by different genders has come back in new forms and features.[53] Once again, walls and window levels are higher. More windows are covered with thick curtains and thick bars. Balconies are camouflaged with materials that are not intrinsic to the structure. The profitable high-rise construction business has resulted in spaces in which segregation and control become difficult for the police or vigilantes.

Cities with their hodge-podge of styles reflect turgid or major discontinuities, changing self-perception, its dogmatic view of the past, its troubling relationship

with the West and the Western notion of sexuality, and its dramatically differ-ent perceptions of women and their place in Iranian society. Although Western architectural space designers sometimes ignored women, most such instances occurred in the past. Diana Robin writes, "But the new humanist ideology of space and spatial expansiveness that was so decisively expressed in fifteenth- and sixteenth-century painting, architecture, city planning, and literature also reinforced a consciousness that was increasingly narrow and exclusionary in its social and sexual dimensions."[54]

Facts Are of No Consequence

But perhaps Iran's most daunting contradiction has been its predicament with the very meaning of sex and with sex education. Religiously, sex has been presented only as male penetration, with no discussion of female enjoyment. And no comprehensive study has been done in regard to the kind of education that mothers provide their daughters at the threshold of marriage.

By all indications, however, penetration has been perceived as carnal; the spiritual aspects have been reserved for mystic realms. Sex has traditionally been presented as prurient and an activity that could pollute both the body and the spirit. A very recent and timely book by Willem Floor in fact documents a social history of sexual relations in Iran reviewing issues related to marriage, temporary marriage, homosexuality, and prostitution and shows the centrality that male satisfaction holds in all its history.[55] Sirus Shamisa documents literary works on some sort of homosexuality and pedophilia to show they existed prominently in Iran's medieval society.[56]

There has never been a systematic curriculum on sexuality in schools, and prior to the Internet, there have been a few scattered, and hardly accessible, sources for sex education available to youth. Even Mehdi Jalali's 1952 inhibited transla-tion of *Helping Children Understand Sex,* by Lester Allen Kirkendall, did not have much to offer.[57] To this date, debates about birth control can be unsettling.

In the absence of state-sponsored sex education (in schools or elsewhere), clerics and religious books preached that after touching a dead person or after ejaculation, a full absolution (full shower or bathing in a tub or a visit to the public bath) was necessary, whereas after defecation and sweating, only a partial ablution was recommended.[58] Safdar Sanei's *Ta'alim-e Behdashti-e Islam* (Islamic teachings on hygiene, 1960), which consisted of incongruous short translations

of Western sources juxtaposed with divine verses, had less than a page on the hygiene of a woman's body and, in so many indirect words, simply suggested that women's pubic hair should be shaved for issues of both health and prayers.

Was the author sincere about his reasoning? If so, why did he state that intercourse during women's menstruation is dangerous?[59] Such rare publications no doubt lacked any substantive information about anatomy, stages of pregnancy, or lactation. Lack of knowledge and inhibitions also prevented parents from offering any substantial education to their own children in private.

Consequently, while couples were instructed on the significance of spotting blood on the wedding night, they knew too little about sexual organs, the clitoris, G-spot, women's orgasm, or climax.[60] Even if they knew something in addition to the traditional female concerns about sexuality that would pass through the generations in traditional fashion, it is not clear how the new knowledge would be shared through the language. Descriptive words, to the extent there are Persian equivalents for them, never became part of common parlance, except for cursing in some cases.

This is not to suggest that Westerners knew all about these issues from the outset. For example, while talk of the G-spot can be found in fourth century BC texts, many Americans were misguided about it until the 1950s. However, discussions and debates about it and related topics did occur, and curiosity about these issues did not meet systematic cruel chastisement throughout its history.

Consequently, no public dialogue about proper and enjoyable sexual relationships exists to dispel ignorance about the roles of foreplay, undressing, and means of ensuring women's enjoyment. A six-volume small size sumptuous book on marriage advice for parents and the couples in their negotiations published in the early years of the twenty-first century devoted only a few pages to intimate relations.[61] On those few pages, the authors displayed an astonishing ignorance about women's sexuality. They warned against what they perceived as a "common" mistake between the vaginal opening and the urethra.[62]

The situation with popular culture, including popular arts, was somewhat different and will be addressed at length later.

Just a Glimpse

The popular women's magazine *Zan-e Ruz* promoted the importance of feelings and emotions in personal intimate relationships when it published the

translation of scattered portions of some English or French articles, in which penetration is perceived as spiritual. But the magazine never used straightforward language. For example, one article tried to answer the question: "Do you think that today's modern couples are more coherent and more flourishing in their sexual lives than those of the previous generations?"[63] The answer was not clearly stated. Such entries reinforced the traditional teaching that "Emotional attachment in marriage is considered desirable on the part of the wife towards the husband, but not vice versa" and that "The male's power and control over his wife is considered in jeopardy if he is overly fond of his wife."[64]

The pictures of blond Western men and women that accompanied the partially translated articles also, I believe, distanced the topic from the local populace, rendering the whole attempt futile. One could come away with the feeling that happiness exists only in distant places. And the journal *Khandaniha,* a sort of *Reader's Digest,* which published a series of translated portions of an American book about sex, began with an entry titled "Women's Sexual Perversions; Sexual Attraction in Men and Women" with the statement, "Rarely one can find a woman who does not have a sexual perversion."[65] The rest of the article is almost incomprehensible. It is, however, accompanied by an advertisement for the 1958 Ford, with a black-and-white drawing of the classic car. Interestingly, another translated article of the same journal, entitled "Can Men Fall in Love with Several Women Simultaneously?" gives examples of situations in which this can happen.[66] Around the same time, the journal *Sepid o Siyah* devoted many pages to "Fighting Against Prostitution," which in the opinion of its writers was an urgent social problem.[67] Women's social participation was tacitly blamed for the rise of the phenomena. In fact women were often blamed for all sorts of social calamities.

Even the famous humor magazine *Tofiq* constantly flirted with nudity and sex as it denigrated women who participated in the public sphere. The colorful cover of the 1970 New Year edition portrays a very young Western blond woman showing her breasts though two small stars cover the nipples. And the first joke is the caption of a drawing that shows two Iranian women exposing their legs entirely and reads, "Why doesn't your fiancé talk to you anymore? Did you do something wrong?" "No! I did not do the wrong he wanted me to do."[68] The next "joke" reads, "The best New Year's gift one wife can give her husband is a day home alone with the servant."[69] In another drawing, a man seems to be

shouting upon arriving home when he finds his wife naked and in bed with a man. The man in bed says, "You have been driving my car for two days and I am not shouting at you."[70] A majority of the jokes, cartoons, drawings, poems, and other pieces in this volume and other issues of *Tofiq*, the epitome of satirical journalism, ridicule women's sexuality and sexual activities and degrade them in the case of urban laudable marriage.

In the mid-1970s, a sort of indigenous *Playboy* entitled *In Hafteh* appeared on the scene, creating more confusion about Western culture and human sexuality. The centerfolds of the indigenous popular sexy stars were to accompany, not replace, the Western ones.

Contradictions are manifested in the cultural perception of an obsession with the hymen. For example, there are numerous praises and references, albeit in metaphorical forms, to the hymen in classical Persian literature. Even the works of Nezami (Nizami) Ganjavi (1140–1202), which generally portray women in a more progressive light, offer dozens of such metaphors.[71] For example, he refers to the hymen and virginity as the *ganj* (treasure), *ganj-e dor* (treasure of pearl[s]), *ganj-e gohar* (treasure of gem[s]), *khazineh* (treasury), *ganj-e qand* (treasury of sugar), *dorj-e qand* (jewel box of sugar), *kan-e la'l* (mine of rubies), *dar-e ganjkhaneh* (treasure house door), *qufl-e zarrin* (golden lock), *mohr-e gohar* (jewel seal), and *mohr* (seal). In contemporary literature, being chaste is the cornerstone of an unmarried woman's overall virtue. While it had become increasingly acceptable for a young man to have sex (available via burgeoning prostitution houses and other forms), preservation of the hymen was still, in the 1970s, a cultural imperative. It served as the proof of a woman's morality and virtue and for the sake of a man's self-confirmation when he consummated the union and broke the hymen.

Paula Drew writes, "A girl who loses her virginity before financial matters [dowry, alimony, etc.] are agreed upon is not only considered to have behaved immorally but also is seen to have given the other side an advantage in negotiations, in that the girl's parents cannot threaten to withdraw from the match, however poor the terms offered."[72]

The author admits, however, "The general lack of privacy inhibits all but the most perfunctory intercourse."[73] If true, such performances could not have provided any chance for the exchange of romance and emotion. As we will see, the obsession showed up in all sorts of cultural products in the 1960s and 1970s from

movies to journalistic works. Even translated articles in pop journals often had headings such as "Girls: Do Not Lose Your Virginity," arguing that any premarital sexual relations will destroy their lives.[74] These notions gained a renewed dark significance after the revolution in the dominant state discourse.

To this date, the official talk or "presentation" of sexuality is aimed at the creation of a fear of jeopardizing virginity. If a girl lost her virginity before marriage, she would gain a bad name, be denied a union with a desirable husband, and imperil her future family life.

An Unpredictable Bit of Anatomy

It is interesting to note that a membrane that is found only in some females had been, for centuries, a very powerful regulatory element in traditional culture, which did not know (or refused to acknowledge) that not having one is also a common natural phenomenon. If the mother-in-law did not have blood evidence of the breaking of the hymen (although in some cases, women with an intact hymen may not bleed during intercourse), the bride was adversely affected for the rest of her life. The marriage could be dissolved without delay. Therefore, Schelegel's observation pertaining to modern societies suggesting that "one way to assess a woman's autonomy is to ask whether she controls her own sexuality" becomes entirely extraneous in Iran.[75] In fact, tension between nature and the social construction of virginity has been, for a long time, the basis for all cultural rules surrounding sexuality and its representation.

Although customary and dependency culture (close relationships between family and extended family members) manifest themselves differently in different social classes, and although gender roles are in transition in Iran, there is still a contradiction between the traditional notion of virginity, hymen, and sexual satisfaction and the modern understanding of these human aspects. A large segment of Iranian society accepts the notion that "it is thus part of the female role, in the capacity of mother, aunt, or grandmother, to participate in the continual supervision of younger females, leaving no opportunity for behavior that might jeopardize nuptial agreements.[76]

Poorly produced movies, journals, and other media in the 1960s and 1970s only increased the young generation's sense of dissatisfaction and lack of fulfillment. These representations, despite their nontraditional form, did not promote, due to their absurdity, the development of romantic love or a familiarization with

women's sexuality nor did they satisfy the need for romance. Some of the early and mid–twentieth century novels collectively known as prostitution literature were equally awkward.[77] Moshfeq Kazemi, Mohammad Masud, Hedayat Haki-molahi, Mohammad Hejazi, Jahangir Jalili, Rabi' Ansari, and Javad Fazel, who wrote in this genre, were neither well known among the populace nor able to properly construct a modern notion about sexuality.

Since the revolution, and despite, or perhaps because of the generational change of attitude toward sex (mostly due to information technology and general access to Western images and thoughts on sex and relationships), these concepts have increasingly occupied an expanding space in the society's judiciary system.

You Can't Win!

Article 1128 of the Civil Code reads, "If a special qualification is mentioned, as a condition of the marriage, to exist in one of the marrying parties and if after the marriage it is found out that the party concerned lacks the desired quali-fication, the other party has the right to cancel the marriage."[78] One of these conditions is related to the concept of *tamkin* (obedience or submission). *Tamkin* generally refers to the duty of wives to obey men in all affairs. However, more specifically, it is about the wife's submission to her husband's sexual needs and demands under any circumstances. Not complying with *tamkin* is grounds for the husband to divorce the wife, according to Iran's current religious law.

Such a demand, as Mojgan Kahen states, stands in direct contradiction to all social, psychological, and medical findings about sexuality.[79] Fatima Mernissi's "explicit theory" provides an explanation of this tension. She believes the per-ceived sexual roles are that men have strong and capricious desires but are also providers for women, and that women maintain their virginity and lose it only to a lawful husband, to whom they will show loyalty, chastity, and dedication.[80] In such circumstances, women's efforts to remain chaste (based on the traditionalist discourse of sexuality) conflicted with their desire to integrate into society.

The concept of sexuality in Iran has never included the more straightfor-ward issues of eroticism, repression, and sexual relations. These contradictions, tensions, and moral conflicts are sending flocks of people to courthouses at alarming rates trying desperately to settle all sorts of sexual disputes. And the judges in these burgeoning courthouses are the young graduates of religious

seminaries of Qom, Mashhad, and Isfahan, who are heavily armed with a medieval notion of sexuality.[81]

Similar assumptions and more critical problems exist in regard to sex between males in Iran. Historically, male sex in Iran cannot be conceptualized as homosexuality because the giver and receiver were viewed differently; the former was perceived as normal and the latter was considered abnormal. Today, however, both men can get the death penalty by hanging for their behavior. Other forms of physical contact such as touching, holding hands, and frequent kissing of cheeks are practiced among members of the same sex group without any association with homosexuality. In recent decades, the number of kisses and their frequency among men has even increased. For example, before the revolution, two men kissed one another on the cheek twice after coming back from a trip or after a long lapse in their visits or friendship; however, recently they kiss three or four times and almost every time they meet.

Therefore, religious texts—including the most holy books that contained numerous references to sex, albeit a medievalist sense of sexuality—as well as traditional and local customs and a male-dominated culture all contribute to the existence of a sense of reverence, almost awe, pertaining to sexuality and chastity.

Abdelwahab Bouhdiba's frank criticism of Western sexuality illustrates my points. He writes, "The open sexuality, practiced in joy with a view to the fulfillment of being, gradually gave way to a closed, morose, repressed sexuality. The discovery of one's own body and that of another, the apprehension of self through the mediation of otherness, turned in the end into male selfishness."[82] This stigmatized discourse and the religious stagnation imposed on freedom of sexuality prevented the emergence of sexual behaviors in Iran that could mesh with the changing times and with attempts to create a balanced society and opportunities for all members to thrive.

Popular Culture and Cultural History

Iranian popular culture dealt in a limited, apprehensive, and precarious way with pornography and the representation of sexuality, especially in the late 1960s and 1970s. As mentioned, the Iranian meanings of the concepts of "popular arts," "high arts," "popular culture," and "high/elite culture" differ somewhat from their Western meanings.

Western modernism has largely blurred the antagonistic distinction between "high" and "popular" culture and arts. In Iran, in addition to traditional religious ceremonies or some nearly extinct theatrical forms, popular arts include FilmFarsi products, dance, commercial movies, television shows, talk shows such as Mikhakh Noqrei (silver carnation), serialized stories in popular magazines, and the pop music that most people consume and appreciate. Performance arts, often expensive to produce and consume, noncommercial movies, and poetry and literary works are examples of high, fine, or elite arts. Popular, or pop, culture includes such elements as daily discourse and interactions, costumes, tradition, habits, clothes, and cuisine. In the twentieth century, due to technological advances, this list expanded to include other pop cultural phenomena such as media production, fashion journals, popular stories, and the popular arts mentioned above. High or elite culture, in contrast, refers to activities that take place in locales such as museums and performance halls and include the high arts mentioned above.

Numerous scholars have analyzed the high cultural products from different disciplinary perspectives. In my previous works, I provided an explanation about how creative works such as elite literary output have produced, functioned, and interacted with history. I believe many questions regarding popular culture and popular arts and those who produced them require similar attention. A particular question to ask here is about the axiology of the social roles of dance, cinema, music, popular magazines, and their roles, if any, in Iranian mass uprisings. For example, as Chehabi believes, music, nationalism, and the quest for modernity had close affinity during the late Qajar period and under Reza Shah.[83] To be sure, these elements help establish the conditions necessary for democracy, and their connections were very well understood by the late nineteenth century early nationalist/modernist thinkers.

I believe their production has been inconsistent either as responses to Western entertainment genres or as expressions akin to Soviet ideological genres. In either case, popular cultural products covered some of the preoccupations of the high culture and political ideologies. The problem is that as paradigmatic responses, foreign ideologies took different forms upon their arrival in Iran.

Liberal thinkers, since the Qajar period, have resembled their Western counterparts only in some of their wishful credos. The true ideas of liberty and freedom were never absorbed, embraced, or expressed, even in arts, as poignantly as

in European contexts. Those ideas were either lost in highly metaphorical language or mutilated through the imitation process.

The French critic Jean Baudrillard could have witnessed the real "death of the real" In Iran.[84] Iran's Tudeh Party, for example, hardly resembled the European socialist forces who were respected for their rich history of the defense of the working class. Similarly, movies and literary works inspired by Marxist ideas never gained the ephemeral quality of some of the Western products in the same fields. Instead, cultural producers, in both high and popular cultures, ended up believing that society's problems could be resolved only through a political uprising, that is, in the revolutionary movement of 1976–79. New Wave cinema and FilmFarsi, Marxism and Islam, poetry and oration, word and image all united to provide more reasons for the use of force against the regime. When Al-e Ahmad noticed the problems of traditional gender roles and the problematics of traditional matrimonies, he did not hesitate to blame those problems on the regime's quest for modernization.[85]

A Common Thread in Shahrzad's Movies

Let us pause briefly on FilmFarsi, which came close to dealing with some aspects of sexuality.[86] Nearly all of Shahrzad's sixteen movies arguably belong to the FilmFarsi type. As I mentioned in chapter 1, the problematics of the concept of genre and the diversity (in terms of themes, message, technique, etc.) of movies produced in the 1970s make it difficult to refer to what is known as FilmFarsi as a genre. Nevertheless, I use this term to refer to commercial movies of the 1960s and 1970s that suffered from weak plots, simplistic messages, and slipshod forms and were yet able to entertain a segment of society. Most of them mixed the epitome of an irrelevant moral point with music, dance, and fleeting nudity within an inane plot.

FilmFarsi, including Shahrzad's movies, did not initiate a serious discussion of sexuality in any modern sense. The nudity in FilmFarsi did not appeal to self-defined intellectuals, and consequently the number of criticisms multiplied in film industry journals. The escapists among that generation preferred Western genres now permeating all corners of society.[87] To them, Iranian movies, particularly FilmFarsi movies, were repetitive, dreary, and repulsive.[88] They believed that the themes, acting, songs, and dances were mediocre, sometimes indecent, and lacked socially satisfying messages.

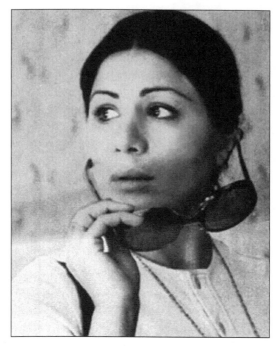

1. Shahrzad in a photo originally published in *Ferdowsi Magazine.*

In retrospect, the tragic failure of FilmFarsi to deal with sexuality on a higher plane is a factor that hindered the greater social and political development in Iran in the late 1970s. Despite the scenes of dance and nudity, the male protagonists constantly promise women respect only if they follow traditional rules of chastity. The films, like other cultural manifestations discussed earlier, were merely a declaration that women who want a place in society must be chaste, obedient, and modest. In some cases, an education would be desirable. These messages were in contradiction with the medium that delivered them. FilmFarsi employed half-nude women and sought to entertain cheaply. Reviewing these issues helps us to understand what happened and how things changed between the screening of Shahrzad's first movie, *Qaysar* (1969), to the production of *Maryam va Mani* (Maryam and Mani, 1978), a movie she directed as her last cinematic work.

These movies, like the pop magazines' repetitive and mediocre short stories, anecdotal tales, and letters to editors, constantly strove to negotiate female space

(and identity) but did not know where and how to begin the debate. The female readers' letters to the editor regarding news, stories, or movies demonstrate disillusionment with modern heterosocial promises. These promises were made in the early stages of the alleged modernization by the Pahlavi kings and by the men in public affairs (who, by the way, made similar promises based on a national identity).

Did village women who left their so-called homosocial spaces to become equal to men in urban areas feel they lived in a heterosocialized urban space?[89]

Did FilmFarsi normalize the harassment and abasement of women?

If these questions are answered in the affirmative, it means that women remained outsiders to the public spaces provided by the Shah and did not share the same identity as men. And then came the revolution, with its new legal and institutionalized limitations on women and their space in society.

The Legacy Continues

The effect of the messages of FilmFarsi persists. It is visible in the postrevolutionary regime's justification for the harsh treatment of women's subjectivity.

It is carried in the psyche of the former intellectuals and revolutionaries in their dealings with the nation's popular artists.

It is evident in the treatment of Shahrzad.

On a Personal Note

While I was researching this project, a woman activist tried to discourage me based on the sensitivity of the regime regarding this topic and Shahrzad. One former movie executive, now in the business of music concerts in North America, insulted the subject of my inquiry as unworthy or at best frivolous. Even the artists whom I interviewed seemed to be frozen in rancorous memories of the past, in a time lost, in a tiny world for which they had no definition, unwilling to speak. Key entertainment industry people I contacted in California were either oblivious to the topic or uninterested. A writer of prerevolutionary journals now living in Europe, who wrote about FilmFarsi actresses and interviewed Shahrzad, did not arrive to keep our appointment. He knew I had crossed the Atlantic for the sole purpose of speaking with him. One wonders how certain feminist theorists might interpret such an unlikely project, a project which, after all, deals with the biography of a woman who is part real and part constructed, a fictional as well as cinematic "bad" woman.

Nevertheless, there is ample evidence to show that in 1970s Iran, popular culture did include some genres that were amenable to imitation of the Western models, albeit often with average results, but it was also under the pressure of ideological discourses very much like literary discourse. That is, cultural and literary production in Iran has always been responsive and discontinuous, a process in which ideological representation and ideology in general have played a decisive role. Ideology no doubt guides people's life.[90] However, as Pierre Bourdieu indicates, people's sense of judgment, taste, and views are also formed by patterns of upbringing or schooling or what he calls "cultural capital."[91] In analyzing the works of women artists, we should therefore be mindful of "cultural capital," "popular aesthetic," and "high aesthetic" as well as the revolutionary and religious ideologies, all which have been in flux due to paradigmatic responses of Iranians to Western thoughts.

A focus on Shahrzad's works and life story, constructed based on her three literary books, which I rendered into English for the sake of this project, and exchanges and missives that include three thick volumes of her hand-written answers to questions posed provide a convincing case study to examine all these abstract notions. Aside from the political relevance of the topic, Shahrzad is indeed a unique woman. She is an iconoclast and a fighter, a woman who has suffered under the traditional notion of sexuality but who has challenged social limitations all her life. Her works belong to diverse genres, and her life serves as an allegory for the lives of many other Iranian women who entered the world of art, show business, and entertainment and experienced an anguished existence. Through an interdisciplinary approach and through contextualizing her works and her social activities, it is possible to go even beyond the above discussion of the problematics of modernity and sexuality. Shahrzad's story reveals that even at the height of her career before the revolution, she was misunderstood, misrepresented, and mistreated. She was never able to secure an institutionally protected space in Iranian society. After the revolution, she faced an even more disconcerting destiny. Her story would be important, pertinent, and historical even if she did not participate in the events of March 8, 1979.

Shahrzad's Story Enlightens Us

Shahrzad's story and those of other female artists of the 1970s help us understand the serious ramifications of revolutionary ideologies for women's life and

creativity. It demonstrates how radical shifts in Iranian culture have led to fierce conflicts, taking a toll not only on political activists but also on women active in nonpolitical areas such as art and entertainment. She embodies the situation of women caught between the shifting positions and the forces of modernity and traditionalism.

I hope to answer, albeit indirectly, a number of additional questions.

How can an ideology change the face and fate of a nation so dramatically?

Why do women's bodies so often become a battleground for ideological conflict?

What is it about ideology that it allows its advocates to shift their positions on certain issues so radically and yet remain committed to the same ideology?

Perhaps Foucault had it right when he wrote that "discourse can be both an instrument and an effect of power, but also a hindrance, a stumbling-block, a point of resistance and a starting point for an opposing strategy."[92] This amalgamation best provides an area in which one may simultaneously examine the problematics of ideology, modernity, and sexuality, and the questions related to women's social roles and the space they occupied in Iran in the 1970s, in both high and popular arts. Others have discussed the use of some of these categories as a useful means of historical analysis.[93]

My emphasis on making a connection between all these areas of social elements is based on my belief that the idea of the project of modernity, so fixated on by this ancient nation, has to permeate both high and popular cultures, as it mostly did in the West, in order to be ultimately successful.

3

Iranian Women and Public Space in the Seventies

Shahrzad, a Woman of Her Time

> I love art, food, and money, and I have been blessed with a wealth of violence.
>
> Shahrzad

IRANIAN CULTURE, even in the heydays of the 1960s and 1970s Westerniza-tion, lacked an open approach to an indigenous eroticism, disparaged artis-tic genres that could represent eroticism, and refused to tolerate—let alone embrace—Western eroticism. Classical notions about sex and erotic imageries as represented in classical poetry, in genres such as narrative romance poetry and *Shahr Ashub,* and in the cabaret vulgarity of the 1970s became less and less familiar or acceptable to subsequent generations of Iranians.[1] And in the contem-porary period (even in the 1960s and 1970s) literary authorities have not shown much interest in literary eroticism. Literary critics often admired certain poets for having clean language (devoid of sexuality). This led to the "veiling" of art, literature, music, and the Persian language, even before the Islamic Revolution of 1979. Among ordinary people who might have a somewhat lax attitude toward sexual expression and sharing sexual experiences, the discussions often almost take a grotesque form, repulsive to some others.

This puritanism along with censorship, self-censorship, and the heavy use of metaphors, symbols, and tropes ensured that eroticism and sexuality were effec-tively banished from Iranian formal culture. Artists who unveiled their hair (as Tahereh did), their poetry (as Farrokhzad did), or their bodies (as Shahrzad did) faced severe consequences.

46

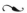

Shahrzad indeed unveiled herself in three ways: in language, on the dance floor, and in the movies, an act that came head to head with the reality of a modernoid society.

Who Is Shahrzad?

Shahrzad's first "official" name was Kobra, a name that had belonged to a sibling who had died before she was born. Her parents decided not to cancel the birth certificate and to use it for Shahrzad. Her mother called her Maraym, and her father called her Zahra. As a dancer, she was called Shahla. And as an actress and poet, she chose the name Shahrzad.[2] Some referred to her as "the Shahrzad of our time," in the same way they called Simin Daneshvar "the storyteller Shahrzad."[3] In Iran, hardly anyone chooses Shahrzad as a name or a nickname without being conscious of its reference to Shahrzad, the loving, legendary character of *The Thousand and One Nights*. The expression "daughters of Shahrzad" is most meaningful under the current situation in Iran as all women are fighting to secure their places in society.

Shahrzad (Kobra) once nearly received a contract to play the role of the ancient storyteller in a movie that featured one of the episodes of the tale.[4] Enderwitz writes, "In Europe and America as well as in the Near East, writers in the twentieth century (in fact more so than ever) still used the characters of Shahrzad's tales and her narrative mode as models for their own writings."[5]

Shahrzad of *The Thousand and One Nights* faced a grim situation but solved it with skill. King Shahriar had discovered that his wife was regularly unfaithful during his absences and, not satisfied with simply killing her and her lover, he sought revenge against the wiles of women in general. He resolved to marry a virgin every night and kill her the following morning. Shahrzad stepped forward to put an end to this disastrous cycle. She decided to marry the king herself. Every evening she began to tell a story but left it incomplete, promising to finish it the following night. The stories were so entertaining that each day King Shahriar postponed her execution in order to hear the end of the story. He eventually abandoned his vindictiveness and stopped the killings.

But *The Thousand and One Nights* is a tale from centuries ago. In 1970s Iran, in real life, the contemporary Shahrzad (Kobra Saidi) danced, acted in movies, and entertained a new generation of men to face a new set of problems. Mohammad Reza Shah had encouraged women's social participation, and women took

the opportunity and achieved success in many areas. Shahrzad too set out to ful-
fill one of the promises of Iran's modernization, which was supposed to facilitate
women's artistic activities. By any modern standard, Shahrzad was a successful
artist. She was a fine dancer, having embarked upon her entertainment career by
performing in nightclubs and theaters, and then in films.[6]

Shahrzad's Career in Cinema

Shahrzad acted in more than sixteen movies, and although she never had
the leading role, her performances were occasionally praised, and she received
two awards. In addition to writing and directing *Maryam va Mani* (1978), featur-
ing the then-celebrated actress Puri Banai, Shahrzad might have also written a
part of the screenplay of another movie called *Baluch* in which she played a role.
The name of the award was Sepas, an Iranian cinema award. On the day she was
arrested, she had an 8 mm camera with her to film the demonstration, perhaps
an attempt at documentary production.

A Poet, a Writer

Shahrzad also wrote three volumes of poetry, a book of prose, a screenplay,
and several commentaries for film journals. Her published writings and her let-
ters all indicate that she was well read. Before her arrest, she had studied every
book she could purchase. Her dismay over the loss of her library during the time
she was in prison remains keen, and even today she still strives to study and learn
new things.

Both Shahrzad of *The Thousand and One Nights* and the contemporary
Shahrzad struggled to gain acceptance in their societies. The first one wanted to
be accepted by the king as a woman and was, in some ways, successful. Through
her success she served her gender and prevented the king from further slaugh-
tering women. The contemporary Shahrzad aimed for public acceptance. She
responded to the Shah's modernization project, which promised women a space
in public. And she proved to be talented. However, gaining a public space and
then being cast out of it had astounding consequences for the contemporary
Shahrzad.

Unlike the Shahrzad of *The Thousand and One Nights*, who was a vizier's
daughter, our Shahrzad was born to a poor family that had been rocked by many
tragedies. For example, while she endured all the pressure of work and worked

hard to change her lifestyle in the seventies, one of her sisters committed suicide and her brother was arrested and apparently executed for killing their sister-in-law. These incidents did not affect her success, though. The king and the ruling elite could have been proud of the modernization policies that allowed a woman with a difficult past to achieve so much in just a few years in the newly created space for women.

Some Background

The history of the creation of this space goes back to the time of the first Pahlavi king. Reza Shah Pahlavi (ruled 1925–41) embarked upon his modernization projects in 1936. He promoted a Western lifestyle, put an end to British and Russian occupation, gained Iranian control of banks and other financial institutions, developed industry, and created a modern educational system. At the same time, his government began gradually to limit the influence of the clergy and to glorify Iran's pre-Islamic history. All of these steps provided women, especially those from higher social echelons, with opportunities for social participation. In fact, his boldest initiative was to force women to unveil, which brought about a manifest increase in women's social activities. Such development continued under the second Pahlavi monarch, Mohammad Reza Shah (1941–79), even when he was a constitutional monarch sworn to defer to the parliament. When the government of Dr. Mohammad Mosaddeq, the elected prime minister (1951–53), was toppled in a 1953 coup, Iran came once again under direct and sole rule of Mohammad Reza Shah. The country's economic situation began to improve, due in large part to a sizable increase in the price of oil. From 1960 to 1972, Iranian national per capita income grew at an average annual compound rate of 8.7 percent. Soon oil prices quadrupled and that resulted in a 34 percent increase in the gross national product by 1973–74.[7] Between 1953 and 1979, Iran experienced rapid economic growth, industrial development, and the Westernization of its society in terms of education, law, and its defense system. Mohammad Reza Shah's so-called White Revolution (1963) wrought significant changes—in some areas well beyond his father's reforms—in land ownership, industry, education, and the treatment of women.[8] Mohammad Reza Shah's new government early on established the Organization of Iranian Women led by his sister, Ashraf Pahlavi.

New opportunities arose for women to join the work force and obtain higher education in a widening choice of fields. In 1962, women gained the right to

vote and to be elected to office. In 1968, the Family Protection Law was ratified, according to which divorce was to be decided by the family courts, not religious ones. Further reforms were seen in the areas of property law, polygamy, marriageable age limits (raised to eighteen), and the right of women to have guardianship over their children in the event of divorce. Many women gained high-level positions, including Mahnaz Afkhami, who became the first minister responsible for women's affairs in 1975.[9] The number of women in cinema, theater, and entertainment also increased dramatically. Faeqeh Atashin or Googoosh (also spelled as Gugush, b. 1951), who sang and played in the movies, became a symbol of modernity, and Marzieh, who sang traditional folklore songs, became a national icon. These well-publicized developments led many to believe that Iran was on an irreversible path to modernity.[10] Social critics, scholars, and even political opponents understood modernity in terms of Westernization and industrialization expressed by one or another authority or author.[11] Many of them even tried to make a connection between modern Iran and the pre-Islamic ancient Persian Empire, as discussed earlier, though they did not work hard at it.[12] Commitments to a modern ideology were supported by the regime's presentation of women as free and modern. Even though the struggle between traditional ideas and Western influence was boiling, women continued to shine in new-found social arenas and accepted the role of being an emblem of Iran's modernization.

But were women aware of the fragility of this new life?

Did they think that they could achieve a modern life without a national discourse on sexuality?

Would the fate of these women prove erroneous those academic presuppositions about "modernities"?

To answer these questions, I further examine Shahrzad's life story, exploring her achievements up to the revolution and tracing it through later developments. The biographical information about Shahrzad is based on her own books, journalistic writings, and cinematic activities; on a few short interviews with her that were published in small journals in the 1970s and that now are archived in libraries in Tehran and the United States; and on my own written interviews with her and with those who knew her.[13] Despite their enormity, these sources have not allowed the reconstruction of a precise life story of Shahrzad. The materials are inclusive, but often are incomplete and fragmented enunciations which—for political, personal, and psychological reasons—are wrapped in vagueness and

mystery. In both her written works and in her personal unpublished interviews, it is challenging to distinguish fiction from facts, to discern which ideas are Shahrzad's and which are her expressions of others' ideas. For example, in response to my question about where she was from, she wrote, "As written in *Tuba*, the coffeehouse is in Tehran, which means I am from Tehran." But her book *Tuba* was published prior to the revolution and, according to her own repeated statements in several different places, it is a piece of fiction. Such problems are further exacerbated in her poetry and prose, when she shifts between first person singular and plural to third person viewpoints, an issue I address more closely in chapter 5 on literary works. As frustrating as it was not to be able to fill in the gaps, such inconsistencies and ambiguities are indeed parts of what this project strives to explain in the end.

Shahrzad's Story: The Early Years

Shahrzad's father was born in Eyvanakay and raised in Ray, and her mother came from the village of Kamu or Joshqan of Golestaneh near Kashan.[14] They married in 1944, when he was forty and she was twenty-two. Their marriage was not very happy, leading Shahrzad later to doubt the functionality of the institution of marriage altogether. In general, however, she believed that she had been blessed with many good things, such as toys and the proper love of her mother. Shahrzad was born, I have concluded, on October 27, 1946 (5 Aban 1325), at the end of World War II.[15] She was born in Vaziri Hospital in Tehran. She grew up in the Amiriyeh area of that city, but the family moved frequently. Until she was fifteen, she lived in or frequented neighborhoods such as the Central Railroad Station, Khani Abad, Amiriyeh, Shahpur street, and Naziabad. Later, her family lived in Khazaneh, on the outskirts of Tehran, where her father bought land on which he built a coffeehouse. She went to school in the southern parts of Tehran, not far from the train station.[16] Apparently, she spent her childhood in her abusive father's coffeehouse, which offered not only tea and water pipes but also a traditional menu and, occasionally, a bed or room for travelers.[17] The coffeehouse was frequented by many drunks and addicts. Shahrzad recalls her father as a "brave, honest, and polite man but he drank and smoked opium."[18] Sometimes she was beaten up for ridiculous reasons, for instance, going out barefoot, or for no reason at all. Her parents were not religious, but religion was all around her.

Tehran must have looked very different in these years before World War II.

Books, memoirs, and photos all indicate that black-topped horse buggies were the main means of transportation and that black Mercedes cars were novelties in which only certain people could afford to ride.

Even later, with a population of less than one million, there was little traffic or noise and less pollution. City buses could not have been crowded as they traveled between the few big squares of the time such as Tupkhaneh, Baharestan, and Maydan Tajrish. Water was distributed via delivery or open ditches and canals. The postwar years would witness Tehran's rapid growth into a big capital with highways, a modest international airport, and neatly laid out streets and squares.

An Active Child at Home and in School

As a child, Shahrzad was very active, clever, and competitive. She was five years old when she saw a movie for the first time. Although she fell asleep in the middle of the film, she nevertheless enjoyed it very much. She loved to play all games and was good at them. She always won in games such as hopscotch, hide and seek, volleyball, jump roping, and even those games that boys played with two sticks,[19] so she was popular, and teams always wanted her to be on their side. She enjoyed everything to which she had access. She writes, "We did not have these new toys, parks, and games but I did play somehow. I used to grab the bar behind the horse carriages to get a free but dangerous ride, and I used to run around in circles on the streets in my neighborhood. I also learned the usual skills. I learned to ride a bicycle, to swim, and to drive so early that I do not remember learning to do them. I learned gymnastics without a teacher, played volleyball without a coach, and threw discus without knowing the rules." As she grew older, she continued to speak with men freely, played with them, and even went on walks around the neighborhood with them. Her father beat a few of these boys who tried to get too close to her.

In the southern part of Tehran, Shahrzad spent two years in what was then the equivalent of a preschool education (*maktabkhaneh*), during which students learn to read mostly religious texts.[20] She then attended Shahrbanu and Anoshirvan Elementary Schools, which she finished in 1960, after a two-year delay. In the former school, she remembers, she was once punished by bastinado.[21] She insinuates in her letters that the hiatus, however, seems to have been connected to the impact of a blow she received on her head by her father or by some other health problems related to similar beatings. She spent those two

years in a special boarding school/hospital. Although almost a decade separated her elementary education from mine, the curriculum was the same and included Persian language, math, dictation, religion, physical education, geography, history, and so forth.

A Blow on the Head Blew Her Education

Next Shahrzad attended evening classes at Mehr School on Alborz Street.[22] Apparently she also attended a few other schools but never graduated with a diploma. One reason for this was that she would fall half asleep or slip into half consciousness as she listened to the lessons. She attributes this problem to that blow from a hard object that she had received on her head when she was ten or so years old. Her medical condition was perhaps further aggravated by intense menstrual pain, which persisted between the ages of fifteen and thirty. She later tried to finish high school but was only able to go as far as the tenth grade in the social science division (after the revolution, she took some exams in order to get a certificate but eventually gave up altogether).

Not only her father's beatings but also her choice of career interfered with her formal education. Sometimes in her later days in school, she would put an evening dress in her school bag so she could go to discothèques after school. She danced in those places many times before she began dancing on a regular basis, perhaps before the age of fifteen. She says:

> I learned many dances, international dances, and I do not know how. I learned about Western classical music and I knew how to whistle Mozart and Beethoven. I became familiar with the music of Hossein Tehrani, Rohollah Khaleqi, Ali Asghar Bahrai, Darvish Khan, Ahamd Ebadi, Qamar Ol-Muluk Vaziri, Ruhangiz, Aref Qazvini, Said Hormozi, Mirza Abdollah, Ali Akbar Shahbazi, Ali Akbar Shayda, Ali Naqi Vaziri, Rohani, Ibrahim Khan Solati, and now Shajarian and Entezami. I know Iranian music well; I know its systems. I know Miniature Dance [a traditional form depicting Persian miniature paintings] very well.[23]

Shahrzad recalls that at that time, Persian courses were taken seriously. She and many others of her generation have confirmed that teachers were serious about making students memorize poetry. She seems to have read both classical and new poetry on her own. She says:

At the age of fifteen, when I was dancing in the clubs and cabaret and played in Pars Theater, I used to read poetry. In that theater and between the plays, I used to read poems by Nima, Farrokhzad, and Shamlu with [a] student apprentice. Later the manager expelled the student saying this place is a theater and not a school.[24] He and I then met outside and continued to read poems together and one time he brought me a book by Amad Reza Ahmadi.[25]

Violence at Home

All through this period, her home life was rather violent. According to some accounts, she was stabbed by a drug-addicted brother;[26] however, Shahrzad wrote in a letter that it was her father who stabbed her.

We have already seen that he beat her often, leaving her with her head injury, as well as scars on her hands and face.[27] Once he beat her for singing out loud at home, when she was already dancing secretly in cabarets. When he finally realized her daughter's career was in dancing and acting, he was too sick and old to interfere. Before his death, he did not see any of her movies. Shahrzad observed violence outside of her family as well. At the age of three, she witnessed the death or murder of a pregnant woman; however, she does not remember the details. She also mentions that she witnessed the drowning or murder of two women in a swimming pool in a garden in Shemiran.[28]

Men in Her Early Life

Shahrzad entered several conjugal relationships (marriage, temporary marriage, or common situations), including two after the revolution. All, without exception, proved disastrous. The first time, she was married for a few days when she was just seventeen. Her father, who had always wanted his first child to be a boy, wanted to minimize his own responsibility so had worked ceaselessly to marry her off as soon as possible. She did not love the man and ran away from his house during the very first week. Soon after, she was married to another man who frequented their neighborhood in the southern dry plains of Tehran. This match did not last long either. She says she found both husbands (Akbar Taheri and Ali Salmasi) to be incompatible with her. The subsequent two marriages or temporary marriages after the revolution were apparently forced on her while she was in custody or as part of a scheme to rob her of her belongings. The two men succeeded in taking everything she still possessed, including her valuable book collection.[29]

Before the revolution and after the failure of her first two marriages, Shahrzad found herself still living on the outskirts of Tehran, near the brick factories where people built their houses themselves and dug their own wells (the city would not issue construction permits for those outlying areas). Her memories of that time are reflected in her book *Tuba*, which is discussed in chapter 5. One of the few bright spots in her life at this time, she recalls, was that she found a meaningful way to pass time: teaching adult evening classes organized in the neighborhood.

A Fascination for Modern Life

As she became more independent, she traveled to many cities and places in Iran. She was interested in and curious about the country's culture and history. She was also fascinated by all of the modern developments and Western phenomena being introduced to her society and becoming available to the youth at that time. As her work brought her more money, she followed fashion and bought nice clothes and shoes. She says that she has always loved life, wealth, food, and culture and has tried to enjoy as much of them as she can. In all her correspondence she expresses love for the old Tehran, when "it was clean, unpolluted, with blue sky during the day and shining stars at night, and boasted of beautiful mountains in the distance and when an airplane passing by would provide us with excitement."[30] She says she liked sport clothes, sport shoes, coffee, and cigarettes. In the early postrevolutionary period, she remembers that she sometimes wore miniskirts under her chador to go on dates. In retrospect, she believes that she did these things out of curiosity and a desire to educate herself.

She writes in a letter, "I was not after having sexual adventures. Every boy and girl should be able to date in order to learn about the opposite sex, but this does not necessarily mean that they need to have a sexual relationship."[31]

At one point, right before she began dancing in Café Jamshid, she dated a rich man who wanted to marry her. With his help, she managed to provide herself with a good life for a while. The relationship, however, proved problematic, as she did not love him. Moreover, another older man for whom she also had no feelings became involved in her life, which caused her significant confusion and headaches.

Traveling to Europe

It was perhaps during this more affluent period that she was able to travel to Europe, where she absorbed many more modern trends and cultural experiences.

On her trip to Italy with a sister (who before the revolution moved abroad for good), she purchased many books.[32] She paid for the books with money that she had made on the trip by babysitting for an Italian family. Although she had loved the babysitting, she quit when one of the children in her care almost choked on a piece of smoked bacon or a slice of bruschetta.

During this trip to Italy, she also met a Sicilian man in a coffee shop in Rome, and they fell in love.

This love brought a whole new cultural experience to her. Although conditions did not allow the relationship to develop into anything serious or long term, it was satisfying and beautiful. She writes, "He was in the army and he looked like a movie star. His favorite drink was café au lait and he did not smoke. He did not object to my smoking. We first spent a couple of hours chatting together, but the friendship naturally extended itself."[33] Describing her feeling about him, she writes:

> I loved his cologne which I had never smelled before; it was the scent of a man who could feel and understand a woman. We kissed only once. I saw him when my sister and I finished our merry-go-round ride, my face and lips were red because of the excitement of the ride. He approached me and we kissed. That kiss was one of true love. I have never had an experience like that again.[34]

In her fifties as she recalled these memories, she also observed her own countrymen.

> I know too many of my countrymen who present themselves as intellectuals. But they are actually stupid and backward. These men are some sort of creature that has to yet be defined and conceptualized. That Italian man truly wanted me because of who I was not because he was a man in need of a woman and not because he needed to feel like a man. He saw me as a woman with feminine needs. He had confidence in himself and elicited confidence in me.

Shahrzad's memories of her experience with the Sicilian man are not mere illusion; they corresponded for a while. Eventually, however, Shahrzad ended the relationship because she feared possible scandal.

Still, a Tough Life

Shahrzad grew up in an unusual and somewhat dangerous environment and experienced many traumas at a very young age. She was even nearly sold

to a house of ill repute by a family who had first planned to abduct her to get her to marry a man whom she did not even know. But she survived all these traumas and even before becoming famous, she worked as a photographer, a sales person, and a dancer, while managing at the same time to gain new skills and knowledge and keep her hopes high. Though she was not as prominent as other women artists, one can say that she eventually belonged to a generation of women who made their mark in the fields of music, acting, dancing, writing, and reporting. But this did not mean that life became easy.

The Cultural Context

All this happened at a time when parts of Iranian society were burning in desire for more Western products: not only technology but also products such as the music of the Beatles and Elvis Presley, affordable record players, movies made in the United States and India, magazines resembling *Playboy* and *Penthouse,* and European fashion news. It all happened just when the "old guard" of Iranian film stars such as Majid Mohseni and Abas Tafakori were being supplanted by exciting new actors such as Mohammad Ali Fardin and Taqi Zohuri. Affluent urban Iranians began to travel abroad for vacations and to shop. Poor villagers began to migrate to the outskirts of the big cities, drawn by jobs and a hope for a better life. Opium smoking was officially outlawed, but it and other illegal narcotics were readily available. Prostitution houses proliferated in "red-light districts" in all major cities, even though they were located on the outskirts of the cities and had virtually no street lights at all, red or otherwise. The walled "red-light" zone in Tehran that consisted of just a few houses only a few decades earlier became a huge neighborhood within Tehran by the mid-1970s known as the Shahr-e No (New City). Then, according to a few published accounts in newspapers and based on some of the historiography of the place, in Shahr-e No, the lights were never turned off and drugs and diseases were exchanged discreetly; discreetly because there is no record that the issues of prostitution, drugs, and disease were publicly or privately addressed.[35] And apparently, this was not Tehran's only area for such business. The surrounding streets and many other distant street corners provided opportunities for men to purchase sex.[36]

Bars, restaurants, and nightclubs mushroomed throughout the city, providing a venue where frustration over the dearth of intimacy could be expressed through drunken cries and obsessed eyes.

It is interesting that the first attempt to regulate the sex business was made by the Westerners who were in charge of the city's police force in the early years of the twentieth century.[37] But as R. Rudan's rare study of prostitution in Bandar Abbas indicates, the situation remained horrific; almost all women who worked in this dangerous and abusive situation did so due to poverty and illiteracy.[38] Research conducted under the supervision of Setareh Farmanfarmaiyan and the resulting published book also reach similar conclusions about the status of prostitutes in Tehran (in Shahr-e No and elsewhere), except that they do not attribute all problems to poverty.[39] An article by Mehrtaj Rakhshan strived to publicize the problems of prostitution and the suppression of the prostitutes.[40] A few other attempts were made to address the issue of prostitution, but they were mostly through stiff literary writings.[41] But these writers approached the issue from a moralistic point of view, blaming society, a failed educational system, or—later on—class issues for the problem. Sexuality was not discussed in any depth or with an eye to opening a public debate.

The sudden proliferation of prostitution, limited presence of pornography, and the dismal nudity offered by the cabarets and movies all helped the portrayal of the regime as corrupt. By the 1970s and despite his efforts at land reform, women's rights, and mandatory education, Mohammad Reza Shah faced mounting opposition from religious leaders and from intellectuals. He responded by suppressing the opposition and ruling in an increasingly arbitrary and repressive manner.

A few years into the 1970s, venues for the expression of social dissent were closed down one after another. Books and articles critical of social life were subjected to brutal censorship, the violation of which entailed severe consequences such as imprisonment and torture. Leftist, Marxist, or any liberal activity that questioned the legitimacy of the Shah's rule or his plans for the country were also forbidden. You could pick a fight in your neighborhood and stab your enemy and go to jail for a limited amount of time and get out by paying a bribe to either the plaintiff or to the authorities. In the case of political prisoners, however, no amount of bribe could help.

Even religious ceremonies, such as segments of Ashura (the commemoration of the martyrdom of the third Shiite Imam) that involved self-mutilation, and any loud noise of mourning and prayers from the mosques were prohibited. This infuriated not only the religious men but also ordinary people in small towns, who had few other opportunities for public or carnival-type gatherings. Abolishing these

religious ceremonies did not help the cause of modernity either; in fact, it led to a retreat from modernity. Shiite rituals such as Ashura were not merely symbols of backwardness or expressions of conflict with democracy and civil society. The climax of Ashura commemorated the actual day of the massacre of Karbala, which was a mournful event. Yet it served as an excuse for many social interactions. Excited children played hide and seek. Women in chadors, standing on the sidewalks to watch the parade, provided the best locations for the game. Teenagers moved around them freely and joyfully, smelling their mothers' perfume and the aroma of rosewater sprayed in the air. It was for many so much fun. Young men used the occasion to date. After all, in small towns or in the traditional quarters of the city, celebrations such as Ashura provided a rare opportunity to get quite close to the opposite sex on the crowded sidewalks. Young women had their own fun by putting on makeup and going out unveiled to spot good-looking guys in the procession, often well shaven and groomed, who after realizing that they were being watched, proceeded to beat their bare chests or shoulders more rhythmically, almost dancingly. It was not like the days before the spring break in American colleges but some of those men actually worked out before Ashura day. They not only wanted to look good during the ceremony but also wanted the top spot in the flagellation line. The older men had to make sure the lines were moving straight and orderly. Younger men were rarely allowed to lead the lines because the big eyes of the female onlookers could easily distract them. To be in the flagellation line, you also needed to have a handsome chain, otherwise, you would be relegated to being a chest beater. Chest beaters, nevertheless, followed a certain fashion too; they took care to wet-comb their hair and wore a tight, elegant black shirt unbuttoned all the way. Moreover, an intense and amusing competition between different adjacent neighborhoods marked the event. The competition involved issues such as who had the longest lines, who featured the better singer, who came up with the most creative chant, who could afford the loudest speaker, and who had more elaborate, colorful, towering decorations. The parade route of the team with the better singer and better decorations and longer lines would attract a larger crowd. For these reasons, preparatory activities were also quite intense and fun. Men had to make sure that on Ashura, they could move and beat their shoulders in absolute unison. Sometimes, my mother let us go watch the practice sessions in the nearby mosque or fairground. The problem was that these ceremonies did not benefit from any "reflexive auto-innovative quality"[42] changes

toward being modern. The event served as a motive for ideological literary production but did not serve as context for love stories, for beneficial literary works that could help the development of a discourse on sexuality. Very little creative effort was invested in the representation of the related ceremonies. And most importantly, women did not play a role in any of the rituals. Even in the related theatrical representation, men played the role of the female characters. At the end, and to counter the regime, religious elites did all they could to keep the spirit of these events as it was 1,400 years ago.

Eventually, however, the Shah's restrictions on and propaganda against these ceremonies, and their stark differences from Western representations of religious and national ceremonies and carnivals (in which women had substantial roles) occasionally portrayed on media, caused many members of the younger generations to despise it. In part this is because each year's commemoration of Ashura is based on the experience and memory of the previous year, and spectators always compared the parade to the last year's.[43] In time, the memories can become corrupt, leading the celebration to be viewed as archaic, primitive, and superstitious. The Islamic Republic has put its own stamp on the celebration but did not restore it to its earlier form. In the twenty-first century, the songs and rhythms used during these days of mourning have been criticized as indecent and sexually explicit. It is amazing how a suppressed sexuality finds unlikely and ridiculous venues for its expression.

As confusing as life had become in the 1970s, the young generation to which Shahrzad belonged was attracted to Western phenomena and revolutionary ideals at the same time.

They talked politics over a shot of vodka mixed with cola, in dimly lit bars where slow jazz or chamber music played in the background. Alcoholic beverages, both imported and domestic, were widely available. In fact, there were more bars than coffee shops in those days. Moreover, intellectuals would rarely frequent those traditional teahouses near bazaars to talk about the important fate of their society. But as men got drunk in those newly created establishments, they realized that they could not be revolutionaries if they remained separated from the masses and their daily struggle.[44]

So they started to read the banned books written by both Marxist and revolutionary Muslim thinkers and ended up rallying behind the banners of both Marxism (though they did not know it completely) and Islam (though they had

no idea what fundamentalism meant). At some points in the late 1970s, it became difficult to pick intellectuals out of a crowd; everyone was now revolutionary and attracted to revolutionary ideologies. And in order to gain knowledge about those ideologies, one had to leaf through the few translated books available, seeking support for one's ideals; the works of Jean-Paul Sartre, Che Guevara, Franz Fanon, and, in a very indirect way, Régis Debray were typical sources. Even anti-Marxist books were used for finding and indulging in quotations of the works of Marx, who was often referred to by a code name: the learned man of the nineteenth century. No one made clear, nontranscendental, unbending distinctions between different revolutionary ideologies; this occurred only outside Iran, within the ardent Iranian students' movement. When these students and political activities returned to Iran in the wake of the revolution, the lines of division within student and intellectual movements on the mass level became clearer.

Suddenly, many of the youth discovered an organization they could affiliate with and defend. In the midst of all this enthusiasm and vigor, no one thought of the consequences of the rise of revolutionary movements on gender issues and women's situation in the country.

Shahrzad's Life in the Seventies

This cultural and political situation, rather than rebellion against the past traditional culture, was simmering in the 1970s. Shahrzad had already long ago embarked on her artistic careers in Tehran by dancing (perhaps beginning in 1963), acting (in the late 1960s), and writing poetry, fiction, and screenplay (during the 1970s). She much admired modern qualities, and this went beyond her love for a foreign man. In fact, she showed a love for Western civilization every time she pondered social problems that had hindered her social and private life and every time she responded to criticism of her lifestyle or work, even when she worked as a journalist. As a young woman in prerevolutionary years, she had tried to learn Italian when she visited Italy with her sister. Later, after her release from prison, in a desperate time, she auctioned her belongings in front of Vahdat's Hall (Talaar-e Vahdat), a theater and art center near Hafez Street in central Tehran, to raise money to go to Germany, where she stayed for a number of years. There she tried to learn German and probably would have learned it well had she not fought with her teacher, torn the textbook, and left the school, which offered free language courses to refugees.

When she became more interested in acting and poetry, she stopped dancing and made sure that the media (a few journals who cared) acknowledged the shift. In an interview with *Setareh Cinema* (The stars of cinema), she said, "Even though dancing beautifully is an art, I stopped doing it to save my character and gain recognition and respect for my other talents and thoughts."[45] When Shahrzad completely stopped dancing after some of her movies, including those directed by Mas'ud Kimiyai, became hits, she wrote, "I stopped dancing so that men could stop watching my body and so that they could listen to what I had to say."[46] She had begun writing her poetry while acting in the movies, but wanted it to take center stage in her life.

Among her talents was one that remained largely unknown, even among Tehran's small community of artists. This was her film directing. She directed a movie entitled *Maryam va Mani*, which featured the then very famous Puri Banai.[47] The final preparation of the movie for screening was hampered by revolutionary events, and it is not available anywhere today. However, several people have talked about it, including the famous actor Behruz Vosuqi in his memoir.[48]

The Construction of a Public Image

These shifts coincided with a rumor that she was involved with or was even supposed to marry the celebrated Mas'ud Kimiyai, director of *Qaysar* (1969) and *Dashakol* (1971), in both of which Shahrzad played successful roles. She allegedly fell in love with him during the filming of *Baluch* (1972). According to the tabloids, he was going through a divorce (from his wife Gity Pashai) at that time.[49] Shahrzad dismissed the rumor in an interview with *Setareh Cinema*. She first restated that she no longer danced, that she considered herself to be an artist, and asked not to be referred to as a dancer anymore. She then refuted the rumor of her relationship with Mas'ud Kimiyai saying, "Even though I am not the source of this rumor, I do apologize to him."[50] Yet, in another issue of *Ferdowsi Magazine*, after Mas'ud Kimiyai denied the rumor about his possible marriage to Shahrzad, stating that the journals should focus on his work, Shahrzad states, "Mas'ud Kimiyai and I have been friends for years and we respect each other very much. Since his divorce, we have been living together. He has denied the existence of this relationship perhaps to avoid further rumors."[51] Yet again, when she was about to travel to Italy for the second time, an interviewer noticed the picture of Kimiyai on the wall of her room and asked her, "Is it true

that Mas'ud Kimiyai writes the poems and you publish them in your name?" Shahrzad replied nervously: "If he was a poet, he would have been known as a poet. However, I do not deny that he too discovered the poetic talent in me. I owe him all I have."[52]

None of this tabloid banter helped improve Shahrzad's image. Moreover, the interviewers and commentators added their own interpretation as they published a few lines from her poems to create an even more controversial character. She found these commentaries so awful that each time she gave an interview, she began by refuting the earlier interviews.

A Near Fatal Blow

A conversation with Alireza Nurizadeh, who is now a prominent reporter and widely read political analyst, is one of the few times she appeared in a significant or serious journal. More than thirty years later, she still sounds bitter about that experience, which she feels was nothing but abjection of a woman artist. Alireza Nurizadeh, perhaps in the early days of his journalistic career, published an interview with Shahrzad, "The Woman Who Came out of the Darkness," in *Ferdowsi Magazine,* alongside reports about the Year of the 2500th Kingdom Celebration. The title and headings of the piece on Shahrzad, written in large font, included "The Baptized Sister of Loneliness," "A Fugitive Bar Woman," "A Residence of Darkness Joined with Light," and "An Artist Escaped from Trite Past Problems."[53] These titles referring to an alleged "bad" past sum up the way Shahrzad was perceived by the journal. Then the interviewer writes (my literal translation):

I see a familiar face, someone from the corner of my memories. I am so close to her that I can see her wet eyes. I am walking between the two rooms of my office and a voice stops me, asking "Do you know Ms. Shahrzad?" I shake my head, and being poor at doing the Persian pleasantries, I replied with a smile implying "nice to meet you." The voice introduces the woman whom I had seen in the movies as the nightclub woman in *Qaysar* and the cupbearer in *Dashakol.* "Did you know that this is the same Ms. Shahrzad whose poem you were talking about the other day?" I did not know so I am surprised. To be a poet in my estimation, you do not have to reside in the coffee shops; you do not have to meet certain conditions. I believe you just need to be in love to become a poet. This is indeed, what Shahrzad is saying. She reads my mind. This time I am

preparing for an interview that is going to be definitely different from all the previous ones. I review my headings: here is the baptized sister of loneliness, a fugitive bar woman, a residence of darkness joined with light, and an artist escaped from trite issues. My comrades and colleagues in journalism will certainly say that this interview with the city's dancer contradicts our commitments and responsibilities. I will reply to them that what may really contradict these two sensitive and manipulated aspects of our profession is indeed silence. Let me then talk and let Shahrzad talk. I sit down with her to ask questions and she has some answers; perhaps we can know each other this way. I pick up my paper and pencil.[54]

This introduction sets a distrusting and supercilious tone. The interviewer begins the interview by saying, "Tell me about yourself, Shahrzad, about your past, of the darkness in your past, and about the way you joined the light. Tell me about your new life." But before he conveys the reply of the interviewee, he precedes it with "Shahrzad begins to talk calmly and I see at the depth of her eyes a sort of truthfulness that I had seen before in the movie, *Dashakol*."[55] Then comes Shahrzad's extended reply without interruption by the interviewer or by follow-up questions for the most part of the interview:

I was twelve when I began going to the nightclubs. The reason was nothing but poverty and parents who were indifferent. I was told to dance and I did. I was told to marry a strange man, and I did. I married that man without knowing who he was and what he would do to me. And that was only my first husband. He was a low ranking police officer [*pasban*] and I liked to play with his hat when he left it to go outside of our room. That was the only thing that seems to have mattered in my life with him. My father, however, had profited in that deal. Therefore, there came other deals. My second husband was a mason. The third one a parking garage owner, a rough man indeed, always fuming. After him, I did not want to be a wife to any other man. They all would control and limit me.

My father would receive some money for each marriage and he intended to live on the income coming from these transactions. It was during one of these years that I rebelled. I began to work in a photo shop, and I stayed there for a while. Then I worked in a tailor's workshop. And of course, I continued to work in nightclubs in which I continued to be drowned. I was being drowned

in destruction, opprobrium, and corruption. And I did all that partly to protect my sisters and brother.

In the cabarets and nightclubs, I encountered shrewd men, con men. I was beaten up frequently. I strayed from one nightclub to another. Everywhere I worked, I had to sign some sort of contract with legal and financial obligations. Everywhere I worked, drunken men often struck me at the end of the night. This situation was unbearable. I thought of going to school. I thought by continuing my education, I could wash off this shame from my life and from my home. I signed up for evening classes and studied until the tenth grade. I could only bear to live the dark life because I could see the light and brightness in the face of my two sisters and brother.

A long time passed and then one day, a film producer invited me to dance in his film. And then the invitations arrived for further movies until I received a role in the movie *Qaysar*, a role that was similar to my own life story. I played in subsequent movies one after another and most presented me with similar roles. Playing in those movies was not financially a breakthrough because I had obligations to the nightclubs, and I was forced to pay them for not being there. For two years, I kept paying them, paying them until there were no more claims. The cinema and movie roles brought me in contact with people with expectations different from the drunken audiences in the nightclubs and bars. Being in the cinema also encouraged me to study. It gave me a chance to read literature, poetry, and try my hand at painting. I had always liked these art forms but because of the kind of work I did, I had almost destroyed any taste and talent I possessed. Finally, I became decisive to improve myself in these areas. Something, I felt, was boiling in me.[56]

As mentioned, Shahrzad spoke without interruption to this point in the interview. There were no questions in order to clarify any of the points she was making. It seems that she had agreed to the outline laid out by the interviewer to explain the process that led from her being a "bad woman" to being somewhat literate and finally a poet. In doing so, she portrayed herself not as a normal woman or as a victim but as the sinner who is redeemed when she enters the world of poetry. Poetry somehow even helped her cinema career, so she proclaimed.

In her reply to that interview, there are also plenty of facts and information, some of which, as we will see in the forthcoming chapters, can be confirmed by

her book *Tuba* and some of which can be questioned by her letters. The facts and information are presented in the most direct language. They refer to some fundamental social problems that were eclipsed at that time either by the big events of the celebration of the Year of the 2500th Kingdom or by the loud voice of the oppositional groups. She continues:

> I began to write. I wrote poems, stories, and novels. I embarked upon a new life style. I played less in the movies until I received an offer to play in *Dashakol*. The first thing the producer told me was that I did not have to dance any more. That I did not have to be the person I used to be. I became curious; what was going to be the difference between this and my previous roles? I asked him and he said, "You have a talent that if you cared for, you can become a good actor." I followed his advice and I realized that he was right. I accepted the role. Besides, if I did not, I would have been financially ruined again, especially because I had rejected several other offers before this one. Some of them were not even acceptable to any woman artist.[57]

Here the interviewer interjects: "She seems a bit tired. Talking ceaselessly about the past is tiring anyway, especially about a past that you would want to forget and delete from your life, a past that you are not interested in remembering. Yet I ask her further questions."

And when asked how she felt about roles that ostensibly paralleled her own life story, Shahrzad responds, "My physiology fits these roles. Shirley MacLaine played such roles in a couple of movies. I should not make such a comparison of course, but I found the answers to such questions to be the case when I played in *Qaysar, Dashakol,* and *Taleh* [The trap]."

About the fact that her roles were usually minor, she noted that her role in *Dashakol* was important. "In the past before *Dashakol*, I would play three scenes in one single day. They told me that my role was to fall in love and then to dance and I did. The difficulty with that arrangement was that I faced so many problems, and I had suffered so much from men that I would vomit from the idea of falling in love with them. I could not do it anymore. In *Dashakol*, however, I experienced true love. If there is supposed to be a man in my life one day, he has to be like the hero of that movie, Dashakol himself."

The interview then shifts to Shahrzad as poet. He writes, "So much for cinema! Now I want to talk to Shahrzad the poet. I want to speak with the writer of

these lines: 'The tablecloth is so empty / that I am ashamed to / utter the word, bread.' I also want to talk about the line that reads, 'One drop of morning dew / was enough for me / to grow beyond the midst of cobbled city streets.' How did you start to write and when?" Shahrzad replies, "I always felt a poetic sensibility in me. And then I found the words. In the past, life did not release me to find the words. In the last two years, since I have found some peace of mind, I feel that something that was dead in me has revived, and it is boiling out of me. I was troubled and sequestered when I wrote my first poem. I closed my door and windows and did not go anywhere for three months." The interviewer asks, "When you write poetry, what do you feel?" Here Shahrzad's response is helpful when it comes to the interpretation of her work. "All my poems are memoirs, memories, and reminder and remembrance of the past. My poetry reflects my life. In my opinion, a poet must deeply experience and understand poverty, pain, and despair. . . . Before writing, I was nothing. I was useless, loose, licentious, and good for nothing. . . . But when I found poetry, I thought I was born again. I tried not to consider all of my past as parts of my life. . . ." She goes on, "When I write poetry, I am like a mad person who expresses her love through her crying because crying was indeed the main feature of my past life. But now poetry has become the life for me." The interviewer also asks, "Which poet has influenced you the most?" She replies, "Yes, I like the works of most of the contemporary poets. I am specially drawn to the works of Forugh Farrokhzad and Nima Yushij. Of course, I am not in a position to express opinions about these things."[58]

At this point, the text of the interview is interrupted again, and the interviewer interjects a short comment by saying, "I can see in her face something that has not been expressed verbally. She is too shy to say it." However, he does not elaborate on his point and it is not clear what else she could have said that would be more difficult to express than what she has already said in the above sections. The topics shifts to Shahrzad's short stories. She explains, "I write short stories as well. I was good in composition classes when I was a kid. That is, I was good but not mature because even now, I confuse myself when writing short stories. Some of my stories are imaginative and in that regard, there is no resemblance between my poems and my stories."[59]

The interviewer summarizes some of what Shahrzad shared with him. "Shahrzad likes Hedayat more than she likes other fiction writers. But she has also read some works such as *Golistan* of Sadi and the translation of *Fear of Life*

and *The Skin* by Malaparte and *Jean-Christophe* by Romain Rolland. When she read *Jean-Christophe*, she was so influenced that she did not stop writing poetry for one month."[60]

The interviewer then asks about her private life again: "What are you doing now?"[61] "I live with my little sister. I arranged the marriage of the other sister. I try to help the younger one in her schooling. . . . I do not want her to suffer from the effects of our parents. Of course, I cannot blame them either; poverty forces people to do anything. I even let my brother live with them. But I cannot forget those foreboding, bad omen years. I cannot forget those libertine caves, profligate, dissolute caves, and those darken protracted moments of my life. They will always be with me, much like the memory of a nightmare." The talk goes on, "What are your future plans?" She states:

> I am trying to find a job. I would like to be offered at least a good film each year. I am willing to work in movies with directors such as Mehrjoie, Moqadam, and Kimiyai. If this is not possible, I will not play in any movie at all. Some movies are no different from the commonplace, trite nightclub spaces where I used to work. It makes no difference to dance in a nightclub or in a Persian movie. That is, Iranian cinema today offers two different levels of films; one on the college level and one the level of *maktabkhaneh*, the old traditional Sunday schools. On the one hand, people see good movies, they go to the university. On the other hand, they see bad movies and they attend outdated schools. I am embarrassed to say that I have played in filthy movies. Perhaps for this reason, I have turned down a dozen contract offers to play in the latter type of film. I hate being opportunistic but I cannot do otherwise. I would like to find a normal job to support myself. I am not the same woman. I must be helped to amend my ways, all the way, victoriously. Even if the directors that I named hire me as a scene secretary, as an assistant, or something like that, I will be happy. I do not mind not playing in their movies; it suffices to be associated with them. Or if I had money, perhaps I could make a short film myself one day.

Finally, the interviewer asks Shahrzad, "What was it that transformed you? And why do so few other women strive to go through such a transformation?" Not knowing what the word "transformation" means in the question, she responds, "In the first place, it is the fear of society, the fear of family, and the fear of being reproached for the past life that prevents some people from wanting to change."

She explains, "In order to improve one has to have the desire first. I was one of those people who had the desire. When I noticed I was being destroyed, I changed. And now, I should not be concerned about what the society may think of the past."[62]

With this, the interviewer concludes by saying, "Shahrzad relaxed on her sofa. She indeed appeared to be a stray who has found her way out of the darkness into the land of light, a land she built for herself. She opens her book and with a low, hoarse, scratchy voice reads some of her verses."[63] On that note, the text of the interview ends.

The Constructed Image

Despite all of Shahrzad's efforts during this interview to put her past in an understandable context and to demonstrate that she was a new person, a poet, and a literary author, the cover of the magazine sardonically depicts her in a photo from a movie in which she wore a short skirt, holding some thick books.

The image was intended to mock her based on the construction of "The Woman Who Came out of the Darkness." It complied with the constructed "notion" that Westernized women do not know anything about the world and yet pretend to be a student of some branch of knowledge. This notion was ridiculed even in children's plays such as the famous *Shahr-e Qesseh* (The city of tales, 1967) by Bijan Mofid.

Thirty years later, Shahrzad expressed anger and indignation at the title and headings of this interview in her letters. She blamed the interviewer for his portrayal of her character and for insinuations. She wrote:

> My father's skin was tan because he worked under the sun all the time. My mother's skin was white, very white, shiny white. The interviewer of the piece published in *Ferdowsi Magazine,* whose name had made him believe that he was born out of light [Nurizadeh means born from light] was simply jealous of my cleanness and of my skin. Despite my appearance as a fresh, shiny, young girl, he must have thought that I had come from darkness because I was now in the presence of someone who was born of light.[64]

She goes on:

> We had too many such fake heroes in the realm of morality, the very ones who created all the headaches. In the final analysis, however, I should be happy that

they wrote those things about me. It was the time when we were supposed to celebrate 2500 years of the kingdom. We were celebrating that occasion in a country where poverty was prevalent, kids were deprived of basic necessities, and many adults were illiterate. We were celebrating the Shah and the Kingdom while we could not freely talk about politics and our life's daily problems. Everyone was fighting the system and the oppressive regime; some with their pen, some with guns, and some by escaping from the country. And I was up against the editors, the dirty editors of such journals. I have spoken in my poetry about the real darkness and light. I did not mind, however, providing an occasion for criticizing our situation, and mocking the occasion, and undermining the celebrations by having them talk about me in the same issue that was dedicated to such a grandiose event.[65]

Apparently, not only the postrevolutionary authorities considered Shahrzad insane; many journalists and even her colleagues casually expressed similar sentiments or failed to change their perception of Shahrzad as a sexy dancer—or as they would put it, as a misled woman. One of *Setareh Cinema*'s commentators wrote a few times about the controversy surrounding her relationship with the director Mas'ud Kimiyai while trying to remind his readers of her previous life and her attempt to reconstruct it. Another piece about her appeared in the magazine *Film o Hunar* (Film and art] entitled "From Dancing the Hips to Moving the Brain: Half Nude Shahrzad of Bars and Cabarets to Today's Intellectual Actress."[66] Monsef, the author, starts by describing her as a woman "who is silent but if you disagree with her, she changes, becomes mad, and disrupts everything."[67] Then he says that Shahrzad's first book, line by line, brings to mind the works of Albertine Sarrazin who has also jumped from "there" to "here."[68] It is an interesting comparison. However, the comparison also indicates that accusation of insanity against starlets is universal.

In response to all this, Shahrzad ripostes, "I knew from my childhood that I was not pretty and that I could not become an actress by means of that gift. But I am not worried now because I found in myself the talent required for acting."[69] She continues, "When I danced, I cared about people, and now as an actress and poet, I feel responsible to people."[70] Monsef, however, continues to ask her about her past and her family, about hot issues. Inevitably, she restates, "My parents have not been good for me but I try to be good to them. It is difficult to take care

of a family of nine, and that is what I am doing now and it is time consuming. Nevertheless, I find time to study, listen to music, and see good movies. I don't spend time in beauty salons and boutiques you know."[71] And when she notices that questions keep coming, she goes on to say, "If you asked me about my past when I was twenty, my answer would be bitter. Now, at twenty-five, I have come to terms with my past, I am even capable of remembering some good moments in those years. The good thing is that being in love, being a poet and in love, I can be oblivious to the bad things of the past."[72]

What is ignored in all these exchanges is Shahrzad's astounding success in overcoming all obstacles to make a multifaceted career. She is not congratulated on her achievements but she is chastised for what is perceived as deviated morality. Finally the topic changes and the next question is, "How did you end up writing poetry?" Even here, one senses a cynical tone. But Shahrzad explains it well:

> When I danced, when I was a dancer, people called me Crazy Shahla [*Shahla Divuneh*]. I was not really crazy but the reason they gave me that nickname was simply because I stood against the wickedness and injustice that I encountered. However, I suffered badly for that resistance because I was one person facing a mob. I looked for a way to express myself, a way to shout, even if it was only to myself. I strove to stay alive. At the same time, I thought of men as monsters. Yet, being a woman, I needed a man. And then love came. Or rather belief in love came. And the thirst for writing came. I dare to say that it was only with this very love that the poetry found me, and not the other way around.[73]

In some ways, the answers in these interviews are clearer and more straightforward than the explanations Shahrzad has provided in her letters. However, her letters indicate a sense of confidence and a more decisive understanding of some issues related to male-female relationship and gender problems. About her experiences with men during this period, she wrote in a letter in 2002:

> Honestly, I know men. And like a doctor I know what medicine they need. They need to know that they are men and that they are loved. Many can only be certain of their manliness if you sleep with them, marry them, or let them have you in one way or another. But I am a woman, very woman, and I would not tolerate disrespect. At this point, you need to look at these individuals from sociological and psychological points of view."[74]

Despite all her deliberations, the journals and the intellectual communities refused to take her seriously. They all preferred to let the image of the "crazy woman" persist. Indeed, I was told by a few members of the Kanun-e Nevisanedegan-e Iran (the Association of Iranian Writers) that she did not act normally when she attended the association's meetings. Some mentioned similar incidents occurring in the meetings of the Iranian Cinematic Guild, Khaneh Cinema (the House of Cinema). For example, before the revolution, when she was still dancing in the Lalehzar Street cabarets (and in Nasr Theater), she once started a fight with a manager who refused to pay her. She chased him with a sword that was used for acting in the scenes. That incident earned her the title Crazy Shahrzad in that place. Another notorious incident occurred while filming *Baluch*. According to Behruz Vosuqi, she once arrived at the scene of filming in a rental car and slapped the director Mas'ud Kimiyai (with whom Shahrzad had a relationship at the time) for sleeping with one of the actresses. In response to Vosuqi's objection over this behavior, Shahrzad said, "You have no idea what he has done to me."[75] Another incident belongs to the days immediately after the revolution. She went to the House of Cinema one day in 1979, happy and cheerful. She then saw Hossein Gil, an actor with whom she played in a few movies, and she hugged him. She had not cared that a religious regime was now in power that prohibited men and women from touching each other in public, let alone men and women who were not related by blood or marriage. And she also did not know that Hossein Gil had become religious after the revolution. He threw her off himself, calling her "crazy."

The Mad Woman Construct

Imagining or perceiving "women artists" such as Shahrzad as people who lack cultural norms or as schizophrenic patients so ill that they cannot communicate effectively is not unique to Iran. However, conditions in Iran during the immediate years after the revolution did psychologically damage sensitive thinkers. That is what persecution and prison did to Shahrnush Parsipur, who could only overcome the resulting problems after moving and establishing herself in the United States. However, such labeling is also the result of the skewed way of thinking about sexuality, the expression of which, in any minor way, can cast an assertive woman as culturally abnormal. What Iranian social and literary critics did in analyzing Shahrzad and other women of show business is indicative of

such a mode of thinking, establishing an ideological dichotomy between nudity and poetry, sex and art, sexuality and intellectuality, all in order to locate their so-called wrong or right place, their ideological value system. Even Monsef failed to see that the life and art of Shahrzad and Sarrazin had been interconnected. While accepted to some extent as an author, she was always looked upon as a cultural outcast for dance and cinema, and she was always scolded for her lifestyle. It is in this context that schizophrenic and crazy labeling provides the critics with a sense of relief from further examination and analysis.

Shahrzad after the Revolution: Life Only Getting Worse

By the mid-1970s, despite economic growth and Westernization, Mohammad Reza Shah had lost his credibility as a result of his iron-fisted control of the state, the lack of personal freedom, and rampant corruption. The anti-Shah movement attracted people for various reasons. Women in particular participated not only because revolutionary discourse had become widespread but also because they believed that a revolution could bring them more freedom and equality with men. While Mohammad Reza Shah was in power, Shahrzad may have been rejected by the intellectual community, denigrated by the press, and forced to struggle for acceptance, but these hardships were not really significant compared to what was about to happen to her and her sisters in the world of popular art. Even as Shahrzad honed her artistic talents and entertained audiences, anti-Shah activists overthrew the ruling elite in the Iranian Revolution of 1979. But this did not bring women the freedom and equality they had craved. Instead, a new regime came to power that opposed Westernization and sought to undo much of the modernization achieved by the Pahlavis.

The new regime believed that Iran needed to look Islamic, and this was most quickly achieved by having women veil again, which in turn changed the way women participated in social activities. Legal repeals of other Pahlavi reforms affecting women followed. Women lost the right to divorce, the right to the custody of their children in the event of divorce, the right to travel freely, and the right to equality in the workplace. The state's Islamization of society redefined women's position in society, in family, at work, and in public life. The state actively promoted gender segregation, causing gender to be a social determinant. According to the new leaders, veiled women symbolized Muslim virtue and the rejection of the West. Although some poets and female literary authors, such

as Simin Behbahani and Simin Daneshvar, continued to be active and popular, albeit with many restrictions imposed upon them, other public figures, such as the dancers, singers, and actresses of FilmFarsi, disappeared. They secluded themselves in their homes or went into exile. Men in show business and women who did not show much skin, however, could safely stay in Iran, and some even played in films produced in the new Islamic Republic.

Shahrzad was forced to stop dancing and acting completely, not only because the nightclubs were closed and film production halted but also because such activities were now considered sinful. She could perhaps have continued to write poetry, but events made that impossible as well. As mentioned in chapter 1, in March 1980 Shahrzad was arrested during the International Women's Day street demonstration in Tehran. She was jailed in the Revolutionary Committee's notorious Evin Prison and then sent to a series of mental institutions. The day after her arrest, authorities confiscated her camera and notes, and fundamentalist newspapers ran her picture on the front page and portrayed the women's demonstrations as an imperialist conspiracy. Shahrzad had no political affiliation with leftist organizations, nor had she participated in organized feminist activities before the demonstration that led to her arrest. Her presence at the first women's independent demonstration may even have been accidental.[76] No Marxist, feminist, or other leftist organizations came to her defense. Her destruction after the revolution was a continuation of the misunderstanding, misrepresentation, and mistreatment that had marked her career and later became representative of the constitutive elements in the treatment of all women who resisted the new limitations on their activities, sexuality, and identity.

I am not sure exactly how long she spent in prison and in mental institutes; it could have been nearly five years, during which time no one ever mentioned her name in any journal inside Iran or abroad. During this time, no one could trace her. An encyclopedic publication actually reported that she had committed suicide and died before the revolution.[77] Ebrahim Golestan too once surmised that she was dead.[78] The biographical note accompanying a piece of her work that was translated into English states, "Shahrzad's actual birth date is unknown."[79] The note goes on to explain, "Because contact with Shahrzad herself or someone who could help in this respect was not possible, included on this page is a short introductory passage found in one of Shahrzad's books of poems published in Iran."[80] The translator and author of the book was right about the difficulty of contacting

anyone in Iran in those days. But what Shahrzad later found most troubling was the next comment, "It is believed that Shahrzad's *Hello Mister* [a novel] which is the story of a prostitute, is also her autobiography."[81]

The state-sponsored newspaper *Kayhan* once again renewed all these assumptions about her death and suicide and the accusations against her. The newspaper writes, "At the height of her physical and psychological illnesses, Shahrzad traveled to Germany in 1985 and returned to Iran after seven years and has since spent seventeen years in homelessness, wandering, and distress. What she cannot find any more is the attention and trust of her acquaintances and people in cinema industry." The paper further quotes her as saying that the greatest difficulty about staying in the streets and sleeping in the park is finding a restroom in the morning and securing a place for one's belongings. The piece concludes that all of this is the result of dancing in the cabarets on Lalehzar Avenue.[82]

However, in a two-volume edited book entitled *Ketab-e Zendan* (The book of prison), one contributor named Maryam A., writing about the women she met during her own imprisonment in 1980, documents her encounter with Shahrzad. According to this memoir, Shahrzad was incarcerated in the women's section of the Evin prison in that year. According to Maryam A., Shahrzad had been whipped and tortured. She replied to a guard who derogatorily addressed her as *raqaseh,* the dancer, by saying that she danced only because her father was poor, her sister was sick, and her family did not have a proper shelter.[83] The guard then tells Maryam not to think of defending Shahrzad. He says, "She is a prostitute and has a bad name. We arrested her in the demonstration against veiling. We have several films of her dancing in the cabarets. She has been proved to be 'Corrupt on Earth' but still has a big mouth."[84] Apparently, the prison guards knew that Shahrzad was sensitive to the word *raqaseh*. She once explained to Maryam that her father asked her to dance in his coffee shop from morning to evening in a short petticoat to attract more customers. "Since I was nine, I had to dance, clean, and wash. Then I slept on one of those benches when customers left. Why should I now be flogged?"[85] She further explains to Maryam that she hated her previous career as a dancer and wished to die and be reborn as a different person. According to Maryam, Kachui, who was the head of the prison, had asked Shahrzad to join him in a temporary marriage and since she refused, he always called her *raqaseh* and beat her on a regular basis. In addition to all the psychological pressures, some of her wounds were infected but she did not receive any medical

treatment and instead tried to work out, make dolls, and read poetry as often as she could. At one point, she went on a food strike, demanding attention to her case. She was hoping that people outside, especially the members of the Iranian Writers' Guild, would hear about it and support her. However, no one wanted to get involved in a case that in their mind was not political.

According to Maryam, after Shahrzad ended her ten-day hunger strike, she also ended her normal behavior toward other prisoners.

"She broke down as she realized how doomed and lonely she was. She began to hate everything and everyone."[86] On the day Maryam was released, Shahrzad hugged her and sang a revolutionary song for her.

Abuse in Prison and in Society

Many allegations have been made about sexual abuse in prisons in those days and even during the Shah's time.

According to Iraj Mesdaqi, a former political prisoner, all sorts of sexual torture occurred in Vahed-e Maskuni (the residential unit) of Qezel Hesar Penitentiary and other prisons where they kept women prisoners.[87]

In his prison memoir, he lists a number of torture techniques that were designed to sexually suppress or belittle the prisoners.[88] Although there has not been any independent report or any substantial studies to support these claims, around 2005, a series of films were discovered and displayed on satellite stations abroad that corroborated some of the former prisoner's points. They showed how the interrogators tried to force the prisoners (both female and male) to confess to sexual deviations and extramarital relationships. They constantly used abusive sexual slurs and threatened the prisoners with sexual assaults. Forcing such confessions are supposed to break the prisoner's will and make them cooperate with the jailors. A few other former prisoners were also asked during their interrogation to confess having "illegitimate" sexual relations.[89] On the other hand, there are almost no reports of sexual relationships among prisoners.

When she was finally released, Shahrzad had nowhere to go. Her belongings and properties had been confiscated. She had no one to take care of her. Members of her family had either died or moved abroad. Even though she has talked about much of her torment, she has yet to speak about her experience in prison. And that is not unusual; many Iranian women who went to Evin or other prisons in Iran tend to be silent about their ordeals.[90] Her choice of vocabulary

and her fear of being stoned are indicative of the deep-rooted fear she has developed.[91] We know that in 1985 or 1986, she become a refugee in Germany for a few years. She had only a few dollars, a blanket, a jacket, a book of Hafez's poetry, and two cans of subsidized cheap caviar with her. She had hoped to sell the caviar, but ended up eating it in her first few days in exile, overcome by her hunger. She was soon forced to return to Iran by her inability to find a means of financial support (and for some insincere promises she received from Iran) despite the fact that she could expect another round of humiliation, accusation, and maltreatment.

The Most Prominent Homeless Person in the Country

When she reappeared in the early 1990s as a homeless person on the streets of Tehran, she was not only poor but also sick. She was in need of eye surgery and psychological treatment. She slept in parks where she woke up to the sounds of cars, mice, birds, and cats. She lived in a number of remote villages where she hoped to afford rent but woke up in absolute loneliness with no newspaper stands anywhere close by.

In Tehran, she spent most of her time on the streets near the House of Cinema, now a deteriorating, forsaken building in which she was eventually given a temporary room to stay.[92] About the living conditions in that room, she wrote in a letter:

> Have you ever had to write your letters under candlelight in a crumbling house without most of the necessities of life? Have you ever experienced the state of mind in which you need to take a shower and you cannot find one? Have you ever craved a glass of wine and not been able to get any? Have you ever wanted to take a walk in the evening or in the early morning and yet not been able to do so for the fear of being mocked, stared at, and ridiculed in the streets? Have you ever shouted and cursed the world because of what wicked and foolish things people do to you? Have you ever been belittled and offended to such a degree that when shouting, your voice sounds strange to your own ears? What would you do if they stole your radio and cassette player, to which you are used to listening to when writing poetry? Do you know what happens to an artist who does not have a sound system, a television, a video player, a phone, or something with which to make contact with the world? Can you tell the difference between

the person who has not had anything, who does not have anything and a person who has had everything, or a person who wants to have everything? Can you imagine someone used to a courtyard, a garden, and open spaces being tossed into a small room with such opaque window glass that it makes the color of the air outside appear perpetually dark and gloomy? How would you feel if you received deceit and mistreatment in repayment for all the good you have done? How would a sane person feel if she were constantly referred to as mad, crazy, and insane? How should she feel in the face of constant accusations, especially sexual accusations and promiscuity? Lies, fabrication, forgery? Am I a monster? Do I have to tear my throat out to prove my innocence? What if there are people who don't want you to smile, who don't want you to be pretty, who don't want you to have teeth to chew on your food? How do you define gender and sex in our country? What does freedom mean? Why does so much violation of human rights occur in the name of religion and freedom?[93]

No one can provide any effective response to such moving expressions. In fact, there is nothing one can say in response. There may be things one could do to ameliorate the grave circumstances. But to do so, from a distance and under the current political conditions, becomes hard and problematic as well. Later, Shahrzad moved to a different room on Shariati Street. However, the conditions there were still dreadful. About the new place, she wrote in a letter:

One of those men who owes me money, a lot of money, now has given me a room to live in. But he owes me more than that and has for a long time, since the old days. He owes me for my art work, my writing, my journalistic work, my dancing in Tehran and Shiraz. Yet he has made me live in this crumbling house, inside a room where the rain drops from its ceiling in the winter and from its stucco in the summer. It is damp and cold, and it smells. It is frightening. I have to walk to warm myself. I have to borrow pens and papers and food from the grocer. I am the richest and poorest woman in the world. I am dying slowly. And the owner is living in the U.S. with my money.[94]

During all this time, what bothered her most constantly was that, despite her efforts, none of her belongings that had been confiscated at the time of her arrest or shortly thereafter were ever returned to her. About this bitter experience she writes in her letters:

Since my childhood, this is how they have treated me and my things; no one ever respected my private belongings, my dolls, my toys, my carpet, and areas of my body about which I cannot speak. And once more, I had many things that I lost again; new dolls, books, music tapes, personal items that I had brought back from Rome and elsewhere, and they are all gone. I loved all of them. Two dirty generations have treated me the same way, but they have not gotten lost yet; they are still here and all over the place.[95]

Despite the ambiguity in these lines regarding the perpetrators and despite the lack of reference to prison, imprisonment, and the authorities with whom she had to deal, one can easily sense the severe pain and sorrow she had to endure. She was neither able to collect the money that others owed her for her work prior to the revolution or to regain the belongings and properties that were taken from her after the revolution. She was rendered destitute. In 2004, she moved to a village to live near a shrine. Several months later, however, I received reports that she was trying to get out of the country again.

Popular Culture and Sexuality in Iran

In the West, popular culture is part of the historical memory and in many ways it contributed to the formation of a modern identity for Westerners. In Latin America, as William Rowe and Vivian Schelling show, popular culture manifested by radio shows, television soap operas, the samba, carnival, fashionable drama, and oral poetry has assimilated Western mass culture while keeping some of its own characteristics.[96] In Iran, noticeably, popular cultural products and activities have been divided into two opposing categories: "modern," "foreign," or "Westernized" versus "traditional," "religious," or "national." The first category includes cinema, television shows, and pop music. The second category includes rural culture, religious ceremonies, some traditional art forms, and antagonistic denunciations against dictatorial regimes (the later subcategory is what Iran may have had in common with Latin America). After the revolution, many Iranian male actors who had played in the same movies as Shahrzad did and who had paid to watch her and others like her dance shifted from the first category to the second. They therefore remained safe, and some even continued their careers in the newly established Islamic cinema and arts. Shahrzad's dancing and films were perceived as belonging to the first category, however. The

only shift she made was to move from popular-culture dance and film to the high-culture art of poetry, and that was not enough to stay safe. As discussed in chapter 4, myriad actresses and singers worked in nightclubs or acted half-naked in Persian movies during the era of Mohammad Reza Shah. They, too, were made to attend revolutionary courts, go into exile, or remain in Iran in silent seclusion.

In this section, I would like to illustrate from another angle how the absence of a modern discourse of sexuality in Iran caused the contradictions between branches of popular culture and between the popular and high cultures. I focus especially on the issue of nudity, which as presented failed to contribute to any conception of plausible modern relationships between the sexes and did not result in a historiography of sexuality, especially of women.

In the seventies, the question of sex in cinema was debated in Iran. Shahrzad participated in that debate, perhaps hoping thereby to protect her character. But this debate on the nature of Iranian cinema and the representation of sexuality that was pursued in some popular culture journals was incoherent and limited; it was primitive, unsubstantial, inadequate, and pedestrian; and it often was circular, repeatedly returning to the most trite rules of morality. The debaters usually made some reference to the consequences of the White Revolution, which gave women more freedom. They also made reference to increasingly popular Western fashion and dress styles as a threat to authentic Iranian culture. Those who were critical of nudity for these reasons blamed Westernization for ruining the indigenous culture. Revolutionaries of all sorts pointed to nudity and the representation of women's bodies as signs of societal corruption under the second Pahlavi regime. No one mentioned that they could not really hold the West responsible for the creation of sexual oppression, sexual deviation, and promiscuity as the phenomena have existed since the dawn of history, more so in closed societies. This mis-conceptualization of the West was greatly helped by the Soviet Union anti-Western propaganda and by the ulama's suspicion of and resistance against Reza Shah's reforms and in particular his emancipating initiatives. I shall return to the unveiling event and laws of the 1930s during the reign of Reza Shah, even though this occurred before Shahrzad was born.

For modernity to have taken hold in Iran, such debates should have started even before Reza Shah's unveiling project in the 1930s and should have continued unabated throughout the seventies.

To Veil or Not to Veil

Official historiographies of the unveiling event rarely discuss how it occurred. *Zan-e Ruz* (Today's women), which generally promoted Western styles for women, published a special issue with a series of entries and interviews and retrospectives to tackle the subject. That special issue commemorated the unveiling day of January 8, 1936 (17 Day 1314), and presented a sort of belated discussion of the history of unveiling. Formal narratives usually credit Reza Shah for initiating the idea. In addition, poets such as Aref Qazvini and Iraj Mirza supported the initiative and women's rights, and many ordinary people also took part in the movement. Many minority women aided the process, and many translators promoted the idea by rendering into Persian works about women's rights written in other countries. These early intellectuals, including the poet Iraj Mirza, associated the veil with women's suppression, backwardness, limitations imposed on women, and the fact that women were prisoners in their homes. However, the government's campaigns for unveiling downplayed these aspects and instead associated unveiling with modernization and Westernization in their most symbolic sense. Although many intellectuals and ordinary people, male and female, recognized that the veil was just the tip of the iceberg of cultural backwardness, their recognition did not translate into a movement for modernity and enlightenment, and it spurred no national dialogue, no greater discourse about women's overarching sexual and individual sexual freedom.

A review of these debates in popular cultural magazines might help explain the position of Shahrzad and other women in the popular arts and show business in the subsequent decades.

The memoir of Gholam Reza Sahebqalam, printed in the special issue of *Zan-e Ruz,* mentions many incidents and violent acts that occurred after the unveiling process began. For example, he writes, "A store was completely looted because it sold women's socks."[97] He remembers that when his mother removed her veil, his father told the children to "be scared, she is the werewolf, though she is your mother."[98]

The same issue of *Zan-e Ruz* also contained harrowing memories submitted by women. Hajar Tarbiyat writes, "The day my unveiled photo was published, I received a collection of letters filled with sexual profanity from readers."[99] More pertinent to Shahrzad's experience, Esmat Safavi writes, "The day I appeared in a

theater scene, many concluded that I was insane, unwise, or retarded."[100] Indeed, a review of news items from the period shows that the brave parents who allowed their daughters to wear the newly designed and still conservative school uniforms were pointed out in the neighborhood, condemned by religious authorities, and socially despised. The mothers were often accused of being prostitutes. Women who wanted to take advantage of the situation and find work outside the home faced similar accusations. They were ridiculed because they supposedly did not know how to dress, do their hair, or even how to walk without their chador. Apparently guidelines about proper social conduct without the chador were printed in the Shah's missives but were not implemented on a grand scale.

Mosio Hambarson, an Armenian tailor, remembers that Reza Shah, after his 1936 initiatives regarding the unveiling project, sent for him and requested his help in the unveiling initiative. The king told Hambarson to bring help from Europe if necessary, in order to design a conservative overcoat or jacket to help ease women into life without the head-to-toe chador. Hambarson invited a tailor from Belgium to Tehran to help him, and thirty Armenian women opened five tailor shops on Mokhberoldoleh Crossroad. The king, upon hearing of this accomplishment, said, "Well, it is a relief to hear that."[101] This happened less than a month before January 8, 1936, the day of the announcement of the unveiling. Of course, a few other measures were taken as well. For example, Manokian, a hat seller, ordered 10,000 hats from Belgium and sold them in no time. However, his next 10,000 hats did not sell because, in just a few months, the fashion changed and women were looking for more colorful hats. Even the introduction of hats for women was done with no long-term plan in mind. Manokian mentions that "a woman bought a hat and put it on her head. Then she saw one of her male acquaintances outside the shop on the street. The man took his hat off to greet her. The woman did the same in response, causing her hair to blow around; it was a ridiculous scene."[102] Soon, perhaps to avoid such mishaps, the few available barbers for women were cutting women's hair "à la garçon," thinking such a haircut to be practical and likely soon fashionable.[103] Some women also did not know they had to take the tags off their hats, which prompted men to mock them on the streets, all indicating the lack of sufficient preparation and education for the implementation of the project.

The religious segment of society firmly believed that unveiling and allowing women to work in public would lead to the corruption of society. Religious

activists took their message to the ordinary people. Many religious associations and gatherings soon were formed to promote virtue. For instance, Khanom Kharazi preached to 150 students on a weekly basis when she was only thirty years old,[104] arguing that women should preserve and guard their beauty instead of showing it to strange men and causing corruption in society.[105] Faced with resistance and accusations, some women unveiled but went out in male disguise.[106] The campaign in favor of unveiling, led by Reza Shah's daughters, Ashraf and Shams Pahlavi, did not reach ordinary people like that of the religious activists. Clearly, the cultural dialogue and activities necessary to provide a context for unveiling were virtually nonexistent. The initiative lacked a carefully planned nationwide campaign and a grassroots or intellectual-led movement to connect unveiling and women's freedom with progress and modernity. The will, the resources, the knowledge, and most importantly the historical conditions for such a connection did not exist and were not fostered. As a result, an initiative designed to be the emblem of Iranian modernity led to a stronger, more audacious reaction that embraced traditional and "antimodern" culture.

Another factor that fostered traditional reaction was that opponents of unveiling were not the only ones to shame women and commit violence. Many memoirs describe how government officials, instead of educating men, tried to shut up the opponents of unveiling with counter-violence.[107] Sometimes local authorities took the law into their own hands, mistreated people, and ignored the guidelines from the capital, which (theoretically) encouraged a nonviolent approach to the unveiling process.[108] A survey of the government guidelines, bylaws, and communiqués issued from Tehran shows that there was a significant amount of confusion among the police and local authorities in the provinces about the nature of unveiling; where, when, and how it should be implemented; and about what to do in the case of resistance.[109]

Thus, the chador crisis was never resolved philosophically, theoretically, or culturally; it was simply removed from the heads and bodies of a number of women.

Mohammad Reza Shah abandoned his father's bold approach, but nonetheless the trend of women diversifying their wardrobe accelerated under his rule with the introduction of miniskirts and other Western outfits. Decades later, at the time of Shahrzad, popular journals wanted to discuss the representation of nudity and sexuality in Iranian cinema and in the nightclubs but could find no historical discussion on which to rely or reflect. The attempt by *Zan-e Ruz* to

review the history of unveiling, in order to discuss the problem of sexuality in the movies and in the nightclubs, although laudable, led to no tangible result. Apparently, no one recognized that even if they stopped nudity in Iranian movies, they could not do anything about nudity in imported Western movies, nudity on the streets, and nudity at the beaches where people were attempting a Western lifestyle. Western movies indeed inspired both Iranian movies of the same ilk and the beach life. In foreign films, nudity and sex were plentiful, and the censor laws were somewhat relaxed about them. Some film festivals showed those movies uncensored. Western pornographic magazines and pornographic playing cards were easily accessible. Therefore, the problem was not created only by Iranian movies; the movies and life imitated each other.

To Reveal or Not to Reveal

Popular journals of the time criticized Iranian-made movies that included nudity or revealing cinematic scenes and therefore connected nudity with morality, identity, and nationalism.

Moralist critics believed that it was wrong for women to take off their clothes in front of the camera because by doing so, they would corrupt the young men who watched them on the screen. Nudity, they believed, would destroy society.

One article in *Ferdowsi Magazine* was titled "Nameless, Disreputable Iranian Women Have Lost Their National Identity Card."[110] As if it is quoting a sentence from a future constitution, the article reads, "When a woman loses her identity, she, instead of using traditional customs, obtains every piece of her clothing and makeup from alien nations, nations as far from us as China, Japan, Italy, Africa, etc."[111] Like other magazines at the time, and in uncanny twist and irony, the article cited above was accompanied by a picture of a woman in a Western white naval-style top and pants next to a miniature depicting a woman in traditional Iranian dress. Another issue of *Ferdowsi Magazine* contained the article entitled "Ruspigari dar Filmha-ye Farsi" (Prostitution in Persian movies).[112] It states that in years past, women would not agree to play the role of a prostitute but that they now compete for such a role. It also reports that Foruzan (Parvin Sajedi-Khayrbakhsh) has played the most roles as a harlot. And it featured pictures of a few women in revealing dresses. When one reviews the materials from that decade, one cannot help but wonder about the purpose of those photos. Maybe they wanted to publish those photos, and the articles were just a legitimizing excuse.

Another author criticizes the construction of the image of rough manly women in the movies, such as women wearing men's suits and a fedora (trilby) hat, holding lock-blade knives, talking tough, and gradually taking their clothes off to reveal parts of their bodies. The author believes that exploiting the sexual depravity of the society and exploring "women's psychological complexes" further creates social crisis and disastrous sexual chaos.[113] Again, this article is accompanied with images of semi-nude women and drawings of bare breasts.

Ferdowsi Magazine printed another article entitled "The Miracle of Narcotizing People's Thoughts through Pictures Is the Most Traitorous Activity Going On."[114] The author laments that many new female stars emulate Mahvash, who was one of the first Iranian women to dance and sing in cabarets and in the movies.[115] He refers to this emulation as Mahvash Zadegi (a phenomenon termed as "struck by Mahvash" or "Mahvashism," implicating other artists, such as Shahpar, Afat, and even Shahrzad). But while Mahvash used her style of dancing and singing meaningless, funny folk songs to create excitement and try to engage the audience in the singing, these newest female stars pretend to be intellectual and interested in philosophy. The problem, the article explains, is that they really are just used to increase the profit of investors in show business. These corrupt Mahvashes, the article maintains, prevent a serious rapprochement of questions about women's problems. Although the author does not explain those problems, the article finally gets to the point:

> We are different from the U.S. society where people do not forget their social responsibilities and daily work when they see the naked body of Raquel Welch. Here in Iran, men will go nuts when seeing such nudity. They go nuts seeing a woman's accidental winks. Seeing naked bodies, they become mentally unstable, and psychologically ill. As a result, men who are sexually deprived are living with a psychological crisis and women who are delirious about freedom are living with different psychological complexes. All this will result in crimes, murders, and possibly even honor killings.[116]

There was some credibility in this analysis about the effect of such movies on deprived men, but until the rise of the revolutionary movement of 1976–79, when religious revolutionaries began to burn movie theaters, Iranian films sold well. Moreover, the article looks at sexuality only from the male point of view; there is no discussion of what movie actresses and singers faced in their jobs as

entertainers, and there is no reference to the documented effect of these movies on women or on their families. In fact, these popular journals avoided any serious discussion of women's issues and hardly translated or published any serious articles related to the universal women's movements. They never addressed the fundamental question of whether Iran should try to be like a Western society where men no longer go "crazy" upon catching a glimpse of a woman's body.

Reza Barahani, an author and literary critic, entered the debate by arguing that the portrayal of sex is to some extent natural, an element of social life, and even presented in classical Persian literature. He felt obliged to state, however, that sex cannot be all that comprises a work of art.[117] "There are works that are all about sex (*Fanny Hill*) and that are not considered art by most, and there are arts that contain sex (Henry Miller's *Tropic of Cancer*, sculptures and paintings in Musée du Louvre for example). We need to make a distinction between the two."[118] These informed comments could have potentially been another occasion for the discussion of the field of the study of erotic imagery and its relation to modern Iranian society. However, the debate over what constitutes high erotic art and what does not was not part of Barahani's article. Prerevolutionary Iran had no canon of aesthetic sexuality in art and literature that could have allowed an intellectual debate about art and sexuality. Instead, Iranian culture frowned upon the visual arts and literature addressing sex.

Discussing Sex?

Any discussion of sex, nude imagery, or eroticism was overshadowed by complaints by those social activists who considered the presentation of nudity a conspiracy to ruin their culture. These complaints grew louder through the seventies, when the closed culture of the Iranians that "protected" their women behind tall walls became threatened by unveiling and then the revealing of the Iranian woman's body in Western-style bedrooms. Iranian society had traditionally strived to preserve female virginity; girls constantly dodged sexual activity until marriage so that they would not be labeled bad, loose, or sluts; and gynecology was not an accepted field of medicine. Then suddenly, three-quarters of the way into the twentieth century, women appeared on screen and, worse, represented nutty and sluttish characters. But no discussion of this nudity and promiscuity addressed the issues of women's sexuality, women's needs, the way a woman might be aroused or might physically or sexually be satisfied, or any

allusion to sexual choice. The debates and the movies that were the subject of the debates had no educational value in any sense. It may be "natural" for the movies to lack any education or artistic value in regard to sexuality, but then critics did not use them as a stepping-stone to serious discussion. Iranian society produced them before going through a sexual revolution, society switched from cashmere pullovers to tube tops (tank tops, halter tops) and coarsely looped skirts to mini-skirts without any intellectual debate, which, for example, occurred in the United States between the 1950s and 1960s. Iranian women in the seventies then felt pressured to be social, participate in social activities, be fashionable, find a job, go to school, and find an engineer or a doctor for husband all at once. Yet, to protect themselves, they had to "behave" in public, avoid any sexual (mis)behavior, and be accountable to their fathers and brothers.

The situation was not comfortable for the newly Westernized boys, either. On the one hand, they wanted to socialize with women, and on the other, they were still influenced by their parents' culture, which upheld abstinence and virginity. All elements for the failure of modernization were there. If one can say that a Western modernized society's tolerance for the portrayal of nudity and eroticism, as a form of freedom of speech and a form of personal freedom, is also an indicator of democracy, then Iran was neither Westernized nor modernized. People did not have the tools, the knowledge, or the means to initiate a discourse over sexuality. When Denmark legalized pornography in 1969, the country was ready for it. Indeed, based on their social and cultural history, the Danish seemed to have been ready much earlier. Other Western countries did not wait long to follow course. The legalization did not bring disaster or religious revolution upon those societies; in fact, one may argue that it improved knowledge about human sexuality in those societies. When Danish crime and sexual assault statistics did not climb, Westerners no longer assumed that eroticism perversely influenced or harmed people. Instead, they concluded that pornography and eroticism could be beneficial for inhibited and sexually shy people. If women believed that pornography objectified women, they were free to raise a new theoretical debate over the issue. For example, Andrea Dworkin, who was abused on a few different occasions, presented sexuality as constructed domination in her book *Intercourse* in 1987. Her dominance theory, along with the works of other scholars such as Catherine MacKinnon, created a model for antipornography ordinances linking pornography to tangible harm to women.[119]

In the Western world, many fought to present and popularize the ideas related to modern sexuality and eroticism, and many appealed to the courts to defend their freedom of expression. Now many feminist critics may argue the opposite. But the point is that the discussion of sexuality was going on everywhere; a new biblical exegesis even emerged and contributed to feminist thought about sexuality. That is, the history of modern sexuality in the West has been relatively short, void of any major violence, with no need for regime change, and always forward-looking. In the process, however, the contribution by Western women has been enormous, heroic, and fruitful. And they continue to challenge all barriers that hamper women's sexuality. In contrast, women were rarely able to voice their concerns, if any, in Iranian debates about nudity and women's representation in the arts and movies. Highly educated and intellectual women, as mentioned before, were heroically and enormously busy with "more fundamental" issues related to social justice and political change, and thus their efforts have not been as productive as the Western women's.

Shahrzad's Contribution

Not perceived as an intellectual or revolutionary, Shahrzad entered the short, uncertain debate in the 1970s through her journalistic works, perhaps more for personal reasons than any clear artistic or social theoretical purpose. In her bold contribution, she relied on her own experience to prove that under those circumstances, within that culture, women would get hurt if they succumbed to the Iranian cinema's obsession with the portrayal of breast and buttocks. She does not mention any instances of her bitter experience in any of her journalistic writings or interviews and saves her personal memoir for her poetic writings.

During her brief stint as a columnist for *Setareh Cinema* in 1974, Shahrzad wrote about the general issues related to FilmFarsi and women artists in show business. Her columns are often convoluted and seem to be responses to criticism and opinions she had read or heard somewhere else.

Shahrzad ended up a writer for the journal, the editor explained, because one day he entered a coffee shop and saw Shahrzad sitting in the corner working on her book. He asked her to write for the magazine. Shahrzad agreed and said that she wanted to start by interviewing the renowned interviewer Oriana Fallaci. The editor was surprised by this proposal and suggested starting a piece involving Iranians. Shahrzad concurred. She suggested interviewing Iren, a pioneer artist,

dancer, and sexy actress of FilmFarsi.[120] She also suggested writing about Qamar, a pioneer female singer. In her writings for the journal thereafter, she frequently mentioned these two names, praising them as genuine artists. Very conscious of her role in the artistic community, she probably sought to legitimize what these two provided for Iranian women in the entertainment industry.[121]

Shahrzad thus began to write for *Setereh Cinema,* starting with an entry on Iren, a prominent actress at that time. She launched her entry with an anecdote about a time when she and Iren went shopping together. They began to talk about their lives, the city, and their work, and they both cried together. In the rest of the entry, Shahrzad offers insight into Iren's artistic work. The first question she asks Iren is very interesting. "How can we be good women?" she asks. "I mean being good women by getting married and making a husband happy?" Iren replies, "It is too late for me, however, if there is going to be a marriage in my life, it should be accompanied by happy love." Shahrzad next asks, "Do you wholeheartedly believe in love?" and Iren replies, "Love is like air without which we cannot live." They agree that love has nothing to do with physical needs and that love can even be what one feels even when one is playing a role. They also exchange thoughts about work, what good work should be, belief in one's work, characteristics of good cinema, freedom of opinion, colleagues who have helped them, the necessity for abiding with the law, and the necessity for learning European languages in order to learn the latest techniques and technology in cinema. Similar to the enigmatic efforts of *Ferdowsi Magazine,* which published nude photos beside articles condemning nudity, this interview is surrounded by advertisements and photos of the French movie *César et Rosalie,* directed by Claude Sautet (a 1972 display of sensual feelings); the Italian *Paolo il caldo* (titled *The Sensuous Sicilian* in the United States), starring Barbara Bach; and *Maschio Ruspante* (which has bold depictions of nudity), featuring Marisa Merlini, Barbara Bach, and Giuliano Gemma (also known as Montgomery Wood for his role as Ringo in spaghetti western movies, a subgenre of western films produced by Italian studios in 1960s). All of these ads include pictures of nude couples holding each other.

In a later article, Shahrzad addresses a sobering topic: "Why do we have so many vulgar movies and so many banal actors, directors, and ideas?" Her response to the question is self-reflexive and one of the very few consistent and clear pieces of writing she published in that journal:

The makers of this banal, vulgar cinema don't think of anything but sex. They produce their movies for the wrong consumers; for the young guys who still do not know how to treat the opposite sex, for the girls who fall in love by looking into the eyes of the opposite sex, for a young generation who knows the swimming pool, the beach, the sauna, and cafeteria only through movies. And this is the cinema of sex, a cinema that is armed with sex as a tool against the sanity of the youth.[122]

To explain the problems associated with the use of sex (which mostly consisted of partial yet provocative nudity), she goes on to say:

The guy sees the woman's naked body, loses his appetite for good cinema, and then is left alone at night all by himself. But these movies cannot do a good job either. *Playboy* and *Lui* are much better for that kind of mission; they are colorful and harmless and they do not waste the time of those who have just hit puberty and need them. Perhaps for a rich Western guy, who drives his motorcycle for fun and carries his girlfriend on the back to a bowling alley, sex is not so problematic. But for the average Iranian who watches average movies in average theaters, such sex scenes are a problem. Iranian cinema must get rid of that kind representation of sex; Iranian cinema must be disarmed.[123]

To substantiate her points, Shahrzad refers to her own experience with nudity. She writes, "I am saying these things as a person who knows these things. I have traveled that rocky road. I have been there, done that. I danced. I danced at nights. And when I danced, they did not look at my face or my eyes. They watched my body and my curves."[124]

In the same article, she goes on to name some of the sexy actresses who are supposedly the weapons or means of the sexy cinema and warns them to reconsider their understanding of the cinema because what is being produced will eventually give rise to horrible social antagonism. Her comments were quite sober and full of eerie foresight because they were written in early 1970s, when there was yet no sign of a revolutionary movement in society. On the contrary, the Shah was at the height of his power, reforms were going forward, and the economy was strong. Everyone seemed to be having fun. An Iranian weekly, entitled *In Hafteh* (This week), soon hit the stands. It tried to offer indigenous nudity along with Western naked bodies, and every week it not only featured a nude woman on the cover but also had

a poster in the middle, very much based on the model of *Playboy* or European soft porn magazines. In the summer of 1971, not long after it began publication, it offered reports about the marital and sexual lives of European women as well.

Shahrzad's views and concerns regarding the issue of sex in cinema as discussed in her articles are more social and artistic rather than ethical, revolutionary, or religious. She criticized the entertainment industry for its lack of merit and credibility. She tried to legitimize her views by interviewing prominent people in the Iranian cinema industry.[125] Under such titles as "Sexy Actresses as Social Destructors" (*kharabkaran* also referred to terrorists in those days) and "Why Do the Cameras in Iran See Only Sexy Pictures?" she interviewed a number of critics, actors, and directors and shared her views with them in order to elicit their stances. These included Bahram Raypur, Jafar Vali, Faramarz Qaribiyan, Ali Abasi, Jalal Moqadam, Mas'ud Kimiyai, and Farzaneh Taidi.

In other articles, she appears defensive and uses rambling language to answer accusations directed at her and her movies while also trying to offer her own criticism of Iranian film. One case pertains to her review of Amir Naderi's *Tangsir* (1973). She praises the movie, its message, and the acting of Behruz Vosuqi but remains critical of the director. The director seems to have originally promised her the leading female role but then instead hired Nuri Kasrai for the lead.[126] She throws some of her criticism at Kasrai's character. Then she goes on to reveal the incentive behind her complaints: "At the age of twenty-six, I have now spent sixteen years dealing with all sorts of people in show business and most of these people have tried to deceive me and to rob me."[127] It is from this point of view and in defense of the marginal laborers in this business that she wrote an article in defense of stunt actors, the behind-the-scenes laborers, and general helpers in the filming studios. She says, "These general workers are not sufficiently paid and they are subjected to outrageous discrimination."[128]

Shahrzad then featured two other women in her writings for the journal: Esmat Savafi (b. 1911) and Farzaneh Taidi (b. 1943), to which she added her own experiences to create a three-way conversation.[129] According to the brief biography provided, Esmat Savafi began, somewhat secretly, taking acting classes offered by the City of Tehran in 1936. The classes were taught by Mr. Daryabaygi (educated in the art of theater in Germany). The theater became what was known later as Nasr Theater (which had by then moved to Lalehzar) and was led by people such as Nasr, Moez, and Halati.

Farzaneh Taidi started acting (mostly also in theater) at the age of sixteen, married the actor and comedian Parviz Kardan, had a baby, got a divorce, went to the United States, married an Iranian man there, and then divorced him when they returned to Iran. At the time of her interview she had just finished playing in the movie *Baluch*, directed by Kimiyai. Shahrzad had expected Kimiyai to give her the leading female role of Shokat in *Baluch*, but he had given it to Taidi, and she had already written angrily about that unfulfilled promise elsewhere.[130] She believed that with the color of her hair and eyes, she would be the right person for the role of Shokat. But Taidi, who was blond and thus unqualified for the role, received the contract. By the time of this interview, however, the bitterness seems to have dissipated, and Shahrzad was not critical of Taidi. She started with a compliment about Taidi, "It might be difficult to believe, but almost no Iranian actresses read books or listen to music. Farzaneh is an exception."[131] It was an original idea to arrange such a meeting between three women and discuss material in show business, so Shahrzad was as friendly as possible.

The ensuing discussion among the three women revolved around their roles in theater and cinema and the problems that the two guest artists faced in their constantly changing society. They also talked about marriage, love, friendship, and relationships. Farzaneh Taidi said in the interview that she changed when she went to the United States, but she did not get a chance to elaborate on the nature of the changes she went through except that she now felt free to be truly in love with a man. Shahrzad's questions in many ways seemed to relate to her concerns about her own career. Obviously the other two were perceived as superior in the field because of their educations and roles, so she tried hard to fit in, to make sure that the two more famous, or at least more experienced, women accepted her as one of their own. One statement that she inserted into the discussion is that beauty is not and should not be the top criterion for acting; it is talent that should count. And she begs for confirmation of that idea from the two guests. Retrospectively, and in comparison to some of her colleagues who now make frequent appearances on Los Angeles Persian satellite stations, she seems to have been expressive in some of those journalistic works and always opined. The excerpts discussed above leave no doubt about Shahrzad's intellectual ability in raising questions and initiating debates.

Again, however, these articles appeared on pages along with sensuous advertisements, such as one for the movie *Solange,* known also as *What Have You Done*

to Solange? (1973), a shocker by Massimo Dallamano about murders in a girls' school in England that was filled with violence and nudity.[132] It seems that the magazine's editorial managers could not care less about who wrote what. It seems that they did not have any editorial policy or journalistic mission whatsoever.

Under those circumstances, clearly, writing about all these debates and personal observations does not constitute a history of sexuality in the seventies. It may, in fact, generate more questions. But no other attempt has thus far been made to construct such a historiography. With no discourse, no history, and no effective contact with the West except through movies and their advertisements and related tabloid items, women could not benefit from the more successful experience of their sisters in the West, and the traditional Iranian society had very few lessons for the new situations. The women's valuable early twentieth century activism—as reflected in the pages of the eight or so women's journals published at the time—often had to be limited in the criticism of the existing social conditions and hardly had the chance to cover the details and depth of the issues of modernity. Shahrzad, her guests, other women artists, and even women who participated in the revolutionary movements of 1976–79 were all equally deprived of some of their basic rights, such as freedom of dress, by the end of the decade. Their worries, predictions, and the abuses they experienced did not, in the end, count for a historical improvement.

Chapters 4 and 6 introduce even more of those actresses who played roles similar to those of Shahrzad. After the revolution, most of them kept absolutely silent for fear of being stoned, as that punishment could easily be given to anyone accused of adultery and promiscuity. A few managed to find jobs outside their homes. Iren, that prominent pioneering star, for example, worked as a stylist for a short while. Some, such as Taidi, escaped the country to live a life of nostalgia in Los Angeles. Women in all branches of entertainment were indeed affected. Delkash, who had started her singing career in 1943, died in 2004 at the age of seventy-nine after remaining silent for twenty-five years. She too had played in some movies in the early days of her career. Elahe, another singer of almost the same era, disappeared into oblivion after 1979. Homayra, Hayedh, and Mahasti and an entire younger generation of singers fled in time to pursue despondent destinies in Los Angeles, and others, such as Googoosh, joined them twenty years or so later to shine at least for one more time in front of her now-aged fans. These women are now almost invisible in the face of a

new generation of Iranian musicians born in Los Angeles who have not even seen Iran.

Iranian intellectual communities, including literary circles, belonged to the high culture and were too puritan and too anti-imperialist, and too driven by their limited understanding of Marxism-Leninism, to risk analyzing the issues of sexuality and women's space, which to them represented bourgeois topics. Like their fellow revolutionaries who took power in 1979, they believed that Shahrzad and her like were the manifestation or the result of the corruption of an innocent society by the West.

In general, men never took women artists seriously. Even in the field of cinema, Iraj Qaderi and Fardin, two giants of FilmFarsi, said that female actresses were "empty."[133] Qaderi admitted that he wanted them only to play sexy roles.[134] Rarely can anything be considered modern about these and other ideas floating around the intellectual and artistic communities, as rarely was anything in their discourse ever concerned with women's sexuality.

Sadly, Shahrzad's movies and their popular-culture orientation caused intellectuals to ignore her poetry as well. Poetry offered a limited meaning in the prerevolutionary committed literature movement because it was mostly about revolutionary messages. For Shahrzad, there was a peculiar connection between the two forms in the sense that the more she undressed before the camera, the more she concealed her meanings and her character in her words. That is, in reaction to her public image that associated her with FilmFarsi movies, she then tried to distance herself from the roles that she was assigned through her interviews and journalistic works. It was partly a reaction to the ways she was treated by the limited media attention she received. Moreover, as regards her works, she clothed her poetic meanings and strong feelings with such unconventional language that critics did not bother to deal with them even if they would have considered paying attention to a woman in her position. The next two chapters analyze Shahrzad's cinematic and literary works to better understand her career, her works in different genres, and how all her achievements were affected by issues related to modernity and sexuality.

4

Seduction, Sin, and Salvation

Spurious Sexuality in Dance and Film

> I know many dances but my movie character was always required
> to do one dance, the cabaret.
>
> Shahrzad

Dance as an Art Form in Iran

In her study of tango, Jane Desmond states, "Dance remains a greatly under-valued and undertheorized arena of bodily discourse."[1] This is particularly true in the case of Persian or Iranian dance.[2] Throughout the medieval period and into the contemporary era, dance remained in the private domain in Iranian culture. Nevertheless, in the contemporary era this private activity has entered into the public domain and has become highly political as well.

In the twentieth century and especially during the 1970s, a sort of folk and theatrical dance first became part of public entertainment and propelled numerous dancers into cabarets and nightclubs and into the movies. The latter in particular helped the genre move into the public domain and gain a new level of popularity. The movies featured not only folk but also a variety of Western dances. In retrospect, it is easy to discern that dance is an inseparable component of FilmFarsi, whose plots frequently portrayed the life story of a cabaret dancer who, after a period of singing (lip-synching in reality) and dancing in nightclubs, is saved by the protagonist, a man who seeks a housewife. In FilmFarsi movies that do not include this plot, some male character inevitably ends up visiting a cabaret during some late-night escapade. Some of the dance performances were quite bold or radical for a society that would soon (in 1979) go through a religious revolution, for they include erotic, semi-nude, and at times wild Western styles

of dancing. New songs were also produced to match these scenes and were often performed by prominent singers such as Delkash, Elahe, Puran, Susan, and perhaps more than anyone else, Ahdiyeh. The latter sang nearly one thousand songs for FilmFarsi productions.[3]

While one may read the public emergence of such dance performances as a sign of Westernization of society under the Pahlavis (1925–79) and as an indication that women were integrating into artistic production, most prominent social commentators along with the leaders of the religious establishment at the time saw them as symptoms of a growing decadence. They referred to the proliferation of genres such as FilmFarsi as a sign of the regime's cultural corruption.[4] All of these might be true on the surface. After all, dance is an art as well as an integral feature of a modern society far beyond its primitive functions. And the appearance of certain forms of dance can easily become a symbol of any type of perceived cultural corruption. However, in the context of their plots, those cinematic dance scenes in Iranian movies reveal something else about Iranian society.

On a deeper level, FilmFarsi filmmakers used bold dance scenes as a cinematic element to communicate simplistic moral conclusions and complex political ideologies.

First, the movies of course responded to men's voyeuristic and moralistic needs. By having a man save the corrupt female dancer, the films tried to restore or maintain the culture of male domination on a moral and even quasi-religious basis.

Second, they presented dancing women on garishly lit stages in a way that could be interpreted as a sign of the regime's alleged moral corruption (even though as we will see, there was no evidence that the Shah's government made any deliberate attempt to promote nudity in the movies or on the stages of the nightclubs).

These movies tacitly and sometimes boldly rejected the social bravery that is required of men and women to achieve a modern life, which also required such social activities as dancing. Instead, they asked women to sacrifice, to safeguard gender boundaries, to uphold tradition in order for men to discover and cherish their masculinity. This flew in the face of other attempts to achieve modernity and actually helped the revolutionary culture of the late 1970s.

In order to advance these arguments, I first address some issues related to the dance genre in Iran. Then I discuss the history of Iranian cinema, giving

particular attention to the FilmFarsi genre. In doing so, I also hope to be able to locate Shahrzad's dance and cinematic work in the context of the cultural and artistic milieu of the late 1960s and 1970s and the postrevolutionary period.

Artistically, dance refers to a form of expression that presents a powerful impulse and a skillfully choreographed artistic body movement designed either to serve a ritual or to delight an audience.

The history of this art form is documented and researched in its textual and iconographic forms and, more recently, in its film varieties. Desmond writes:

> That dancing—in a Euro-American context at least—is regarded as a pastime (social dancing) or as entertainment (Broadway shows), or when elevated to the status of an "artform" is often performed mainly by women (ballet) or by "folk" dancers or nonwhites (often dubbed "native" dancers) are surely also contributing factors to the position of dance scholarship.[5]

Ballet and ballroom dances, which have old roots, may also be seen as a showcase of modernity, which improved and facilitated contact between men and women.[6] With the emergence and progress of sexuality discourse, however, other dance forms appeared in Western societies. For example, the burlesque form of the 1940s through the 1960s gave rise to such stars such as Zorita, Betty Rowland, Sherry Britton, Dixie Evans, and Lois de Fee, who were able to invoke impossible fantasies even for the mighty men.[7] Their performances left little—but just enough—to the viewer's imagination. Research and documentaries have reevaluated burlesque in light of new theoretical findings and have legitimized the genre as an accepted dance form. Likewise, the premodern tradition of geisha artistry played a similar role in Japan. Living in an ambiguous, exploitive, and suggestive sexual situation, geishas were beautiful, graceful, talented, refined artists who entertained guests through various performing arts in teahouses called *ochaya*. Even though their numbers declined in modern times, their legacy and influence have continued,[8] perhaps helping to create an appreciation for women's dancing and public work in that society. Importantly, these women's lives are often documented in print or films, and their works serve as cultural references today.

In Iran, however, the art of dance has lacked a disciplinary methodology. Explaining the difficulties of historiography of Persian dance, Anthony Shay writes, "the Iranian/Islamic world presents a special situation in that it forms

what I term a 'choreophobic' society, one in which dance is regarded with ambiguity and even negatively by a large segment of the population."⁹ Very few efforts were made prior to the revolution to introduce Western dance and its discipline to Persian choreography, and the art of dance was not documented when the country was struggling with modern ideas. After the revolution, dance became a clandestine art form and pastime. The pioneers in the field remained quiet, migrated, went into exile, and in numerous cases were summoned to revolutionary courts as well.¹⁰ Only in the 1990s, in California and in other diaspora communities, did some Iranians, such as Mohammad Khordadian, take it upon themselves to approach Persian dance art more systematically and try to address a wider audience beyond their communities.

During the reform movement of the 1990s and thereafter, a number of assiduous and persistent female artists began to offer private lessons and some acceptable forms of presentation.¹¹ They began this under a condition in which even the word *raqs* (dance) and *raqaseh* (dancer) were not (and still are not) used. Instead, the officials have coined ambiguous terms such as *harakat-e mozun* and *raqs pardaz* for dancing and dance. The attitude of course has its root in the earlier times when the word *raqaseh* was close to meaning prostitute, somewhat similar to the word *artist* (in referring to female dancers and singers) in some Arab countries. Such connotation was perhaps part of the reason Shahrzad insisted that she not be called a dancer.

Public Dancing in Social Context

As mentioned, Shahrzad's fate is related to her dancing and acting. To understand her work in those areas, we first need to understand the relationship between public dancing (in movies and in nightclubs) and the greater social issues in the 1970s. It was not intellectually correct to watch FilmFarsi-style products in the less stylish movie theaters in this decade, and many intellectuals and the advocates of the oppositional discourse disparaged the genre particularly when they were in university, but perhaps everyone from that generation did see some FilmFarsi movies at some point for some reason. Brothers or cousins would facilitate the visits to the movie theater for the younger members of the family. Memories persist of the fresh parsley-sprinkled sandwiches consumed before the movies began, at sandwich places next to the theaters. Viewing these movies again (as I did for this project) refreshes the remembered joy experienced while

hanging out in the waiting halls of the movie theaters. They were nice, modern, and air conditioned in the summer and heated in winter.[12]

Nightclubs and Cabarets

Tehran boasted several famous nightclubs or cabarets that featured live female dancers as less than obvious temptresses. Iran's religious authorities and intellectual moralists were effective in restricting the number of such cabarets in smaller cities such as Shiraz. Yet, Shahrzad mentions in a letter that she danced in Shiraz once in 1967. Café Abbas was the only place for that kind of dancing, and it may well represent not only a typical cabaret in the cities but also in the movies.

Café Abbas was a small establishment that featured female dancers. The movies that depicted that place or similar establishments, the remaining photos, and the descriptions in the newspapers of the time, as well as the memories of some people, help reconstruct the ambiance of Café Abbas.[13]

> *The Café's summer outdoor seating area is filled with men gulping vodka and whiskey mixes as they pierce the stage in front of them with their gaze. Most are middle class local men, some in poor attire and incongruous ties; male tourists from the Persian Gulf states are distinguishable by their long sleeved one-piece dress and head covers. The dancers, one after another, enter the stage to deafening music. One of them, a woman in her mid-thirties, is introduced as the star of the night. The cabaret has put her name and photo on a board at the gate. She enters the stage twisting her body like a snake, dancing to an even louder mix of Persian and Arabic tunes. She wears a long see-through gown that is open in the front. And "under" that, she wears a glittering panty and top. Her heavy makeup, powder, eye shadow, mascara, and an audacious reddish blush are all as loud as the music. Her long hair, waving to the side of her body every time she twists, matches her carefully trimmed eyebrows, which make her two somber eyes look larger and more mystifying. With each twist, she displays a different part of her body: she extends a leg out of the lingerie, she displays her partly visible breasts, she completely exposes her back when removing her see-though robe. Colorful lights brighten the stage, making her, her jewelry, and the colorful sequins on her dress and parts of her body shine gloriously and imaginatively. When she moves to the part of the stage that is lit with red and green lights, she looks even more mysterious.*

The men speak absentmindedly to each other, drink, eat their chicken kebab, and smoke American cigarettes as they stare at the stage, trying to interpret favorably the expressions on the dancer's face and body, which seems enticing, inviting, boasting, puzzling, and fatigued at the same time. They are mesmerized not only by the dancer's performance but also by the place. The courtyard is noisy with the music (amplified through the conical speakers hanging from tall maple trees around the courtyard), laughter from drunken men, the prattle of harried waiters zigzagging among the tables, and clinking glasses. Some men dance in their seats, extending their arms out, rolling their shoulders, snapping their fingers, and laughing contentedly. The musicians—men playing the violin, santur, tonbak, saxophone, and clarinet—play even louder after the dancer relinquishes the stage to the acrobats.

Café shows such as this may have been traditional for many Iranian men, but it was a dramatic experience for young boys in the 1970s. Families had tried to be modern by encouraging their daughters and sons to pursue higher education and by not forcing on them any sense of religious duty even though both parents practiced their faith. But despite a secular upbringing, many young men felt a sense of guilt over their desire for such entertainment; they even felt guilty about going to a pool hall to play billiards.[14] In the West, one simply likes the game or not; one's position toward the game reflects no ideological and moral position.[15] But in Iran, billiards came to be seen as a Western phenomenon with the potential to lead youths morally astray. This led not only to young men's guilt about frequenting pool halls but also provided the context that allowed the postrevolutionary regime to close all of the billiard halls abruptly for several decades.[16] Viewing half-naked dancers evoked similar complicated feelings in men. Men had been advised religiously, morally, and ideologically throughout the history to not lay eyes on women's hair or skin. Indeed, even until the mid-twentieth century, Iranian men were supposed to advise their women to cover their hair, their body, and even their voice. Yet, cafés provided titillating entertainment with a sexual edge and thus evoked a sense of both excitement and guilt in young men who attended such shows.

Dance in Cultural Context

In a country where dancing was considered by religious tradition to be a sin and by leftist intellectuals to be a popular art form (and, thus, unworthy), dancers

could not achieve notable artistic prestige.[17] Karin van Nieuwkerk observes a similar phenomenon in Egypt where not only Islamic fundamentalists but also Egyptian feminists regarded the female dancers who worked in nightclubs and elsewhere as immoral or prostitutes, especially because of their practice of sitting and drinking with the male customers, as often depicted in FilmFarsi.[18] Restrictions, lack of resources, an interrupted history, and the politically charged environment of art and intellectual activities prevented Iranian society from fully exploring dance as an acceptable art form.[19]

The history of dance in Iran, like many other cultural phenomena, has been choppy, discontinuous, and problematic, and then altered when the dance paradigm collided with its Western counterpart. True, there are references in classical Persian literature and in pre-Islamic and Islamic historiographies to women dancing in ceremonies. But religious discourse over the centuries rendered the profession of dancers shameful and led women to internalize that shame. Women were not members of entertainment groups in these early eras, and even on the eve of the Pahlavi period, very few women participated in the entertainment business.[20] Women who dared to join a local folk music troupe as singer, dancer, or player were considered near prostitutes and could not pursue a normal life.[21] And throughout the Pahlavi period, cabaret dancing and dance scenes in movies were seen as a crude means of sexual pleasure, in no way able to convey the complex meanings and methods of classical Persian dance. Then in Iran in the 1970s, many women began to dance with men at parties, at weddings, on the beach, in discothèques, and in the movies. A few ventured to do folk dances. Religious discourse was not powerful enough to inhibit such behavior and expression.

Two Pioneer Dancers: Mahvash and Afat

It all started with a few women. Mahvash and Afat were among the pioneers who introduced folk and belly dancing to FilmFarsi. Jamileh (whom I introduce later in this book), through her much-ignored performances and films, played the most significant role in popularizing the Iranian version of belly dancing. Soon, folk and belly dances found their ways into public places such as restaurants and at private events such as wedding celebrations and into nightclubs and movies. Journalists' comments, political exposés, and the contents and reviews of FilmFarsi products indicate, however, that men could not distinguish between these dancers and prostitutes.[22] Sinful or not, men could not resist craving or at

least watching women in public, on the buses, and in the parks, and sometimes scantily clad, twisting, and dancing on stage or in the movies. So, public dancing spread quickly in the 1970s, and soon hundreds of dancers entertained men on stages all over Iran. The pioneering dancers, Mahvash, Afat, Jamileh, and Shahrzad, gained national fame through cinema. Cabarets provided opportunities for other dancers and singers to become famous and to find their way into cinema. Delkash (in the early fifties), Ruhbakhsh (in the fifties), Shahin (in the fifties), Puran (in the sixties), Susan (in the seventies), and the pop singer, Googoosh (in the seventies) are among the female singers and occasional dancers who performed in cabarets and then entered cinema and gained an enduring reputation. Each of these women may provide a case in which a female presentation of her voice and body were tested against a tough and yet confused male crowd, a crowd that had numerous physiological and cultural problems, including identity crises, lack of understanding of women, lack of any knowledge of sexuality, and lack of familiarity with anything modern save for the brand names of the imported vodka, beer, cigarettes, and loudspeakers.

The conditions surrounding the Iranian women's dancing jobs were far different from those that prevailed in the contemporary Western nude clubs or their earlier versions. As we will see, the quality of life of Iranian dancers, the fates they faced, and the way their art has been perceived all differ significantly from American and European burlesque dancers such as Ann Corio, Sherry Britton, Dixie Evans, and Gypsy Rose Lee.[23] These American queens of burlesque (and joie de vivre offered by Moulin Rouge in 1889) played a role in normalizing sexuality.[24] But the reception by society of Iranian female dancers and their fate and legacy are quite different from their American and European counterparts. Iran's first public dancers in the 1930s (e.g., Nahid Rezvan) could perform only outside Iran, as is again the case since the 1979 Revolution. And as opposed to numerous American dancers, the lives of Iranian dancers have hardly been noticed, let alone documented.

Sociopolitical Context and Historical Misinformation

Further, the fate of Iranian dancers has been connected to political discourses. A common myth has been circulated that the Shah's government promoted dance and nudity in order to corrupt Iranian culture and promote Westernization. But in truth, the Shah's government remained in many ways cautious about supporting some types of dance. Iranian dancers belonging to the

popular-arts genre received no government aid, and yet government monitored the entertainment industry because it was concerned about the rise of risqué dance genres. Many documents show that the regime tried to promote ethnic (Kurdish, Turkman, Baluchi, and Mazandarani) dances, but for students to be accepted in the newly created vocational art schools, they had to also be familiar with Iranian folk dances.[25] Early in the reign of Mohammad Reza Shah, the deputy prime minister reported to Manuchehr Eqbal, the king's then prime minister, about the annual work done by the commission on limiting the works of foreign actresses and dancers. He was particularly worried that these artists would "engage in other work" beside their arts.[26] Foreign dancers and actors were allowed to stay in Iran for only four months at a time. The Ministry of the Interior, more specifically the SAVAK Secret Police, wanted to restrict television entertainment options and seemed most concerned about indecency.[27]

Another deputy prime minister advised the prime minister that *European Nights* (1959), a semi-documentary film that looked at European show business acts, should be banned, partly because its actors took their clothes off and partly because the movie promoted "lunatic rock and roll dance."[28] In the mid-1970s, when Iranian films reached the peak of their obsession with nudity and gratuitous flesh, many within the Shah's government voiced concerns and objections. Ministers, deputy prime ministers, parliamentary representatives, army personnel, and governors objected to such "moral decadence." In one case, the interior minister deported two Turkish dancers from the country for partial nudity during their performances.[29] At one point, the special inspector of the office of the prime minister made a request to the deputy prime minister to "ban dancing with the Hula-Hoop in public and private gatherings, the way they banned rock and roll dancing."[30] In a follow-up, the chief commander of the national police force asked for permission to confiscate Hula-Hoops from stores and private places.[31] Correspondence among the highest-ranking authorities indicates that they also were concerned about the quality of movies produced in Iran: many showed revealing female dancing scenes that were not even connected to the plots of the films.[32]

A navy admiral and member of the Senate by the name of Resai gave a presentation on the senate floor on the occasion of 17 Day Mah (Women's Day in Iran in the prerevolutionary period, January 7) condemning nudity in Iranian cinema. He began his speech with saluting the Shah as "the protector of Islam" and continued, "Iranian culture values women's modesty and all original Iranian

dance features women in dress. Now why do we allow the nude pictures of women to be hung from the top of movie theaters?"[33] He prophetically concluded that drugs, sex fetishism, and nudity will deter Iran from its path toward growth. In brief, it was not only the religious elite who opposed the latest developments in show business and women artists' participation; secular authorities also wanted to prohibit any portrayal of nudity.[34]

Another Iranian governmental report condemned and belittled the political ceremony of the prerevolutionary Iranian Students Confederation in Germany on behalf of Iranian political prisoners because their programs included European dancing in addition to antiregime speeches.[35] Finally, the only major survey of the issue of prostitution, referred to in previous chapters, was sponsored by the Ministry of State based on its concerned for the growth of the problem and the potential "destructive effects" it could have in society.[36]

Based on such notions, in the early years of commercial cinema, the authorities banned movies such as *Qaseh-e Behesht* (The story of paradise, 1958), *Jonub-e Shahr* (Southside of the city, 1958), and *Mohalel* (Mohalel, 1971)[37] for a period of time, allegedly for their portrayal of nudity; they were released only after some modifications were made.[38] Eventually, in the late 1970s, the regime developed guidelines to oversee and improve the quality of the artistic production and combat mediocre films and dance scenes.[39] But such guidelines and similar measures were too late. The regime was not, after all, as harsh on such cultural expression as it was, say, on the Marxist presentations. Many were already suspicious of the Shah's initiatives in the arts. In the eyes of the critics, even the high-quality Shiraz Art Festival in the 1970s served only to promote the regime's image, and they saw the 2500th Celebration of Iran's History the same way. Although Iranian arts were received positively in the West during those festivals and at other times, the anti-Pahlavi forces considered such activities to be signs of the corruption and arrogance of the regime. The harshest criticisms and the strophe lines of the critics were always targeting the nudity present in the uncensored films and theatrical productions, as if the presence of that nudity behind the closed doors where intellectuals and art lovers gathered brought calamity upon the land.

Dance is still a political issue in Iran, but attitudes toward dancing have slowly improved. Iranians welcome dancing products such as music videos from California and dance in spite of rules against doing so. Unlike during the time of the Shah, dance is now seen as a means of resistance. Bourdieu believes that taste

"functions as a sort of social orientation, a 'sense of one's place,' guiding the occupants of a given place in social space towards the social positions adjusted to their properties, and towards the practices or goods which befit the occupants of that position."[40] Taste also "implies a practical anticipation of what the social meaning and value of the chosen practice or thing will probably be."[41] Iranian people's taste is conditioned by their social context, and it is possible that competing with Western and Indian movies can explain the use of dance and nudity in FilmFarsi. But Persian dance, a fun means of expression, apparently has always been there, within the Iranian people, a part of their identity, whichever way they expressed that identity. We see in the following pages that unlike Adorno's assertion that the culture industry, as an official system, controls society by creating standardized culture artistic commodities, in Iran, a bottom-up cultural creation always challenges the political system.[42] So, while dance challenges the prevailing goût, it remains to be seen if the contemporary interest will do anything to "rehabilitate" or change attitudes toward Shahrzad and other women who danced in FilmFarsi and in cabarets.

The Iranian Cinema Industry

Before I turn to a study of Shahrzad and other women of show business in the social context of the 1970s, we must understand Iranian cinema, its history, and its shifts because it played a significant role not only in the lives of those women artists but also in bringing cultural change.[43]

The study of the shifting history of Iranian cinema in fact reveals many secrets about that society. This is true of cinema in any country. Michael Marsden writes: "Movies are the mirror by which the American culture surveys its molted complexion. . . . *The Journal of Popular Film* does not ignore the unalterable fact that the box-office, the American public, has determined the developmental thrust of its films."[44]

Iranian cinema has faced many challenges, not only during the rule of the Pahlavi dynasty (1929–79) but also since the 1979 Revolution, which changed the way culture is produced in Iran. Nonetheless, Iran has been lauded as one of the great exporters of cinema over the past two decades. Iranian films have won countless international awards and enjoyed great reviews. Iranian cinema has been viewed with interest not only by Iranians but also by the West. This may be explained by the simple fact that Iranian films provide a means to understand

other cultures, entertain the idea of the Other, or offer a view into a society that for most is not easily accessible. But Iranian cinema has been able to satisfy an even greater thirst. It has been able to say something beautiful about life, something as genuine as a girl's preoccupation with a goldfish or a boy's fascination with a bird's song. It has also achieved this level of success without benefiting from the most advanced film technology.

Iranian cinema has a short history (first endorsed by Mozafar-al-Din Shah who reigned 1896–1907) and was highly affected by sociopolitical changes wrought by the 1979 Iranian Revolution, but it also has played a role in bringing about change—both before and after the revolution. Further, gender and sexuality have been among the central points of contention in all these transformations. A glimpse of the history of Iranian cinema reveals that it corresponds with the way gender is constructed in that country, the way sexuality is allowed to be expressed. These are central to the way Iranian culture has changed in a rather discontinuous fashion.

But the expression of sexuality has been a very problematic notion in Iran. In Western societies, dealing with human sexuality required deliberation about human physiology, gender identity, and ethical considerations. This deliberation to some degree resulted in the acceptance of the idea that sex is separate from reproduction, and all together this facilitated sexual expression. The association of sex with reproduction was strongly challenged in Western societies in the 1960s, especially with the advent of *Playboy* and other porn and soft porn publications. Iranian society requires women and, to a lesser extent, men to equate preoccupation with sex and sex outside of marriage with unforgivable sin. In the prerevolutionary period, the presentation of the female, the female body, and sexuality was linked to a greater Westernization process, affected by a mode of modernity that did not completely work and resulted in a backlash in more traditional segments of society. Even some filmmakers, directors, and actors who were involved in such productions condemned the production of sexually explicit movies, believing that nude actresses were social terrorists.[45] In the postrevolutionary period, the presentation of the female and the expression of sexuality came face to face with new Islamic codes of morality, with which all artists and filmmakers were forced to comply. Thus, Iranian films in both the pre- and postrevolutionary periods reflected and affected the process of cultural change through the representation of the female and sexuality.

Already in the late nineteenth century, cinema was a point of contention between reformers and the traditional forces in Iran. Religious leaders banned movie-going and accused the movie theaters of "showing women with bare heads."[46] In the early 1930s, a few silent films produced in Iran (mostly comedies) moved people emotionally and psychologically.

These movies added local flavor to a film menu that for thirty years had only offered foreign films. People were amazed by the ways this "foreign" art form could tell their own stories.

The short-lived but influential works of such pioneer filmmakers as Ovanesian, Sepanta, and Moradi between 1930 and 1933 marked the beginning of the local production of films.[47]

People fixed their gaze on the screen and soon accepted this art as one of their own.

Dokhtar-e Lor (The Lori Girl, 1932)

This movie was the first talkie of several to debut in what proved to be a productive year. Prior to the debut of this film, prominent films such as *Abi va Rabi* (1930) and *Haji Agha Aktor-e Sinema* (Haji Aqa, the actor, 1932) did not include female actors; if they did, the actresses were not Muslim. But *The Lori Girl* prominently featured a woman. Golnar, the Lori woman, played by Sediqeh (Ruhangiz) Saminejad, is captured by bandits and forced to sing and dance in a coffee shop. Later, she helps to release a captured soldier from the hands of tribal bandits and plans to go to Tehran with him to take up her career. An Iranian immigrant produced the film in India, and it deeply affected Iranian artisans and eventually the whole society. *The Lori Girl* amazed viewers to such an extent that cinema soon became as popular as poetry, which is saying a lot given the Iranians' passion for poetry. But perhaps equally important was the fact that a woman was featured in this groundbreaking movie and even in its title. Men could see a woman acting and talking and socializing with men openly, without any inhibition. It did not create any major reaction from the traditional and religious sectors of society, perhaps because the woman's character belonged to an ethnic tribal group.[48] However, as we will briefly read in chapter 6, the actor who played the role of Lori Girl suffered tremendously for her pioneering act.

In fact, the plight of the Lori Girl was not improbable. It was rather common for rural women. It indeed foreshadowed what was to come for Iranian women,

not only on the wide screen but also as the result of their participation in public affairs in general.[49]

More Movies of the Early Period

From 1907 to 1941, silent films were accompanied by a small traditional music band (later, a troupe consisting of a pianist and a violinist) in the movie theatre.[50] This band did not include any women. Indeed, even in the movies, women were not yet assigned any major dancing and singing roles. Between 1948 and 1970, a new wave of Iranian films emerged when Ismail Kushan, with his *Tufan-e Zendegi* (The storm of life), ushered in a period of filmmaking characterized by relatively low-quality but widely popular melodramas and comedies that featured more and more women. The success of these films established a market for commercial cinema in Iran. During this time, Iranian cinema grew and produced a number of films of various quality and genres. Out of those experimental and formative years emerged an Iranian cinema with its own identity. At the core of these commercial movies there came to exist a mélange of music, dance, and the depiction of the bodies of female dancers who gyrated in strong makeup and lingerie and who turned and twisted their limbs according to the methods of Persian dance, an art hitherto confined to the private sphere and a very few nightclubs in Tehran.[51]

Iranian filmmakers faced enormous challenges. They had to find consumers in a population that was unaccustomed to pondering sexuality publicly. And they had to recruit increasing numbers of women into this highly suspicious profession, at a time when women had not yet secured a public space for themselves. To some extent, the Shah's Westernization policies in the 1960s and 1970s helped women's participation in film, and filmmakers took advantage of the market's demand for female singers and dancers.

There were technical problems as well: primitive sound equipment and outdated editing machines. Nonetheless, the male viewers were mesmerized by the dancer's intricate and detailed moves. These are exemplified by the dancing of Foruzan's character in *Raqase Shahr* (The town's dancer, 1970), in which a pious middle-aged man falls in love with a cabaret dancer. Of course, exposure to these pictures on the big screen did not help curious urban middle class men better understand female sexuality or better understand the relations between the sexes; it did not inspire greater sexual freedom. Many male viewers were recent immigrants to Tehran and other large provincial capitals, from villages and

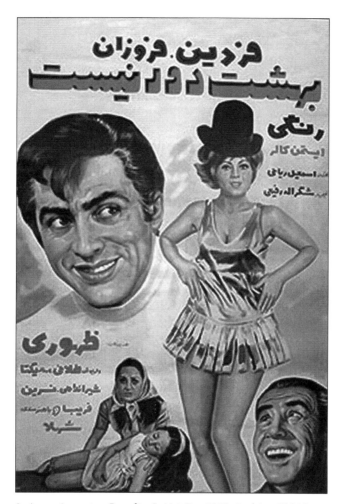

2. A movie poster: *Paradise Is Not Far,* 1969. Archive Old Movie
Posters/Iranian Forum.

small towns where their lifestyle had lacked any intimate public relations with
the opposite sex. To quote Laura Mulvey, the notion of scopophilia, the desire to
see, which according to Freud is a fundamental and sexual drive, kept the specta-
tor glued to the screen and fascinated by the films' structures of voyeurism and
narcissism presented through the story and the image.[52] This notion also applied
to the crew members and often a live audience who watched the dancers perform.

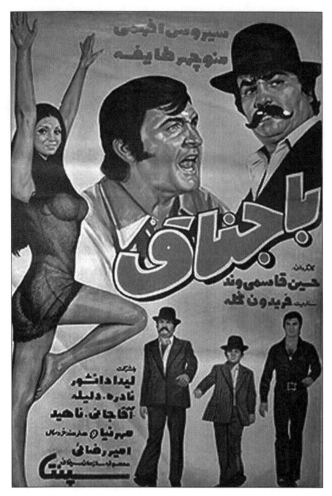

3. A movie poster: *The Brother-in-Law,* 1973. Archive Old Movie Posters/Iranian Forum.

FilmFarsi Movies of the 1960s and 1970s

Here I am not using the term FilmFarsi to refer to a particular prerevolutionary genre but rather to a number of movies that were produced in the sixties and early seventies, which, as defined before, were simple and depicted dance and cabaret life. Many of these movies featured the superstar Fardin or other actors who followed his style of acting, lip-synching, and dancing. These

films were also particularly problematic in terms of the presentation of gender and sexuality.[53]

In such movies, women's roles included

- the poor girl who had to face the rich family of her beloved
- the rich woman who wanted to elope with her poor boyfriend
- regretful prostitutes
- mean and kind dancers
- evil mothers-in-law
- women caught between good and evil
- women in a relationship with a foreigner[54]

Relatively speaking, they offered plenty of nudity and were noted even then for the contemptuous way they did it. They were described as *abgushi* sexual, and *abgushi* literally means "soup," thus implying a cheap product.

FilmFarsi lacked the seriousness of the New Wave movement that followed it, which was intellectual and political in nature and strove to find a place in the market at the same time.[55] FilmFarsi did not seek to comment on the political situation directly, but rather commented on class differences in the context of society's grappling with Westernization and modernity. American and Indian cinema influenced FilmFarsi, but FilmFarsi had a distinct Iranian flavor, especially in the portrayal of violence and sex. Directors depicted violence without guns, because weapons were illegal in Iran; sex and nudity had to be handled slyly (for example, a woman would remove her chador for a moment to show legs mostly uncovered by her short skirt). Directors would find any flimsy excuse to include otherwise incongruous sexual scenes. The predominant method of including nudity was through dance scenes, whether Western, belly dance, or Persian erotic dance. If the movie's plot provided no reason to show a dance scene, the hero would be cajoled to enter a cabaret to drink or meet a friend, where he would then see a dance. Overall, unlike most of the Indian movies of the time, the Iranian movies created a feasible context for their dancing scenes, which by the way did not require choreography, decoration, and extravagant costumes (as was the case with the Indian movies).

The woman portrayed in those prerevolutionary movies, often in a revealingly short skirt and halter-top shirt, dances on the stage in response to a prolonged rhythm created by a synchronized ensemble of traditional and modern

instruments. She snakes her arms in the air, rotates and repositions her hips, gestures boastfully toward her breasts, and cuts the air with her body curves. The dancer performs a symbolic, sensual, seductive walk across the stage, makes slow or quick passionate whirling movements, rolls her neck suggestively, and moves her eyebrows teasingly. At the same time, she thrusts her hips, rolls her pelvis, and extends her arms. The camera rotates around the dancer, focusing at close angles on the breasts, hips, shoulders, and legs of the actress. Each voluptuous move invites the audience, and each feigned look of innocence in her eyes rivets them to their seats. At the end of the night, the protagonist, the good guy, will end up alone with the dancer.[56]

This action primarily served to satisfy the hungry gaze of the male population. It is hard to speculate to what extent women who accompanied their men to those theaters found the dances attractive and worthy of emulation. But Iran's devout zealots maintained that these dancers allowed Iranian men to daydream pleasurably as they watched the bodies. At the same time the devout perceived a woman's career in cinema as reprehensible, shameless, and the sign of a decaying society no matter how enjoyable.[57] The opinion of the leftist intellectuals of such activities did not differ that much. In fact, even the state officials and academic authorities also equated dancing in bars with prostitution. The only state-sponsored research on prostitution in the late 1960s defined the profession in such broad terms to include dancing in bars or dancing seductively anywhere.[58] According to many feminists, female characters who represent a subversive sexuality (the expression of sexual sensation, sexual intimacy, sexual identity) are dangerous to men and are ultimately punished by men in one way or another with death on a religious, social, cultural, or political pretext. In Iran, women who performed this function were indeed punished, both on the screen and in real life.[59]

The easy way to solve the Iranian male spectator's dual and contradictory response was to provide an acceptable moral ending, that is, to redeem the leading female characters. In such a way, male sexuality could be reassured and patriarchal social codes could be reinforced. A man could enjoy the woman's body even in dancing scenes; then, the minute she became his exclusive woman, his own property, she needed to leave the public space, the dancing scene, or anywhere that other men's gazes could fall on her. To be completely redeemed, she needed to be confined in a veil and within walls. Female cinematic figures thus provided a

context in which masculinity, male desire, and male sexuality could be expressed, confirmed, and reaffirmed through female exploitation and degradation.

Female figures made no decisions in the process; their desire and sexuality were expressed only in response to the male's call to appropriate her body.

In the context of resisting modernity in the guise of criticizing the Shah's cultural corruption, such expressions and productions that included sex, violence, and the display of power did not need to be negotiated with women, as the movies eroticized rape and violence against women to convey the most masculine message. It was a battle between men.

It Was All about Men

In addition to countless melodramas, the 1970s witnessed the production of a series of comedies that dealt with the notion of men's sexuality in a more explicit way, though still wrapped in metaphorical language and within a moral and ethical framework. The works of Nosratollah Vahdat (b. 1927) best represent this genre. He played in forty-three movies, thirty of which he produced or directed. The themes of these movies (which often also featured Arham Sadr, a famous comedian from Isfahan) revolved around male/female relationships, male impotence, marriage, extramarital affairs, and Western/Eastern lifestyles. The plots usually involved some sort of misunderstanding among the characters, a mild criticism of some social problem, and always somehow included some scenes of nudity. Men occasionally took their clothes off in these movies, but that nudity was somehow justified by the plot. There was no gaze, male or female, whereas often in the movies, a crowd in a cabaret or nightclub watched the female dancers as part of the plot.[60] As far as I can tell, there was no attempt to eroticize men's nudity.[61] Productions such as *Ki Daste Gol be Aab Dadeh?* (Who has been naughty? 1973), *Shohare Kerayei* (Rental husband, 1974), *Yek Del va Do Delbar* (One heart and two lovers, 1969), *Shohare Pastorizeh* (Pasteurized husband, 1971), *Tavalodat Mobarak* (Happy birthday, 1972), *Ajale Moallaq* (Hanging death, 1970), and *Yek Isfahani dar New York* (An Isfahani in New York, 1972) are good representatives of the genre and all deal with similar issues. In some ways, they teasingly approached an aspect of sexuality only to provide a silly, comic situation and set the stage for a moral conclusion.

Vahdat and Sadr should perhaps be credited for introducing the topic of sex, even though their work remained void of any artistic portrayal.[62] *Arus*

Farangi (The western bride, 1964), which Vahdat directed and played in, was the film that combined all elements of FilmFarsi (also referred to as *FilmIrani*, a term which did not gain the primacy of FilmFarsi).[63] In *An Isfahani in New York,* American women are portrayed as sex hungry; Iranians who live in the United States as corrupt; traditional religion as superficial; and sincere Iranian men (portrayed by Ahmad, the character played by Vahdat) as honest, pious, and extremely supportive of Iranian culture. In the movie, Ahmad is the first Iranian to perform his ablution and prayers in a Manhattan square, long before Islamic fundamentalists made their first appearance in the mosques there.

Nosratollah Karimi and his movies are also pertinent to these developments in the 1970s. *Takhtkhabe Seh Nafareh* (A bed for three, 1972), in which Shahrzad played a role, features a man whose wife is sterile and unresponsive to medical treatments. Despite his love for his wife and in the hope of having a child, he takes a second wife, a widow named Sakineh (Shahrzad) who already has a child. Having two wives in his house turns his life into a living hell. He orders a bed for three but that does not solve his problems. Sakineh puts one of her father's snakes in her rival's room to kill her, but the snake bites Sakineh herself, and she dies. Mahmud thus ends up living with his first wife and his second wife's child. A public bath scene provides the occasion for Shahrzad's revealing dance and her singing of the folk song "Hamumi ay Hammui," which is a hallmark of the popular culture of dance and music.[64]

Though these movies included numerous sexual references, they did not lead to an open discourse of sexuality in society, outside the theaters. Those expressions were vague and wrapped in layers of cultural inhibitions. In fact, classical Persian literature spoke of some aspects of sexuality, including this very issue of impotency, more directly and more seriously.[65] Classical poets such as Fakhrodin Asad Gorgani, Nizami Ganjavi, and, in a peculiar way, Obaid Zakani approached issues of love and sexuality rather boldly.

Sexual Tragedies and Cinema as Political Commentary

In the late 1960s, some filmmakers began to produce somewhat more serious, tragic movies, even though they too suffered from repetitive themes. The hosts of actors, their acting, the music, the dubbing voices, and the cabaret dances were all almost identical. In these films, the problem of sexuality, prostitution, and the theme of honor-based violence often haunted the plots, as filmmakers struggled

with the presentation and even conceptualization of gender relations, virginity, family honor, virility, and manliness. Suspicion about sexual contact outside the marriage or the competition over controlling the body of a prostitute could lead a man to kill his sister, fiancée, or someone else. Examples of these movies include *Toqi, Deshneh, Teshneh, Kafar, Haydar, Kayfar, Qadir, Mokafat,* and *Gorg.* The majority of these films featured Behruz Vosuqi as the male protagonist, with Shahrzad in some of them as an insignificant character.

Navab

Manuchehr Vosuq played in a large number of similar movies. His film *Navab* (1972) portrays a tragedy that in the final analysis is caused by the sexual depravation of the protagonists and their disorderly male bonding adventures. Underlying all the erotic dances and sexual innuendo, there exists the sad story of three single men ruined by their unclear desires.[66]

Qaysar

The movie that popularized this genre was *Qaysar* (1969), directed by Mas'ud Kimiyai. It was a pioneering production and remained as the best of this kind.[67] It is one of the all-time bestselling movies in Iran. In *Qaysar,* the contradiction in men's view of women is most apparent. Fati is a young girl who commits suicide after being raped and becoming pregnant by a man called Mansur Abmangol. Her older brother, Farman, tries to seek revenge for her death by killing Mansur, but is killed by Mansur's two brothers, Rahim and Karim. Qaysar is the youngest brother in the family working in another town. On returning to his hometown to see his fiancée, he discovers the tragedy that has befallen his family. He sets out to avenge the deaths. He manages to kill Karim at the public baths and Rahim in a slaughterhouse. While he is searching for Mansur, Qaysar's mother dies from a broken heart. He finally manages to kill Mansur, but he himself is shot by the police. Shahrzad appears in this movie as a cabaret singer and dancer. Her character appears near the end of the movie, and only then as someone who shows off her body through her risqué song and dance performance and brazenly brings Qaysar to her apartment for the night. She is seen as taking her clothes off in front of him and somehow teasing him with her actions.

Many people die because two brothers avenge their sister's rape and death. One brother shouts that it is better for the sister to be dead than bring the family

shame. This way, and even though the sister committed suicide, the very modern cinematic genre is used to reinforce the very hallmark of a traditional society about honor killings. At the same time, outside the family, the protagonist, Qaysar, enjoys the company of a cabaret dancer (played by Shahrzad), whom he knows is often forced to have sex, but he does nothing on her behalf. Many of the underlying ideological assumptions are religious. Indeed, the oppressed are portrayed as religious and poor and yet vindictive and vengeful. The movie also glorifies the southern Tehrani culture of violence and use of the knife in dealing with opponents—a characteristic of the Abmangol neighborhood of the capital city. Five of the seven people who die in the movie are killed by knives. All these aspects help create a very strong argument and notion against the process of modernization, Westernization, and secularization. As in many other parts of the movie, the dance scenes by Shahrzad became a memorable representation. Using Desmond's words, the social identity of all these people are "codified in performance styles."[68] Off the screen, in a tired voice, the character of Shahrzad, Sohayla Ferdows, uses the same accent as many other characters, the accent of southern Tehran's tough and roughneck men.

Cinema and Sexuality

A discussion of the consumption of these movies can further illustrate the problematics of modernity and sexuality in the 1970s. A survey of the articles, reviews, and criticism in semi-intellectual journals of the time, such as *Ferdowsi Magazine,* shows that in the 1970s both intellectuals and university students leaning toward Westernization or supporting the leftist discourses did not prefer the mainstream products of FilmFarsi over similar or other Western genres. The works of foreign directors such as John Ford, Francis Ford Coppola, Fred Zinnemann, and Woody Allen from the United States; Akiro Kurosawa from Japan; Federico Fellini and Roberto Rossellini from Italy; and certainly François Truffaut from France were more desirable and were constantly dubbed and screened in nice, air-conditioned theaters in big cities. The Iranian directors whose movies could be watched without "shame" were the socially sensitive filmmakers, such as Daryush Mehrjui (b. 1939), Naser Taqvai (b. 1940), Parviz Kimiyavi (b. 1939), Mas'ud Kimiyai (b. 1941), Bahram Bayzai (b. 1938), Ebrahim Golesan (b. 1922), Abbas Kiyarustami (b. 1940), and a few others.

The Reception of Movies

In Tehran and Shiraz, the best theaters located in the best areas, amid tall buildings and fancy restaurants, cozy bars, and expensive stores, were reserved for foreign films and did not show FilmFarsi products. (Even today, the location of a theater is a good indication of the artistic and class value associated with a film. The negotiation over the location seems to have become a political element in the broader movie industry and its negotiation with the cultural processes.) Such theaters screened Western films, which included many comedies or dramas that also contained nudity. FilmFarsi films were shown in cheaper theaters, indicating the consumers targeted for this industry. This purposeful product placement affected the new generation. The uptown streets of Abasabad, Vozera, and Pahlavi in Tehran, the tree-lined Chaharbagh in Isfahan, Zand Boulevard and Daryush in Shirzad, where some of the better movie theaters were located, were also a locus of voyeurism, at that time, and even largely now, the only means and place (in addition to religious and national events) for many to make eye contact with the opposite sex.

Love on Zand Street

After seeing these movies, one could fall in love with a girl walking home from her high school without even any conversation. Like in some of the plots, all it took was for the eyes to meet. In the late seventies, before and after films, many young men walked up and down those streets to show off clothes, ties, and occasionally a female companion—at whom, by the way, they did not want the other guys to look. But the young women were all dressed in short, colorful, skirts or other fashionable dresses, for which reason those young men's eyes could not miss them. Mary Catherine Bateson observed that in the prerevolutionary decades, "Women in streets of Tehran often get a good deal of attention—compliments, propositions, and some jostling and stroking, from passing men. Some enjoy this, while others are distressed by it. . . . Even the chador, which foreigners tend to see only as a symbol of oppression, can be as flirtatious as a Spanish dancer's fan, besides being a great convenience."[69] However, women with the long head-to-toe chador were rarely seen on those streets or for that matter portrayed on New Wave cinema or the television shows. Since 1936, when Reza Shah had enforced unveiling, the idea of freedom of dress had been taken for granted.

These friends, classmates, cousins, sisters, and brothers now filling the Western-style streets were members of a thriving middle class, dressed in fashionable clothes and well situated in the big cities, going to school, attempting a foreign language; the burgeoning petit bourgeois, if you will.[70]

Despite peoples' boredom with the Shah's arrogant, nonstop self-promotional propaganda, which claimed that the nation was at "the threshold of the great civilization," the middle class did believe that it had everything Westerners had.

During this period, Westerners came by the thousands, and the Zand Boulevard area began to exhibit stronger similarities with the West, but people also found that they were not as happy as their likes in American or Europe. The class orientation was also well reflected in parents' dream: they wanted children to succeed, even if they had to go abroad to get an education, and then find a position within the government or at a school, to become happy evermore. So countless Iranians traveled to the United States in the 1970s but many, upon realizing how "unhappy" they were, ended up joining the leftist students' oppositional organizations.

Things of course changed faster when the many ordinary and ideologically motivated people became disillusioned with the official nationalistic line that revolved around an Iranian identity rooted in the much-glorified ancient Persian past. The official nationalistic outlook on life proved to be insipid and outdated, and it lost support within the intellectual community very quickly. It was reminiscent of an old movement that had remained only in some official discourse. The uncertain connections between Iran and Europe based on the Aryan race and the assumed superiority of Indo-European languages over other languages no longer appealed to the newer generation. Instead, they wanted "new" ideas, action. The voices of opposition were growing, and many began to learn about the oppositional groups. The discussions on college campuses turned more and more political and antiestablishment, often inspired by or reflected in the popularity of Marxist and revolutionary writers. Books by Sartre, Nietzsche, Marcuse, Fanon, Al-e Ahmad, Shariati, and Momeni became more popular, as did Soviet novels whose translations had somehow survived the censors; books that introduced philosophy and economics in simple language; and the poetry of Shamlu, Behbehani, and Soltanpur. Nudity, sexuality, and movies lost their appeal. The burning of the Rex Movie Theatre in the southern city of Abadan in 1978, attacks on other movies theaters and cabarets, the near destruction of the red-light zones

in some cities, and other revolution-related incidents in the late 1970s signified a harsher political approach to sex and an interruption in the way the arts were produced. But as we will see below, cinema itself also contributed to this political development.

Shahrzad as Dancer and Actress

As revealed by her movie roles and confirmed in her interviews, Shahrzad knew many Iranian as well as Western and Arabic dances.

She mentions that she once saw a cabaret in Paris (it is not clear to me whether she saw it in a movie or in person; I have not come across any record of her visit to Paris), where people stood in lines, in an orderly fashion, waiting to get inside to see the show. "Inside, they watched the show, they watched women dancing, and then they went home in absolute civility."[71] It is thought that her father may have taken her to the cabaret where she landed her first dancing job, and she herself testifies that she was dancing in the clubs and cabarets at the age of fifteen.

From Café Jamshid to Cinema

But her dancing career seems to have started in earnest at Café Jamshid on Manuchehri Street. It was one of the oldest establishments of its kind, named after its owner Arbab Jamshid, and many artists began their career there. Apparently, many people working in different sectors of the entertainment industry frequented the place. Shahrzad was noticed, and during her time at Café Jamshid she was first recruited to play in the movies. Before getting any cinematic role, she also kept busy acting in a number of Lalehzar areas theaters such as Nasr, Dehkhoda, and Pars; as mentioned, her first play was titled "Bayn-e Rah" (On the way).

Shahrzad apparently first acted as a stunt dancer or filling a crowd in a tango or similar dancing scene. Referring to stunt actors and those who play the second role and are constantly being beaten by the heroes, Shahrzad later observed, "Iranian cinema is cruel." In an article devoted to defending the rights of the "hidden artists," she says that she can relate to these workers (and those who play the third- and fourth-tier roles) who make the movies possible but get less benefit from them. She writes, "One day I saw a young woman standing in snow and cold weather outside a movie theater without any warm clothes on. I asked her if I could help. She said, 'I have played in the movie being shown here but I do

not have money to go see it.' I took her with me inside. Yes, she had a role; being beaten by a man. And still she was thrilled that she was in a movie."[72]

After her "apprenticeship" as a stunt actor, Shahrzad began to appear more prominently in cabaret scenes of Iranian movies. In those early movies, her roles were as a nightclub dancer who dated the less-respectable male characters. She danced and often lip-synched pop or risqué songs. Nevertheless, she seemed to have been a dancer with a particular style. She performed Baba Karam, one of the most traditional and rather erotic Iranian folk dances, in which the dancer appears as a roughneck but gradually takes off her male garb to reveal that she is in fact a beautiful woman. As she intimates in some of her interviews, producers found her light skin color and her curvy body suitable for appearance in their movies doing these dances. Her photos, published in journals in the 1970s, were usually chosen from her movies and often showed her dancing or walking in big sunglasses. In real life, however, she dressed modestly and appeared without heavy makeup.

We will see in the next chapter that Shahrzad's poetry often speaks of her existence and struggle or, more precisely, her ambiguous emotions, and likewise her films bear an astonishing resemblance to her own life and feelings when she first danced in nightclubs. Shahrzad's movie character is always that of the town cabaret dancer or singer (always with a mediocre voice compared to that of the leading character).[73] Her character is always the so-called loose woman or the floozy. Sometimes she is in love with the star, but that love is never reciprocated. Her character often drinks and is physically and verbally abused by different men who come to see her dance or by women who perceive her as a threat. Sometimes Shahrzad's role is irrelevant to the plot of these movies altogether. However, an analysis of these cinematic works in their cultural contexts will help us better understand why the social and cultural changes that occurred in Iran during the 1970s and in the aftermath of the revolution affected women's situation so dramatically.

Some of Her Roles

In *Farar az Taleh* (Escape from the trap, 1969), the director Jalal Moqdam decides to simply have Shahrzad lounge around seductively, listening to a conversation between two men. She performs superbly. Shahrzad's short part is peripheral to the film's story, which is about Morteza, who goes to prison for five years

for a murder he committed out of love for his girlfriend, Mehri. While Morteza is in prison, Mehri reluctantly marries a man called Faraj to whom she owed money. To get her back, Morteza plans a robbery with his friend Karim, but both are killed. Shahrzad appears only as Karim's subservient girlfriend in the scene when the two men become acquainted and make their plans. She is depicted as Karim's toy, with whom he can play and occupy his time and passion whenever he wishes. She hangs around Karim and his guest, feeding Karim provocatively with her fingers and listening to his every word as if he were her master. Throughout these sequences, Shahrzad does not utter a word. She does her usual erotic dance, however. Her character is passive and only an accommodation to her man, and she conveys this meaning very well with the movements of her eyes, hands, neck, and head.

One can argue that she offers one of her best performances in this movie; she is truly confident and in control.

In *Raqasehe Shahr* (The town's dancer, 1970), the middle-aged owner of a lumberyard, Dash Gholam (played by Naser Malek Motie), falls in love with a dancer named Pari (played by Foruzan) because he is ignored by his wife. Life changes for these lovers and many people around them. When the wife asks Pari to leave him alone, Pari considers the request. Shahrzad is seen in the first half of the movie, sitting idly with Dash Gholam, drinking and attempting to make passes at him. She is envious of the fact that he is eyeing Pari, so continues her binge drinking. She then manages to engage in a rather crude and brutal "cat fight" with Pari in the dressing room, and her clothes are completely ripped off whereas Pari's stayed intact.

In this somewhat more serious movie, not only was Shahrzad's character debased but so were those of Pari and Dash Gholam's wife. Pari is portrayed as a weak and needy woman who, even after being stabbed by the man who claimed to love her, was willing to reconcile with him. Similarly, Dash Gholam had not been around his family since his affair with Pari began, but his wife allowed him right back into her and her children's lives. The real story of this film is about the self-identity of Dash Gholam, a locally respected businessman who frequents the Western-style nightclubs and becomes caught between his traditional wife's lack of sexual interest in him and the modern dancers' generosity toward him. The issues related to sex problematize the man's identity and, by extension, Iranian men's identity. When Dash Gholam takes Pari on a pilgrimage, he uses

religion's power to reestablish control over the woman's body but also answers Iranian men's vexing question about identity: we are believers and we forgive a woman's straying body by giving her a chance to redeem herself. When Pari "fails to come clean," Dash Gholam goes back to his wife, who now is apparently ready to perform better in bed. The repetition of these plots in the movies might have something to do with the invocation of tradition during the revolutionary uprisings of 1976–79 through which the dominant culture and the Shah's Westernization project were portrayed as corrupt. Tradition, which was reinforced even by the oppositional ideologies, was and is still clear about what is acceptable sexuality: man's satisfaction with a woman at the expense of her own pleasure, done in complete privacy and certainly not on the big screen. The process, as mentioned, comprises the joy-seeking man and a sexually active or sexually liberated woman who no doubt is portrayed to be a prostitute, a nightclub dancer, or a troublemaker.

Shahrzad's favorite movie was *Dash Akol* (named after a greatly respected, generous, virile Shirazi man, 1971), a film based on the novel by the same title written by the acclaimed author Sadeq Hedayat.[74] Her professed admiration for this artistic movie shows that even in her cinematic career Shahrzad aspired to be engaged in serious art.[75] It is ironic that even in this "artistic" movie, she played the same type of character: a dancer in a wine house. In this movie, Dash Akol, a local hero, lives with his parrot in a small house. A dying man called Haji Samad asks Dash Akol to become his executor. On arriving at Haji Samad's house, Dash Akol sees Marjan, the young daughter of Haji Samad, and falls instantly in love. However, he believes this love to be inappropriate and begins to drink to forget his sorrows. He speaks of his feelings with no one, only at home when thinking aloud, and his parrot overhears. Against his own wishes, Dash Akol as executor arranges the wedding between Marjan and another suitor. On the wedding night, he goes to a bar, gets drunk and winds up in bed with the town dancer (played by Shahrzad) who has always been in love with him. On returning home, he is stabbed by a rival and dies the next day. In this movie, Shahrzad's character is portrayed as a "loose" woman who is willing to give up her body for one night to the man (Dash Akol) she is in love with, although he does not return the same love to her. Throughout the movie, she is either drinking or being abused physically and verbally by different men, especially Rostam. At the end of the movie, she is seen briefly crying over the death of Dash Akol,

and the viewer is given the impression that she will return to her dancing soon. Her return to her dancing métier seems inevitable because the only potential force who could "save" her, the pious man, has died. Also, very rarely in the movies are the characters who played the second or third role redeemed. As mentioned, sometimes they were not part of the plot; their jobs were to provide food for the eyes, and their stories would never come to conclusion. However, and without exception, the old tradition and old codes of conduct are glorified in the face of modernization attempts going on in society. It is perhaps safe to take the dancer as a symbol of that modernization.

Shahrzad offers a very good performance in *Tangna* (Desperate situation, 1973), directed by Amir Naderi. In a Tehran pool hall, Ali, a well-known town gambler who has lost trust among all of the townspeople because of his debts, becomes involved in a brawl with three brothers and kills one of them unintentionally. He takes refuge in the house of his girlfriend, Parvaneh, who gives up her job and family for his sake. The victim's brothers chase Ali down and kill him. Shahrzad skillfully plays the role of Parvaneh's neighbor, offering to help Ali by pawning a few pieces of jewelry. She goes to her boss, who agrees to loan her money only in exchange for sex. She agrees. The two brothers also brutally rape her right before killing Ali. In the end, two women have compromised themselves and their lives for Ali. A third woman, the mother of Shahrzad's character, is tied up, gagged, and completely helpless during the rape.

Her Other Movies

In addition to her roles in *Qaysar* (1969), *Farar az Taleh* (1969), *Raqasehe Shahr* (1970), *Dash Akol* (1971), and *Tangna* (1973), Shahrzad also played in *Toqi* (1968)[76] and *Pol* (Bridge, 1971), with somewhat significant roles.[77] Shahrzad also played in and helped with the screenplay of *Baluch* (1972).[78] An encyclopedia of Iranian cinema provides lists of additional movies in which Shahrzad (described as Kobra Saidi, born 1946, elementary school diploma) appeared. Consulting other sources, Shahrzad's profile includes *Jodai* (1969), *Khasm-e Oqabha* (1970), *Qahremanan Nemimirand* (1970), *Khaneh Be Dushan* (1971), *Doreshkeh Chi* (1971), *Seh Qap* (1971), *Shater Abas* (1971), *Majeraye Yek Dozd* (1971), *Takhtekhabe Seh Nafareh,* 1972), *Khoshgeleh* (1972), *Sobh-e Ruz-e Chaharom* (1972), *Qalandar* (1972), *Mard-e Ejareh-i* (1972), *Tangna* (1973), *Ayalvar* (1973), *Gorg-e Bizar* (1973), and her own directed movie *Maryam va Mani* (made in 1978).[79] Eventually, for

her hard work she received two *Sepas* awards for best female supporting roles in *Sobh-e Ruz-e Chaharom* and *Baluch.*

Female Directors before the Revolution

Most interestingly, there were only a few female feature movie directors with productions before the 1979 Revolution: most prominently Shahla Riahi, who directed *Marjan* (1956), and Marva Nabili who directed *Khak Sar be Mohr* (1978). However, among these names, an encyclopedia of Iranian cinema states that Kobra Saidi (Shahrzad) directed *Maryam va Mani* (Maryam and Mani, 1978).[80] Shahrzad's *Maryam va Mani* has not thus far been available in public archives or libraries, but according to some descriptions, it was a pioneering film featuring Puri Banai as the main star. It is a serious film. As a reminder of her life, Shahrzad's protagonist in this movie, named Maryam, is financially responsible for her crowded family and is consequently in debt. She robs the company in which Mani, a well-educated artist, is a manager. He is accused of the theft. Maryam's mother, who knows the truth, posts a picture of Maryam in the streets as the real thief, a picture that was sketched by Mani. Jamileh Nedai, an actress and film critic who seems to have seen the movie, states, "In *Maryam and Mani,* the lead role is for a woman and that is very different from any other movies made in those years. The character played by Puri Banai is an independent, strong woman and the sole breadwinner for a large family. She never seeks men's opinion in her daily affairs. We need to reevaluate this film."[81] This film is a significant artistic departure from almost all of the movies in which Shahrzad was given a role, which belonged to FilmFarsi or to a soap opera genre produced for the middle class and others who prospered under the Pahlavis.

Naked Women, Nude Scenes, and Endangered Masculinity

Why was so much effort expended to portray female nudity in its most skewed senses and not at all in any natural, social, or cultural perspective?

Why were so many women naked in FilmFarsi?

Why was sexuality always linked with lust, promiscuity, violence, greed, naiveté, or poverty?

Clearly, a segment of the traditional society was frightened when it observed women's increasing presence in public life, in offices, and on campuses. Some

men even felt they were being emasculated, as they viewed the Shah's Westernization as their castration.

FilmFarsi movies ended up helping these men, boosting masculinity. The stereotypical man in these movies is a strong man with a formidable moustache, who speaks in a loud voice and carries a knife. He often wears a large hat, does not laugh, and always looks handsome and well groomed. He is always superior to the women, thinking ahead of the game, making decisions, and taking action.

The woman dances in a cabaret, cheats on the man, is poor, drinks, or takes drugs. There is a constant attempt to fend off fundamental questions about womanhood.

During the 1970s, women gained "power" in society but lost it in the FilmFarsi movies. The more men lost control over women's bodies in real life and the more the law limited them in the courts, the more they gained control over the female body in cinema. To be safe, there were hardly any sex scenes or eroticism, but there was plenty of nudity.

In Shahrzad's movies the "I," the modern "I," was absent. But in her poetic works, where she strove for sexual identity, the "I" was deeply awash with colors and metaphors, natural, dynamic, and the object of surrealistic imagination.

Her movie career made it considerably more difficult for her to break into the respected realm of poetry. She could not resolve the tension between her cinematic life (public) and her poetry (private). In other words, she could not get the Iranian public to accept her poetry. Just like in FilmFarsi, which always drew a distinction between public (the cabaret and night life) and private (the traditional wife and family life) spheres, Shahrzad's own life reflected the tension between public and private. In FilmFarsi, the public sphere was always defeated, very much like the fate the past architectural greatness is facing now. In postrevolutionary cinema, the public was further reduced to the private; the bedroom on the screen has to be treated as the bedroom in real life. Similarly, Shahrzad's public life, her movie career, "undercut" her efforts to break into the high culture of poetry.

Iranian New Wave Cinema

In the early seventies, the Iranian film industry produced a record ninety-two feature films shown in more than 470 movie theaters.[82] The possibility this offered for reaching the masses was not lost on the intellectual and politically

minded filmmakers. As a result, a sort of political film genre developed, in which filmmakers conveyed ideological meanings about the ills of society and the necessity for political change. This is often referred to as the Alternative Cinema movement or the Iranian New Wave cinema. The movement spawned a group of intellectual artists who denounced the existing escapist cinema and instead produced films with a higher cinematic quality and a higher level of social consciousness. Dariush Mehrjui's *Gav* (The cow, 1969) heralded this new wave. It is a disturbing story of a villager whose life is mired in poverty. He experiences a mental breakdown and insanity after the mysterious death of his cow, the only one in the village.

By its conviction and messages, *Gav* was not concerned with sex and entertainment, and thus, not surprisingly, did not do well at the box office. However, its critical and artistic approach paved the way for additional New Wave films and gave rise to a generation of filmmakers in the 1970s who many see as the masters of Iranian cinema. A number of Iran's greatest directors, including Daryush Mehrjui (*Gav*), Abbas Kiarostami (*Khaneh dust kojast* [Where is friend's house]), Amir Naderi (*Davandeh* [The runner]), Sohrab Shaheed Saless (*Tabiat-e Bijan* [Still life]), and Bahram Bayzai (*Bashu, Gharibe Kochak* [The little stranger]) began their careers in this period and have continued to be active after the revolution. Their works, one may conclude, have provided the context for the success of postrevolutionary cinema. New Wave filmmakers were less interested in featuring women characters and more interested in advocating social change. They adhered to a leftist discourse that sought more than anything else to change the political arrangement by criticizing the unpleasant realities of Iranian life under Mohammad Reza Shah (1941–79). Their thought and actions were based on the belief that social problems, including gender issues, could be resolved only after the political situation was resolved. Because their movies were serious and political in nature, they were reluctant to deal with sexuality; they did not want to condescend in order to exploit the market by including nudity or dance. In such a way, the 1970s type of modernity denied women's sexuality and thus remained modernoid and regressed in some ways.

Because of their political agenda, New Wave filmmakers faced growing censorship. Many of their movies were banned for a long period and released, if at all, only after modifications. In the case of *Gav*, it was eventually released only because it won praise in the Venice Film Festival. Nevertheless, censorship forced

filmmakers to employ an even more symbolic mode of communication to convey their messages about social and political issues. Perhaps because of the temporality and the nature of those messages (mostly political and applicable specifically to the Iranian political situation), no undeniable masterpiece was produced, and thus Iranian cinema did not attract any substantial international attention in this era. The movies moved the viewers politically, but they did not enter into perpetuity as should be the case for great movies. One film that played a political role was *Gavazanha* (1975). Directed by Mas'ud Kimiyai, it was one of the most political films in which Behruz Vosuqi ever played. It was banned for a while and was only released after significant editing.[83]

Commercial filmmakers (and FilmFarsi writers and directors) also adopted a critical tone. *Tangsir* (the name of a region) and *Safar-e Sang* (The travels of the stone) are prime examples of such productions. In response to Mohammad Reza Shah's push for Westernization, they sought to promote the most traditional social behavior. The use of the knife in the portrayal of violence was perhaps the most distinctive feature of this return to tradition. *Qaysar* indeed glorified the knife, even though the way the protagonist acted in his personal revenge was something new in Iranian cinema and was more in line with American movies. Nevertheless, that kind of vindictiveness had the signature of a lumpen culture that also manifested itself in some of the street violence, destruction of the banks, and burning of the movie theaters during the street demonstrations of the late 1970s. Another feature made prominent by this movie was the use of the chador. Hardly ever before in FilmFarsi productions had a chador been portrayed positively or at least seriously. But in *Qaysar,* the beautiful, distinctively Persian-looking Puri Banai wore an elegant chador as she tried to stop her fiancé from murdering thugs who raped his sister and caused her death.

Portrayal of Modern and Traditional Features

In a sense, cinema in Iran began with the portrayal of modern manifestations of life and gradually moved more toward the traditional.

The city of Tehran in the earlier movies was portrayed nicely; scenes were filled with shots of tall buildings, paved streets, tree-filled boulevards, flower-filled parks, neon lights, and shiny American cars. But gradually, the lower, southern parts of the city gained prevalence as filming sites, where women naturally walked in their chador, albeit sometimes a see-through one. The sound

tracks of these movies (or the songs played at the establishments) went more or less through similar changes. The happy, popular, folk music and songs of the early days were replaced by some somber, sad, and even occasionally militant songs.[84] It seemed that those "Western stricken" filmmakers all of a sudden heeded the leftist call to portray the lives of the ordinary people, the downtrodden, the deprived, the poor. Puri Banai, Foruzan, Marjan, Zhaleh, Afarin, Nilufar, and many other sexy actresses found their favorite color and pattern of chador and realized that they could still be sexy, even if at first covered. In that regard, Puri Banai in her role in *Qaysar* was a pioneer. The chador combined with the actresses' large eyes, extended eyebrows, and long burnished black hair to compete with sexy Westerners whose movies continued to be dubbed and shown as well.

In all of these films, one can feel the eventual emergence of a sort of anti-Western sensibility and religious longing and a deep resentment of the monarchy's social system, and a concern for the emasculation of the male population. These movies promoted violence, perhaps consistent with many leading intellectuals and Marxist thinkers who advocated armed struggle as the best response to Mohammad Reza Shah's oppressive policies. At the same time, the films were profoundly antimodern in the way they promoted traditional ethos and religious sentimentalities. *Safar-e Sang, Gavaznha, Tangsir,* and *Baluch* were most direct in conveying such messages. The first three had a revolutionary tone portraying how people's frustration may be channeled toward rebellion. The latter, *Baluch,* portrayed anything modern and Western as corrupt and portrayed tradition and tribalism as innocent and honest. Moreover, in addition to *Qaysar*'s subtlety, Mas'ud Kimiyai's trilogy (*Reza Motori, Dash Akol,* and *Baluch*) glorifies the traditional image of Iranian men as honest, devoted, and pious. The films glorified the village, the desert, and poverty and vilified the big cities, machines, and wealth.[85] Thus, in one way or another, they contributed to the rise of the revolutionary discourse, but not feminism. Even Shahrzad, as we noticed in the previous chapter and in her writings, saw herself as an antiestablishment intellectual even though she never gave that impression and was never welcome in the oppositional communities. These filmmakers, actors, and actresses had no idea what soon was to happen to them.

In return, the regime continued its censorship policies but not to the extent that it could eliminate all means of communications that were now using a

symbolic and metaphorical system. The regime did not attempt to offer a "counter-cinema" to present its version of Iran's historical position. Some efforts on behalf of the regime by private producers failed miserably. One expensive case was a US-Iran co-production. The picaresque *Caravans* (1978) features a young American diplomat (Michael Sarrazin) who seeks the American wife (Jennifer O'Neill) of an Iranian colonel (Behruz Vosuqi) who has run off with a tribal chieftain (Anthony Quinn) in an invented region in 1948. Even though the native people speak Persian, the film tries to portray it as an Arab or Afghan region and offers criticism of the *qasas* (Islamic eye-for-an-eye laws of retribution) and traditional, chauvinistic, and backward culture. It is based on a romantic novel and offers a predictable and brainless story. However, the movie stresses how even such high budget movies failed to help the rule of the Shah. In the beginning of the film, people begin a riot in the marketplace because they witness two women flirting with foreign soldiers, who apparently enjoy many privileges. A few months later, such riots with the same concepts were a reality on the much more modern streets of Tehran where not only *qasas* but also many other medieval Islamic rules were reinstated.

Cinema in Iran after the 1979 Revolution

The 1979 Revolution abruptly replaced the challenges facing cinema. Many of the male filmmakers were able to stay in Iran after the revolution and even be productive after the initial halt in cinema activities. Indeed, some people in show business believed in Islam very strongly. Taqi Zohuri, whose comedies were once vulgar, repented after going on pilgrimage even before the revolution. He tried to do his prayers and twice sent his wife to Mecca as well.[86] But women had a harder time. With the veiling code and other restrictions on social interactions, the new regime tried to control every aspect of social behavior, especially that of women. Not only did they ban the showing of the female body and hair and female singing but also, because of sociopolitical changes, they suppressed Iranian cinema entirely for a few years. Religious activists had set a great number of movie theaters on fire in the course of the revolution, believing that such places promoted Western decadence and a corrupt morality. After the new religious elite came to power, filmmaking came to a halt because new codes, especially those concerning women and their veiling, were so restrictive that any prerevolutionary type of movie was unthinkable. When film production resumed, the first movies were

all about the revolution itself, ideological pronouncements against Marxist and other leftist discourses and about the Iran-Iraq war (1980–88). With those movies, a new genre was born that might be referred to as religious cinema. The films were often sponsored by the government and promoted religiosity as well as the political discourse of the state.[87]

Any film that did not conform to the codes was banned and its producer punished, fined, prohibited from making movies, or even imprisoned. Nor could foreign films be shown. Eventually, the government formulated a set of highly restrictive guidelines for filmmakers. These criteria were derived from an Islamic notion of culture production and from the regime's anti-imperialist attitude. The only benefit of those well-delineated codes to secular directors was that they no longer had to guess what the limitations were. According to the Islamic Republic's regulations of that time, films were censored at least four times and were rated on a three-tier letter system. Nonconformist films, if they ever received the necessary permits, would be shown only in lower quality theaters where they used to show FilmFarsi products and where the shells of sunflower seeds, nuts, and popcorn scattered all over the floor used to be permanent items of decoration.

Most of the new filming guidelines applied to female participation in film activities. Islamic dress codes require women to cover their hair in public places (and the screen is considered public space) and while in the presence of a man who is not related by marriage or blood. Women are required to wear loose-fitting outer garments to cover their body curves. The word *veil* thus signifies more than a head covering (*hejab*). It not only suggests that women's bodies and voice are the subjects of ideological control but also that women's social conduct and even eye contact must be regulated in their relations with men. And such regulations even apply to the fictional world of films. This often results in the production of very artificial scenes where, for instance, a woman must wear a veil even in bed. Film directors must remember that the actors who play couples are not allowed to touch each other, get close, or exchange words of intimacy.

But these rules made Iranian filmmaking more creative by forcing directors to conceive of silly yet innovative presentations of male-female relationships. In *Gabbeh* (1996), by Mohsen Makhmalbaf, the male protagonist intends to elope with his beloved on his horse. In a Hollywood movie, the woman would ride behind the man, holding him, as they disappear into the sunset. Well, that is not

possible in an Iranian movie. The protagonist had to bring a second horse when he came to steal his beloved away.

In *Leila* (1997), by Dariush Mehrjui, a young couple going through some tough times decide not to go to a family party in order to be home alone with each other. In a Hollywood movie, the director would waste no time before he portrayed the bedroom scene, but that is not possible in Tehran. So the fellow says to his wife, "Let us stay home, grill chicken, use the incredible marinating sauce you make, eat the chicken, and . . ." He pauses and then continues, "and watch a movie together." In that two-second pause, the director allows the viewers to imagine what might more logically follow a romantic dinner. In the same movie, the director uses another trick to make a bedroom scene more realistic. The man returns home late and finds Leila in bed. They begin talking to each other in the dark. Leila asks why he does not turn on the light. The man says that he does not want to disturb her sleeping. This way, the film does not have to show the woman in complete *hejab* laying in bed.

In some cases, the characters use mild body language that is suggestive and completes the task of conveying a sense of sexual relationship without words. The directors use symbolic language to portray physical intimacy. Sometimes the characters' shadows, dress, or words overlap to indicate physical intimacy. In *Shokaran* (Hemlock, 2000), a movie about a high-level manager's affair with a nurse, the man, after some comical prior attempts, is finally alone with his mistress. How could the director possibly portray their physical intimacy? They are in an apartment alone, creating nervous tension among the viewers. Finally they simply enter the bedroom, and close the door. The camera remains focused on the bedroom door for several long seconds, during which time viewers get to have a wild time in their own imaginations. Of course, even in doing all these things, the director has to comply with the overall cinematic codes, which do not allow for the promotion of immorality and promiscuity. In *Shokaran,* to make even the allusion to love-making a bit more acceptable, the male protagonist at a somewhat romantic dinner meeting tells his mistress that if they are to have sex, they should enter into a temporary marriage, which religiously sanctions such affairs. The endings of such films must also provide some sort of moral lesson. This explains the tragic ending of *Hemlock* in which the mistress dies in a car accident. However, the movie's success in the box office was, in my opinion, due to all the preceding scenes.

In other cases, the protagonist's emotions are expressed through highly metaphorical or symbolic discourse. For example, they use suggestive language to talk about something related to their beloved, to their faith, or to their situation. *Boutique* (2003), which portrays the difficult relationship between a bored boutique worker and a defiant and beautiful teenage student, provides an example of such technique. The young female character shows a lot of excitement about her male friend's car and sunglasses, which under any ordinary situation away from the camera or watching eyes would have been expressed about the male character himself.[88] Other actions, particularly during the ride, are suggestive in the same manner as Golshifteh Farahani's later movie, *Santuri: The Music Man* (2007), in which the female and male characters touch each other frequently using objects such as their scarves. In one scene, the woman asks a mullah, who is marrying them, to kiss the groom for her, a statement that may make sense in the context of the film but also becomes a social statement outside the cinematic text.

The Islamic Revolution led to changes in the way sexuality was presented in Iranian film to reflect men's rescued masculinity. Gradually, directors found creative ways to present sexuality without making things look too suggestive or too threatening. Sometimes their methods border on the ridiculous and actually impede the rise of a discourse of modernity. Or, the filmmakers may portray what they consider to be the symbol's modernity (such as a boutique, a brand new car, loud music produced by a car's sound system, or colorful subway trains) too grimly, in order to convey or challenge the idea of social change. Today, Iranian films may not show flesh and dancing, but the topic of sexuality (sometimes too nervously) and gender roles and women's place in a modern society (sometimes too bleakly) are on the mind of many filmmakers, very much the same way that these tensions run through social fabric of the society. Part of this new cinematic interest in gender issues is rooted in the rise of feminist discourse in the literary production of the late 1980s.[89]

The cultural engineers of the ruling regime in Iran are a minority and thus cannot completely control the way sexuality is perceived and represented; they cannot completely control the issues of representation and spectatorship in the streets, in literature, or on the screens. However, as always, the more they try, the more subtle the art producers become. Eventually, therefore, a new generation of female film directors has emerged in unprecedented numbers in the postrevolutionary period. They show more interest in the presentation of the female than

the male directors, who themselves are quite interested in women's themes.[90] The defeat of the reformists in the 2005 presidential election may not necessarily mean the end of the exploration of sexuality in Iranian cinema either. Cinematic production and the manipulation of new themes regarding gender issues, children, nature, and cultural problems will continue to feature in the movies as they did in other areas of culture production.

However, the views and actions of the traditional segment of society, the ruling elite, and the conservative governments will also continue to impede modernity. In fact, they have already given rise to cultural, social, and civil movements. Moreover, and despite the use of modern technology, modern themes, and modern symbols, Iran lags painfully behind when it comes to sexuality and basic concepts related to modernity. It cannot be said for sure that modernity has even established itself in such artistic genres as filmmaking. Like the elevator that is about to disappear into the depth of the earth at the end of *Boutique,* sporadic struggles for and manifestations of modernity in arts often fade away in the face of strong state discourses or political ideologies. Indeed, the story of Iranian cinema, despite its achievements in recent decades, and the story of dance, despite the talent of artists such as Shahrzad, and the story of the artists who are active in these fields clearly point to an abiding lack of the will to embrace modernity as earnestly as necessary. This story of Iranian cinema and review of Shahrzad's cinematic activities indicate how the basic ideas of modernity were never steadily absorbed or expressed in cinema and dance or—as we will see in the next chapter—in the area of literary creativity. The next three chapters thus will study Shahrzad's literary activities; the activities of other women artists of cinema, dance, and music; and how life has been affected by ideologies that proscribe sexuality.

5

Shahrzad as a Writer

The Question of Literary Modernity

> It was a short distance from my school to the sunset. And I have
> yet to smell the fragrance of my favorite flower.
>
> Shahrzad

SHAHRZAD'S CAREER in dancing and acting in the 1960s and 1970s has provided a case study for understanding the role of women in popular arts and show business in Iran. Her own impression of her career also has added to our knowledge of the place of women artists in Iran.

In the same way, her literary works, written in the late seventies, can shed light onto her life and the lives of women of her time by illustrating (or portraying the consequences of) Iran's suppressed womanhood and repressed modernity. By studying Shahrzad's literary works in this chapter, I will corroborate that the notions of private intimacy (predominantly a modern notion), gender relations (supposedly governed by social norms), and sexual experience (ideally recognized by society) have hardly been represented in Persian literary genres. Very much like the themes of rape, women's bodies, or menstruation, those notions have been underrepresented. I attribute this inability in Iran to represent and discuss issues related to sexuality to the absence of the sort of modernist literary trend that existed in the West. Western literary modernism, despite current criticism leveled against it, contributed to social progress and normalization of the rhetoric of the body. In Iran, social and cultural construction of the female body was linked with corruption and Westernization, both of which fostered a moral resistance—a resistance shared by diverse ideological groups. In her own way, Shahrzad was one of the women who attempted to overcome Iran's reluctance to

discuss gender relations, sexual experience, and intimacy. She resisted the social construction of her body and those of other women by the agents and consumers of the absurd entertainment industry of her time. In this chapter, I illustrate how her resistance influenced her literary endeavors and how her works manifest her struggle with representation.

Two of Shahrzad's books—*Salam, Aqa* (Hello, sir, 1972) and *Ba Teshnegi Pir Mishavim* (Thirsty, we age, 1978)—contain only poetry, and they revolve around a variety of themes and concepts. A third—*Tuba* (1977)—combines prose and poetry, weaving together the strands of an account, or perhaps a eulogy, of the childhood of a girl called Tuba.[1]

In addition, Shahrzad published a number of short stories and poems in different journals. Regarding the problem of representation in these works, several important questions arise before even getting to the motives in and behind her literary constructs. From a semiotic point of view, it might be interesting to know how Shahrzad's meanings are constructed, negotiated, and possibly perceived by a potential reader.

Her readers may ask, who is the narrator, what does she say, to whom, when, and where does she speak?

Why does this author employ certain nouns, adjective, and verbs and not others? What are her motives in writing those words?

For whom did she write?

Because most of the poems lack a narrative or a story, or even a point, one may think that Shahrzad simply published her notes that she had collected for books. But I am concerned with issues related to gender and representation. What metaphors speak to Shahrzad's preoccupation with her womanhood? Does the voice in the poems belong to a fictional character or to a traumatized personality? What do the words tell about women's oppression? Shahrzad has never been too clear as to whether these poems tell her story or not. The reality is that discerning the voice of the character and the voice of the author is significant and central in understanding her works, and for that, we need to study her entire works and meanings.

Shahrzad's Poetry and the Influence of Other Persian Poets

Despite certain flaws and the lack of coherence, narrative, and clarity, Shahrzad's poetry contains passages that can be compared to the works of the

legendary Sohrab Sepehri (1928–80) in their imagery, tone, and use of nature motifs. She wrote in one of her letters that she was in love with Sepehri's poetry, and these similarities illustrate the depth of her appreciation and understanding of Sepehri's work. Indeed, she shows sensibilities to some of Sepehri's poetic expressions that much later become canonical, for example, his "The Sound of Water's Footstep," which became popular toward the end of the seventies. In Shahrzad's poem "The First Word," from *Thirsty, We Age,* the influence of Sepehri is clear:

> One drop of morning dew
> was enough for me
> to grow beyond the midst of cobbled city streets.
> One small word
> was enough
> to shake
> the earth
> the sky
> the sun.
> One small act of the lover's kindness
> was enough
> to wash
> the wind
> the rain
> the name.
> To move into singing
> the world
> the night
> the forest.
> —One flame
> was
> enough
> to cleanse yesterday's disgrace.
> One root
> was enough
> to bring into flight

the flower
the plant
to decorate
—the prairie
the depths.[2]

This brings to mind Sepehri's famous poem "The Sound of Water's Footstep," where he writes, "Young vines pouring over the wall / dew pouring over sleep's bridge" and "My soul is still / It counts raindrops / It counts the gaps between bricks."[3] Shahrzad's rhythms and words when she writes "Is it not better to place my dress in the cage / for the bird to come to the city" reminds us of Sepehri's words where he says, "I swear by Observation / And by the beginning of the word / and by the flight of a pigeon from one's mind / that a word is captive in a cage."[4] Elsewhere Shahrzad writes, "Where is the wedding of the pigeons and my house / my house is on the other side of the seas," again echoing Sepehri where he writes, "There is a city behind the seas / I'll make a boat."[5] Shahrzad in fact acknowledged the existence of similarities between her work and the works of Sepehri and admitted that she has been directly inspired by him. But she could have also been inspired by other writings, such as the religious works of the medievalist cleric and author Majlesi, whose *Bahar Al-Anvar* contains the phrase "God has a city behind the seas."[6]

Colorful luminosity turning into darkness appears to be the most characteristic and most frequent metaphorical metamorphosis in Shahrzad's poetry. The glow originates very often from a fire, a flame, or the prairie's splendid light, and the color flows from everywhere. The poems paint a picture with words: white winds and hands; red iron and ships; black wall of time and manes; blue wings, shirt, carnation, water, and marble; green silk and eyes—to name but a few of the phrases she has constructed to do this. In another poem, she ends the journey through colors by writing, "I conquer the green blue crossroads to reach your home."[7] These images and colors were also predominant in Sepehri's poetry. He writes:

A color has died
silently
next to the night[8]

The fire is burning inside the night[9]

There is the sunshine, and how vast the prairies
where there are no plants or trees[10]

The sound of the steps of water
I saw prairies, I saw mountains
I saw water, I saw the earth[11]

Not as directly, she also resonates Forugh Farrokhzad (1935–67) in the constant longing for love, acceptance, and fulfillment.

In fact, Shahrzad's poetry mirrors in more instructive ways the poetry of Forugh Farrokhzad. Farrokhzad wrote:

A red rose,
A red rose,
A red rose.
He took me to the rose garden
And in darkness, he placed
A red rose in my windswept hair.
He made love to me
On a red rose petal.[12]

Forugh Farrokhzad, whose early efforts in self-portrayal eventually led to her mastering Persian poetics and gaining acceptance into the literary canon, was not able to foster a feminist literary movement. She recalled once that her early attempt at writing about the self was painful. "I abhor those folks who / to my face, befriend me / but in private, arraign me."[13] Hers was, however, a unique situation. No other female poet in the prerevolutionary period had such an experience with words: she boldly explored them to express her femininity.[14] A patient reader might, however, glimpse Farrokhzad's bold and at times mysterious depictions in the poetry of Shahrzad as well, when she writes:

In my heart, there is no one.
There is a rose in my left eye,
and my right eye
is a flower. . . .
In my heart, there is no one.
And

I became

a rose

your powerful chest

your powerful head—

Wrapping me inside the bouquet of your arms

We stood in the middle of a garden:

wheat

jasmine

in morning light

I wore a garland of roses

your teeth—

fruits to my lips.[15]

Even if these lines do not compare to Farrokhzad's exceptional poetic output, they do contain a distant similarity in their motifs, images, sensibilities, and that constant longing for a fulfilled love relationship.

Shahrzad wrote other passages that resemble or are influenced by Far-rokhzad's works in terms of themes of femininity and fluency of language though they failed to bring her any serious recognition as a poet. In the poem "I am a Woman," from *Hello, Sir*, Shahrzad writes:

I was a Woman

Darling

I broke your guitar

When you played, you did not need me.

I broke your guitar.

Darling

Darling

Oh when playing your guitar

I was a woman.[16]

Here, the woman asserts her femininity, revolting against norms by breaking the man's guitar, his "instrument," thus castrating him. As far as one can tell, such phallic imagery of this instrument, however, was not presented, explored, or at least common in Iran at the time. Therefore, it remains a question as to how Shahrzad came up with this portrayal.

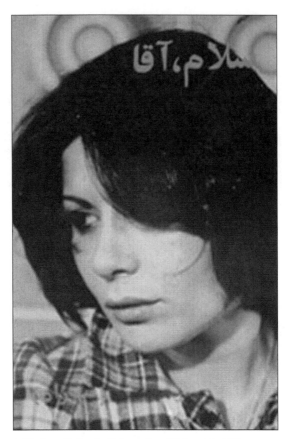

4. Shahrzad's book, *Salam, Aqa* (Hello, sir), 1972.

In the title poem of *Hello, Sir,* Shahrzad portrays a confused moment between innocent childhood and the world of grownups.

Sir,

You came to visit me

You covered me

With jasmine perfume

You gave me to drink

Milk,

Milk,

The milk that the lion had milked from the moon's breast.[17]

This passage, too, resonates with Farrokhzad's short elegy, "Leaving: The Poem," in which she remembers her joy at being with the man she loves.

> All night something was telling my heart
> How excited you are to see him
>
> . . .
>
> My body burning beneath your touch
> My hair abandoned to your breath
> I blossomed in love. . . . [18]

Both enjoy that spellbound moment of contact with the men they muse.

Symbols, Metaphors, and Themes

Shahrzad's poetry often features vague and unconventional images and symbols as well as confusing and subversive concepts, features that are hardly found in the works of Sepehri, Farrokhzad, or other Persian poets. Examples abound. It may take some guessing on behalf of the reader to find them. In most Persian verses, water, rain, and dew have a weighty presence, indicating hope and the coming of better times. Such hopes may be of what some conceptualize as God's blessings (treated more often in the classical period) or may be related to the desire to improve social and political situations (a subject more common in modern literature). In Shahrzad's poetry, however, rain comes close to its natural essence, that which gives life or revives. She assigns no political meaning; she simply asks for "one drop of dew" to enliven—to revive herself and the world. Such departure from convention and tendency to depict the simple and the natural occur in all of her poems. Moreover, with a "small word," she shakes the whole world, and with small acts of kindness she performs the impossible act of washing "the wind, the rain, and the name." These unlikely images contain important and literal expressions as well. "Washing a name" happens when a person behaves properly to eradicate the memories of previous wrongdoings. The meaning becomes more clear if we read the lines in the context of the accusations that were leveled against her.

On other occasions, the subversion of Persian poetic canons is more obvious, as in the poem "Speak" from *Hello, Sir,* which partly reads:

> There is no forest
> There is no water

And in the water, there is no mermaid.

I am prophetless

in the middle of paradise.[19]

Nima Yusij, known as the father of modern Persian poetry, wrote a poem about a mermaid who lived in the waters of the northern forests, and yet here, Shahrzad's mermaid does not exist in any water or in any forest. Moreover, according to religious conventions, she has to be a follower of the prophet in order to find her way into paradise, and yet the poet offers her own prophetic apparition conveying no need for believing in a particular faith.

Elsewhere, she muses, "The thirst, if it existed / would be in the unforgettable nonexistent summer."[20] What is this thirst? Does the narrator's nonexistent thirst in a nonexistent summer suggest that she has not been afforded the opportunity to realize basic human needs? Is that why she chose *Thirsty, We Age* as title for her book? Just when the readers carry on, curious to find a clue to decipher a poem that is made of words that barely convey any meaning, it appears that a thirst for something has caused disillusionment in the narrator herself, preventing coherent communication. Yet her juxtaposed words present strikingly strong images that are not necessarily meaningless. These palettes of images are mysterious and their meaning concealed, but they are not entirely inexplicable. Shahrzad alludes often to her life, her childhood experiences, and her suffering in relationships with men. Part of "The First Word" from *Thirsty, We Age* reads:

The vice principal's hand

Struck the air with a hammer

It turned the innocent morning breaths

To red iron, hanging from the school's pine tree.

Bang!. . . . Bang!. . . . Bang!

The silence tortured the innocence

The first prayer, clearly,

Was a curse.

All rise.

All be seated

I

Did not say present

Then

I was absent.[21]

If we agree that this passage evokes images of the fear and agony of one's first day at elementary school, then we realize that the poem also questions the necessity, sincerity, and use of formal and unfriendly rituals, such as forming the morning lines and prayers in school, that often haunt students for the rest of their lives. This nerve-wracking experience opens her *Thirsty, We Age,* a book of poetry that sometimes dwells on the past, a story about a repressed memory that keeps returning to haunt her and goes on without clear direction. In all of these poems, the initial timorous, frightened mood carries to the end. As we will see later in more detail, through some rather obscure metaphors, she describes love, virginity, disappointment, and rape. She addresses these issues in a melancholic mood and by using images of horses, birds, bees, flowers, prairies, deserts, coppices, forests, and mountains. The prairies might sometimes be only an obstacle, a distance that the protagonist has to cross in order to reach a promised destination. It often functions like the sea in Sepehri's poetry, where the sea separates the protagonist from an ideal destination. At other times, it is difficult to distinguish between the prairie and the desert. The latter, of course, has its root in Shahrzad's location; an assumption that can also be made in regard to the horse.

The prairie and the desert are not the only symbolic locations where Shahrzad's dreamy stream of thoughts flows. They are sometimes entrapped in the walled spaces of the city and in the abysses of poverty, even when using such seemingly nonurban images as horses. We must remember that in Shahrzad's first neighborhood, where her family lived before they moved to the outskirts of town, there was a huge statue of a kingly horseman on a large horse. Moreover, she grew up in time when horse carriages were still used in the central areas of Tehran. Given these facts, combined with all the cultural significance that a horse has in Persian culture, it is not surprising that she frequently used the image of the horse in her poems. In fact, many aspects of her real-life location soon show up in her writings: the desert, wells, water, and strange men. Going back to symbols, the word *desert* in Shahrzad's poetry, with all its negative attributes, indeed might refer to the wastelands around Tehran, upon which newcomers and working-class families built their houses. She refers rather negatively to this location in her poetry, fiction, interviews, and letters. Those areas were

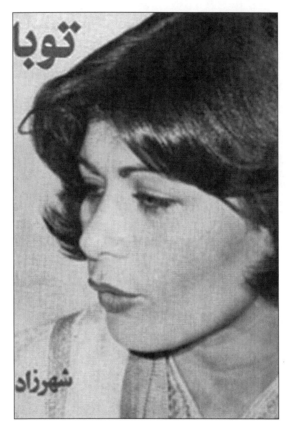

5. Shahrzad's book, *Ba Teshnegi Pir Mishavim* (Thirsty, we age), 1978.

always dusty, especially with the slightest wind, and the image did not escape Shahrzad. In *Hello, Sir,* she writes:

> I began from you
> The blossoms fall on our barren land
> And wind removes dust from faces of polite children.[22]

The dust, for example, is portrayed as a cloud in *Tuba:*

> Our sorrow is our error, taking us up the heights of a cypress
> Our reunion blossoms on the blade of swords and daggers
> Extending the lake to morning

The storm passes by our house without making dust

. . .

I heard the last breath of a star
In the last shadow of the dust.[23]

All of these images convey scenes from the remote past—something unpleasant, something controversial, something unspeakable except through metaphor. The poem "Second Word" in *Thirsty, We Age,* for example, reads:

In the alleys,
you hung my hand.
The black wall of time
is growing
from the lagoon of two red ships
on the surface of swollen breaths.
In the alleys,
my hand
lies silent on the numbered doors.
In the bakery,
I saw the injured handkerchief of virginity
on the scales of justice . . .
They cut the verses
from my body
in the season of puberty.
In alleys,
my hand
caressed baskets of voices.
The other was a river running silently.
How calmly the thunder comes
in the alleys
purity in my veins becoming verses
and I had the heat of the equator in my hands
and my face had the picture of disaster.[24]

In the intricacy of the old alleys, a young woman may fall in love or be harassed. She may be raped or voluntarily involved in premarital intercourse. The consequences

are the same as far as the psychological effects are concerned. She will not be treated justly. Shahrzad takes the issues to the most public space—the bakery line where all Iranian children stand when sent to buy fresh bread and which may yield bitter or sweet memories. What Shahrzad bitterly displays at the bakery is the most private item a family may hold—the virginity handkerchief. The bride's mother is supposed to hide this item in a safe place immediately after the wedding night, after showing it if necessary.

The narrative goes astray, becomes feral and boisterous, suggesting that a sane person is not supposed to speak of this taboo and that to hint of rape or sinful intercourse burdens the narrator too much, opening another realm of surrealist partition. Later in "Second Word" she writes:

> My regrets are as sour as those bitter mock oranges
>
> Yet, they smell like grass
>
> And in all this confusion
>
> We age, thirsty,
>
> Like drunken grapevines.[25]

The phrase "We age, thirsty" is meaningful and indicative of a recurring sadness about an unfulfilled life, but the combination of words such as *orange, grass, grapes,* and *drunk,* yet another set of symbols, may be more challenging to decipher. Culturally, the sour or mock orange tree is most famous for its blossoms and is used in several drinks and food recipes. In poetry, the sour orange and its blossoms symbolize much-praised greenery, gardens, and happiness. Many Iranians adore its smell and feel ecstasy when they have a drop of its essence in their tea. However, sour orange has never come close to smelling like grass. Likewise, while grapes and grapevines symbolize drunkenness, either from the love of God or the actual act of drinking, they too have never before been used to portray people. In Shahrzad's poetry, these elements symbolize people, and people symbolize the drunkenness, which makes more sense given the attribution to grapes. The beloved here is simply so intoxicating that he can sweep the poet away with one drop of his existence. In these verses, we see a character with a lingering problem caused by intercourse or rape, a problem that has ruined her reputation, forcing her to struggle to clear her name.

Symbols, Sexuality, and Autobiography

Shahrzad's work touches upon many themes, symbols, and metaphors in her attempt to articulate her poetic concerns—nature, animals, childhood, suffering, love, redemption, female identity, compassion, and sexuality. The latter theme, although it occurs less frequently than, say, the themes of childhood, speaks more directly to the author's overall artistic life.

Tuba, *the Book*

And in a sense, her sub-story of sexual abuse as a child in *Tuba* connects the two themes. That story is entitled "How Fast One Grows Old," and in it, Shahrzad writes:

Sayyed Hossein was standing in the hallway. When Tuba was going back through the hallway, he called after her. She didn't answer. The hallway was too narrow. He always did that, and Tuba always ran away. That day he looked at her very differently as if he knew she had turned ten. He grabbed her hand and pulled her into his office by the hallway. She screamed the whole time in the office. Eventually, Mr. Ahmahdi came with his violin, hit Sayyed Hossein, and took Tuba with him. His violin was broken. Hossein's head was bleeding. Tuba's skirt was torn. Mr. Ahmahdi brought a needle and thread. He hadn't touched his food, since he was mending her skirt to stop Tuba from crying. Sayyed Hossein came with a policeman who took them both to the police station. They shaved Mr. Ahmahdi's hair. Tuba's father beat her and asked Sayyed Hossein what Mr. Ahmahdi had done. Sayyed Hossein was instructing Tuba to say that Mr. Ahmahdi had hugged her. Both Mr. Ahmahdi and Tuba were crying. When Mr. Ahmahdi left, the neighborhood children booed at him. Her sister played his broken violin. The thread and needle were still on the skirt. At night Sayyed Hossein held Tuba's hand and her father burned it with the hot iron rod from the samovar. Sayyed Hossein confined her in the basement filled with charcoal with only one small window above her. Her hand was burning. Sometimes she could hear the footstep of someone passing by the window, and she could see the shadow covering the window frame. The coffeehouse was filled with mice, but Tuba was frightened of cockroaches and Sayyid Hossein. She knew no one could hear her scream.[26]

While the images used in describing these scenes are less metaphorical and symbolic, one can still take the items named as symbols of modernity (the violin and the policeman) and tradition (the iron rod and the needle). There is an ongoing antagonism throughout the text. And Tuba is just the victim of this encounter in a most cruel way. At the core of the battle lie some questions related to sexuality and an abhorrent case of child abuse.

Who Is This Girl, Tuba?

Tuba, though, seems to be more than one character in this book. She seems to be in more than one place simultaneously. This might be related to the author's writing style but Tuba's multiple presence also gives her a sort of universality. It is through her that the questions of sexuality and rape, the rape of a child, come together. Shahrzad writes:

> One night when her mother screamed, and when her father beat her, the constable took them both away. It was hot. Her sister cried. Majid, who was night watchman for the coffee shop, called Tuba. He wanted ice. Tuba's family used to cover the ice blocks in canvas and keep them in a wooden box; Tuba kept the key; hung it from her neck. She put the ice in a glass of water, pushed the curtain aside, and gave it to Majid. When Majid pushed the curtain, Tuba was shaking her sister's bottle to cool it. She did not scream for fear of being taken by the constable.

Tuba in this passage seems to be responsible beyond her years, and more explanations about Majid's molestation of her could have been offered on her behalf by the author. But the next paragraph is not related to the one quoted above; the reader is left hanging. At best, the reader may consider it a dreamscape or mirage. Or perhaps the taboo subject of sex (especially related to a minor) has caused its vagueness. It reads:

> A doll's eyes sleeping. The innocent eyes of a little bird fallen from its nest. I learned the way to your house. Among all the wickedness, the kind die. Or stays alive to read the evening paper nicely. Read it again. Read it nicely. The water spring does not flow down the mountain for the hope of filling the earthen jars of the village.

Obviously, this series of passages seems disjointed. And the "I" in the second sentence can refer to more than one person: to Tuba or the author, or both; that

is, Shahrzad may be Tuba, or a third person who represents both Tuba and the author. Even more confusing, a few poetic lines that do not shed much light on the plot follow this paragraph. It sounds more like a eulogy for the "kind" one who dies in the passage.

> Ah, young men
> Young men in love
> What do you want to know about Tuba?
> We can walk through the city every day.
> We can count the tall trees.
> In this snow
> I have stared through windows
> I have passed through doors
> And have returned.
> Every time I was away from the mirror
> I looked at myself in windows.
> When the glass broke, I broke too.[27]

Due to inconstancy, change of viewpoints, and confused shifts, it may take effort to even follow the "storyline" in this work, but it does not take much imagination to think that the author's creative efforts stop at the moment where she has to reveal a bitter, horrible, and dirty event that occurs when a young sexually deprived man is left alone with a little doll-like girl in a dark backroom filled with bags of charcoal. How universal is this little girl's experience? Is the "I" in those lines referring to Tuba, the author, or someone else? Why can't the author talk about the experience more openly? And how is Majid different from Sayyed Hossein? Why is a person in the position of Shahrzad, once an emblem of "modernity," utterly incapable of making references to this horrific experience? Girls who experience trauma such as a sexual abuse may not wish to ever remember it, let alone to be able to talk about it. So, in a culture where girls do not talk about even positive sexual experiences, it is not surprising that a stronger taboo is attached to talking about abuse. Nevertheless, Shahrzad should be credited for making the attempt.

A bit further down, the text reads, "How can you remain in love when you know that Sayyed Hossein, the grocer, causes Tuba's small breasts to ache. They were too unripe. Tuba was too young."[28] Is the confusion caused by the author's

understanding of the reality? Is there is no difference between Majid and Sayyed Hossein? The even more pungent irony is that it is Tuba who has to pay, not only with psychological scars but also with a beating from her father. "Her father beat her. Her father liked the grocer."[29] The father is indeed forgiving, or at least ignorant, of the abuses that occur around him and his family. Throughout the story, Majid, Sayyed Ali, and perhaps worst of all, Sayyed Hossein are revealed to be predators who do not discriminate among their victims. About Tuba, Shahrzad says in one of her letters and out of any perceivable context, "Every woman whether seven years old or ninety wants to take revenge on Sayyed Hossein."[30] She further adds a passage that is a testimony to the biographical nature of her book:

> I had seen some photos in my father's coffee shop and in the soldier's room. I saw a man standing in front of the cabaret who had dressed like the man in the pictures I had seen at Behmanesh's house. The man in front of the cabaret greeted Mehri who had brought Tuba to the cabaret for the first time. In the photos in the coffee shop, a man was greeting a woman. The cabaret was always filled with men, however. There were watching a woman who was dancing to the sound of music played by a few men sitting on the top of a stage. My Tuba laughs because seeing the women in the back of the cabaret reminds her of her school.[31]

To be sure, in an interview with *Setareh Cinema* (The star of cinema), the interviewer picks up on phrases like "my Tuba" and makes a reference to *Tuba* as the story of its author, and Shahrzad does not deny it.[32] But more importantly, these confusing, mixed, and ambiguous statements tell a story obliquely, the way Freudian dreams can be telling; these words carry additional meaning that can be deciphered only with effort. Mehri is the woman who finds Tuba a job, the place where Tuba is supposed to work is underground, and in that workplace, men are sitting above on a high level surface and women at the end of the room. In all likelihood, this is what happened to Shahrzad herself when she began dancing.

Did Anyone Portray Sexuality?

The author's notion of sexuality continues to be obscure and vague, turning the poetics she intersperses in the text into random expressions of thoughts and images. She writes:

Blood spilled over

My instrument didn't echo anyone's footstep

With bruised feet I run from you

That were pierced by my henna braid

My scream sacrificed for the soil

My scream as long as my net.[33]

Her obtuse language often obfuscates her meaning, and she does this also in other sections. For example, in "The Fifth Season," in *Hello, Sir,* we read:

From my desert beliefs

I fall into your placeless religion

Not for embracing love

Not for the sake of time

Not for the sake of place

Not for the desert

I fall into you

As my place is in your small hand.[34]

Her insinuations about love and sex become ever more obscure, leading to the conclusion that she still has not come to grips with the overwhelming experiences of her past. In this context of horrifying experience, one may understand the meaning of her phrases "pierced . . . henna," "scream," and "placeless religion."

The contention that this poem has some personal relevance may further be substantiated by the frequent shift from the third person (that of Tuba) to the first person (that of the author), a feature that has haunted all of Shahrzad's writing—both poetry and prose—and has caused ambiguity, confusion, and incoherence. Furthermore, her poems and the story of Tuba clearly reflect her own horrific and agonizing past life, as revealed in her short interviews published in *Setareh Cinema* and *Ferdowsi Magazine* in the mid-1970s.[35] Most relevant is the interview in *Ferdowsi Magazine,* where she confirmed that her father had married her off a few times for profit and that all those men had limited her in her activities.[36] Those husbands she described in that interview bear a strong resemblance to some of the male characters in *Tuba.* Shamefully, the *Ferdowsi Magazine* interviewer introduces Shahrzad with phrases such as, "I review what I have said before about her, the baptized sister of loneliness, a bar woman, escaped, a residence of darkness

joined with light, an artist escaped from a commonplace, trite past [from *ebtezal*, a word that also connotes aberrant sexual practices]," and then never asks even one question about those men and their treatment of Shahrzad.[37]

Further exploration into the autobiographical nature of *Tuba* is illuminating. In her written responses to my interview questions, she offered more references to her husbands Akbar Taheri and Ali Salmasi. Those references, too, match some of the male characters in *Tuba*. In real life, Akbar was a policeman and Ali a mason, and both (as well as her father) abused Shahrzad. Tuba is abused by her father and two other men. In real life, Shahrzad comes across a gendarme who served as the head of security for the Aliabad area and who also wanted to sleep with her; Shahrzad hated him for his lust and for his criminal activities such as distributing drugs. In *Tuba*, a gendarme by the name of Abas figures as well. Finally, the village or the illegally established neighborhood on the outskirts of Tehran where Shahrzad once lived, married twice, and which she finally left to enter the world of acting corresponds with the village in *Tuba* called Aliabad.

The policeman character deserves further explanation. Both the actual and fictional accounts portray him as an abusive man. He is presented in Shahrzad's letters as the man to whom she was married off when she was seventeen. On the wedding night, she made fun of him. However, the rush to relate her memories prevents her from describing the characters and events in a way that can be understood fully, and this is in addition to the difficulties associated with reading handwritten journals that were written hurriedly, in uncomfortable conditions. The policeman in the story of *Tuba* seems to be a man who goes to Tuba's bed and touches her though she is but ten or twelve years old; she seems to be a guest in his house, which he shares with a woman a decade or more his senior. In life, however, Shahrzad married a policeman later, at the age of seventeen. On her wedding day, Shahrzad's father was most anxious to ensure that she had preserved her virginity, despite his several previous examinations and the fact that he was not religious at all. But Shahrzad knew everything about his backwardness, and the issues made her mad. She was also angry that her mother did not go to the bathhouse with her after the wedding night. Only a few days after she moved to Akbar's house, she decided to run away. After fleeing from Akbar's house, the news ends up in a newspaper under the heading "Run Away Bride." Finally, the mason who builds himself a house in the dusty outskirts of the capital in *Tuba* is based on a real character named Ali Salmasi, who was interested in marrying Shahrzad after she left

Akbar. These aspects of Shahrzad's life are all similar to the plots in *Tuba* and the other short stories Shahrzad published in *Ferdowsi Magazine,* but also sound very much like FilmFarsi plots. After all, she has repeatedly stated that she started to dance at an early age, so it is curious that after so many years she is still upset that her mother did not accompany her to the bathhouse on the night of her wedding. True, she was only seventeen years old, and Akbar Taheri, her husband, whether he was the policeman or not, left after the wedding night for a mission in another city. But the anger seems a bit melodramatic.

Shahrzad and Shahrnush

One may also find a few similarities between Shahrzad's *Tuba* and Shahrnush Parsipur, especially her *Touba and the Meaning of Night.* Parsipur once mentioned that many plots in her book have roots in real life. But the two works are even more similar in that they try to convey the universality of issues. Moreover, they both use the same female name in their title, which refers to a tree. *Touba* and *Tuba* are the best choices of transliteration to distinguish the two works; however, in Persian the sound of *T* can be presented by two different letters and each has used a different letter *T.* The long *A* at the ends of the words is also different; Arabic in Parsipur's choice and Persian in Shahrzad's. Both works offer vivid imagery and symbols and at times use a surrealistic style. Parsipur especially evokes this style in *Touba and the Meaning of Night* when she speaks on behalf of the characters named Leila and Prince Gil. In a passage we read:

> Then, in the midst of the night, you hid from the third boy, who stole from you to hand the booty over to the hunters in return for a reward. He also stole from them to receive rewards from you. You would all go to the silo to count the remaining grains of wheat. And I danced continuously, hoping to calm the men from the wilderness. I would grow dizzy, and yet there was no end to them. They mated in the wilderness and poured down on your village. They prostituted me in order to dominate you, and you slapped the faces of your other daughters to warn them of their fearful fates and of the danger of becoming like me. Touba, I took your hatred to my heart. I no longer danced as the waves of the sea, nor as the wind in the branches, nor even like the law of union between the earth and the sky. I only moved enough to keep them calm. I now danced in cities; I hated men and hated you. I had been separated from my pure roots and defiled.[38]

The life stories of both T(o)ubas can reveal many realities of the issues related to women's sexuality that have not been addressed seriously and openly elsewhere.[39]

Mode of Writing and Mode of Sexuality

As much as Shahrzad's literary works are autobiographical, her letters sometimes take a fictional form, presenting strange, unusual characters. Nonetheless, the characters in them are described realistically and have names. The most important problem with her letters, the problem that prevents a precise analysis, is that they do not have a linear narrative and a thematic consistency. Shahrzad moves in time, switching from her childhood to the present, from her memoir to her philosophy, and from fact to fiction. There are too many deaths in her childhood, for instance, to make the narrative sensible. There are too many little issues that still haunt and anger her upon remembering them.

The reader's confusion is exacerbated by the fact that Shahrzad's writings in general belong to a surrealist mode of poetic expression marked by symbols, metaphors, and frequent shifts of perspective (from third person to first person), and so on. Surrealism has been associated with Freudian (and Jungian) psychoanalytic theory because they share an interest in the free associations created by the subconscious mind or "deep thought."[40] The free flow of associations, the unedited expression of thoughts, and consequently a well-expressed paralogism are detectable in Shahrzad's writing of the prerevolutionary period. As David Loma points out, sexuality assumes paramount significance in surrealistic modes of expression.[41] For example, in "Prelude: With Him the Night Is Prolonged," which is reminiscent of the work of Paul Eluard or Arthur Rimbaud in its nonconformity,[42] Shahrzad mentions some of these names in her writing. However, lines such as "She has the color of my eye / She has the body of my hand" by Eluard and "I shall travel far, very far, like a gipsy, Through the countryside" by Rimbaud could have been sources of inspiration to her. To show further connection, Rimbaud wrote, "I Embraced the Summer Dawn" and one of Shahrzad's verses reads, "I embraced the poetry." Notwithstanding of this, Shahrzad is very creative and original:

A hundred years have passed
a hundred nights,
no,

it was yesterday

right before the drop of water from the stars rained upon the stones' surface.

Right before the drop became night

—before it became a shell on the pearl's body.

Then

the heat from our burning bodies

the cold from our lifeless bodies

came

together

on the surface of the sea

and I do not deny the timely storm and rain

and tonight

it has been a hundred years.

With a body made of light

right after the darkness falls

the night passes

among the flowers.

The trees

from among us

trapped in smoke

sitting in fog.

I passed by the window's refuge

by the plants' eyes

through the opaqueness of the glass

of homely heads

through every brick in the wall.[43]

The protagonist's sexuality is portrayed in terms of the self's loneliness. The burning bodies become lifeless on the surface of the water in the shape of a pearl. This is a stark departure from any conventional representation of sexuality.

In prerevolutionary committed literature, metaphors of day, light, or stars prominently featured positive metaphors in referring to hope, revolution, rain, and social change; conversely, night, darkness, and the cold referred to the status quo, to the faulty social situation.[44] But Shahrzad assigns new meanings to

these words or removes their meaning entirely in this poem: "Tonight, tell me the name of the night / I have repeated it in the mirror of the dark."[45] One can envision the narrator repeating the words verbally before a mirror. The absence of light may relate to the repetition. And the night, in all likelihood, is a reference not to the political situation but, rather, to the abhorrent situation of Tuba or the author's frustration with suppressive culture.

It is safe to assume that the mirror, a classical metaphor for self-consciousness, has been broken into pieces in Shahrzad's poetry, and each piece of her identity has been picked up by a different person in those nights of darkness, which the author uses to also refer to her culturally "suspicious" cinematic career. Such a depiction reminds us of Lacan's mirror stage theory, which is also presented in terms of a metaphor. In Lacan's mirror stage human infants go through a process of an external image of the body (in a mirror or represented through others). The infant at this stage produces a psychic response leading to the mental representation of an "I." In the mirror stage, the fragmented infant desires to have an image of wholeness.[46] In Shahrzad's poetry, the mirror metaphor is identified with subjectivity.

Foucault and Lacan, among other Western thinkers, have pondered the way that language shapes subjectivity and the way the "subject" (a position in a sentence) differs from a "person." These thoughts cause further contemplation on Shahrzad's system of representation. In Shahrzad's works, can we assume that every time the narrative in *Tuba* shifts into the first person it is the author who is speaking? The reason for this question is that we cannot justify these changes in voice and viewpoint in terms of lack of editing or the author's lack of experience in writing. Moreover, *Tuba* is her second book, and it is in prose, as opposed to her first and third books, which were poetry and in which the author might have felt freer to make such switches. Understanding this "Socratic problem" may be the key to understanding the unrefined yet profound, somewhat grammatically flawed, and inconsistent and yet impressive imagery in her writing, as well as the author's sociopsychological perspective. A woman caught in the middle of a social debate, living in a changing time, and surrounded by hostility and backwardness might understandably be unable to find her voice or may attempt to mask it. The voice in Shahrzad's writing, therefore, is the author as she wants to be a poet and wants to censor herself at the same time, and that of a woman who wants to move beyond her past. It is no wonder that in responding to my questions about

some aspects of her life, Shahrzad wrote that "it will take a few novels to answer questions" related to her life and experiences. She also wrote, "I could have talked about many people in *Tuba,* many who did evil. But I refrained."[47]

The parts unsaid in Shahrzad's poetry and letters are also meaningful to this project. If we consider language as a system through which communication is accomplished, power is exchanged, and identities are formed, then censorship and self-censorship have to be considered to be parts of that system. Indeed, Foucault makes a connection between sex, discourse, and silence, emphasizing what is not said—the "empty space" in utterances of sexuality.[48] He believes that in the West, the seventeenth century ushered in a discursive explosion of sexuality. In Iran, there has never been such an explosion. Moreover, in light of the fact that there was a disconnect between Shahrzad's writings and the dominant literary discourse of her time, it seems natural that she treats the question of sexuality as very "secret," for indeed there was nothing to discourse with, nothing against which she could shape a comparison and contrast. I tend to think that the half-expressed sexuality in Shahrzad's poetry arises from her own distorted image in cinema. The broken image, the multiplicity of the cameras, and lack of control over the presentation of the external image of the body all have had an impact on an adult perception of the "I," causing the subject to be constantly in suspicion.

Shahrzad's Works and Western Literary Influence

Shahrzad herself is critical of her three volumes of work, but she does not denounce them altogether. She believes that she is capable of producing good poetry and that she understands poetry. She says that people did not have the faintest idea about her background at that time, her knowledge of the world, her knowing how to dance, her knowing the waltz and the cha cha, and her poetry. Early in her career, she wrote like many novice poets, whom she refers to as *Maeran* (a meaningless word to replace *Shaeran,* poets). Some of her poems are certainly deviant, not only in terms of grammar and basic linguistic conviction but also in terms of basic poetic styles. Based on any standard definition, a poem is supposed to be a literary enunciation expressed, if possible, in meter or in an organized set of words; it can be free of rhyme, even close to ordinary parlance, but in many poetic traditions, such free verses still must follow some organizing principles to be considered polished and pretty. Shahrzad occasionally displays such qualities within a poem, and when she does, the results are glaring. To be

sure, she was warned about the significance of editing once, and she seemed to have given the advice only passing thought. In her introduction to *Thirsty, We Age,* she mentions that she took the book to a famous poet's house for comments and feedback. The poet is in all likelihood Ebrahim Golestan, whom according to some unconfirmed and unverifiable reports, became a close friend of hers.[49] Without mentioning the man's name, she writes, "I wanted to see him and I used my poems as an excuse. My best dress was black and I burnt its cuff while ironing it, and on the way I was thinking how I could hide that part of the sleeve. He asked me how many years of school I had completed. I said ten and a half. He asked why did I not want to dance anymore. I said because it was difficult to get naked and I did not want to be naked." She left her poems there with him and then when she got them back during a very short meeting, she was upset by his comments. "He wrote, the poems are good if you make these changes." Shahrzad briefly refers to his comments in this way: "This is nonsense. Do you even know what this means? These [sections] are sometimes excellent, sometimes nonsense, and sometimes average. You need to make a decision about your work."[50] Apparently, she only listened to him halfheartedly.

However, in terms of imagery, sensibility, and sensationalism, she offers a poetic experience that may interest many readers. Her irony and poetic discrepancies grow on a reader over time. She said in an interview with *Film and Art* that in her poetry she does not follow any one form. "I observe, absorb, and inscribe. I write about anything I see; a courtyard garden for example. I don't want to write only about my parents and my sibling and wickedness."[51] Perhaps in doing so, she goes too far in subverting poetic conventions. Persian sentence construction is subject, object, and verb. This does not have to be followed in poetry. However, the subject–verb agreement, even if one of them is missing, is always respected. This basic convention or rule is missing in Shahrzad's poetry. Sometimes I think the reason that these works seem to be so inconsistent in the use of pronouns and tenses (and the fact that sometimes there is no subject–verb agreement, for example) is that the author, as she was writing, was thinking of more than one person and more than one incident and more than one time—and they all get jumbled together. Is this style what one calls "reflexive construction?"[52] Or is it the inclination in the reader to see it as what Gilbert and Gubar term a "schizophrenia of authorship" or an "infection" plaguing women writers?[53] Many of Shahrzad's contemporaries made many such false accusations.

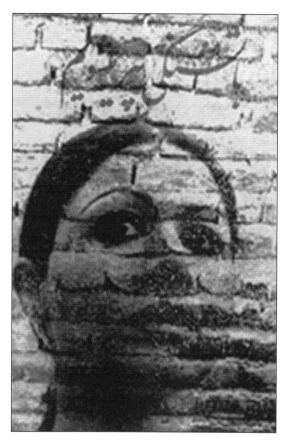

6. Shahrzad's book, *Tuba*, 1977.

Decades later, Golestan describes Shahrzad as the former dancer, and her poetry as piercing and lively expression. This goes back to his memory of a meeting with Akhavan Sales in which, as he hands the book *Thirsty, We Age* to the prominent poet, describing Shahrzad as the former dancer, he causes Akhavan Sales to cry upon reading a few lines and say that her poems bleed like a severed vein.[54]

Yet Shahrzad's writing may also be a response to some established literary styles with which she had come into contact during her early years of writing. In almost all her writings, Dadaism—a disregard for aesthetic, a resistance against the diction of clarity—comes to mind; the readers understand some things and do not understand other things. In that regard, we must visit an earlier question:

did these qualities result from her lack of proper schooling?[55] Or are they the product of her ability to draw an image, a perceptual display, or a visual metaphor with her words? In that regard, Péret's spoken verse "Hello" comes to mind:

> my opal snail my air mosquito
> my quilt of birds of paradise my hair of black foam
> my tomb burst open my red grasshopper rain
> my flying island my turquoise grape.[56]

Although such European modes of expression are rooted in the postwar European mentality, they, like many other literary discourses and ideological trends, found a reflection in Iranian society.[57] Or rather, Iranian authors came up with responses to the phenomena introduced to them. Shahrzad too pours words and juxtaposed images on paper.

This relation between word and image, I believe, corresponds to the relation between her poetic and her cinematic arts.

The frequent disconnectedness of her syntax gives her poetry a mobile quality, as if we are witnessing a motion picture. So is it safe to assume that she had a wild imagination before she became ill, a type of Salvador Dalí paranoiac representation? Dalí painted the image that came to his mind and then added to it all other associating images.[58]

Shahrzad's imaginative abilities are similar where she uses the image of a horse, for example, which can mean anything at any moment to anyone who comes in contact with the animal. But Shahrzad uses it as if the horse represents her innermost nature and a forbidden desire that can even contradict itself:

> I can pass by you
> through your arms
> through your eyes
> like that mounted Horseman
> who on his horse all ablaze, burned and passed through the fire.
> Oh, your black eyes are blue
> in my marble.[59]

On occasions like this, one realizes that the "you" in her poems is none other than a lover. Her imaginative abilities are also apparent in the way she adds all the words that are suggested by the use of the horse metaphor. Like the

pomegranate, dates (*khorma,* when the fruit is ripe) are like the horse, associated with female sexuality in classical Persian literature.[60] The horse (which to a woman may signify servility, declaration, victory, exalt, purity, or essence), however, is almost nonexistent.

In response to questions about the meaning of the predominant horse image, she wrote in her letters that once sugar is mixed with water, you should not look for it in the resulting liquid, nor should we look for the salt, which we use to spice the food, after they are mixed. Further, she mentioned something about liking to look at a painting that was hung in her childhood house and that featured a chariot pulled by two horses across a river, carrying a blond, blue-eyed woman with a Jesus-like child. In order to analyze the poems, one should therefore rely on some sort of formalism as the safest means of understanding poetic expression. In this way, whether related to a childhood memory or not, one may assume that its image would represent male sexuality, and it might be so in this poem. However, Shahrzad changes this dichotomy in the next poem:

> I saddled my horse
> I was ill . . .
> The sound of my horse's hoofs
> I abandoned goodness, I had two sweet dates
> which I offered to my horse.[61]

Here she feeds the dates to the horse. Are these animations of a love-making scene? And does the horse imply being deprived of sexual experience when she writes

> In my wakefulness
> you are
> So in love
> That you don't hear
> The thirsty horses thundering over
> The burning land. My horse shrieks from afar, beads
> of the rosary hang from its neck
> made from burned soil.[62]

Metaphors, symbols, the subversion of literary conventions, the existence or nonexistence of any form, and even occasional grammatical inaccuracy all come

together to convey Shahrzad's meaning, albeit a confused one. With all these fleeting love occasions, the protagonist seems to have been exempt from experiencing a meaningful relationship, as was Shahrzad's own case. Each of those occasions had a different effect on her soul. At times, the love experience seems to have been alarming, frightening, or enchanting, but always temporary. Such diversity plays out in the way she portrays the horse figure in her writing. In a poem entitled "Darkness, Who Are You?" she writes:

> Darkness
> At the end of the road, darkness.
> A horse runs in the whiteness of the wind.
> In the distance
> under the tall trees
> a girl is sleeping
> dreaming of forty dervishes.
> At the end of the road
> a white horse startles.
> My children, welcome to your pilgrimage inside the earth's darkness
> to the feast of the apple's redness
> In the journey to the ivory house,
> in the temple of wine and sword
> a girl
> visited by the wind-up demon.
> The sound of the snaps on her dress
> wakes the white horse at the end of the road.[63]

The poem presents all sorts of images: gothic images, the face of innocence, portents, sacrifice, blood, the virgin, the demon in a man, and so on. However, the darkness at the beginning of the poem conveys her meaning best: a sense of fright, to the extent that even the whiteness of the wind does not negate it. The image of the white wind, in fact, adds to the sense of horror, like a foggy night. Here too, the images of the horse and the apple's redness symbolize the protagonist's sexuality and seem to portend a future. As the dervishes in the poem may spin, the poem too spins around the concept that is expressed through the allegorical scene of a girl entering the "temple of wine and sword" to visit "windup demons" to hear the "snaps on her dress" that make the "white horse" wake up.

Shahrzad's Literary Works, Cinema, and the Realities of Life

Shahrzad is not seeking to change the world, as the postwar French surrealists were and as Shahrzad's contemporaries, Iran's committed literature writers, were with their realism. Shahrzad does not even want to change her own life too radically; she simply wants to make a transition from her condemned cinematic persona to attain a poetic personality. She strives to come to terms with the reality of her life, with her own sexuality, with her past. She is even tired of the change she herself has already gone through. In *Thirsty, We Age* she writes, "After all these years / Awakening is my right / In Awakening, I am tired."[64]

As unusual and subversive as her poetry seems, it was itself entirely subverted by her cinematic image, which led to critical neglect of her written works. To be sure, there is a close relationship to and correlation between her writings and her cinematic and dancing arts. I have made several references to such a connection already, but it would be helpful to see how a very short story/piece entitled "Loneliness," published in *Ferdowsi Magazine* along with her interview with Nurizadeh, can further corroborate such a relationship. The story corresponds to her role in the movie *Qaysar* (which was analyzed in chapter 4 on cinema). The piece reads:

> I arrived at home late at night, lonely, tired, and dragging, like other nights. I turned the key in the lock to my apartment, went in, and closed the door behind me as quietly as possible. There I heard my breathing. I had come up stairs in the dark. I did not turn on the light in the stairway because I did not want to wake anyone up. Fifty-five steps. I brought my sore fatigued body up fifty-five steps to reach the fifth floor. When I closed the door, I heard my breathing.
>
> Is this a life? I have to work all day, go around the town to run errands, wander in offices with a bunch of files under my arm from a supervisor's office to his assistant's room, from the manager to his clerks, take orders, fill all sorts of requests, tasks that never end. Then I have to keep quiet for the fear that others may talk behind my back. I have to struggle with myself in my lonely cocoon. I have to go see the movies alone, otherwise, they might talk behind my back. Then, she is home, alone, I arrive in it alone climbing the stairs like a thief. I must not awake the neighbors and arouse their curiosity. I must not encourage them to intrude. In the morning, the murmur, "What is a single woman doing out so late in the night?" Is this really a life in which all my existence is connected to the people's invisible murmurs?

There is a scene in *Qaysar* in which Shahrzad's character arrives at her small, lonely apartment with the protagonist (played by Behruz Vosuqi) and expresses her frustration with life and the neighborhood. The plot of the story (as is the case with several of her movie roles) corresponds to her real-life situation. At one point, Shahrzad herself lived in a one-bedroom apartment in Amir Abad, a neighborhood in the middle of Tehran. She chose to sleep on a sofa in the living room and let two sisters sleep in the bedroom. Soon her sister found a job in a photo shop. A customer fell in love with her and asked the shop owner for her hand in marriage. The shop owner told Shahrzad that he knew the suitor to be a decent man. Shahrzad approved of the marriage, and soon that sister was gone. Shahrzad continued to stay in the living room anyway. Somehow, she thought that not having a bedroom would empower her to say "no" to men who invited themselves to her place. It would empower her to stop the gossip machine at the apartment front door.

Her preoccupation with men in media and cinema waiting for juicy gossip impelled Shahrzad to experiment with writing short stories for popular journals such as *Ferdowsi Magazine.* In one story, "Me and My Sister," she depicts two sisters who, after their father's death, decide to live together in a single room until they each fall in love and get married. They both happen to fall in love simultaneously, get married, share their grievances over their husbands' treatment, and then get divorced after a year. At the end, they are back together; one of them works as a medical assistant and the other stays home to care for their children.[65] In contrast to her poems, this little story is very realistic, more like a minor headline in the local accidents column. It does, however, resonate with other stories of failed love that were popular in some of the mediocre journals of the time.

During her interview with Nurizadeh, published in *Ferdowsi Magazine,* and before she wrote the above short story, she also wrote a poem to make sure that she was taken seriously as a literary author. The poem sheds further light on the relation between her literary creativity, her cinematic career, and the reality of her life:[66]

> I do not believe
> If I did not see the morning and
> my mother saying her prayers,

If I did not see the patience of my lips,
and my ancestors whose skin was cherry.
I would have believed your departure.
I have seen the migration of the pigeons in winter.
And in spring, there were no pigeons.
. . .
I have heard the messages of the amorous trees
under the snow.
But in the summer, the trees were not green.
If I had not seen the sugar reed
become bitter in the past,
I would have believed your departure.
I swear to the thousands of migrating pigeons
to first word
that I do not believe your departure.
I swear that my body is the beginning of the blossoming season
that I have heard your message under the snow in the winter.
. . .
I am sitting in a season
that is the beginning and the end of all seasons.
In this season, the pigeons do not migrate.
In this season, leaving is the beginning of staying.
I will never believe your departure.

While she mixes her childhood memories with her more recent recollection of her professional work, she constructs the poem around a few different sets of symbols that are religious (prayers, god's first word, etc.), corporeal (lips, skin, etc.), and natural (summer, blossom, etc.). There is a simultaneous sense of harmony and tension among these sets of symbols, a sort of dichotomy that she tells us existed in her real life.

"Me . . . Want . . . Candy"

In 1991, in a very rare move, a short story by Shahrzad was translated into English under a different title of "Me. . . . Want. . . . Candy"[67] and published in an English anthology of translated works by women from Iran. The editorial preface

states that the stories included are written or published after the revolution; however, at the time the book was compiled, Iran had not yet witnessed the profusion of women's writing, and most of the works included are actually from the prerevolutionary period. Shahrzad wrote her piece before the revolution and published it after the revolution in the leftist-oriented *Ketab-e Jomeh* (Friday's book), edited by Ahmad Shamlu in those early open days before the major crackdowns on the oppositional groups began. Publication of her work in such a journal, alongside authors such as Gabriel García Márquez and Maxim Gorky, was a rare occasion. The story is about a young girl named Shadi who loves to rent and read children's magazines. The story is very picturesque, as when depicting the young girl walking home while reading and bumping into other people. One day when she brings her magazine home, she gets caught in a crowd that has gathered to witness her mother giving birth to new child. At the same time, she notices that another sibling in the house is dying of a children's disease. Shadi grows increasingly dizzy amid the sea of people, young and old, who surround her mother while screaming all sorts of religious names and prayers. A blow on her head from an onlooker causes her tongue to bleed. Somehow, everyone begins to blame her, calling her a bitch, brute, whelp, filthy, and shameless. The blow on the head of Shadi is an incident that had appeared in *Tuba* as well. It seems that in depicting the events in this short story, the author is also recalling a real event. The story certainly evokes her own life experience in which she received a similar blow to her head, causing permanent damage.[68]

While the publication of the translation of this story should have been good news, Shahrzad seems upset about it in her letters. The reason for her unhappiness is that the story's introduction portrays Shahrzad as a deceased former prostitute who depicted her life story in her book *Tuba*. She was also unhappy with the translation of the title of the story, which I find very creative.

Since the publication of her interview in *Ferdowsi Magazine,* many had called her crazy and other names, and the publication of the translation of this short story, when she became aware of it after her return to somewhat normal life in Tehran, brought all those memories back. Does this confirm what Gilbert and Gubar call the "madwoman in the attic," a "madwoman who dares to rebel against authority?"[69] Not only was she maddened and troubled by the accusations of sexual promiscuity, but also by accusations of plagiarism. On the eve of Shahrzad's trip to Italy (perhaps her second trip), a reporter asked her if she was going

to publish any new collection of poetry. Shahrzad replied, "I have some poems that are not published yet because I have been writing my memoir [which has not been published since] and perhaps I will publish them in Italian first and then in Persian."[70] The interviewer goes on to ask, "It has been said that your poems all belong to Mas'ud Kimiyai, and that he is the one who has written them, that you take them and publish under your own name."[71] Shahrzad smiles bitterly and says, "If Mas'ud Kimiyai were a poet, he would certainly have a great reputation as a poet. I have heard things like that before, a lot of it." Then she goes on to say, "He taught me many things, how to think, how to write poetry, and how to live. He discovered my poetic talent. I owe him everything I have. Therefore, I don't mind people saying these things." Then, instead of asking pertinent questions about her poetry, the interviewer asked, "How long have you known him? Did you know he was married?"

And while Shahrzad's eyes fill with tears, as explained in the interview, she says, "I did not care about anything but him; we both wanted each other."[72]

These statements of course bring to mind Farrokhzad's situation with Ebrahim Golestan. There were points in her life when Farrokhzad so lacked confidence that she did not want to be acknowledged as a poet, though the role of some men, and in particular, Ebrahim Golestan, in her poetic development has been exaggerated grossly. I seriously doubt the common belief that the poet's acquaintance with Golestan was the only or even a major reason behind the shift in her social and stylistic representations. But Farrokhzad does connect her fate to the fate of those whom she dates, literally or poetically, feeling good about them or feeling guilty. In her culture, obviously, engaging in sexual acts and talking about them are both inevitably associated and ridden with guilt. The "I" in Farrokhzad poetry is filled with guilt.[73]

Therefore, Shahrzad's display of the issues related to sexuality in her works and her literary preoccupation with the issues of modernity are not accidental. As she states in her letters and depicts in her stories, she has learned many things by experience and has faced many dramatic situations in life. Once, she went to a friend's house where she got to know a woman who taught her more about sexuality and women's bodies. In her letters, she states that she believed many children were sexually abused in her days, and that impression is certainly reflected in *Tuba*. Some young girls looked sexy, or sexually appealing. "I did not feel sexy despite how I looked. Indeed, I think I was cold. Many tried to create a sexual

object out of me."[74] And she goes on to talk about the bitter experiences related to her first brief arranged marriage. "In some villages, they taught the girls to kick the man in the chest and out of bed as soon as she sees the blood resulting from the loss of virginity, and that is what I did."[75] I am unaware of such traditions in any of the villages then or now, but Shahrzad writes, "At least in Tehran, the capital, things should have been different. But it was not. They checked me several times from 1959 to 1962 to make sure I was a virgin."[76] This divided her family with false certainty, she says, because she believes that in some of those examinations, she was molested. This type of molestation she refers to even has a name, "las khoshkeh," meaning dry touching/flirtation. Even in the few dream-like days of her short-lived marriage, she encountered many little incidents of sexual pressure and intimidation, including an encounter with a man who played with his pigeons on the roof of the neighboring house and who also expressed an interest in her.

Shahrzad and Literary Modernity

Based on all these elaborations, I have come to think that Iranian society never achieved Western or any creative form of modernity, so no Iranian poets—especially not even Nima Yushij, whose inventions gained him the title of "the father of new verse"—can be said to have achieved poetic modernity in the Western sense. Literary modernity could not possibly exist in a society that lacks a progressive discourse on sexuality, on individualism, and on modernity itself. However, concerning Western literary modernity, Daniel Juan Gil writes, "In some ways, the early modern category . . . resembles the modern notion of private intimacy which is also a sexualized experience of others that stands apart from society and yet is recognized by it." Gil further states, "During the early modern period . . . literary texts open sexuality in order to convert social trauma into pleasure by converting the impossibility of establishing a functionally social tie into the felt reality of a sexual tie."[77]

Modern Persian literature as it took shape in Iran did not, in general, include a discourse on sexuality. Of these, Jamalzadeh's *Masumeh Shirazi* (Masumeh of Shiraz); A. M. Afghani's *Shohar-e Ahu Khanom* (Ms. Ahu's husband), *Bafteh-haye Ranj* (Woven of pain), and *Shadkaman* (Prosperous); and Mahmud Dolatabadi's *Kalidar* are most notable. They approached the topic with a severely reserved, censored, and withdrawn language and often strictly from a male point of view

in the context of the male-dominated revolutionary literature of the period. A few even portrayed pederasty in their verses, a continuation of backward classical themes.[78] The early and mid–twentieth century novels such as *Tehran-e Makhuf* (The dreadful Tehran, 1923), *Tafrihat-e Shab* (The night's leisure, 1932), or *Ba Man Be Shahr-e No Biya* (Come with me to the whorehouse, 1932), which may be referred to as prostitution or obscene literature, were equally awkward and may even be considered as a criticism or reaction to modernity.[79] A few such samizdat-type literary works have been published in recent years, however, only outside Iran.[80] What underpinned these writers' work instead was their love for the Persian language and literature, their love of the pre-Islamic era, their tendency to favor rapid modernization, and their opposition to Islam. These ideological distractions began during the constitutional movement (1906–11) and predominated when the modernization program of the government of Reza Shah (1925–41) provided an additional impetus for the de-Islamization of literature. In addition to these issues, some authors like Nima were also extremely preoccupied with self-portrayal.[81]

Shahrzad did not belong to any of the dominant literary discourses in pre- or postrevolutionary Iran. She was never affiliated with any political or ideological tendencies. These facts have naturally influenced her voice. Further, she believes that poetry came somewhat naturally to her, conveying a bohemian notion of "art for art's sake." She writes:

> I started writing poetry at an early age, as early as when I learned the meaning of words. Poetry has to come to the poet, it has to occur, and it did occur to me. Sometimes, half asleep, I worked with words, I walked with them, I washed them, and I wrote poems. When I wrote them, I cried and sometimes laughed.[82]

There is no mention of social or ideological motivation, as was customary in the 1970s. She wrote, perhaps spontaneously, about a whole range of issues she faced in her private as well as cinematic life. She used a highly metaphorical language, a new one, unknown to Iranian readers. Her poems, despite their narrative flaws, offer scattered and confused images that together accumulate into an almost supernatural universe of meaning.

In the prerevolutionary period, poets often used a particular discourse containing a set of common metaphors to denounce the ills of society. The dominant mode of poetry during this period was hardly an outlet for emotional expression

or a means of expressing the self. Truly, the young readers did not perceive Shamlu's love poetry as a personal expression of love for his wife Aida. At best, the portrayed Aida represented that ideal human being the new generation of intellectuals wished to be. They strived to resemble the subject of Shamlu's love poetry. In fact, if a poet wrote about entirely personal issues, he or she would not be considered a committed literature author. We should also remember that early personal poems of Forugh Farrokhzad were soon eclipsed by her more "serious" poems, and this is what led to her acceptance into the dominant literary discourse of the late sixties and seventies.[83] Other women literary activists with more decisive direction were accepted from the outset. Simin Daneshavar (b. 1921), Simin Behbahani (b. 1927), and Tahereh Saffarzadeh (b. 1936) had gained fame for such critical prose and poetry. And their works contributed to social changes in the 1970s in Iran. As was true in the classical period, more female names could be found if you searched through the pages of journals. However, in both periods, only a few women could enter this rather male-dominated field of literary activity. The reason that some younger female poets did not succeed was because of their love poetry, in which they expressed their feelings and sentiments. These poets include Afsar Nikravi, Batul Azipur, Delara Qahreman, Fakhri Tushanlu, Fariba Momeni, Forugh Jafari, Goli Khalatbari, Homa Arjangi, Kafiyeh Jaliliyan, Layla Kasra, Mahnaz Azarnia, Mahvash Mosaed, Malekeh Sani'i, Manijeh Mostafidi, Manijeh Nazari, Mansureh Hoseini, Mayam Hakimi, Mehrangiz Maleki, Mehrangiz Salahshur, Mehrnush Sahriatpanahi, Nasrin Masumi, Parvaneh Maiman, Parvaneh Milani, Parvin Sedaqat, Ruya Masudi, Shahin Qavami, Shahindokht Yasrebi, Simin Ehsasi, Zahra Ranjbarzadeh, and Zhila Mosaed. Only the names of Mina Asadi, Shahin Hananeh, Parto Nuriala, and Shadab Vajdi stand out; perhaps because they continued to be productive in the years following the revolution.

These Iranian culture producers in the seventies also kept a good check on each other. None were to produce any works that could be favorable or indifferent to what they labeled as oppressive, bourgeois class, although nobody defined what bourgeois meant to them. In retrospect, I see that bourgeois was a "referent" that "referred" to nothing outside the language, an amorphous concept that helped to construct a vague nihilistic, leftist, quasi-Marxist-oriented ideology that in turn became a gauge for the evaluation of the culture. Many of these authors and filmmakers traveled to the United States and Europe, but there they

were often hosted by leftist fellow Iranians who had built an enormous network to fight the Shah's regime.[84]

The way in which Shahrzad crisscrossed her poetry with her cinematic life, the unusual metaphors she used, and her tendency toward surrealism made her work incongruous to the prerevolutionary cultural discourse. As a result, she was never accepted within the dominant leftist-leaning committed literature circles of her day. Her poetry was never studied or translated in any regular way, while the works of other women poets, such as Farrokhzad, have been the subject of numerous studies and translated into many languages. Even *Ferdowsi Magazine,* that rather conspicuous semi-intellectual, somewhat leftist journal, portrayed and misrepresented her as a woman who had to struggle with prostitution before being able to write,[85] when in fact the only such experience that she acknowledges in her letters is when she was abducted by a family who tried to sell her to a house of prostitution located in the Tehran's red-light zone, not too far from where her family then resided.[86] Regarding this incident, she writes that she tried to memorize all faces—the face of the driver, the gendarme, the policeman, the man outside. However, she continues to say that "the blow on my head has made everything look like a dream. Perhaps if they had succeeded in selling me to the merchants in the red zone, I would have remembered everything, and then I would have been able to write about the important things that were happening not too far from my house, the place I was told to avoid."[87]

How to Marginalize a Published Woman Writer

Shahrzad also had a hard time publishing her works. Even when helped by the prominent actor Behruz Vosuqi (with whom Shahrzad appeared in a few movies, including *Qaysar, Dash Akol,* and *Baluch*), her poetry was not printed in high numbers, was not reviewed seriously in any literary journal, and was not included in any anthology. She was simply and completely ignored as a poet. She mentions that Behruz Vosuqi gave her 5,000 tomans to help publish *Thirsty, We Age* (2,000 copies). Amir Naderi, a director, helped with the photo and the design of the cover. In her letters, volume 4, she writes:

> I first went to Mr. Tahbaz who was a publisher at the time and was publishing the journal *Jong.* He did not accept my manuscript. I inquired from another publisher about the cost of publishing a book and he said it would cost at least

three thousand tomans to print three thousand copies of the first printing. I told him that I could pay that much money myself. The next day, I met Behruz Vosuqi in the studio, and I asked him for the money and he gave it to me. And I acknowledged him in my book for his help. I continued to have difficulty publishing my other books.

Why could she not find a publisher? Why was she limited to publishing her books in small numbers financed by donations from a fellow actor? The answer lies not in the difficulty and obscurity of her poetry. Other poets with fewer works of less significance have been recognized in Iran, where poetry is part of the basic cultural fabric and the muse of intellectuals. Moreover, the occasional incomprehensibility of Shahrzad's poetry did not cause her exclusion from the dominant, highly realist literary discourse of the prerevolutionary period; it actually resulted from it.[88] Lacking interlocutors in the literary establishment, she felt less need to be comprehensible, communicative, or even to respect poetic canons. Ultimately, the explanation for why Shahrzad's literary endeavors were ignored lies in her other artistic activities—dancing and acting and her portrayal by some as a sexually loose woman. This distorted the image she desired to project, as a person interested in reading and research.[89]

When Shahrzad writes "my face portrayed tragedy" (*chehreh-am naqsh-e faje'e dasht*),[90] she speaks about all the abuses, pressures, harassments, unfulfillment, failure, and fraudulence that a confused, somewhat ill, often angry, and yet highly talented and ambitious girl had to experience in a society—or, rather, in an environment that resembled cabaret life as portrayed in the mediocre movies of her time. The slap on her face in childhood and the memories of life in the coffeehouse turn out to be the underpinning or the constructive elements of most of Shahrzad's creative works. For her, poetry seems to be the function of a dream, which in Freud's words "relieves the mind, like a safety-valve."[91] And her fate seems to be a social mistake. Aside from the similarities between the author of *Tuba* and its main character, in the grand picture, the sound of the name of Tuba, its image, its secure position as a tree in paradise, and its reference to a calming musical instrument all stand in sharp contrast with the fate of the girl.

All of Shahrzad's early mishaps pale in the face of what she endured during her imprisonment in the early 1980s. The experience is so horrific that she cannot even articulate it. She alludes to that period with vague references to incidents

or men who abused her and continued to abuse her even after her release. She insinuates that her health problems, the shock, depression, and nagging melancholy caused her to resemble a schizophrenic patient. Other women authors such as Shahrnush Parsipur have been more expressive. She has mentioned that she suffered schizophrenia and chronic depression after she was released from three years of imprisonment for writing about sexuality in her novel *Women Without Men*.[92] Parsipur received medical attention in the United States, but Shahrzad did not. Her tendency to wander off makes this even more difficult. Almost three decades after the revolution, among her convoluted, bewildered, and scattered writings, one can hear of the horror an artist has to face living in fear of persecution, poverty, and malaise. And occasionally she writes with dazzling declaration, "All these many men I met in my life consider a woman a hole, their own frontal tail a nail, and now, I am just shouting on paper."[93]

Sexuality in Literature

What would have happened if Shahrzad had a chance to learn more and to expand on her literary modernity?

What would have happened if Shahrnush Parsipur's *Women Without Men* and many other postrevolutionary novels, short stories, and poems that dealt, as artistically as possible, with the issue of virginity, sex, and sexuality had been produced earlier and had been recognized and had started intellectual discussion about women's roles?[94]

If all that had happened, would Shahrzad have had so much trouble writing about a rape experience?

Only a few works from the prerevolutionary period dealt with sex and sexuality. Forugh Farrokhzad's occasional mention of the words *breast* and *bed* were either condemned harshly or condoned intellectually. It actually provoked a great sense of guilt or sin in her own narrative. Male authors did not foster a literary environment in which women or other men could write (and read) freely about sexual experiences. The minimal existing "sex" scenes were connected to the peasant struggle in *Kalidar,* ridiculed in *Shohar-e Ahu Khanom,* and criticized in *Masumeh Shirazi.* Literature and many other forms of arts were devoid of sexuality. In fact, in prerevolutionary works, obscenity, immorality, or anti Islamic sentiments rarely appear. This, as Sprachman argues, marks a

shift from classical Persian literature. He writes: "Many important Arabic and Persian writers of the medieval period generally did not use circumlocution when referring to private parts and functions in literary works; however, contemporary theologians determined that any such references were anathematic to Islam."[95] Nezami's liberal portrayal of women's private parts is, for example, demonstrated through metaphors for male-female relationships, carnal love, and men's and women's sexual organs.[96]

Postrevolutionary authorities to this day maintain the undignified custom of subjecting arrested women to a virginity test to make sure their hymens are intact. In all likelihood, this custom would have been abolished if contemporary Persian literature (and other art forms, including cinema) had normalized virginity and sexual relations, at least in the abstract form and in certain segments of society. That explains my hesitation to equate this body of literature—in which the libido, especially the female libido, is so absent—to modern Western literature. World history is rife with sexual and gendered oppression, especially where women's bodies were the site of male contention and competition. However, in Europe, as early as the Middle Ages, we find the portrayal of the forbidden fruit of love, insatiable libido, and erotic and sexually suggestive themes (in, for example, the works of Hue de Rotelande and Gottfried; in late-medieval German literature, its verse narrative *maeren;* and in old French *fabliaux,* etc.).[97] Even if they appeared in waves and inconsistently, they still left an effect on the culture. And many of these works are in one way or another rooted in classical or late antique writings. Furthermore, a study of this body of literature may indicate that in late medieval European societies there were certain places in which men and women in mixed company discussed and even engaged in all aspects of sexuality.

In the midst of all today's political travesties, the serious discussion, the serious educational discourse that can pave the way to a meaningful modern social, political, and literary behavior, is lost. It is still mysterious to many Iranians that the traditional and religious notion of virginity is based on the experience of men with young brides. They all still expect blood at the wedding night, not knowing or not wanting to know that that the "curtain" changes with age and can very well "disappear" by the time women reach the age of marriage, which is significantly beyond the age of the ninth year, which was the approved age in medieval times. Thus we still see that a man is judged to be sexually a man if he ruptures the hymen of his bride on the wedding night, a handkerchief-proven victory. For

a woman to be perceived as a woman, she must eventually conceive. No literary work has seriously challenged these standards.

I would like to end this chapter by pondering on a passage from Parsipur's *Touba, the Meaning of the Night*. It reads:

> What could a veiled old woman do? She started walking in the courtyard. She thought she would keep the walls and demolish the interior, she would build a many-floored building to contain bathrooms with tubs, central heating and hot and cold water pipes. She would carpet the entire floor. Then after everything was done, she would demolish the old walls.[98]

The author's question above seems rhetorical. A veiled woman can only do so much. For fundamental change, the walls have to be demolished, perhaps even first of all.

6

Social Change in Iran and the
Transforming Lives of Women Artists

Can you envision a former dancer in a lawless land? Have you ever
been accused by a sexual predator?

Shahrzad

THIS CHAPTER EXAMINES the postrevolutionary status of Shahrzad and other
women artists (some even in literature, education, and other more "acceptable"
forms of social activities; a prosopography, in a sense) who began their artistic
activities in the 1960s and 1970s, rose to fame in those decades, and faced a more
or less similar dreadful fate after the revolution (many of them were born in the
1940s, including Shahrzad). Such an examination sheds additional light on the
role of popular culture, religion, and the revolutionary attitudes in the lives of
women in general and female artists in particular. In fact, these women's stories
suggest that gender segregation and the decision to enforce the veiling code after
the revolution were connected to 1970s debates about popular culture. Deep-
seated cultural and religious beliefs about women have prevented them in both
the pre- and postrevolutionary periods from achieving a modern emancipation,
without which, as I have been arguing, Iranian society cannot achieve modernity.

Lonely in Public: The Influential Careers
of Women Popular Artists

Iranian women have fought for participation in all social fields since the
Constitutional Movement of 1906–1911 to the present day. Zhaleh Bakhtiari
(1884–1947) with her poignant poetry against male domination, Sediqeh Do-
latabadi (1882–1962) with her activism in women's movements and women's
journalism, Parvin Etasami (1906–1941) with her great contribution to Persian

176

literature, Zandokht (1909–1952) with her Revolutionary Association of Women and the journal *Daughters of Iran,* which she established around the age of eighteen, Simin Behbahani (b. 1927) with her literary and social leadership over several decades, Shirin Ebadi (b. 1947) with her legal defense of women's rights, and the brave founders and organizers of nongovernmental organizations and the One Million Signatures Campaign exemplify those who have, over the past century, sought to bring about positive change in the situation of women in different periods.

In popular arts, dancers such as Jamileh and Shahrzad will be remembered as contributors to their art. Actresses like Parvaneh Masumi and Farzaneh Taidi and postrevolutionary popular actresses like Leila Hatami and Hediyeh Tehrani have already been eternalized in their movies. Singers such as Qamar, Parisa, Homayra, and Susan will always have a place in the history of Persian pop music. In the perceptive and pioneering words of Houchang Chehabi, "The emergence of female musicians, especially singers, into the public sphere in twentieth-century Iran [is] a particularly interesting chapter in Iranian women's quest for emancipation."[1] However, the life, artistic activities, and contributions of women in pop culture and performing arts are for the most part unknown or significantly less known compared to others in high culture, especially of men.

Most Iranian actresses in the early period of cinema launched their careers through theater, and many of them from theater halls of then stylish Lalehzar Street.[2] As we saw, Shahrzad experienced theater early on in her career. Shahla Riahi (b. 1926) entered the theater and cinema through her husband, who was already active in both arts. Later she became the first female film director (*Marjan,* 1956). Zhaleh Alev (b. 1927) began her work in radio. Responding to an ad in the paper with the encouragement of her literature teacher, she launched a successful career in cinema with the movie *Tufan-e Zendegi* (The storm of life, 1968). Others, such as Mahvash, Afat, and Shahrzad, began by singing or dancing in cabarets. To the social critics of that time, it made a huge difference as to how these women began their careers. For example, in 1946, the journal *Tehran Mosavar* featured short pieces on Iran Qaderi, Iran Daftari, Niktaj Saberi, and a few other first-generation actresses who played in the theater. The journal referred to them respectfully as *banu* (ladies).[3] Singers, especially those in pop and popular music such as Mahvash and Afat, in contrast (and just like Shahrzad), received derogatory titles such as *zanan-e kafeh-i* (bar women) or *fahesheh and kharab*

(prostitute and rotten) and were often the subject of disparaging gossip. Whether actresses or singers, however, all of these women struggled against a traditional and male dominated culture.

Havoc off the Stage

Deirdre Lashgari's work deals with the "the place of violence, anger, and transgression in women's response to violence."[4] She maintains that the transgression has to redefine the original rules: it is not only to violate the boundaries of the master but also involves "crossing over."[5]

As we witnessed, contextualizing Shahrzad's literary works exposes the culture that perpetually seeks to silence free expression of liberal ideas and sexuality. Her poems evoke troubling sensations in terms of both structure and meaning that can be seen (read) as a presentation of the experience of powerlessness and abuse so common among Iranian women artists. Seeing the careers and performances of popular artists against the background of these cultural complexities explains better how the degradation of these artists began before the revolution and why afterward they were forced into silence, imprisoned, hospitalized, or exiled.

All this upheaval happened in a country in which the first female orchestra was reportedly formed in the fourth millennium BC. According to *Encyclopedia Iranica*, "The oldest record of an arched harp in Persia is an engraving on a seal datable to 3400 b.c. found at Choga Mish in Khuzestan during excavations by Helen J. Cantor and Pinhas P. Delugaz in 1961–66." The picture on the cylinder, according to the discoverers and Taqi Binesh, features women artists who play music and sing. This is the same country in which, according to a poll conducted recently by the current regime (interviewing 1,190 people), about 78 percent of the respondents were interested in music in varying degrees.[6]

However, many traditionalists, ideologues, religious fanatics, and men who sheepishly and curiously watched half-naked women in the movies collectively began to frown upon, often retrospectively, any expression or act of sexuality and even individuality.[7] They supported penal codes that allowed severe punishment such as imprisonment, hanging, or stoning for any illicit sexual act. According to the newspaper *Entekhab* on May 1, 2001, a woman convicted of acting in pornographic films was stoned to death after eight years imprisonment. To stone a woman, they bury her in a pit up to her armpits and then pelt her with stones until she dies. She denied that she was the woman in the film, but several witnesses

showed up to testify that she was indeed the actress on the screen. The actress was thirty-five at the time of her death.

Suddenly, women artists had to stay quiet and out of public sight; they understood exactly why the Rex Cinema in Abadan went down in flames with hundreds of the audience trapped inside in August 1978 and why many more theaters were damaged violently during those heated revolutionary days.[8] To be sure, consequences of the continued policies of the fundamentalists now in power are nowhere more apparent than in the fate of the women who were once featured in those theaters. Their stories demonstrate the havoc wrought in their lives during these critical years and how deep-seated ideas about gender differences and gender hierarchy prevented any serious discourse of sexuality.

They Sing, They Act, They Dance: A Musical Melee

Generally, Iranian women artists' stories are either untold or told ambiguously. And generally, it is not easy to reconstruct them. Even given the existing information available on Shahrzad's life through her letters, her journalistic writings, and her cinematic and poetic works we are still left with many questions about her experiences in those days when she frequented cinematic communities, theaters, and cabarets, her state of being in prison, her treatment in hospitals, and so on. Nevertheless, the information we do have allows us to conclude that her real character was very different from that portrayed by male journalists, postrevolutionary authorities, and the *Kayhan* propagandists. Indeed, these men presented her character and personality as fictional, eerie, or perverted, modeled on some of her roles in FilmFarsi. In reality and as soon as she had the chance to express herself in her letters, she wrote:

> I know that I have always wanted to be myself; I hate pretending to be something I am not. The only exception to this quality is when I was on the theater stages or in front of the movie cameras. I love life, even with all its miseries and misfortunes. I detest sins, committing sins, even small sins, but I have committed numerous sins any way, and that is why I constantly seek redemption. In my sins, however, I have always been a victim as well. I have enjoyed the opportunities to gain benefits but I have not been jealous, vindictive, and cruel."[9]

The phrase "In my sins, however, I have always been a victim" also seems a bit ambiguous. It sounds like an excuse in response to an inquiry performed during

the Roman Catholic Inquisition. Shahrzad's letters portray, very creatively, some of her missed opportunities, victimizations, cultural instability, and the enormity with which people always misunderstood her. They show a profound bitterness for not receiving help and encouragement from anyone and for being scolded by everyone instead.

Yet, despite all this, she did not lose her poetic sensibility when she tried to introduce herself and her social and artistic orientations. She writes:

> I have had many lovers: Sohrab Sepehri in poetry; myself in women's poetry; Plato and Socrates in ancient writing; all prophets in all religions; Ferdowsi, Hafez, Rumi in classical Persian poetry; Homer in non-Persian classical poetry; the Arab poet Al-Bayati; Juan Ramón Jiménez in Spanish poetry; Alain Delon in French cinema; Orson Welles, Marlon Brando, Robert Redford, Gregory Peck, and Vivien Leigh in American cinema. I have been truly in love with Vivien Leigh. In music, I am in love with Beethoven and Carl Orff. In modern music, I love pop music, blues, and Pink Floyd. In politics, I adore George Washington, Abraham Lincoln, and J. F. Kennedy. In the area of social research, Karl Marx and Engels are my lovers.[10]

When one listens to Shahrzad and reads her works closely, one realizes that she is a well-read, cultured, and contemporary woman who, though homeless and living in poverty, has not allowed herself to become disassociated from the world of art and knowledge. If for nothing else, the juxtaposition of the American presidents and the founders of Marxism in the above passage is truly telling, demonstrative of her active and open mind, refuting the attempts at portraying her as the mad woman.

Shahrzad's Sisters

In some ways, Shahrzad's story is not new. Crossing the line between fiction and reality, one comes across many cases in which women in Iran who pursue a public space take significant risks. The tenth-century *Book of Kings* by Ferdowsi contains many such stories of women. Azadeh (or Fetneh in Nezami Ganjavi's version), one of King Bahram's female slaves, is a beautiful harpist who accompanies the king on a hunting trip. She challenges the king to kill two gazelles with one shot. A good hunter, he accomplishes this. However, instead of praising the king's skill, she dismisses the significance of the act. Bahram then kills her

brutally under his camel's hooves. The killing in the *Book of Kings* is portrayed to be justified because she challenged the king's authority. The story concludes that he should never have taken a slave girl on a hunting trip.[11] Jami's *Salaman and Absal,* and *Yusof and Zulaykha* portray women as "deficient," "ingrates," "bare of . . . fidelity," and full of "craftiness" and "treachery." As a result, women are constantly tormented in his narrative. This attitude is pervasive throughout his poetry. In *Salaman and Absal,* Absal represents ardent sexual desire and bestial, carnal love, while the king represents reason, and Salaman the immortal soul. But Jami is only one example.

Two points should be mentioned here. First, Jami is not the only poet in the classical period to hold a negative view of women. The allegorical use of women as symbols of unreliability was pervasive not only in Iranian medieval literature but also in many other parts of the world. Second, Jami's understanding of Islam and Sufism is not necessarily representative of the official view of these discourses.[12]

In real life, just a century before our contemporary Shahrzad, Tahereh Qorratol 'Ayn, another female poet, was, according to some accounts, murdered in 1852 for her social and spiritual activities.[13] At thirty-six, she was killed for what were considered heretical views and for the promotion of the Babi faith. Born as Fatimeh Baraghani to a renowned religious family, she received an education similar to the family's sons. She learned writing and reading and studied religion thoroughly. Tahereh further excelled in her knowledge by attending classes with men.[14] She surpassed many of them.[15] After accusations of heresy were leveled against her, Tahereh was arrested and held captive in a house before being strangled and thrown into a nearby well.

Over a century later, all women in Iran faced dramatic—and dangerous—futures in the wake of the 1979 Revolution. Not only were most artistic activities outlawed; other professions such as fashion design and hairdressing were also denounced. Right after the 1979 Revolution, the new regime considered female singers as temptresses and ordered them to be silent. Records, cassettes, movies, and posters featuring female artists were confiscated by religious revolutionary militants and destroyed. All clubs, cabarets, and bars were also closed down. Even Googoosh (Gugush), who had promised to sing her "My Dear Lovable Sir," a popular anthem during the revolutionary movement in honor of the revolutionary leader, was not an exception. The ayatollah said that he did not want to hear her.[16]

The life stories of these women indicate the significance of their cultural influence, a cultural change that took a radical turn with the revolution. Their suppression by the postrevolutionary system is tantamount to a diversion from the idea of modernity itself.

Contemporary Women Artists

I briefly present some of these stories in an order that is chronological as well as thematic (i.e., singers, dancers, cinema stars) and to some extent from best known to least known. Elsewhere, I have written on the works of some of the literary figures; however, each one of them has a robust story to be told. Yet information about their lives is often scarce and in many cases, it is not clear if they are still alive.[17] The lives of women in popular arts particularly have yet to be documented.[18]

However, a few scattered works in Persian and other languages do tell us of the lives of women in popular arts. Chehabi briefly discusses three prominent emancipated singers—Qamar, Mahvash, and Googoosh—and provides valuable biographical information about other singers as well. Some Web sites on Iranian cinema include information about many Iranian artists. A book has been published about Googoosh in Tajikistan. Several cinematic encyclopedias have appeared even inside Iran that list older artists. However, all these publications offer limited information about women in show business, and none of them cover stars of early theater such as Niktaj Sabri, Badri Hudfar, Iran Qaderi, Mahin Dayhimi, Iran Daftari, Parkhideh, and Maryam. A very pertinent work published in 2001 was immediately banned, and its copies were destroyed right after its publication: Maleki's *Zanan-e Musiqi-e Iran*.[19] One of the reasons, according to Qom Seminary School's Research Center, for banning the book was its claim that the Prophet of Islam also enjoyed music. However, the book still suffers from the limitation imposed by the censor regulations. The information about a number of prominent artists is too trivial, and some artists are not even mentioned by the name with which they were best known.

Ruhangiz (Sediqeh Saminejad, 1916–1997)

Ruhangiz is none other than the actress who played in *The Lori Girl* (1932)—the first Iranian talkie that was shot in India.[20] According to some historiographers, Sediqeh Saminejad received the role because her husband worked in India's Imperial

Film Company and was an acquaintance of A. H. Sepanta, who directed the film. Her role paved the way for other Muslim actresses, a profession that heretofore had been more common among Iran's religious minorities.[21] Parviz Ejlali, however, reports that Sediqeh Saminejad paid a high price for her pioneering role in show business. In a conversation in 1971, nearly four decades later, she admits that playing in *The Lori Girl* turned out to be a nightmare for her. She broke into tears and said that fanatics, especially those from her home town of Kerman, harassed her tremendously. Similarly, in a documentary film on *The History of Iranian Cinema: From the Constitutional Period to the Time of Sepanta* made in 1970 by Mohammad Tahaminejad, she cried when she explained her tormented experiences.[22] They had assaulted and insulted her repeatedly in India. Her family had not been supportive either. She later divorced her third husband and found a minor job in the small town of Jiroft. She ultimately died lonely and in poverty in Tehran in 1997.[23]

Parvin Ghafari (b. 1920s)

Parvin Ghafari is one the few artists who have written about their experiences. She published her memoir entitled *Ta Siahi* (Until the darkness) in 1997 in Iran.[24] Here, "darkness" has the same meaning as was used to refer to Shahrzad's past, though Ghafari's book is about how she arrived in the darkness of sexual promiscuity. In one sense, her book reads like a novel about a defeated risqué love affair between the blond protagonist and author and the adventurous young king during his divorce from his first wife, the Egyptian Fuzieh. When she realizes that she has no chance of becoming the country's queen, she begins a life of promiscuity and nightly parties, apparently a socialite with a resolve to revenge the king over his rejection of her love. She began her acting career with *Faryad-e Nime Shab* (Midnight shout, 1960) and later played the role of her own character in more than a dozen movies. In *Mu Talai-e Shahr-e Ma* (Our town's blond, 1965), to mention just one example, she played the role of a woman whose predicament was based on her life story. The story was serialized in the pop magazine *Tehran Mosavar* under the same title, a name by which she was known in the more influential circles of Tehran (as opposed to Susan or Mahvash, who were known as artists of the streets).[25] She refers to her cinematic works, in some of which she also sang her own songs, as a "sad story."[26]

In another sense, Ghafari's book is similar to others that have been published by prerevolutionary figures to expose the corruption of the Pahlavi court.

She portrays a negative image of many of the personalities of Persian literature and Iranian cinema, with the Pahlavi family being portrayed as particularly sexually devious and perverted.[27] Even the old Queen Mother is said to be a lesbian. The publisher's introduction to the text mentions that many of the accounts narrated in the book might very well not be historically accurate.[28] Ashraf Pahlavi, Mohammad Reza's twin sister, is particularly portrayed as a source of many wrongdoings. Indeed, many such works border on mendacity when it comes to the description of the Pahlavis. No matter how accurate these stories are, they all surely conveyed a clear picture: that royal modernity, Westernized associates, and attempts to relax traditional customs regarding sexuality led to what the Shah's opponents perceived as a corrupt perverted society. The fervor with which the current authorities allow the publication of such books that draw upon the constructed images of prerevolutionary promiscuity is astounding and telling of the problematics of sexuality.

Delkash (Esmat Baqerpur, 1925–2004)

Delkash, singer and actress, traveled to Europe twenty years after the revolution to try to sing again; however, she mostly represents the fate of those singers who stayed out of the public's eye for the greater part of the postrevolutionary period. Only in the 1990s and during the reform period did she produce an audio tape on which she chronicled her life.[29] She explains that she began her singing career singing classical or traditional songs under the nickname Nilufar. But soon, because that form had lost its prestige, she tried to be creative and innovative. She was fortunate to enter the profession just when the first famous female singer (Qamar Moluk Vaziri, 1905–59) was retiring.[30] She worked with several prominent composers and soon became a leading singer whose voice was frequently broadcast on national radio. Her songs sometimes blared outside some of the summer movie theaters in small towns where movie theaters were able to function. In particular, "A Renewed Spring Arrived" (*Baz amad nobahar*) was a perfect song to hear while waiting for a movie to start. It has been assumed that she in fact composed that song herself.

She also played in several movies, including *Sharmsar* (Ashamed, 1950), *Madar* (Mother, 1951), and *Dasiseh* (Intrigue, 1954). The former depicts a village woman who is brought to the city to sing and dance in a cabaret, echoing her own life story and playing with the dichotomy of modern city life and indigenous

rural simplicity. In most such movies, the woman would return to her "previous, simple, decent" life, leaving behind her colleagues who dressed in Western styles and followed a promiscuous life. In all of her movies, she sang her own songs, which at least for the first decade of her career guaranteed the success of her movies. During the last years of her life, she took a trip to Europe where she was interviewed by BBC Persian and where she performed for a small group of loyal fans.[31] Very few noticed her death.

Marzieh (Ashraf os-Sadat Morteza'i, b. 1926)

Marzieh was one of Iran's most prolific singers. She stayed in Iran for a long time after the revolution but made no appearances, arousing the curiosity of millions of her fans about her whereabouts and state of being. Then, in a surprising move in the late 1990s, while in her seventies, she joined the exiled oppositional group Mojahedin Organization outside Iran to sing again, occasionally in praise of the organization's leaders. She was of course labeled a traitor for joining an armed organization that was seen by many as the enemy's collaborator during Iraq's invasion of Iran; however, to many others she was brave for joining an opposition group and letting her fans enjoy her art again.

Elahe (Bahahr Gholamhosayni, 1934–2007)

Elahe, another equally acclaimed singer, was approached by the same oppositional group as Marzieh for cooperation but she refused to join. Elahe produced a few albums while outside Iran and reportedly sang in her establishment in Europe. Both Marzieh and Elahe belong to the group of singers who contributed to the highly admired radio programs referred to as *Golha-ye Rangarang* (colorful flowers) and *Golha-ye Javidan* (eternal flowers).[32]

Iran Sadeqi (b. 1946)

Iran Sadeqi was well known by her stage name, Jamileh. She danced in cabarets, danced and played in the movies, and was known as a great entertainer and promoter of Persian dance, which a few decades before her time had been considered inferior to Western dance. She was master of *raqse arabi* (belly dance), *raqse jaheli* (in which the dancer imitates a roughneck man in the beginning), *raqsi qasemabadi* (a style of the Caspian Sea area), *raqse bandari* (a style of the Persian Gulf area), and some of the classical Persian dances such as the miniature dance.

She took up her acting career in the 1960s, and she played and danced in more than twenty-five movies while continuing her cabaret dancing career. She played fairly prominent roles and sometimes even leading roles in FilmFarsi, but she is not known to have written poetry. After fleeing Iran, she ended up in Los Angeles where, for more than two decades and until well into her fifties, she danced in an establishment called Cabaret Tehran for a modest income.

Iren (Iren Zazians, b. 1927)

Iren, the Armenian actress about whom we read briefly in previous chapters, began her career in theater in 1949, in cinema in 1957, and in television in 1975. She played major roles in more than twenty movies. After the revolution, she remained in Iran as well. Ferdowsi theater, where she first started her work, featured Western plays very much like other such establishments during that time, and one of Iren's first roles was in one of Oscar Wilde's plays.[33] She entered the world of cinema, at a time when Iranian movies struggled to compete with Italian and other Western movies, for which reason directors wanted Iranian actresses to reveal as much as possible. Perhaps as a non-Muslim woman it was easier for Iren to adjust, but after the revolution, she too was forced to stay home and denied permission to work.

Foruzan (Parvin Khayrbakhsh, b. 1936)

A pioneer of acting and dancing in sexy roles in FilmFarsi, Foruzan began her acting career in 1962 with the movie *Sahel-e Entezar* (A shore for waiting). She played in dozens of movies until 1978. She too remained in Iran after the revolution and was as frustrated as all the other women artists whose careers are summarized here. On the surface, she seems to be the master of sexual suggestiveness through the use of her eyes; however, in real life, she was suffering at the hands of the producers. Due to her bold sexy roles, Foruzan was the subject of gossip and the center of controversies in the 1970s, but her disenchantment with the art of cinema actually began prior to the revolution. Though she continued her acting to the end of the seventies, she was contemplating retirement at the height of her career in 1972. In an interview in that year she said in a tired voice:

> I am bored and annoyed by cinema. It has been eleven years since I began acting
> in front of the camera and the ugly light of projectors. You think I just go there

and shake it but you do not know that every one of those shakes ruins my life. I am sick, sore, and exhausted. I am tired of standing in front of the camera listening to the director telling me "be a little sexier, a little more lustful, bring your skirt higher, be a little more inciting and provocative." I also want to tell you that every time I go to Europe to take a rest, people create a thousand rumors.[34]

Apparently, she remained in Iran after the revolution and never had the chance to travel again. And since then, she has never appeared in public or given an interview.

Googoosh (Faeqeh Atashin, b. 1951)

Undisputedly the most endearing popular artist of the 1970s, Googoosh was very productive in music and film. At age six, she was a star on radio programs, and at eight, she appeared in her first movie. According to Jon Pareles, "Her songs were romantic, not political, and while they drew on Western styles, they held onto both the fervor of Persian love poetry and the sliding, quivering, impassioned phrasing of traditional Persian music."[35] In her twenties, she began to participate in international music festivals and received the first prize for her French songs at the Cannes Festival in 1971; she also earned high recognition for her Italian and Spanish presentations for the Sanremo Music Festival in 1973.[36] A generation of Iranians literally watched her grow up, because her career began when she was still a child.

Like many other women artists, Googoosh endured many bitter experiences at the hands of people who surrounded her in her childhood, such as her stepmother, her husband, her manager, and the owners of Tehran's cabarets, before she achieved success. Her first husband was Mahmud Qorbani, the father of her only son, Kambiz. Later, she married Behruz Vosuqi, Homayun Mesdaqi, and finally Mas'ud Kimiyai.[37]

Religious and political edicts of 1979–80 drew Googoosh into two decades of utter silence, broken only by some sporadic concerts in her mid-fifties. The postrevolutionary authorities deprived her of any public activity, banned her from singing, and subjected her to interrogation and arrest after she returned from the United States, where she had been when the revolution occurred. In the intervening two decades, she was forced to sell her clothes and other belongings to support herself. She was not allowed to leave the country again until the reformist government of Mohammad Khatami issued her an exit permit in the late 1990s.

After managing to get out of the country with Mas'ud Kimiyai (her last husband) and organizing a few concerts outside Iran, she recaptured the hearts of millions of her fans. She continues to live abroad.

There are several interviews published on the Internet in which Googoosh talks about her experiences in Iran and the United States. I am not sure, however, about the accuracy of the related commentaries. Later in the chapter (note 71), I refer to a book by a Tajik author that seems to be better documented.

Leila Forouhar (b. 1958)

Leila Forouhar stayed in Iran for a while after the revolution before moving to California. The daughter of a well-known actor, she had started her cinematic career at the age of five and had later become a famous singer who followed a style of singing similar to that of Googoosh. She belonged to a generation of pop singers who crowded the music scene in the last years of the Shah's regime, along with such singers as Nushafarin, Ramesh, and Marjan and such male singers as Daryush, Satar, and Shabpareh, representing a brand of commercial, folk, and pop music that was harshly criticized by the older, more educated generation of musicians. The product of this genre of music was mostly consumed by the youth, upper middle class members, and the cabarets, dance clubs, and bars in northern Tehran as well as affluent sectors of the big cities. Then, suddenly there was nothing for Forouhar to do outside her home. She was even denied a license for a beauty salon by the revolutionary government.[38] After settling in North America among the expatriates there, she became active in music and acting again, mostly on Los Angeles based Persian radio and television networks and concerts.

Simin Ghanem, Shahla Riahi, Puri Banai, and Batul Fakhri

These women were also known and productive in the 1970s. However, like many other pioneering women female singers, they became suddenly silent after the revolution. When they survived this harshness, they largely became housewives. The talented and creative singer Simin Ghanem purchased a garden in Karaj and spent her days gardening.[39] Shahla Riahi, who acted in more than one hundred films and plays and was the first woman director in Iran with her movie *Marjan* (1956), is now very old, complains about being lonely, and wishes that there were a system that could recognize women artists' contributions through some sort of compensation. In the 1970s, Puri Banai was a

successful star, appearing in about sixty movies along with the greatest actors of her time, such as Behruz Vosuqi. According to some reports, she lives in a rented house in complete solitude; according to others, she is ailing in her loneliness. Batul Fakhri, known as Betty, states that she was imprisoned, psychologically tortured, and interrogated constantly for many years after she returned from a professional sojourn in Israel.[40] She could only manage to get out of the country for good nearly three decades after the revolution. Even before visiting Israel, like many other women artists, she had been summoned to the revolutionary court to answer many questions posed by the revolutionary clerical judges. If their "crimes" were not that great, these women could sign a document that they would never perform, and then they were allowed to stay home.[41]

Susan (Golandam Taherkhani, 1940–2004)

Susan was a singer who began her life in poverty, experienced popularity, and died in poverty. She belonged to the older generation of women artists.[42] Susan's career peaked in the 1970s when she sang and played in movies and on the nightclub stages of the capital city, though mostly for the fans in the southern parts of Tehran and working classes in other cities. She rarely used her real name, Golandam Taherkhani, in her professional life. She went instead by a number of nicknames, of which Susan was the most enduring. Writings about her life and work are scarce, but anecdotal pieces and memories of people's encounters with her indicate that Golandam was born in Tehran and attended school for only six years. At a young age, she began singing in buses around Shahr-e Ray near Tehran, in order to help her single mother. When her mother died of cholera, she moved in with a neighboring woman, whom she affectionately called "Auntie." Later, another neighbor woman took the then twelve-year-old Golandam to a cabaret and found her a job as a meagerly paid singer.[43] That job, however, caused the end of the relationship between Golandam and her "Auntie," who did not approve of that line of work.[44]

The police eventually placed Golandam into a foster home, where she gained additional chances to sing the famous songs of her day. Under the nickname of Victor[ia], she found yet another singing job in a different nightclub, where she came into contact with Rashid Moradi, a famous song-writer. He took her to a more prestigious nightclub and gave her the name Susan. However, because of her small eyes and because she squinted when singing, she was also known,

rather unreasonably, as Susan Kuri (blind Susan). Finally, through her acquaintance with Jamileh, a prominent dancer and actress, Susan found her way to Shekufeh No, which at the time was the most prestigious nightclub in Tehran. This move improved her career. Along with Aghasi, Susan became known as the most prominent of popular "street and alley singers" (*Khanandegan-e Kuche va Baszar*), presumably admired more by the lower middle and working classes. Her music was simple and infused with popular lyrics. Some of the lines she sang became very famous. A popular segment proclaimed, "There are three things that cause scandals in the matter of love: the dogs, the neighbors, and the moon. I will feed the dogs, I will bribe the neighbors, oh God do something for the moon not to shine." In another song, she sang, "Drink wine, burn the pulpit, but do not harass people."[45] Susan was featured on radio in 1969 and then on television shows, especially on occasions of national celebrations.

There was, however, a delay for some artists in being recognized by the official media, which could have been related to the quality of their work, despite their popularity as traditional, folk, and street singers. Another reason might be related to the fact that these neighborhood singers often used Arabic melodies in their song and that element was not appreciated by the state, which controlled the radio and television. Indeed, in the 1970s, very few Arabic artistic productions could be presented in Iran. Conversely, the reason for featuring them on radio and television could have been their popularity among the ordinary people, whom the government did not want to antagonize.

Susan played and sang in numerous movies, including *Donya-ye Por Omid* (A world filled with hope, by Ahmad Shirzad, 1969); *Panjareh* (The window, by Jalal Moqqadm, 1970); *Faryad* (Shout, by Nostratallah Karimi, 1971, playing a major role); *Hasan Kachal* (The bald Hasan, by Ali Hatami, 1970); *Ali Bi Gham* (Carefree Ali, by Abbas Kasai, 1970); *Miveh-e Gonah* (The fruit of sin, by Mahmud Kushan, 1970); *Sogoli* (Favorite wife, by Faridun Zhurak, 1970); *Morid Haq* (Pious man, by Nezam Fafi, 1970); and *Mardan-e Khashen* (Rough men, by Saber Rahbar, 1971). Mas'ud Kimiyai's *Qaysar* (1969), for which Esfandiar Monferedzadeh wrote popular music, included a song by Susan. Shahrzad lip-synched Susan's song. Among the recognition Susan received was a tribute by the famous poet Mansur Owji, who named one of his books after her. *In Susan ast Keh Mikhanad* (This is Susan who sings) is a collection of poems from five different books written between 1964 and 1970. It contains a poem of the same title;

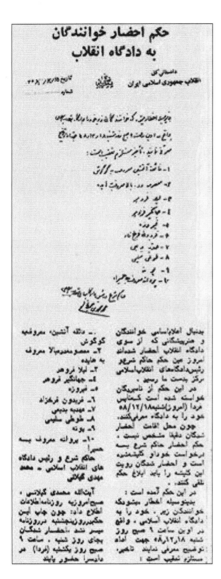

7. This summons published in *Ittelea'at* and other newspapers about a month after the revolution states that the singers mentioned on the list must report to the revolutionary court by 9 a.m. on March 8, 1980. It also states that failure to attend the court on time will result in their prosecution. It is signed by Ayatollah Gilani, the religious prosecutor of the revolutionary court. The list includes Haydeh, Homeira, Googoosh, Leila Forouhar, Ahdieh, and others.

however, the lines of the poem contains no direct reference to the singer. Part of the poem reads, "This is Susan who sings / shouting the nights of agitation, in the valleys of snow, and under thousands of hanging daggers."[46] Perhaps the singer's lower working-class background was an inspiration for the work.

After the 1979 Revolution and a short period of imprisonment (apparently for illegal singing), Susan left Iran, eventually settling in California. Some Persian

satellite television stations in Los Angeles featured her material and conducted interviews with her. According to their reports, Susan suffered a broken bone several months before her death in 2004 at the age of sixty-four. According to interviewers, she did not have enough money to pay for the medical expenses. Thus, despite some periods of significant success, she died in poverty.[47]

Women Active in Politics and Literature

Women who belonged to show business or were active in popular culture were not alone in being tormented or exiled. Literary and social women's activities and all acts associated with the Shah's government were scrutinized by the new regime. Many were summoned to revolutionary courts in groups. Even women active in the more acceptable pursuits of public life were pressured to step down.

Farrokhru Parsa (1922–1980)

Under the Pahlavis, Farrokhru Parsa became a member of the Iranian Parliament in 1963. She advocated legislation to amend women's and family laws. In 1968 she became the first Iranian woman minister. Immediately after the revolution, she was sent to the religious, revolutionary court and was executed in the days after the revolution by a firing squad. The charge against her was that she was a minister under the Shah.

Mahnaz Afkhami (b. 1940)

Another high-ranking female official in the parliament, Afkhami survived the revolution but went into exile. She joined a huge community of Iranians, women and men, who have left the country since the revolution for a variety of different political, ideological, religious, and educational reasons. She remains an active women's rights advocate in the United States.

Shahrnush Parsipur (b. 1946)

A prominent novelist and short story writer, Parsipur was imprisoned in 1980 on suspicion that she might be politically active. According to her *Khaterat-e Zendan* (Prison memoir), her arrest was related to her brother's wish to create an archive of political journals. Parsipur spent more than four years in two different prisons.[48] Apparently, her imprisonment was extended because she protested against the cruel and inhumane ways authorities treated women prisoners. In

particular, they wanted women to wear the Islamic veil, even in all-female prison cells. She was eventually released in 1986, only to be catapulted into the harsh living conditions of postrevolutionary Iran without money, work, or any solid opportunity. Under such conditions, she could not write and produce fiction. Only in 1987 did she publish *Touba and the Meaning of Night,* which proved to be very successful. When later she published *Women Without Men*—a far more radical portrayal of women's sexuality and male patriarchy—she was arrested twice more, along with her publisher. The authorities told her explicitly not to write about such topics. These experiences were horrific enough to haunt her physically and psychosocially for many years even after she moved to the United States in 1995.[49]

Ghazaleh Alizadeh (1947–1996)

Alizadeh represents the tragedy of women artists who commit suicide because they cannot not bear the transitions in life.[50] Her story is indeed telling. She was born in 1947 in Tehran and eventually studied political science at Tehran University. She then studied philosophy and cinema at France's Sorbonne. She returned to Iran after her studies and published several significant novels and short stories. Her novel *Khan-e Edrissiah* (Edrissiah's house) had been considered by many critics to be an outstanding novel, and she even received the Golden Pen, a prize awarded by the then prestigious *Gardoun* literary journal. In her other fiction, she illustrates that the situation of women has changed, that they struggle insistently, and that because they do not gain much success they become highly disappointed. In May 1996, however, she hung herself from a tree near a village in northern Iran. Some believe that the reasons for her suicide were her personal problems and illness. Others think that she was not happy with her career and accomplishments. There is certainly a connection between her life story and the stories depicted in her work.

What Did They Do?

The output of the women artists often included a dozen or so movies in which they played a variety of roles and, in some cases, made a few music albums that became popular when broadcast on state-controlled radio. In addition to popular magazines, some television programs, such as *Mikhakh Noqrehi,* produced by the showman Faridun Farrokhzad (who was murdered in Europe a decade or so after

the revolution), or *Qarib Afshar's Show,* helped promote these actresses. They also contributed to fashion and, in a few cases, humanitarian activities. There were soon also pageants and beauty competitions in which actresses were active.

For these, they paid dearly after the revolution. In addition to the brief stories above, there are many untold that are perhaps as relevant as Shahrzad's. It is not clear why and how Azar Shiva, a highly successful prerevolutionary actress who remained in Iran, ended up selling cigarettes in front of the University of Tehran. Some who migrated soon after the revolution faced grim situations abroad as well.

Others had to wait longer to get out, and when the time came, they often went through a bordering country such as Turkey, the United Arab Emirates, or Pakistan before they reached Europe and Canada. Often they had to spend a few years in the neighboring countries before they obtained proper visas to Europe or the United States. In other words, it often took them three to twelve years before they could find a home in the West. Shohreh Aghdashloo (b. 1952), who gained some prominence at the age of twenty right before the revolution, worked hard to establish a career in Hollywood after residing in the west.

Thus, whether women artists and authors stayed in Iran after the revolution or left, they all experienced a period of fear and agony during the last months of the revolution and in the years immediately following.

As many of them express in their interviews on Persian satellite stations, when the movie theaters showing their pictures were set on fire during the course of the revolution, they could not easily go to sleep or walk the streets. And after the revolution, many (or perhaps all of them) were called to the revolutionary courts and committees. Their houses were searched and their belongings and properties were confiscated. In California, more specifically in Los Angeles, life was still difficult for the artists who finally arrived there. They found it challenging to make a living by selling their art to an older generation of Iranians who, for nostalgic reasons, craved the arts, singing, and dancing of the Iran they remembered but did not spend large sums of money on their entertainment. These artists, therefore, continued to live modest lives, occasionally also selling some of their videos or CD products. Of course the situation of the second generation of Iranian women artists is entirely different.

All this also indicates that the advocates of the fundamentalist traditionalist discourse on sexuality fear women, their awareness, and their activities, and

in fact their very sexuality. They feared them before the revolution and they fear them now. As the last chapter shows, the battle between these advocates and women activists will, to a large degree, determine the course of the future.

What about Men?

Iranian men in the 1970s show business were affected by all these changes but they did not face the same ordeal, and they did not feel the same urgency to leave Iran. If they left Iran to reside in California, it seems that they did so by choice and with fewer hassles. If they stayed in Iran, they were given the chance to continue to work. The actor/director/producer Iraj Qaderi stayed in Iran after the revolution and remained active and productive in cinema. In fact, he used Mohammad Ali Fardin and Naser Malek-Motiei in a somewhat controversial movie about nationalism and the sacrifices of a group of criminal "antirevolutionaries."[51] Nosratollah Karimi, Fardin, and Malek-Motiei remained in the country and enjoyed the protection of the artists' community, which sometimes even celebrated their accomplishments or birthdays, albeit unofficially. Recently, on the occasion of the celebration of his eighty-third birthday in Iran, Ezzatollah Entezami was given the title of "Sir" for his great acting career.[52] Many FilmFarsi directors, such as Ali Hatami and Mas'ud Kimiyai, continue to produce financially successful movies.

Filmmakers such as Iraj Qaderi attempted to take the state's message about the religion and turn it (or even subvert it) into a commercial achievement through their own peculiar populist understanding of social issues, very much the same as they did with the issues of Westernization and modernity during the Shah's rule. However, the Islamic Republic has been, since its conception, very vigilant about ideological enunciations in the country, stifling the slightest deviation from its official discourse and thus initially trying to thwart such productions.

Often, newly created archives about cinema and music (in print or otherwise) offer comprehensive information about the accomplishment of the prerevolutionary male artists and much less, if any, on the works and products of women artists in the same period. This is particularly evident in audio or video clips.

Popular and Traditional Cultures, Religion, and Women Artists

In the absence of a serious discourse on sexuality and an openness regarding sexuality, popular and traditional culture and religion affected the lives of

women artists in complex ways. For examples, FilmFarsi, as mentioned, presented nudity and then condemned it. In a movie entitled *Bi Hejab* (Unveiled, 1973), before the film reaches its moral message about the value of chastity, viewers were presented with many revealing dancing and singing scenes. Similarly, popular magazines promoted nudity, trying to benefit from the coverage and at the same time conveying moralistic messages. FilmFarsi prominently featured and commercialized the images of women. Not only *Ferdowsi Magazine* and *Zan-e Ruz* (which were discussed earlier) but also many other publications questioned the integrity of women artists, or any emancipated woman in those days, through direct and indirect insinuations. They published gossip along with their half-naked pictures. They projected their cinematic roles onto their stories and anecdotes.

How Could They Come Up with Stories like These?

An entry published in *Khandaniha* in 1949 illustrates this point.[53] Entitled "We Women Are All Unchaste" and bearing no author's name, it features a monologue of a girl called Manijeh.

While in ninth grade, Manijeh notices that all her friends in her uptown high school have boyfriends, and she herself soon begins to date. Her father did not care, and her older sister encouraged her.

On one late-evening outing with her boyfriend, she sees her literature-composition teacher walking in a romantic corner of town with the tenth-grade history teacher who is married and has three children. Worse, the next day, the composition teacher assigns her class to write about "chastity and nobility," after lecturing students on the topic for half an hour.

Witnessing such hypocrisy affects her deeply. Manijeh breaks up with her boyfriend because he does not have a car. She also breaks up with the next boyfriend because he, despite having a car or perhaps because of it, dates too many girls at the same time. Eventually she marries a guy who had frequently given her and her sister rides from a northern part of town (Shemiran Bridge, a hangout place for youth then and now) back to central Tehran. After her marriage, she ends up staying home more often, but her husband begins an affair with her sister. Manijeh gets a divorce and is happy that she is free again to date as often as she likes. When her father dies, she mourns only for a couple days and then goes back to having a good time with guys.

This story depicts every single girl (indeed every young person) as promiscuous. This may make an appealing confession/short story that would please the readers of the day, but the actual purpose of the piece was clearly not the promotion of sexual liberty. Instead, by assigning grotesque to sexual freedom and by fabricating or exaggerating the promiscuity of the characters, the piece denounces sexual freedom. Historical writings about the late 1940s do not reveal any such social freedom for girls, nor were there in all likelihood many young people with cars roaming the streets of Tehran in those days. Movies had not started depicting bold nudity, just unveiled women. Ultimately, the piece must be seen as similar to a typical FilmFarsi construct: it portrays open-minded and Westernized women as whores and bitches. And at any rate, the plot, the story, the writing style, and all of the wrong assumptions made in the piece indicate that the author is not even a woman.

Around the same time, on its twenty-first anniversary, the weekly *Taraqi* (Progress) featured an article entitled "Avoid These Women." In line with many such articles it published every week, it reads:

> There are many types of women . . . If you want to be happy and lead a headache-free life, you need to stay away from the following types: women who are married, women who are selfish, women who act, women whom you may love, women who surround themselves too quickly, women who are jealous, women who cry, women who are pretty, women who are pretentious, women who are quiet.[54]

For a moment, today's reader might think the piece was meant to be humorous. However, the conclusion is solemn: "Alas, there are no women outside of these categories. If you know of one outside these categories, convey to her my greetings."[55] Similarly, an article in *Tehran Mosavar* claimed that many homicides occurring at the time were caused by the revealing fashion of women's dress and that these "killer beauties" should be avoided.[56]

Of course, all these articles are accompanied by photos of Western female movie stars, blond women in revealing dresses, and photos or cartoons of revealing female bodies, which are nothing but the "teasers" against which the declarations are made, a style or tactic perfected by *Ferdowsi Magazine*. *Sepid o Siyah* once published a cartoon captioned "An Ugly Scene" that pictured a woman revealing breasts and buttocks while trying to adjust her stockings.[57]

Even *Tofiq,* a Persian humor and somewhat political journal, was filled with photos and cartoon drawings of half-naked women with captions that made fun of them.[58] Often, the woman in the jokes was promiscuous and unfaithful. These journals certainly demonstrated a simultaneous fascination with and struggle against sexuality by mis-portraying it. I showed earlier how this dualistic attitude played out in the cabarets and movies. When studying the scattered memoirs and interviews of women popular artists during the FilmFarsi era, it becomes clear that many of these women received offers to play the role of a prostitute in the movies but then were chastised for accepting such roles.[59] It seems that the Iranians were appalled by their own sexual fantasies. This sexual abhorrence turned into an ideological denial of sexuality and thereby the ideas of Western modernity.

There Are So Many Examples

One entry in a series of translated articles that aimed to provide information about marital sexuality began with an ominous sentence: "One can rarely find a woman who is not entrapped in a sexual perversion."[60]

An article in *Taraqi* entitled "Iranian Women Are the Most Pretentious in the World" states that Iranian women think that they are the most beautiful women in the world and expect men to be obedient to them.[61]

Another piece starts with "Girls, do not lose your virginity," arguing not only that "men would choose only virgin girls" to marry but also that any sexual intercourse before marriage would lessen the length of married life.[62]

Besides the hubris presented by the statement, it carries a contradiction as well. These proclamations summarize the perception of gender and sexuality presented in the popular journals of the time. Journals such as *Tehran Mossavar, Khandaniha, Taraqi,* and *Sepid o Siyah* contained information based mainly on excerpts from Western sources, the image of women presented in media (i.e., cinema), and a long tradition of male-dominated culture. Their portrayal of Western women was also quite erroneous, as they relied solely on the misperceived Western entertainment industry or dubbed movies for information.

The Consequences of These Writings on Women Artists

In this cultural milieu, women who sang in cabarets and nightclubs were very vulnerable and easily blamed for all of society's ills. Literally, they led unsafe lives. Just as sometimes happened in the movies, in some of these

establishments men could lose it and rush to the stage to "catch" the singer or dancer. This happened frequently in the early days of the singers of the popular genre and the dancers of pop culture such as Mahvash (d. 1961). Mahvash was an orphan who began her career while working in a brothel in the Shahr-e No red light district of Tehran, thus providing "reasons" for her audience's vulgarity and "reasons" for casting other artists in the same light.[63] A scar on her face, it had been rumored, was the result of such an attack in Jamshid Café.[64] For this reason, again like in the FilmFarsi movies, most of these women entertainers had to accept the protection of the ruffians who frequented those establishments and who also abused them.[65]

These artists faced constant criticism and accusations by the media as well. In 1974, *Khandaniha* published an article by a writer named simply Kiyamehr entitled "FilmFarsi Is Without Culture, Without Identity, and Alien: Why Do They Make Them?" The author states, "The stories of FilmFarsi are a domestic nightmare" and goes on to level all sorts of criticism against the genre. However, the author eventually blames female actresses for the existing social faults:

> Now we are at a stage where the bed and bedroom activities in their most bogus form are showed off to the face of oppressed viewers. Following the wave of sexy movies in the West, the "majestic" ladies of FilmFarsi are auctioning off all parts of their bodies. The showing of the fat breasts of these stars no longer amazes the oppressed viewers but if the filmmakers continue the trend, very soon they will begin to show the remaining parts of women's bodies as well.[66]

But the showing did amaze the viewers and the filmmakers did not continue the trend for much longer. Blaming the female stars, which by this time had become a common practice in the journals where these movies, gossip about the stars, and every other type of showbiz action were discussed, also turned into some sort of penance.

These assaults and denigrations demonstrate an incredible correlation with the revolutionary discourses that dominated events of the 1970s and culminated in the revolutionary movement of the late 1970s that eventually toppled Mohammad Reza Shah, an event that changed women's status and situation spectacularly, beyond everyone's wildest imagination. As we read, women who played in the movies, who danced in cabarets, and who were active in "undesirable" fields— even women who occupied high positions in the Shah's government—experienced

emotional, social, and physical displacement and even faced death or harrowing fates in Iran or abroad. Hundreds were arrested and detained during postrevolutionary days for things as simple as nonconformist behavior or style of dress.[67] Prerevolutionary popular culture, through the depiction of the prostitute in the movies or dancers on the stage, created an image or an archetype of contemporary Iranian women that was not only false and fabricated but also provided an excuse to prevent women's full and equal participation in social, political, and civic spheres.

Instead of the Canvas

As a result of all this, and given the fact that there was no a priori (ancient or medieval) image of the Iranian woman to which to revert, the ideologues imposed a crisis on the feminine. Some religious thinkers and intellectuals such as Shariati did promote Fatemeh, the prophet Mohammad's daughter, as an ideal model. She was not Persian, but that was not the main problem with this model. More important was the fact that concrete information and facts about her life were scant; as a model, she was not very accessible. Pious and highly religious Muslim women could relate to the archetype mostly as it was defined by anecdotes and centuries-old hearsay. But for others, it was not practical to relate themselves to the mother of Shiism. Even the militancy of Zeinab (Fatemeh's daughter) did not provide a universally accepted model for women who now constantly aspired to a modern life. To this day, the authorities keep changing their definition of "woman."

Again, this crisis too was rooted in the prerevolutionary culture. In the 1970s, there was no single historical cultural authority in Iran. Mohammad Reza Shah and the ruling elite offered their own notion of how Iran and Iranian identity should be perceived, based on ancient Persian history and his vision of a contemporary Iran that, in the King's words, was "on the road to being a great civilization." This vision failed to fundamentally transform women's role in society, however, and made only cosmetic changes and in an overbearing manner. Furthermore, contradicting his own idea of modernization, Mohammad Reza Shah advocated Islam and presented himself as a pious believer, making a show of traveling to the shrines in Shiraz or Mashhad. Moreover, Iranian intellectuals opposed to him believed in an Iranian identity based on indigenous characteristics of the country and class society, in binary opposition with whatever they

perceived to be Western. Their notion of the West and liberal capitalism, however, was warped, because it was formed via the information they received through Soviet and the Chinese cultural propaganda, Hollywood movies, American pop culture and through the limiting prism of the ruling elites who could travel more frequently; it was thoroughly colored by their understanding of the history of colonialism.[68] As discussed earlier, none of these relatively secular groups, who provided a context for women's sociopolitical participation, perceived gender, sexuality, and male–female relationships as significant aspects of their platforms for change.

The Legacy of Women Performing Artists

As shown, since the early decades of the twentieth century, Iranian women have entered the world of visual arts by hard work, through the encouragement of family or sometimes against their family's wishes, through auditions and competitions in high school or summer camps, or by mere accident, but they proved that they could be as productive as men.

Iranian women's presence in the profession, however, also proved problematic in the context of massive social mobilization for political and religious transformations. The preceding life stories of just a few Iranian women dance and film stars show that they paid dearly for their courageous act of breaking the male-constructed boundaries of popular culture and art.[69] Women who were far from cinema and popular culture and who were active instead in, let us say, literature, had a better chance of survival. In the 1980s, when women were still shocked regarding the huge impact of the revolution on their lives, many expressed their bitter experiences in an increasing patriarchal and misogynistic society.[70] But both groups suffered, and not only at the hands of authorities, because their society had not come to terms with women's self-expression, especially verbal or physical utterances that were related to sexuality.

But traditional culture and religion and some secular ideologies helped impede modernity and modern sexuality by "gendering" Iran. That is, Iran has assigned strict and restricted domains to women and has reserved other—typically more visible and powerful—domains to men. In such a gendered society, it is easy to miss the contributions that women artists and writers have made to what I claim is an ongoing distressed attempt at modernity. The significance of their contribution is however only apparent if their works are studied and understood

in the context of the conditions in which they worked. In the next chapter I will discuss how Iranian ideologies helped create a gendered Iran by excluding women artists and women's sexuality from Iranian narratives of modernity.

A Few Final Points

Women in the popular and performing arts in the 1970s dramatically influenced the course of events and social change not only by their contribution and achievements but also by the impressions they left on the minds and thoughts of the religious and social activists about the question of womanhood in the country. In fact, their relevance is still discernable; even though they are absent in the official historiography, their pictures still decorate teenagers' rooms in Iran. Googoosh's posters are everywhere in Tajikistan, and her songs are played in stores and taxis in Iran.[71]

Many artists who left Iran still have loyal fans. More and more materials and photos of them are surfacing on the Internet.[72]

When in 1999, after twenty years of silence, Simin Ghanem was allowed to give a concert to a female-only audience in a closed hall, she was stunned to realize that the audience knew all the lyrics of her songs by heart and chanted with her as though in a choir. She was deeply touched, she stated in a later interview.[73] In fact, even the younger generation knows some of the 1970s hit songs, including "Ghanem's Gol-e Goldun-e Man" and Marzieh's "Kieh Kieh Dar Mizaneh?" and sings them together at parties or at picnics. Since the revolution, there has not yet been a song this popular among people such that they memorize and recite it.

Western Women Entertainers

In the same way that the fate of Iranian dancers was different from, say, their sisters in the burlesque era in the West, Iranian women singers and actors too ended up in a different situation than their Western sisters of the same era in the West, for example, Edith Piaf, Susan Hayward, or Elizabeth Taylor. Edith Piaf's life is very relevant to this discussion. Born in 1915, she was abandoned by her mother and was given by her traveling-showman father to a madam in a brothel. In 1922, she rejoined her father and accompanied him on his travels and started singing in 1930, leaving behind an enduring legacy.[74] In contrast to Shahrzad, Piaf left the street to perform her most beautiful song on the stage singing "Je ne regrette rien." The Iranian female artists were rendered to oblivion,

faced harshness, went to prison, ended in exile, or simply died in poverty and loneliness, and only some were able to continue a struggling career in California. To be fair, some in the West too faced hardship and others resorted to religion as way of redemption. Bettie Page is an example of both groups. Known mostly through her remaining photographs and her pinup modeling in the 1950s, she experienced much abuse before she left the profession for a quiet yet troubled life as a committed Christian. Yet the writer and director Mary Harron revived, demystified, and humanized her in her adoring, seditious, and intelligent movie entitled *The Notorious Bettie Page*.[75] Even if no movies are made about these characters, their works often serve as cultural references in popular culture of today.

What Else to Do?

The amazing stories of Iranian women popular artists need to be told, further investigated, and analyzed in order to provide Iranian society with a nuanced account of women's struggle for emancipation and a lesson for a more attentive approach to the issues related to sexuality. Numerous actresses played different roles in FilmFarsi, and their names, the characteristics for which they were known, or the way they joined cinema may give us a sense of how they worked and contributed to the genre. These include Aaram (her name means clam; she starred in movies during the early seventies); Arezu (her name means wishes; she starred in movies during the early seventies); Baharak (started with commercials); Carmen Oskui (talented; she starred in movies during the early seventies); Fakhri Khorvash (better known as a strong theater actress); Atash (this nickname means fire); Franak Mirqahari (older generation); Fariba Khatami (Swiss; also known for her taste in fashion and her 1969 Ford Mustang); Fereshteh Jenabi (believed that playing in sexy movies was an act of art as well); Haleh (noted for a famous rape scene in the movie *Ali Bolbol*); Hengameh (she starred in movies during the early seventies); Katayun (played in some of Samuel Kachikian's movies); Lili (famous for her role in *Shirzad*, which was labeled the sexiest movie of the year); Nilufar (quit acting for a period of time to write her memoir); Mahnaz (believed sexy stars lose their fame too quickly); Malusak (her name means petite mignon; known for her long hair, green eyes, and ambition in taking her clothes off in front of the camera); Marjan (debuted and made headlines for her first nude appearance; featured in the movie *The Whore*); Mastaneh Jazayeri; Mercedeh Kamyab (dated Reza Safai, a prolific FilmFarsi director); Mojgan (starred

in movies during the early seventies and also modeled); Nadia (dancer at Qorbani's Miami Cabaret; once challenged all Iranian dancers to a competition and then decided to "repent" after her marriage); Nazanin (also played in commercials); Negar (also modeled); Nili (also danced); Nuri Kasrai (quite famous for such roles when she was about twenty); Nush Afarin (appeared on the cover of many film journals); Parvaneh (starred in movies during the early seventies); Roya (played provincial roles); Sepideh (stopped playing in Iraj Qaderi's movies because she was tired of shallow sexy roles; played in some American movies as well); Shahnaz (starred in movies during the early seventies); Shahnaz Tehrani (better known for her role in a popular television series); Shahrashub (means city thriller; received a main role during the filming of a movie); Shurangiz (means sensational, exciter; wanted to have a baby but was not married); Simin Ghafari (traveled to Europe frequently); Soraya Beheshi (her movies had to be censored for very bold depictions); Tutia (also modeled); Zari Khoshkam (had lovemaking scenes in all her movies; also played in Italy); and Zhaleh Sam (who liked to travel to Paris; suffered from rumors about her private life).

During the Tehran Film Festival, these artists had to also compete with other "sexy" actresses who were invited from other parts of the world. Dancers from Egypt, Turkey, and Lebanon also traveled to Iran during the 1970s. It should be mentioned that some of the above actresses and other famous actresses of this period—including Parvaneh Masumi, Googoosh, Puri Banai, Leila Fruhar, Shahin, Farzaneh Taidi, Fakhri Nikzad, Shahla Riahi, and Soray Qasemi—were better known for their acting in more serious movies of the time than for playing sexy roles. Some artists and singers announced that they would not play in sexy movies (even if they had before). These include Delaram, who was "discovered" by Siamak Yasami, a man known for finding new talent. All these are important also to the study of Iranian popular culture of the 1970s and how it affected the course of the looming revolutionary movement.

The study of women's visual expressions in films and their public words in fictional and poetic genres can help us understand the obstacles to modernity that discourses of fundamentalism, nationalism, and Marxism have caused. That is why I believe these women's stories help us understand and further advance the studies of the relation between modernity and sexuality; proscribing women's voice is connected to smothering sexuality.

7

Ideology, Sexuality, and Sexual Agency

An Afterword

> Have they ever stolen your love letters during an interrogation? They
> know who they are but don't know that I am a superior woman.
>
> Shahrzad

THE STUDY OF SHAHRZAD'S LIFE and work indicates that Iranian culture
has suffered from highly complex dichotomization between nudity and poetry,
sexuality and intellectuality, sex and art, all to locate women's so-called wrong or
right place. As I have shown in previous chapters and will reiterate in the pages
in this chapter, a true feminist criticism in Iran cannot circumvent the reality of
these dichotomies; instead, it should take them all, as a whole, into the study of the
problematics of sexuality. That is, for a feminist methodology to work well, atten-
tion should shift to all elements of what Pierre Bourdieu calls the field of cultural
production. To deny the reality of these dichotomies or to leave them unaddressed
is tantamount to obscuring the highly unequal power relations in Iran.

Indeed, the exclusion of sexuality from aesthetics, literature, and other art
forms has led to a more general dichotomization between the body and mind.
In this context, every time any representation of sexuality *did* find its way into
the media and public arena, it created problems rather than prompting a serious
dialogue around gender and the human body.

Shahrzad's story also proves the pressing relevance of the study of sexu-
ality in popular culture and the arts, which also have their own set of binary
oppositions. Iranian intellectuals' ideological criticisms of the performing
arts as Western and corrupt in the decades prior to the revolution led them to
become disillusioned with both the West and Enlightenment principles. Their

disillusionment with these, and eventually with modernity, left the issues in the hands of the producers of popular culture. These promoters, following their commercial exigencies, represented what they perceived of the West, modernity, and sexuality in a most troubling manner.

Shahrzad's life story further explicates some of the problematics of the theories of ideology. At every turn in her life, she seems to have faced some sort of ideological dichotomization, some sort of social predicament. More generally, the study of the career and fate of women performers further confirms that ideology—whether that of the state, the opposition, or religious or secular societal sectors—has played a decisive role in determining the course of women's lives in Iran.

In this final chapter, the prevalence of ideology (and not only of fundamentalism) in Iranian life is discussed to show how it influences the course of intellectual development, women's personal achievements, the understanding of sexuality, and national progress.

Today in Iran: Shahrzad and *Kayhan*

Two decades after the revolution and during the reform movement, mainly because of women's resistance, the authorities were required to pay more attention to women's issues, to relax their ideological grip on gender. They did so to the extent such causes became a significant aspect of the reformists' election campaigns in late 1990s.[1]

The ruling elite were forced in the late 1990s to lessen their pressure on women to stay home. In 2000, among other developments, Googoosh was allowed to perform in glamorous North American concert halls, and Marzieh joined an oppositional group abroad to sing in praise of its leaders, but it was too late for Shahrzad to make a comeback.

After her release from prison and the hospital and particularly during the reform period, Shahrzad traveled throughout Iran and to Europe. In the early 2000s, owing to the kindness of a few people, Shahrzad became somewhat healthier and found a small place in which to live for a number of years. Nevertheless, she continued to be on or off the street and in or out of the country with incredible regularity. The journal *Kayhan*'s recent joyous report on her predicament of being homeless and her nightmare of "having no access to a shower in the morning or a place to store her few belongings" clearly shows how the fundamentalists

continue to reconstruct and proliferate such bothersome dichotomies. Cultural outsiders and "crazy" people are labeled as villains in order to justify their own (i.e., fundamentalists') suppressive rules.

Under the title "The Alarming Fate of the Famous Actress of the Trite Cinema: A Special Report," *Kayhan* writes:

> Some sources and news Web sites report that a famous actress of the commonplace movies of the despotic period is homeless, wandering the streets. According to this report, she, who was known by such names such as Kobra, Maryam, Shahla, and became famous as *Sh* during her acting period, is now having a tense anxious time. She began with dancing in Lalehzar's cabarets which were filled with smoke and alcohol. Then she appeared in the movie *Qaysar* and later in some other known movies, playing the role of prostitutes and dancers. The report adds that in the height of psychological and physical illnesses in 1985, she went to Germany but returned to Iran after seven years. Now seventeen years have passed since her return; seventeen years of homelessness, wandering, disturbance, distress. What she has not found during this time is also the trust and the attention of people in cinema, her acquaintances, and her old friends, all of whom do simply not notice her, some inadvertently and some deliberately. One of the sources writes that according to the book entitled "The Career of Iranian Women," Ms. *Sh* attempted suicide by pills many years ago but today she lives on the meager salary from the House of Cinema. Sitting on a bench where she spent her last night in front of an art institution, and while smoking, she tells us: "When you continue to sleep in the parks, your horror of waking up next to the other homeless people and the mice and the cats changes to friendship with them. In the warm summer nights, you can gaze at the sky, and look for your fortune star for a thousand times and still be unable to find it. However, when you wake up in the morning and feel the need to go to the bathroom, then your real headaches begin. This very rudimentary routine of people all over the world turns into a very enormous adversity. Where can I go, what can I do, where should I store my luggage?" The fate of this actress provides a lesson because such actresses, when they are still young and famous in the center of attention, they do not see their dark future that they have constructed for themselves.[2]

Kayhan of course does not say anything about Shahrzad's nearly six years of confinement in prison and in the psychiatric hospital.

At any rate, was she not declared "out of darkness" by *Ferdowsi Magazine* in 1971? Is there not anything else today about her eloquence that is different from other homeless wanderers of Tehran's downtown smoky streets? I would like to emphasize that such sanctimonious expression of joy over the suffering of a human being, let alone an accomplished artist, cannot simply be attributed to the infamous malevolence of *Kayhan*. It is rooted in the above discourse that dichotomizes human species based on a set of metaphorical and ontological understandings of sexuality.

On the other hand, the literary and cinematic communities have not stopped perceiving Shahrzad as anything more than the revealing dancer of FilmFarsi "gone mad," a fact evident in her trouble with the authorities, other artists, post-revolutionary artistic communities, her financial situation, and her homelessness. Some men encouraged Shahrzad to dance and uncover as much as possible in front of the camera, and later others chastised her for dancing and playing such roles. All of these men were oblivious to her physical, mental, and social destruction. Nevertheless, as mentioned, she was helped with accommodation and other problems, and *Kayhan* might not be entirely right about her invisibility in the eyes of the entire community, either.

In fact, as always, she is trying to learn new things, to speak and write, and she does not seem to be concerned with audience or coherence. Therefore, her case not only exemplifies how individuality is distorted by the exigency of ideological conformity but also magnifies cultural resistance against ideological probity.

Does Ideological Modernity Work?

In eighteenth-century Europe, the notion that *new is better* gained some dominance. In 1970s Iran, through leftist and religious revolutionary ideologies, reflected in literature, politics, and popular arts, *one only heard praise for the old,* the past, the indigenous, and the traditional. Iranian Marxist literary and political activists, who only very loosely perceived Marxism as a body of ideas and speculations about philosophy, history, economics, and politics developed and presented by Karl Marx and Friedrich Engels in the mid-nineteenth century and later modified by others, did not understand the core ideas of modernity. Marxism was rather incompletely understood through limited access to censored materials, but it was embraced by its enthusiasts as an exact science and as sacred as religion, an alternative to all Western structures

and accomplishments. Through such ideological tenets, the Marxists, like the Pahlavis and religious thinkers, thus constructed what they considered to be a "modern discourse." In reality, some of their concepts resembled Western modern models only in terms of form. I have discussed the content and forms of prerevolutionary committed literature elsewhere, which heavily emphasized free poetry and short stories, but here it suffices to provide an example of such poetry entitled "Shiraz" by Mansur Owji. The poem reads: "Have the concrete and steel beams galloped through my childhood neighborhood? / because there is no trace of the smell and the perfume of orange blossoms / in Sa'di's *Orchard*." Obviously, Sa'di's *Orchard* (*Bustan*, 1257) not only serves as a metaphor for the author's native city of Shiraz but also connotes the old.[3] It is remarkable now to note how cordially the poet was received for presenting a medieval moral authority, albeit a literary masterpiece, as a substitute for the Shah's modernization.

In the end, instead of working what they revered of old accomplishments into the Western practicum, they all presented the old culture and indigenous thinking as an alternative. The synthesis of the contact between these competing paradigms was Khalkhali, the hanging judge who also passionately strived to destroy the country's pre-Islamic cultural heritage after the 1979 Revolution. They all collectively failed to bring forth a condition that made women's issues of equal import to other social concerns.

Religious Thinkers, Gender Divisions, and Entitlements

In the religious camp, thinkers such as Shariati, Al-e Ahmad, Reza Davari, and clerics such as Muhammad Husayn Tabatabai and Morteza Motahari were influenced by the leftist ideological resistance to capitalist expansion. They adapted this revolutionary discourse and mixed it with expressions of the medieval Tabari and the Kharijite theologians. They permeated their debates with Koranic verses and addressed the issues of their time—especially opposition to Westernization—while accentuating an obsession with Marxists.[4] They perceived all issues relating to women, however, in the context of their quest for political change and political power.

Since the victory of the Islamic Revolution, the official statements, Friday sermons, parliamentary debates, the police, the official media, and many other outlets constantly warn and threaten women in regard to their veiling or proper

conduct.[5] That is, the state religious discourse from its inception has had an even more problematic relationship with sexuality than the earlier activists.

In a sense, one may argue that in some philosophical and practical aspects, medieval Islam was more flexible than early Catholicism.[6] Nevertheless, one highly problematic aspect of religious sexuality was conceptualized in the eleventh century by Mohammad Ghazali and other medieval philosophers. They viewed sex between two legally wedded people merely as a means of reproduction. It is also interesting to notice that in his *Kimiya-e Sa'adat* (The alchemy of happiness), Ghazali states that men should not even hear the sound of a woman's pestle and mortar, let alone their voice, a notion that is still prevalent in some religious schools.[7] Yet, signs of homoerotic sexuality also appeared in many texts as well as in some Sufi writings throughout these centuries.[8] Current debates of Islam in Iran, which are in some aspects rooted in the prerevolutionary period, are particularly relevant. This reunification of religion and sexuality in the state discourse is extremely premodern. In that regard, religion has contributed to the repressive culture in Iran to further prevent critical thinking in the open exploration of one's self. Originally Islam and the Koran may have offered new ideas regarding the sensitivity of sexual matters and a somewhat different portrayal of women and their dealings with men (the creation of the first woman, purpose of sex, women's rights).[9] However, many do not see the new ideas as progress compared to the ancient culture. In addition, over the centuries, those views have morphed such that their implications today result in a dysfunctional and unhealthy society.

Furthermore, these imposing views are preoccupied with male sexuality and male sexual needs. In the seventies, Muslim scholars worked to reformulate their notions of women and gender for all religious and political purposes, but the result was that these traditional notions were used again and set up in opposition to the views of those who were to some extent influenced by a Western heterosexual model, for the purpose of discrediting the Shah's rule.[10]

During that time, Ayatollah Morteza Motahari, a prominent senior cleric and one of the architects of the postrevolutionary Islamic rule, wrote: "They say that the Islamic *hijab* opposes a woman's dignity. . . . If a man has duties in his relationship to a woman or a woman has duties in relationship to a man, the duty is in order to strengthen and solidify the family unit."[11] Citing a number of Koranic verses, he further wrote that women must "cast down their look and

guard their private parts and reveal not their adornment except such as is out-ward and let them cast their veils over their bosoms and reveal not their adorn-ment except to their husbands" and men who are related to them by blood.[12] However, he used quotations from Western thinkers to support his otherwise pointless view of women, gender, and the veil. His views stood in sharp contrast to liberal Muslim thinkers such as Egyptian Qasim Amin, who advocated the abolition of the veil. I have to add that in another work attributed to Motahari, a less restrictive approach to sexuality is followed. In it, the author argues that Islam since the beginning has seen sex as a joyful human activity, whereas other religions and civilizations including Christianity and the ancient Greeks did not favor the joy of sex.[13]

Ayatollah Khomeini wrote: "If the religious leaders have influence, they will not permit girls and boys to wrestle together, as recently happened in Shiraz. If the religious leaders have influence, they will not permit people's innocent daughters to be around young men in school; they will not permit women to teach at boys' schools and men to teach at girls' schools, with all the resulting corruption."[14]

As explained in chapter 6, Ali Shariati (1933–77) promoted Fatemeh (the prophet's daughter) as the ideal model of womanhood while condemning all liberal and socialist models that were, according to him, partly responsible for the moral corruption of societies. He wrote, "But we see clearly that communist societies. . . . closely resemble the bourgeois West with respect to social behav-ior, social psychology, individual outlook, and the philosophy of life and human nature."[15] Thus, his opposition to orthodox Islam did not lead to a progressive conceptualization of gender relations and instead tremendously helped the rise of the fundamentalist movement.

Shariati and other religious thinkers often misrepresent, misquote, or at best misunderstand Western (and Marxist) views of women, gender, and sexu-ality and thus advance uninformed views of womanhood. Very often, they pres-ent their arguments against an alleged Western view or issue without factual corroboration. In many of their works, the alleged corruption of the women's situation in the West is connected with the "bankruptcy" of liberal democracy.[16] Only the fact that Shariati and others attacked the traditional notion of wom-anhood, albeit without challenging the Islamic notion of sexuality, made their work or criticism attractive.

In fact, none of these people emphatically or directly denounced the notion of women constructed by such religious luminaries as Molla Sadra and Hadi Sabzevari, who saw women as on par with animals.[17] A number of people like Sadeqi Ardestani compiled books on temporary marriage, Islamic polygamy, and sexual and marital relations, trying to re-represent some of the old notions about women in newer and "modern" guise, but women's own voices did not prevail.[18] They, too, combed Western translated materials to find quotations to support their dated notions of sexuality.

Ideas presented by those Iranian Muslim thinkers of the 1970s echoed the broader efforts that were taking place in other parts of the "Islamic world." Like many renowned Arab thinkers, South Asian Afzular Rahman says: "Muslim women should conduct their affairs outside their homes in a manner that does not display and reveal their finery and adornment nor bring them into bodily contact with men. They should wear simple dress and use simple and modest make-up and abstain from excess."[19] Citing historical and hadith sources, he also states that "women should walk in a normal way, not gazing at other people, nor intermingling with men in a way that brings their bodies into contact with men, as is often experienced in modern life in theaters, buses, trains, educational institutions, etc."[20]

Indian Allamah Sayyid Zeeshan Haider Jawadi best formulated these issues in *Women and Shari'at (Divine Law): Complete Rules Regarding Women, in Islam,* which has been translated into other languages. He talks about women's puberty, impurity, menstruation, types of menstruation, irregular periods, the veil, sexual intimacies, divorcing women, and so on. In the section on menstruation, for example, he discusses several types of bleeding such as "beginner," "only temporary habit," "only numerical habit," both "temporary and numerical habits," "irregular," etc.[21] These types, according to the author, have different rules as to what a woman can or cannot do in so far as religion dictates.

These thinkers even devised or concurred with a description of which women's clothes were acceptable to the faith: loose baggy garments made of thick and nontransparent, preferably dark-colored fabric that can cover the female body and conceal its curves. Therefore, they pronounced as sinful not only miniskirts, sensuous and revealing attire, and polyester pants and shirts that showed curves but any clothing that could seduce sex-deprived men and fan their longing for the female body. In addition, they proscribed any attire that made women look

like men and the kind of dress used in *Baba Karam* dance. Of course, they were not the only ones who saw such extreme style of dress harmful and detrimental to Iranian society. Even Shahrzad denounced revealing dress styles. Furthermore, even in the West and in particular in America, many find such dress offensive or immoral. The Iranian and Islamic debates on the issue led to an extreme politicization of women's dress. The veil had long existed in orthodox Islam and has not necessarily ever been an exclusive symbol of Islamic fundamentalism; however, when the fundamentalists came to power in Iran in 1979–80, they made it a central issue. According to the new leaders, veiled women symbolize Muslim virtue and the rejection of the West. They even went beyond that; many new misogynistic and pronatalist policies have been implemented, all targeting women's sexuality. Inevitably, the woman's body was now a *pleasure and political site* for competition among ideologies and a *social site* for religious ideas to be formed and implemented. Shaking a woman's hand was considered preparation for corruption since it could lead to further physical contact. Accordingly, sexual abuse became the continuation of that same sense of control over the female body. Those advocating women's rights are faced with the allegation of sexual corruption. An interpretation of veiling even included a ban on women's singing. The veil, according to some extremists, should cover women's physical motion (dancing) and speech as well.[22]

The Taliban forces in Afghanistan are famous for their edicts against such things, and many movements across the Middle East promote identical ideas. Yet, advocates fail or refuse to see that such a notion of sexuality has proven disastrous in practice. They promoted it simply because in their minds it still presents an alternative to the "Western corrupt" notion of gender. It has turned into a political tool for suppression of progressive women, a means of exerting power, and a mere indicator or sign of the prevalence of their ideology. In this discourse, also documented in the book pompously entitled *The Law of the Power of Sex,* all religious traditions, holy verses, and hadith are used to formulate a theory of sexuality that focuses only on men and what the author believes are their sexual needs. According to the book, the best women are those who produce many offspring, are obedient, function as sexual tools, and have no sexual needs. Any violation of these traits can lead to their abandonment or punishment.[23] In fact the concept of *tamkin,* which requires women to succumb to their husbands' sexual needs, among other things, is widely accepted even today. But clearly, enforcing

tamkin is nothing but the legalization of male sexual violence against women. A clear manifestation of this claim might be seen even in Afghan's post-Taliban civil rights laws, which made *tamkin* mandatory for women.

In the context of such an authoritarian and archaic conceptualization of the female and her presentation, FilmFarsi certainly provided these contemporary religious thinkers with many excuses to attack not only the Western concept of woman, but also Iranian interpretations of it, on screen and off. In fact, Rahman (and Ayatollah Khomeini as well) specifically commented on cinema and drama, stating that movies are by themselves good tools and permissible. However, they further decreed that the content of productions must convey Islamic morality and beliefs and shun any reference to sexual desire.[24] Rahman wrote: "Physical intermingling and free mixing among men and women in movie theaters must be avoided in order to prevent sexual undertones and temptation, particularly because showing a film requires a darkened hall."[25] The same went for male and female mixing in the film itself. When he arrived in Iran in 1979, Ayatollah Khomeini said in his famous speech, "We do not oppose cinema, we oppose prostitution."[26] This pronunciation was used as both a justification of the theater burning during the uprisings by equating the prerevolutionary cinema with prostitution and an attempt to set up a new policy about what was going to be acceptable as postrevolutionary cinema.

Thus, a long ubiquitous manipulation of gender and the gendering processes has led to the construction of symbols, images, and rules for actually reinforcing gender division. These symbols, images, and rules have all focused on bodies and women's sexuality as the *sites* of their political and cultural be*night*edness. This is the discursive context in which *Kayhan* self-righteously summarized Shahrzad's three decades of distress.

Climbing Out of a Ditch Only to Fall into a Well

In addition to ideological efforts, traditional culture, which is tied to religion, also helped to protract the premodern social attitude and solutions regarding women and sexuality. Some of these social features might appear too obvious, too well known to discuss, but we need to contemplate them in the way they feed the ideological constructions. In many rural areas and provincial towns, "Girls were taught from infancy onward to sit quietly, not to stir, not to ask questions, not to be curious, with the result that they became physically weakened

and unattractive, and mentally incapable of self reliance."[27] Through this process, girls inexorably learned to suppress their feelings and be inarticulate about romance or sexual desire, even after they entered adulthood. Such socialization could continue to silence a woman after her marriage when she was often encouraged to remain sexually passive and unimaginative. That is, some things did not change with marriage. Badr ol-Moluk Bamdad explains it this way: "Suddenly, at the end of a wedding feast in which others had enjoyed the fun, she would realize that she was about to be transferred from the prison of her father's house to the custody and service of another man called her husband—'out of the frying pan into the fire.'"[28] This might apply less to the young generation of urban women, but those in small towns and rural areas have seen little change. Also, the new home is not always necessarily worse. Indeed, the Persian proverb in the heading above is sometimes used in reverse.

Many artists and talented women lost their freedom to practice their arts or pursue their artistic desires. For example, in some cases, a husband who was initially supportive would change his mind after witnessing his wife's success.[29] However, I must mention that in some cases, women artists gained more freedom after marriage, especially if their husbands were intellectuals or in show business. A prime example of this is the singer Simin Ghanem, who became more active and mobile after her marriage in the 1960s.[30] Another example is Betty (Batul Fakhri, b. 1952), who had to marry in order to be able to sing for others.

So Much for the Seculars

The works of influential secular social commentators such as Mostafa Rahimi, Ali Asghar Haj Sayyed Javadi, and Mostafa Zamani, who were less imbued with either Islam or Marxism, did not help the cause of modernity either. They focused almost entirely on the alleged negative results of the Pahlavi's Westernization.[31]

Liberal Islamic forces with secular tendencies such as the members of the Freedom Movement Party called for the reform of Islam in order to address the issues of progress and "catching up" with the West. However, they mostly defended Islam as being able to accommodate Western scientific achievements and prosperity. They wanted to use the Islamic worldview to solve all their problems. Besides the fact that they pretended there were no gender issues to deal with, their approach stood in contrast with the Western secularization thesis that required the separation of church and state.[32]

Of course, the views of the liberal Muslim forces indicated contrasting inter-pretations of Islam as well. Islamic modernism and Islamic fundamentalism are two different ends of the same theological paradigm produced in response to capital liberalism and Soviet Marxism.[33] In analyzing all these interactions, I have emphasized that ideology is often a set of structured metaphors that guides advocates' conceptual and perceptual systems within which they think, commu-nicate, and act.[34]

Ideology upon Ideology

Ideology is a systematic, inclusive, universal, ontological construction that guides its advocates (and their audience) even in their social and cultural pursuit. Thus, as opposed to the projects of modernity and modernization, Iranian ide-ologies offered metaphorical constructions, semantic systems, and paradigmatic responses. This resulted in a common way of thinking and a common response to the state and its social agendas through oppositional (and sometimes supportive) utterances and common attitudes toward modernity. When paradigm contact occurs, responses are uttered in terms of metaphor as well, which explains why there is so much similarity between the rhetoric of fundamentalist Islam and Iranian Marxism.

Soviet-style Marxism, Islamic liberalism, Islamic fundamentalism, the iden-tity crisis discourse created by Shariati and Al-e Ahmad, anti-Western national-ism, the leftist revolutionary discourses, and even to some extent Islamic and national liberalism all shared a rejectionist or dismissive approach to sexuality and to the significance of gender. In Iran, these ideologies have shared an anti-modern notion that women have, at best, a "natural" place in society that is given to them by men in power. Even Reza Shah's understanding of a woman, as Cam-ron Amin states, was that she had to be educated, unveiled, integrated into the workforce for her family, be supportive of her man, and be a complement to the modern Iranian man in the civic arena.[35] His son, the Shah, provided women's suffrage, gave women a right to divorce, limited polygamy, and promoted West-ern models of life. Nevertheless, he once professed, "Women are important in a man's life only if they're beautiful and charming and keep their femininity."[36] In the final analysis, men neither fulfilled the notion of the modern male guardian nor became women's equal and welcoming classmate, professor, and colleague. These ideologies all suggested that both women and men ought to be stripped of

their individuality for the sake of ideological conformity. For further harmony, men also expelled women from almost all positions of power as soon as they could, in the first months after the revolution.[37]

The Ensemble

All these forces were at work to create codes of conduct (based on their worldview) for women and to establish a tradition that would prevent women's empowerment no matter in what direction development proceeded. In that regard, some pious men must have found the FilmFarsi products and the appearance of women on the streets and on the beaches in the 1970s as a sure sign of an impending apocalypse. Paradoxically, many men within the field of FilmFarsi production shared these basic moral principles (or felt they needed to pretend to have them). Since they also needed to earn a living, they continued to produce films with empty plots and gratuitous nudity. But they did manage to insert their contempt in one way or another, in order to exonerate themselves in the face of their own conscience or possible criticism from others, very much the way *Ferdowsi Magazine* pretended to crave Iranian popular culture while vehemently rejecting it. Some FilmFarsi producers would ask auditioning girls if they were ready to take off their clothes, already judging them as sullied.[38]

This paradox, a contradiction between conviction and action, of course had another historical background. By the 1970s, women had clearly come a long way.

• In the 1920s, women were forced to ride in carriages separate from their men or walk only on the side of the street designated for them.

• In 1970s movies, they took off their clothes in front of an entire population.

• In the 1920s, "Often a distinguished lady had to listen to the imperious command of a policeman: 'Cover your face, wench!'"[39]

• By the mid-1970s, however, veiling signified backwardness and an obsolete lifestyle.

By the end of 1970s and especially after the revolution, those ideologies became even more radical and more erratic. Religious ideologues began to reject, eliminate, or subvert modernist elements that would celebrate women's art unconditionally and provide connections between femininity and different realms of creativity. Men of all ideological orientations shared a paternalistic notion that women must be chaste, good mothers, and guardians of indigenous

Iranian culture—on man-made terms. None came close to suggesting any level of gender equality, sexual equality, or open discussion of gender, gender roles and society, and freer sexual expression. They all condemned or banned women's protests, demonstrations, and rallies against forced veiling.

A survey of the journals published since the Constitutional Revolution (1906) by modernist intellectuals, religious enthusiasts, and nationalists shows they resemble each other in this way when it comes to women's sexuality.[40]

Journals published by women between the Constitutional Revolution and the 1970s are, however, an indication of women awakening; their desire to be emancipated, their resolve to enter the public space, and their need for equal rights. But they chose to pursue their demands from within the archaic, cultural norms of sexuality and gender notion that men had collectively created and protected for centuries. Thus, their efforts largely came to naught. Though from the outside one may have perceived Iran as progressing and modernizing, emancipating its women and loosening its social mores and dress codes, this was only a paper-thin veneer of modernist achievements. Such shallow attempts at Western and modern arts, literature, and social action could not successfully transform all of Iranian society—urban and rural, religious and secular, rich and poor— into a truly modern state.

By the end of the 1970s, Ayatollah Khomeini and Al-e Ahmad were not alone in their belief that consumerism and women's emancipation were the result of the subversive Western influence on pure, indigenous Iranian-Islamic culture.[41] A few months after the downfall of Mohammad Reza Shah, women on the streets heard, "Wear a scarf on your head or get a cuff on the head" (*ya ru sari, ya tu sari*). The return to traditionalist stances and strictures was easy as it did not have a formidable mode of modernity to undermine.

These analyses might shed light on Ruth Roded's thoughtful statement that "Many observers have wondered why women in the hundreds of thousands, including educated women, actively supported a movement which appeared to curtail their rights."[42] The political developments and the postrevolutionary state ideology were the result of many years of ideological resistance to modernity.[43] The failure of ideological forces to embrace modernity and the absence of a modern discourse on sexuality had prepared women to support fundamentalist vision of womanhood at least at that historical moment.

With the establishment of the Islamic regime one of the significant aspects of modernity, that is, the separation of the private from the public, was boldly and theoretically violated and the sanctity of the private realm shattered. When, in the early postrevolutionary years in Iran, a man walked with a female companion (e.g, wife, girlfriend, female friend, or sister), they were sometimes stopped by the religious agent of the government to answer questions about their relationship. In some cases, they lied, and in all cases they could easily feel the religious state's breach of their privacy. They had no means of protecting themselves. Borders between the public and private, religion and politics, state and individual did not exist. This shift resulted in both real and the self-imposed restrictions on the level of freedom women experienced not only in the street, but now often in their own homes. Private life was scrutinized through a public system of control. Politics and religion were one. The state trumped the individual, and cultural norms and boundaries were defined by a single state-ratified interpretation of religion. Individuality, self-expression, and, yes, sexual expression were purposely undermined. In short, after the revolution religion was the basis for everything, including sexual relations.

The Iranian Marxist or Islamic reconceptualization of not only gender but also of issues such as democracy and human rights had not proved universally acceptable. For example, human rights, as Geraldine Brooks states, are universal and "independent of cultural mores and political circumstances." Yet, "Cloaking their argument in fashionable dress such as cultural relativism, delegates from Iran and Cuba, China and Indonesia argued [at a conference on the International Declaration of Human Rights] that the West had imposed its human rights ideology on nations whose very different religious and political histories gave them the right to choose their own. To me, their argument boils down to this ghastly and untenable proposition: a human right is what the local despot says it is."[44]

For another example, I should perhaps return to the concept of modernity itself, which, as Kolakowski alludes, might still be elusive in the West.[45] However, Hans Blumenberg provides sufficient insight when he states that modernity is not a secularized version of theology or antiquity, since their basic ideals are sharply different and constantly clash. Modernity was born in the process of rejecting the ordering of the medieval universe and transcending the limits of the ancient cosmos.[46]

The history of revolutionary and fundamentalist movements and the account of the states in Iran point to other reverse processes. Even the economic hallmark of fundamentalism, which sought to establish a fair state-controlled or a semi-socialist economy, has begun to disappear in Iran after the implementation of article 44 of the constitution and then through its control by the clerical or police and security forces.[47] In both periods, as we noticed in previous chapters, dancing and acting, as well as daring literary and social creativity, for women in particular, were problematic.[48] Such half-hearted or even contemptuous treatment of Western models created a destructive popular culturalism in the prerevolutionary period and a preventive cultural relativism in the postrevolutionary period.

Iranian Ideologies and Sexuality

We saw in the middle chapters of this book the effect of ideological power on the works, body, and journalistic activities of Shahrzad, who by profession and experience could have potentially instigated a case for the defense of female space before the revolution and modern human rights afterward. We saw her constraint in that she exercised a form of self-containment in life and self-censorship in her artistic work, and we saw this in the way she tried to accommodate dominant leftist discourse in her prerevolutionary enunciations. It was also made clear that striving to express herself from the margins, in the face of the literary mainstream in the past and dominant social discourses in the present, Shahrzad seems nervous in her poetry, fiction, and autobiographical letters. Her experience and that of many other women popular artists reveals that it is often perilous and inevitably tumultuous to transgress ideological boundaries and ideological norms.

Where do these ideological similarities regarding sexuality come from? Iranian ideologies gained momentum particularly in the 1970s. That is when Iranians took an anti-imperialist (and eventually anti-Western and antimodernity) stand on the pretext of centuries of Western adventurism. In opposition to capitalist expansionism and colonial attitudes, native ideologues continued to uphold conservative and historically archaic approaches to sexuality and gender.

According to Judith Lorber, "The basic bodily material is the same for females and males . . . male and female genitalia develop from the same fetal tissue."[49] This may be a biological fact, but Iran has in recent decades fortified the construction of what Lorber calls two classes of people, consisting of "women" and "men."[50]

Consequently, such a society perceives "two discrete sexes and two distinguishable genders" as eternally antagonistic categories. Lorber draws on the works of Foucault, writing: "Analyzing the social processes that construct the categories we call 'female, male,' 'women and men,' and 'homosexual and heterosexual' uncovers the ideology and power differentials congealed in these categories."[51] In doing all this, Lorber intends to argue that there are in-between areas; not all are completely men or completely women. This means that while the West understood that gender and sex are not absolute categories, in Iran, as a modernoid society, these categories have, for a long time, been of great service to the ideological institutions and powers and so were not done away with but, indeed, fortified.

Through sheer bombastic elocution, such ideologies have provoked men to battle over women's bodies and public appearances and to regard female sexuality as an uncanny site of menace and dismay. These ideologies, whether hegemonic or oppositional, often allow their advocates to radically shift their positions on certain issues and yet remain committed to the same ideology and to occupy positions that should be held by cultural or scientific elite.

From all this, we may also arrive at the conclusion that culture production is a discontinuous and disordered process, in which ideological representation and ideology in general play a decisive role, guiding (and misguiding) the conceptual and perceptual systems within which advocates think, communicate, and act. This power of ideology has separated even further the high and low cultures in Iran: high culture is sanctimoniously less concerned with the presentation of sex, whereas low or popular culture is offensively obsessed with sex and women's bodies. Based on these qualities, I should reiterate that ideology is an element related to social and cultural movements, determined by rules of expression that are constantly in flux. When an ideology is established in any social, religious, literary, or gender/sexuality discourse, it motivates political movements with entirely new semantic systems. Because ideology has a constructive impact on representation and because it is based on an ever-changing social context, it makes culture production (and modernization) a discontinuous process. This impact may not be immediately obvious, but it is nonetheless always in play and setting new priorities. Nowhere are changes felt as strongly as in the politics surrounding women's bodies.

Contemporary Iranian ideologies frequently overpower the modern dimension of life and humanism. By hampering the process of the exploration of

sexuality, they have consequently hampered the process of individualization, without which no form of modernity can be fully realized.

As Satan's advocates in *Paradise Lost* urge the members of the council of devils "To union, and firm faith, and firm accord" (II 36), so did and do the ideologues of Shahrzad's society, before and after the revolution. As a result, even though Shahrzad's society is more advanced and developed compared to what existed before the reign of Reza Shah, it has not yet adopted the modern concept of individuality and freedom of sexuality.

Having failed to separate religion and the state, Shahrzad's society never contemplated the separation of the state from private life. In her society, the ideological group, community, family, ethnicity, and even class have carried more weight than has the individual.

The consequences of the domination of these ideologies over the discourse of modernity (and the discourse of sexuality) are most apparent in cultural debates and especially in areas where modernity made progress, such as in women's social participation.

Finally, I should mention that the Persian language also lags behind in accommodating such debates and dialogues. In the prerevolutionary period, Shahrzad, as we witnessed in the discussion of her work, was hardly capable of finding the proper and relevant terminology to articulate her amazing experiences despite her deep involvement with the most pertinent issues related to women and to the female body. And today, as pointed out in chapter 2, the Persian language is in a different but equally dire situation in regard to the expression of sexuality. On the one hand, the state and its cultural workers are injecting more and more Arabic vocabulary of the Islamic period into daily use, and on the other hand, Western media or Western-supported Persian media outside Iran are injecting foreign terminology. In other words, there is an absence of discursive coherence and an absence of adequate and commonly accepted discursive tools in Persian.

Call It What It Is—Scandalous!

All codes and theorization regarding the veil by men, gender segregation, the sexualization of women's *body and hair,* and the ideological control of women's sexuality have led to the marginalization of women's public voices, restricting them to a few countermovements and oppositional activities and, in many ways, depriving them from their sexual agency. All this might be clear by now. What

needs further contemplation is locating all this in the debate on modernity, in the discussion of East and West dichotomization. Sexual agency is indeed a more recent product of modernity or the product of a modern discourse on sexuality. To be sure, the medievalist Muslim obsession with regulating issues of sex often served to deprive women of their own sexuality by taking away their (sexual) agency, a practice that ideological advocates strive to uphold for a variety of reasons.

Iranian law has repressively violated the boundary between private and public, a practice that would be more conceivable in medieval times. The Islamic Republic of Iran's constitution devotes more than twenty articles to punishments for different sorts of gay and lesbian activities, and in the case of repeated intercourse, the death penalty is recommended.[52] Some have even been executed for the crime of seduction and being unchaste.[53] If for Baudrillard seduction simply meant a ritual or a game with signs, in today's Iran it is a game with death, a game with no clear rules.[54] This is a retreat not only from the Pahlavi era's notion of heterosexuality, but also from some of the medieval notions and presentations of homoerotic depiction as seen in some literary genres or the privately tolerated lesbian practice of *khahar khandegi* (sisterhood vows), *se'tari* (daring lesbian love), or *mosaheqeh* (lesbian sex). This is the most formidable contemporary obstacle for the realization of sexual agency.

Another relevant topic related to the debate on modernity is the related notion of the private life. Jürgen Habermas believes that a certain notion of subjectivity developed in eighteenth-century Europe when the bourgeois privatization of life occurred. When bourgeois homes included private rooms and private possessions it led to an acknowledgment of private needs.[55] Moreover, according to Habermas, the lucidity of the self attained and the existence of a safe private realm led to a critical debate about privacy in the public realm. The debate included the topics of self-government and representation, resulting in a central political power, urbanization, and national identity.[56]

These Habermasian notions should not be equated with universalism of the rationality he identified. Further, the notion that liberal culture was not the basis of democracy and a representative form of life does not seem to apply to Muslim societies, where any systematic challenge to gender inequality has occurred only after contact with West.

The powerful and competing ideological construction of the body, sexuality, and sexual identity in each of these historical periods in Iran led to the irregular

and iniquitous treatment of the sexual agency, the private, the individual, and the *woman space.*

To this date, the cultural authorities still refrain from discussing (hetero/homo/bio)sexuality in any serious way.[57] A great number of people are still inhibited and ignorant about the nature of sex. Popular culture still subverts the subject of sex, constantly and scandalously. And intellectuals, who are supposed to be important agents of constructive cultural change, have been baffled by ideologies that shy away from sexuality. As a result, in matters of rape, harassment, and sexism, men are treated in a rather indulgent manner. In fact, the situation has made men the subject and women (even those who support the patriarchy) the object.

As shown, these problems are not merely the products of the postrevolutionary period. The process of modernization began to deviate and indeed deteriorate in Iran even as it began, because, among other reasons, it did not belong to a historical exigency, economical stipulation, and grassroots movement. Because of ideological constraints, it did not gain mass support. And last, modernity was not imported, implemented, or emulated unequivocally or in its entirety.

Resistance to Ideology: It Is Now Modernity versus Ideology

In the postrevolutionary period, the opposition to the state ideological imposition on people's sexuality began in the late 1980s by women and later by unorganized, nonideological youth. These young people desperately seek a sexual identity in the midst of the country's continual struggle for and with modernity. The opposition manifests itself in a variety of forms including civil disobedience, support of promising reformers, and now and again audacious street and campus riots.

Women and Young Adults Are a Spectacular Force

Women in particular have challenged the restrictions through their achievements, and not only in literary areas. Female applicants for university seats comprised more than 60 percent of all applications. Women have won many battles in the areas of custody rights and divorce against a force that deprives them of these rights and restricts their travel. Progress has been made in life expectancy, fertility rates, and infant mortality. Women, however, still try to defend their (sexual) agency through the reinterpretation of existing codes of morality, laws, culture, and even the veiling codes.

Boys and girls in Tehran and other major cities roam the uptown streets to socialize with each other from their car windows and to text by cell phone, ignoring complaints of those who do not want potential promiscuity to be an added aspect of already-congested streets. The police, the vice squads, the religious conservative organizations—none of these can stop this global cultural development. It is simply not possible any longer to stop the youth, who are referred to as the children of revolution, from exploring their sexual identity somewhere, somehow.

These youths frequently pay handsome bribes to the pretentiously titled Organization of Propagation of Virtues and Prohibition of Vices. They do so when police storm their parties to prevent them from drinking and dancing. They ignore the state, its ideology, its force, and their parents. Prior to the revolution parents were more effectively the guardians of female chastity.

The fashion among young women to show hair by wearing the scarf back on the head, without making a knot under the chin, and to show a little skin above the ankle by wearing shorter pants demonstrates rising levels of social resistance and cultural dynamism.[58] This change, though disharmonious, is reflected in a general decline in faith. People readily joke about religious authorities and God.[59] Several surveys since the early 2000s have proved that fewer people practice religion and more people adhere to agnostic, mystical, nationalistic, Western, or secular thoughts.[60]

Music and dancing have not been squelched. In addition to listening to classical and contemporary music, many youth and adults have adopted newer dance styles and Iranian styles of dancing that have been developed in California, particularly the ones by Mohammad Khordadian, an exiled artist and founder of the Saba Dance Company who landed in prison during a visit to Iran in 2002. Others have created their own bands. Several bands led by singers such as Hichkas (meaning nobody), Motezad, Pishro, Lashkari, Shahriar, Falakat, Siavush, and Kiosk are now well known, and some have even been invited to perform in the United States and Europe by Iranian expatriates. Indeed, all of the members of Kiosk moved out of Iran and arranged a successful international tour, including a performance in San Francisco, which sold out a week beforehand. Music parties that feature break dance and rap music are sometimes held in gardens outside big cities.[61]

But perhaps the most far-out development is related to hymen technology. Reports and facts on the ground indicate that many women who lose their

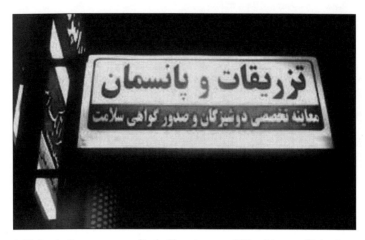

8. Today in Iran many medical office signs read like this one: "Injections and Stitching: Specialized Examination of Girls and Issuing the Certificate of Their Health" (*Payk-e Iran*). In such offices, they offer to repair the hymen (*golduzi*) and certify its intactness (*govahi*).

virginity prior to marriage choose to go through the procedure of *golduzi*, which is a technique to repair the hymen. This practice might, in the long run, help demystify the organ, and a demystified hymen along with freedom of dress may help achieve a level of sexual agency.

In this new milieu, some have even begun to notice the plight of women artists such as Shahrzad. Her recent harsh treatment by *Kayhan* is indeed a reaction to the recognition of her artistic talents, including her "ungodly" dance displayed on the Internet and YouTube. In short, Iranians now feel inspired by many aspects of Western living more directly, free of any specific ideological prism. They are in contact with people outside their own communities and cannot help but broaden their experiences.[62]

Proceed with Caution

These developments do not mean that ideological tensions surrounding the issues of modernity and sexuality are resolved or can be resolved easily with limited reform or even with a political revolution. There is no doubt in my mind that any future uprising and revolutionary movement will be highly marked by issues of gender and sexuality and by the presence and even leadership of young

women, but the work to normalize issues of sexuality will require ideological interludes and the demolition of dichotomies.

In fact, Iranian society is now in a critical and precarious condition in which even creative attempts at modernity are subverted by attacks on sexuality. The conservative faction and their numerous media outlets label every progressive measure as corruption, as a promotion of prostitution. In their eyes, every attempt at providing women with some more deserving space is tantamount with an immoral, depraved assault on their ideological principles and power.

For this reason, I would be cautious about celebrating the limited changes in people's views of sex and their rather more relaxed notion of sexual relations and intercourse as being a sexual revolution. Pardis Mahdavi's own account of Iran's sexual uprising contains many alarming tales. The changes are often unstable and unreliable and always "illegal." The perilous access to pornographic products from abroad and the existence of an Iranian type of porn industry (part of the cultural resistance) have had and continue to have an effect on many aspects of sexuality that are not regulated by modern laws and education, but they objectify women even further and place them at greater physical risk. The scope of pornographic activities is constantly on the rise. According to a report, 12 million people visited Iranian porn sites. One of the sites has had 25,000 visitors a day.[63] The impact of this not-so-underground and dangerous industry that is part of the cultural economy now has already been seen on women's social activities; every time a woman activist intends to express her true self, her modern aspiration, her feminine needs, she is also obliged to express a religiosity, a devotion, a piety, and even an anti-Western sentiment to avoid any possible labeling.[64]

Increases in other sexual activities have been reported, such as in oral and anal sex, which, practiced without proper education, can further harm women's health. These developments may also not be an immediate cause for celebration or as proof of some sort of sexual revolution in the making; they have unfortunately contributed to the rise in honor killings and women's suicide in ethnic areas in such provinces as Khuzistan and Kurdistan.[65] The variables most pertinent to this project are issues of sexuality and sex crimes. And sex crimes against women, reported in the newspapers, are indeed high. I attribute the increase in sex crimes (and some sorts of temporary marriages) for the most part to the negotiation of sexuality, dysfunctional and abusive relationships, and a

generational class identity crisis, in brief, due to the existing tensions related to ideology and sexuality.

Furthermore, women activists are forced to be more cautious and conservative in their appearance to avoid all sorts of labeling, a somewhat effective tactic to slow them down. The newspaper *Kayhan,* which represents the official views of the highest religious authorities in the country, printed this: "The women activists are promoting prostitution, homosexuality, unveiling, the idea of having multiple husbands, and all for overthrowing the Islamic Republic."[66] This statement further documents the ideological connection between sexuality, modernity, and women's issues in the mind of a fundamentalist. However, the accusations and women's defense mechanisms can have psychological effects, hindering their progress and limiting their accomplishments. These changes may not bring about the desired result of a sexual revolution even though some may call it so. Again, while the government tries to bring the public and private spaces under its ideological control, reports indicate that sexual crimes are on the increase.[67]

Finally, despite all the technological and external influences on the topic of modernity and sexuality, the traditional notion of women not only still defines the state ideological notion toward gender but also continues to create unprecedented problems among the populace. Conversely, masculinity is expressed in terms of virility and fertility and by maintaining ideological dominance. Social deterioration may take a dangerous turn.

So, the ruling elite has celebrated for nearly three decades the fall of the "pro-Western" regime who "facilitated" the corruption of the "innocent" indigenous culture of the country. *Kayhan* has been joyful over the peril dancers encountered. During these years, there has been no Shahrzad or Foruzan or any other star of FilmFarsi trying to excite men to gaze at burlesquing or whirling bodies. Googoosh has been silent or far from home. Pioneering singers such as Parvin and Elahe have died. Afat, Susan, and Jamileh have not been "the centers of attention." Therefore, this old ideological powerhouse has had its chances, but all it did was expedite corruption.

The puritanical pretention of the ideological advocates may actually explain the revival of the legacy of the popular artists through occasionally published materials, through some devoted Web sites, or in small expatriate communities. The older generation certainly maintains fading memories of these women, but the younger generation, somewhat less inhibited, now curiously examines photos

or video clips available here and there to get an idea about how their parents lived in the seventies.

Despite all this, for early performers such as Shahrzad, the struggles continue. Her letters and scattered writings in the decades after the revolution are filled with attempts to negate the misconstrued picture of her that was promulgated by the media, in cinema, in *Ferdowsi Magazine,* during her imprisonment, and in the short biographical note to her translated short story. *Kayhan,* which is supposed to be busy with battles that are more important, continues to report on her situation as a part of the oratory campaign against sex, oral or otherwise. The quest for modernity and civility is thus prolonged and the story of failure repeated.

More than a Century Ago

In the late nineteenth century, Zayn al-Abedin Maraghe-i described a similar conundrum perfectly in *Siyahat-name-ye Ebrahim Beg* (The travelogue of Ebrahim Beg).[68] According to the narrative, on the Russia-Iran border, Ebrahim Beg, the protagonist, shows excitement, love, and strong sentiment with the first sight of his homeland. He grasps a handful of dust and kisses it. From there, he and his tutor go eastward to the holy city of Mashhad. He finds the difference between his imagination of the place and the bitter reality of his native country dreadful.

Ebrahim Beg's streak of criticism begins here. In his tour of the holy places and in his meetings, no aspect of life is spared his sharp criticism. From Mashhad, Ebrahim Beg travels westward to Tehran, a trip that takes him thirty-six days. His observations in Tehran, the capital city, include the regrettable condition of the streets, railroads, army, offices, and people's general characteristics such as passivism and indifference and rotten administrative system. While traveling between and within cities, Ebrahim Beg comments on the wretched condition of the means of transportation, customhouses, police stations, industries, and hospitals and on the hypocrisy and illiteracy of government officials, police officers, beggars, clergymen, charlatans, and even ordinary people who tolerate a society plagued by backwardness, corruption, bribery, and lawlessness. Every step of the way, he expresses "regret for taking the excursion" or sorrow "to have been forced to face all these troubles."[69] Even before this travelogue was written, the 1905 free and powerful translation of James Justinian Morier's novel *The Adventures of Haj Baba of Ispahan* (1824) depicted some of the problematic and troubling aspects of the traditional and reticent culture that stood in the way of

modernity; the book criticizes Persia's abusive authorities and the mischievous clerical establishment.

In essence, these are the same contradictory conditions on which people in Iran and expatriates continue to comment, except that the kind of street people Ebrahim Beg or Haj Baba complain about, are, according to many critics, in power now and imposing their guarded culture on all citizens.[70]

To be sure, the inspiration of Taj al-Saltaneh (1884–1936), the daughter of Nasser al-Din Shah of the Qajar Dynasty, who asked for equality of men and women and freedom of veil, still resonates in women's writing today.[71] The face of the guard in charge of controlling women in a court reminds one of the bearded men on the streets of Tehran who are constantly hunting for so-called misveiled or improperly veiled women.

Of course, these calamities are not historically exclusive to societies such as Iran; Western societies have had their own peculiar predicaments. The problem with the case of Iran is that the dominant worldview with its notion of life, flesh, and carnal joy cannot address these social problems as effectively, appropriately, and democratically as can modern societies. This worldview is highly incongruous. Although a woman can easily be stoned to death for an "immoral" relationship, the authorities can come up with the idea of "houses of chastity," in which men can obtain a temporary wife for as short a time as several minutes.

Issues related to sexuality as well as the concepts of passion and love thus remain hampered by archaic social restrictions and conditions:

- Gender equality—by politics
- Sexual awareness—by lack of education and information
- Healthy sexuality—by religion
- Women's freedom—by sexual abuse and stoning
- Struggle against sex abuse—by one-sided man-made laws
- Sexual freedom—by overt significance given to virginity
- Freedom for healthy intercourse—by punishment
- Romance—by tradition
- Dance—by prohibitive rules
- Decent age of marriage and women's economy—by temporary marriage
- Women's psychological health—by male voyeurism and weakness
- Prostitutes—by drugs and harsh punishment

- Pornography—by heavy punishment
- Entertainment—by all sorts of restrictions
- Gay and homosexual rights—by taboos, cruelty, and penalties

The lack of knowledge and pervasive oppressive policies displayed by the ideological advocates tasked with dealing with these issues, and their unrealistic remedies, only widen the gap between a society ruled by radical views and the liberal West, which underscores the affinity of the discourses of modernity and sexuality. Needing to break through these dichotomies and compensating for the lack of the free flow of knowledge, the women's movement faces a greater task in its attempt for sexual equality.

Where to Go from Here

Iranian society has gradually arrived at the right conclusion about the characteristics of the movement necessary to break this deadlock. The point of departure for addressing these dilemmas should be a much greater and more serious debate (academic and otherwise) about the problems of mandatory veiling as a central issue related to sexuality. That is, veiling should not be debated as merely a human rights issue, a women's right, and a sheer religious or ideological topic. Its violent implementation cannot simply be dismissed through the principles of cultural relativism. It should be approached as a microcosmic representation of the broader problems related to sexuality.

The society will have to arrive at the conclusion that it cannot achieve modernity under ideological views that uphold mandatory codes on veiling and restrained sexuality as intrinsic and foremost social principles, that implement a medieval gender policy, and that insist that all other models of gender relationships and sexuality (Western and Eastern) are corrupt.

Once Again, the Veil

The veil or hejab itself can serve as the symbol of the tension between modernity and sexuality. The veil, for a long time, has significantly limited the possibility of personal recognition and the celebration of difference. It has slowed the development of individual and national identity. The freedom to express natural differences and diverse identities is essential for the success of modernity. In response to these limitations, which were caused initially by the veiling codes and other

limiting legislation, women had to struggle to become more active in literature, arts, and cinema, and in social realms. Defiance of the veiling mandates has now led millions of young women across the country to express themselves in other ways, including what is known as bad veiling (bad hejabi), colorful veiling, tight dresses, and many other variations that are frowned upon by the authorities.

At the same time, the veil and mandatory dress code have served the state ideology as so strong and constant a symbol that, I believe, the end of the veil will signify the end of the state as we know it.

Women's veiling is closely tied to the state's ability to exert power, to maintain its ideological posture in the face of the nonideological exigencies of a global economy and rapidly changing population. This explains the creation of endless rules, regulations, decrees, crackdowns, and organizations designed to ensure and enforce the continuity of the veil and the emergence of myriad publications that exist to justify the morality of the veil. Just between 1980 and 1990, more than 150 books with the word *hejab* in their title were published in support of the dress code. One may find numerous books and articles with the word *chador* (long head-to-toe veil) in their titles. Slogans and banners promoting the veil are of course visible throughout cities. And recently, software on the hejab and chastity has been produced. The program contains numerous speeches, documentaries, books, articles, and a searchable database on the views of the grand ayatollahs on the issue of the hejab.[72]

The mandatory veil thus has served as more than just a piece of dress:

• It has been a tool in organizing gender relations.

• It has been a tool in the creation of a society that is (intended to be) antagonistic to Western models.

• It has served as a tool against the renegotiation of female difference and identity.

The state has determined the veil is the battleground for the oppositional, albeit disorganized and sporadic, activities among women who seek more freedom and greater gender equality. Hundreds of thousands of them have clashed in one way or another with the regime's police and security forces on different occasions.[73] Advocates of modernity no longer can eschew, as they did in the prerevolutionary period, the issue of veiling or, for that matter, sexuality.

Sexuality has gained a central stage now even though cultural and political prohibitions do not allow for an open discussion of, say, the use of condoms or the psychological effects of improper sexual activities in which women no doubt have no room for the expression of desire. The future of modernity in Iran will very much depend on how these tensions are resolved. In other words, the challenge facing modernity is closely related to the challenge facing the women's movement, to reach women's agency to alter politics. Women's agency, somewhat achieved in literary works, is required in reality to answer questions about the future of a society, and that includes the future of its female dancers, singers, poets, and filmmakers.[74]

In modern societies, the history of sexuality is pertinent to contemporary life. Western thinkers who have researched and published on gender, sex, sexuality, and the family have in one way or another contributed not only to the development of the notion of the history of sexuality but also to the development and update of the modern legal system.

This legal system provides resistance to utter chaos and barbarism in the practice of sex. Yes, sexual sensibilities are different in different societies, and sexual culture changes rapidly everywhere, but sex is practiced in an enlightened way only if the connection between history, legal systems, and cultural approaches to the body are intact and updated regularly.

In other words, in societies where modernity has been achieved, bodily secretions tend to be the subject of self-control and self-discipline, whereas in places where modernity is constantly hampered, the body and human sexuality are the subjects of ideological, erratic control leading to further contortion of modernity and further harm to women's bodies.

Shahrzad's Daughters

In Shahrzad's story, we can see the result of censorship and codes of propriety and how the representation of sexuality in literature, cinema, and many other art forms has been smothered.

The images of horses wandering in the prairie in Shahrzad's poems and the women "thirsty for the sea" can be interpreted as symbols of the chaos or at least aimlessness that has plagued the society. The images of the endless deserts might represent the existing impediments to women's self-realization.

Following the movements of the horses and the thirsty women who age too quickly has been dizzying for me. So has been the struggle to understand Shahrzad's words that describe the deserts. Now that I think of it, Shahrzad's grammatical blunders, which I believed never affected her imagery, did exacerbate this sense of dizziness. This reminds me of what Jung conceptualized as "synchronicity," or the "meaningful coincidence of events at a single moment."[75]

The tension between the ideological notion of sexuality and the drive for modernity encompasses many of the problems that needed to be discussed in order to understand the relationship between Shahrzad's case and the overall social hierarchy in which she has lived and struggled. Iranians, and in particular Iranian women, will eventually provide a response, a strong response, perhaps a rebellious response, to so many dichotomies and contradictions imposed by pervasive ideological paradigms. And their response will certainly be informed by a progressive discourse on sexuality, one that collides with traditional resistance to modernity, evidence of which is abundant today. If novels and journalistic writings by Iranian women since the 1990s are an indication of anything, they no longer glorify poverty and ideology. For the young population, for pioneering Iranian women, for Shahrzad's daughters, that idealist discourse turned out to be reductive and mere slogans, to some extent lacking eloquence, nuance, variety, range, amplitude, tone, voice, and precision. Young Iranians instead crave freedom, civility, civil society, poetry, progressive laws and justice, and yes, rock bands, weblogs, and Western movies. Their parents, totally alienated, trusted the antimodernity discourse of their day and left their fate and freedom in the hands of ideologues. The current generation struggles to get its hands on the mechanisms that drive society and to steer Iran in a new direction.

Notes ～ Bibliography ～ Index

Notes

1. Academic Writing and Writing about Lives: An Introduction

1. The postrevolutionary authorities and Islamic judges used such terminology to define and condemn those who opposed the new regime.

2. Women's opposition to the compulsory dress code continued in a series of demonstrations in Tehran and other cities, and the first independent women's movement, large and loud, arose. Women continued to hold public meetings, marches, and street discussions, and violent encounters lasted for several days. Many women were wounded, and many were arrested. These events were reported in the journals *Ayandigan* (Mar. 8, 10, 11, 12, 14, 18 and 19, 1979) and *Ittila'at* (Mar. 8–12, 1979). The leftist opposition, particularly the larger organizations, did not officially support the women's movement. The Organization of Iranian People's Fada'i Guerrillas (OIPFG) and the Organization of People's Mojahedin of Iran (OPMI) had boycotted the rallies. They had decided not only to keep quiet on the issue of veiling but also on some occasions to condemn the women's demonstrations. For an analysis of these events, see Kamran Talattof, *The Politics of Writing in Iran: A History of Modern Persian Literature* (Syracuse, NY: Syracuse Univ. Press, 2000), chap. 4, 136–38. Oppositional organizations likely avoided getting involved because they believed that feminism was associated with bourgeois ideology and that independent women's movements would jeopardize the sense of unity necessary for the struggle against imperialism. In the end, despite those few memorable weeks and their bravery, women were deprived of their freedom of dress.

3. Nancy K. Miller, *Getting Personal: Feminist Occasions and Other Autobiographical Acts* (New York: Routledge, 1991), x.

4. Susanna Scarparo believes that the study of diaries, autobiographies, and correspondence and the reevaluation of the status of historical documents challenge the idea that only the lives and the deeds of the great deserve attention. This challenge is possible particularly because in many cases the documents relate to previously unknown women and, as such, stimulate a historiography based on what has been forgotten. Susanna Scarparo, *Elusive Subjects: Biography as Gendered Metafiction* (Leicester: Troubador, 2005), 89.

5. Elspeth Probyn, *Sexing the Self: Gendered Positions in Cultural Studies* (London: Routledge, 1993), 58–82.

6. See Virginia Woolf and Rachel Bowlby, *Orlando: A Biography* (Oxford: Oxford Univ. Press, 1992), xxi; and Scarparo, *Elusive Subjects,* xi.

7. Scarparo, *Elusive Subjects*, xii.

8. I should define the term *intellectual* as it will be used in this work. By an intellectual, I mean a person who reads about and follows the current political, social, cultural issues and who advocates (and often contributes to) a social discourse critical of the hegemonic powers, often in competition with other discourses. Such advocacy might result in unwanted consequences such as persecution in third-world countries. A famous prototype of an intellectual emulated by Iranians is Jean-Paul Sartre. Another, again French, is Régis Debray, a journalist and public figure, and his entourage who sat in the street side cafés in Paris, thinking and talking about world affairs—political, cultural, and revolutionary. He became most famous for writing a handbook on guerrilla warfare entitled *Revolution in the Revolution?* (1967) that for the first time theorized the Cuban revolution. When he was captured and imprisoned in Bolivia, many world politicians and personalities, including Jean-Paul Sartre, petitioned for and helped secure his release. In Iran, political activists, student activists, most poets, writers, journalists, and workers who pursue political activities fall into the category of intellectual.

9. Following Simone de Beauvoir's *The Second Sex* in which she wrote, "One is not born a woman, one becomes one," many Western scholars have investigated the ways people (women or men) are engendered through a variety of discourses and practices. Such an investigative approach is even more pertinent and more urgent in the case of countries such as Iran because there the engendering process involves ideologies, the state, the workplace, the public and private spaces, the economy, and the arts, so that gendered subjectivities are wholly institutionalized. The Western feminist critiques of Enlightenment phallogocentrism, of modernity's sexual difference, of the notion of the bourgeois formulation of gender equality are all irrelevant in the face of dire gender problems in Iran where people still can only dream of the bourgeois self and where all powerful ideologies task women with transgressing gender boundaries for the sake of securing man's masculinity.

10. I use the words *tradition, traditional,* and *traditionalist* to refer to those organized ideas that oppose change and modern ideas. It is true in Iran, as in many other cultures, that traditional culture also possesses many values that indeed can have constructive roles in a transformation process into a modern society.

11. Modernity, gender, and sexuality have been terms under negotiation among scholars of Western cultural studies. All three concepts are enormous and complex, and thus approached by scholars differently. None has disciplinary boundaries, and despite the frequent use of these terms, their interpretive significance cannot be pinpointed easily. For example, some scholars have pointed out that modernity might gain different meanings in different societies or it may be achieved in different ways in different societies. Other scholars distinguish between gender and sex by describing sex as the biological function (nature) and gender as the socially constructed self (nurture). Yet issues relating to transgendered or intersexual human beings subvert such categorical constructs. Nonetheless, I believe these categories, though contentious, are very useful conceptual realms for study of Iranian society. They have recorded the trajectory of social, cultural, political, technological, and artistic change in the world in the past several centuries.

12. The latter part of the next chapter offers an explanation of the distinctions between "popular arts," "high arts," "popular culture," and "high/elite culture."

13. On the validity of such an approach, see Henri Lefebvre, *Everyday Life in the Modern World* (New York: Harper and Row, 1971).

14. The topic has occupied a central position since the Constitutional Revolution of 1906–11 and continues to be a major point of contention among different political factions. To indicate the significance of this issue, I should add that every year witnesses the publication of a number of books and articles and at least one seminar or conference on modernity. Numerous activists, reformists, and intellectuals write and participate in such meetings. These include A. K. Sorush, Sara Shariati, Ahmad Ansari, Mostafa Malekiyan, Hosein Nasr, Y. E. Osareh, H. AghaJari, Hamid Rezad Jalaipur, Said Hajarian, Alireza Beheshti, S. B. Motlaq, Morad Farhadpur, A. Fanai, M. J. Kashani, Farshad Momeni, Morteza Mardiha, Yaser Mirdamadi, M. R. Nikfar, Mansoor Hashemi, H. Payman, H. Kashani, Hadi Khanyaki, B. Khoramshahi, Sorush Dabbagh, Mohammad Rasekh, Alireza Rajai, H. Sarajzadeh, Alireza Shojaizand, Ehsan Shariati, Bijan Abd Alkarimi, Abas Abdi, Alirezad Alavitabar, Rezad Alijani, Maqsud Farasatkhah, and Ebrahim Yazdi as well as such clerics as Masud Adib, Mohsen Kadivar, M. A. Abtahi, A. H. Panahiyan, and Said Bahmanpur. The next chapter will discuss some of these and other authors who have produced scholarly works about Iranian modernity, including A. Milani, A. Karimi-Hakkak, A. Mirsepassi, and others.

15. In these debates and also in regard to Iranian historical experiences, the words *modernization* and *modernity* are closely associated, and the latter is thought to help achieve the former. Westernization, historically, has been viewed as a way for non-Western countries to achieve both modernization and modernity. In the Iranian context, some equate all these words and some try to distinguish between modernity and modernization on the one hand and Westernization on the other, believing that Westernization is simply a limited measure to improve and update different aspects of society. Even if modernity is necessary for modernization, here I am indeed talking about modernity, which is no doubt related more to the Western world.

16. See David M. Halperin, *How to Do the History of Homosexuality* (Chicago: Univ. of Chicago Press, 2002). For Halperin, the history of sexuality is not the mere history of sexual classifications; it includes a history of human subjectivity. Through such an approach, Halperin considers ruptures, continuities, and identity in his study of the human experiences in time and space.

17. Generally, in such a society, contradiction affects artistic production, political development, economic expansion, and women's rights.

18. Caroline Brettell and Carolyn Fishel Sargent, *Gender in Cross-Cultural Perspective* (Upper Saddle River, NJ: Prentice Hall, 1997), 191, quoting Sherry Ortner and Harriet Whitehead, *Sexual Meanings: The Cultural Construction of Gender and Sexuality* (Cambridge: Cambridge Univ. Press, 1981), 1–29.

19. Michel Foucault, *The History of Sexuality,* trans. Robert Hurley (New York: Pantheon Books, 1978).

20. The works of Afsaneh Najmabadi, Camron Amin, Roy Porter, and Nikki Keddie will be discussed.

21. The recent publications regarding these topics include Willem Floor, *A Social History of Sexual Relations in Iran* (Washington, DC: Mage, 2008), and Pardis Mahdavi, *Passionate Uprisings:*

Iran's Sexual Revolution (Stanford: Stanford Univ. Press, 2009). According to Floor, Iran's contemporary problems related to sexual relations are not dissimilar to that of many other industrial nations—the challenge to the male claim to dominance over women, change in the age of marriage, premarital sex, rising divorce rates, rising promiscuity, prostitution, sexually transmitted diseases, homosexuality, and street children. In so many ways, the findings in Floor's *A Social History of Sexual Relations in Iran* support some of the contentions about the problematics of sexuality in Iran. In *Passionate Uprisings,* Mahdavi details the postrevolutionary changes in youths' attitudes toward sexuality, arguing that as a consequence of these changes "a new sexual culture is emerging among Iranian young adults that has captured the attention of the state" (8–9). Azadeh Moaveni writes, "Sooner or later, if you are an Iranian living outside, someone will inform you of all that you have been missing in the Islamic Republic: a sexual revolution behind closed doors, where young Iranians drop ecstasy, host backroom orgies, and generally put Amsterdam to shame." Similarly, Moaveni details many cultural changes regarding sex, partying, and drinking. See Azadeh Moaveni, "Sex in the Time of Mullahs," in *My Sister, Guard Your Veil; My Brother, Guard Your Eyes: Uncensored Iranian Voices,* ed. Lila Zanganeh (Boston: Beacon Press, 2006), 55–61. Most recently, Janet Afary's book strives to present the current dominant sexual polities in Iran as a modern construct. The book presents a history of Iran's so-called sexual revolution, which according to the author began in the nineteenth century and is still going on, indicating the desire for reforms in marriage and family laws and sexual relations. See Janet Afary, *Sexual Politics in Modern Iran* (Cambridge: Cambridge Univ. Press, 2009). I cannot, however, submit the notion that because of some past manifestation of sexuality, mostly the expression of the desire for young boys, Iran was not different from the West. Chapter 2 discusses this point. Moreover, because of the recent surge in sexual activities as a reaction to the social limitation, a sexual revolution in its Western meaning is going on Iran. As the conclusion shows, these changes may not necessarily result in positive development. The works of Mojgan Kahen and Azadeh Moaveni quoted in this book have informed my writing in terms of the effect of all these issues on the lives of women.

22. See Hossein Moazezinia, *FilmFarsi Chist* (Tehran: Nashr-e Sharq, 1999), 8. He also mentions that there is a French equivalent of this genre.

23. Kamran Talattof, "Iranian Women's Literature: From Prerevolutionary Social Discourse to Postrevolutionary Feminism," *International Journal of Middle East Studies* 29, no. 4 (Nov. 1997): 531–58.

24. Talattof, *Politics of Writing in Iran.*

25. Many other scholars have written about modern Persian literature and have written extensively about certain types of writing in certain periods of the modern history of Iran. Michael Beard and Nasrin Rahimieh have written about the early twentieth century; M. R. Ghanoonparvar and Rivanne Sandler have analyzed the literature of the sixties and seventies; and Michael Hillman and Farzaneh Milani have written on women's writings. M. R. Ghanoonparvar, similar to Ahmad Karimi-Hakkak, for example, pointed out the socially "prophetic" roles Iranian authors take for themselves. Homa Katouzian has offered analyses across time and genres, always contextualizing

the changes. In many ways, these scholars have all contextualized the works and have delineated historical boundaries within which they are produced, and they show the similarities between a certain number of literary products in certain time periods.

26. Challenging the notion of episodic literary movements, Fatemeh Keshavarz believes that Shamlu was still popular after the revolution; see *Recite in the Name of the Red Rose: Poetic Sacred Making in Twentieth-Century Iran* (Columbia: Univ. of South Carolina Press, 2006). This might be true, but at that time, Shamlu was mostly in the news for his political activities, for his present controversial comments about Ferdowsi, whom he called a "bastard," or simply for his past legacy. After all, he belonged to a group of leftist intellectuals whose vision had failed to gain the leadership of the mass movements. More pertinently, part of the crisis of poetry that rendered many of the prerevolutionary committed literary activists forgotten and even irrelevant was that the events of the revolutionary period and afterward were of such magnitude that only a novel could deal with them. Poetry seems incapable of responding to the needs of the time in portraying, depicting, or reacting to so many complex issues. The "I" in Shamlu's poetry no longer represented the masses whose lives were dramatically touched by the violent events of the Iranian revolution. That "I" was never terribly personal and was instead collective, one representing the prerevolutionary intellectual community.

27. Reza Barahani has written extensively on this topic. Also, the pages of literary journals such as *Adineh* and *Dunya-ye Shokhan* were filled with articles related to postrevolutionary poetry in an attempt to explain why poetry was in a crisis. I should also mention that an author may belong to more than one movement (Al-e Ahmad belonged to Persianism and committed literature, and Simin Behbahani belonged to both the committed literature and feminist literary movements).

28. More precisely, *Merriam-Webster* defines paradigm as "the concept of a philosophical and theoretical framework of a scientific school or discipline within which theories, laws, and generalizations and the experiments performed in support of them are formulated; *broadly*: a philosophical or theoretical framework of any kind."

29. See Kamran Talattof, "Comrade Akbar: Islam, Marxism, and Modernity," *Comparative Studies of South Asia, Africa and the Middle East* 25, no. 3 (Nov. 4, 2005), 634–49. I should add that these similarities exist in a variety of domains—from politics, economics, ideology, art, and literature to the political careers of players such as Rafsanjani. Most Middle Easterners did not perceive Marxism as a body of ideas and speculations about philosophy, history, economics, and politics developed by Karl Marx and Friedrich Engels in the mid–nineteenth century and modified by others later and were not familiar with its rich tradition in Europe. It was instead understood through limited access and censored materials, as an exact science and as sacred as religion, an understanding closer to Stalinist dogma.

30. All elements of modernity—whether developed before, during, or after the Enlightenment, Renaissance, and Industrial Revolution—such as rationalism, humanity, liberalism, reason, progress, democracy, capitalism, science, and sexual revolution developed in the West, leading me to conclude that modernity is Western in origin.

2. Modernity, Sexuality, and Popular Culture: Iran's Social Agony

1. The English suffix "oid" when combined with a noun makes a new word meaning something resembling the root noun (or having some of its specified qualities), such as humanoid or tabloid.

2. See Mark Bauerlein, "Henry James, William James, and the Metaphysics of American Thinking," in *America's Modernisms: Revaluing the Canon. Essays in Honor of Joseph N. Riddel,* ed. Kathryne V. Lindberg and Joseph G. Kronick (Baton Rouge: Louisiana State Univ. Press, 1996), 54, 55. Bauerlein goes on to explain that in this modernity, "Americans 'assimilate' and claim . . . property as 'ours'" (55).

3. See Mike Featherstone, "In Pursuit of the Post-Modern," *Theory, Culture, and Society* 5 (1988). For a more detailed discussion of Featherstone's views, see Elizabeth Frazer and Nicola Lacey, *The Politics of Community: A Feminist Critique of the Liberal-Communitarian Debate* (New York: Harvester Wheatsheaf, 1993).

4. Farzin Vahdat analyzes early-modern intellectual movements in Iran and identifies a theoretical argument about the position of the subject in relation to God that contributed to a continuous tension between emancipation and domination. Vahdat sees this tension "rooted in pre-Islamic monotheism." His juxtaposition of European theorists such as Kant, Hegel, Marx, and Habermas with Iranian thinkers such as Amir Kabir, Malkum Khan, Mirza Aqa Khan Kermani, Mirza Fathali Akhundzadeh, and Abd al-Rahim Talebuf reveals only a few similarities between the two groups' understanding of modernity. Farzin Vahdat, *God and Juggernaut: Iran's Intellectual Encounter with Modernity* (Syracuse, NY: Syracuse Univ. Press, 2002). Abbas Milani argues that an "Iranian modernity" has, in fact, appeared in several different eras, including the times of Sa'di, the Safavids, and the Qajars. He also diligently looks for the expression of modern ideas in Iranian historical narratives. See Abbas Milani, *Lost Wisdom: Rethinking Modernity in Iran* (Washington, DC: Mage Publishers, 2004). Ali Mirsepassi summarizes well the various theoretical approaches to modernity. "The liberal tradition of modernity (Montesquieu, Hegel, Weber, Durkheim, Orientalism) privileges Western cultural and moral dispositions, defining modernity in terms of Western cultural and historical experiences," he writes. And, "A more radical vision of modernity (as articulated by Marx, Habermas, Giddens, Berman) envisions modernization as a practical and empirical experience that liberates societies from their oppressive 'material' conditions." See Ali Mirsepassi, *Intellectual Discourse and the Politics of Modernization: Negotiating Modernity in Iran* (Cambridge: Cambridge Univ. Press, 2000), 2. Analyzing the ideas of the Hegelian, Marxist, "Orientalist," and the "othering" approaches of Bernard Lewis and Samuel P. Huntington, Ali Mirsepassi, one of the most avid researchers of modernity in Iran, maintains that the 1979 Iranian Revolution was not a clash between modernity and tradition but, rather, an attempt to accommodate modernity within Islamic identity as well as within Islamic cultural and historical experiences (ibid.). He writes, "The ideology of the Iranian Revolution, when viewed in detail, emerges less as a monolithic clash between 'modernity' and 'tradition,' than as an attempt to actualize a modernity accommodated to national, cultural and historical experiences" (13). In a similar way, Zohreh T. Sullivan argues that the question of modernity in Iran did not lead to a dichotomization of traditional and modern. See Zohreh T. Sullivan,

"Eluding the Feminist, Overthrowing the Modern? Transformations in Twentieth-Century Iran," in *Remaking Women: Feminism and Modernity in the Middle East,* ed. Lila Abu-Lughod (Princeton, NJ: Princeton Univ. Press, 1998), 215.

5. See Afsaneh Najmabadi, "Iran's Turn to Islam: From Modernism to a Moral Order," *Middle East Journal* 41, no. 2 (Spring 1987): 205–07.

6. Ibid.

7. Mehrzad Boroujerdi offers a somewhat more historical argument. He traces Iranian modernity back to the "time of Shah Abbas in the sixteenth century" and, concurring with Mangol Bayat, writes that early Iranian intellectuals "attached various amendments and conditions" to European modernity. See Mehrzad Boroujerdi, "The Ambivalent Modernity of Iranian Intellectuals," in *Intellectual Trends in Twentieth-Century Iran: A Critical Survey,* ed. Negin Nabavi (Gainesville: Univ. Press of Florida, 2003), 13–14. He also writes, "Even within the confines of a bona fide theocracy such as that of present day Iran, however, modernity's compulsive and restless presence can be easily detected." See Mehrzad Boroujerdi, "Iranian Islam and the Faustian Bargain of Western Modernity," *Journal of Peace Research* 34, no. 1 (Feb. 1997): 3. Referring to what he terms "authoritarian modernity," he further writes, "Regardless of the debates, modernity has already established itself in such domains as architecture, education, graphic arts, and urban development as well as in social and political institutions" (ibid.) Boroujerdi is responding to Samuel Huntington, who stated, "The central axis of world politics in the future is likely to be . . . the conflict between 'the West and the Rest' and the responses of non-Western civilizations to Western power and values" (ibid., quoting Samuel P. Huntington 1993). In brief, Boroujerdi believes that Iran achieved modernity in some areas but failed to become completely modern because of contradictions in Reza Shah's ideas which led him to purse a sort of "imperious modernity." See Mehrzad Boroujerdi, "Faraz va Nashib-haye Modern Garai Ameraneh," *Iran Nameh* 20, no. 4 (Fall 2002): 475–88.

8. Janet Afary believes that the country is now in many regards a modern nation. See Janet Afary, "Gozar az Mian-e Sakhreh va Gerdab: Degarguni Naqsh-e Zan va Mard dar Iran-e Qarn-e Bistom," *Iran Nemeh* 15, no. 3 (Summer 1997): 365–87. Dariush Homayoun studied the history of modernization in Iran during the Pahlavis and asserts that Iran before the revolution was to some extent modern and that the 1979 Revolution was an antimodern development. He also opposes the concept of an "indigenous modernity." See Dariush Homayoun, "Paykar-e Iran ba Tajadod," *Iran Nameh* 19, no. 3 (Summer 2001): 355. Ramin Jahanbegloo tries to offer a practical definition of modernity and believes that Iran constitutes a "modernity which is not yet modern." See Ramin Jahanbegloo, *Iran va Modernite: Goftgu hai ba Pazhuheshgaran-e Irani va Khareji dar Zamineh Ruyarui Iran ba Dastavard haye Jahan-e Modern* (Tehran: Goftar, 2000), 25. Mahmud Enayat also thinks that Iran was modern in some areas (such as civilization and representation) but not in other areas (such as democracy and freedom). See Mahmud Enayat, *Enqelab va Roshanfekran* (Los Angeles: Sarnevesh, 1971), 47. Mohamad Tavakoli-Targhi believes that, in contrast to Max Weber's assertions, modernity is not the product of Western rationality but a product of interaction between cultures and peoples from all over the world. See Mohamad Tavakoli-Targhi, *Tajadod Bumi va Bazandishi-e Tarikh* (Tehran: Nashr-e Tarikh-e Iran, 2002), 7. Weber was the first to locate modernity's starting

point in sixteenth-century England, where religious radicals established the first modern political nation. See Max Weber, *The Protestant Ethic and the Spirit of Capitalism* (New York: Scribner, 1958). However, Tavakoli-Traghi's views on the contributions of Iran resonate with views presented in Timothy Mitchell's edited volume *The Questions of Modernity*, in which the contributors show little belief in the eventuality of history or inevitability of reason. Mitchell argues that the modern arose through the interaction between West and other, in areas such as modern industrial organizations, nationalism, and even the field of British literature. He writes, "If modernity is defined by its claim to universality, this always remains an impossible universal." See Timothy Mitchell, *The Questions of Modernity* (Minneapolis: Univ. of Minnesota Press, 2000), xiv.

9. Elsa Chaney and Marianne Schmink believe that women in the third world are downtrodden and that capitalist development can help them improve their situation; women's economic and social status can be enhanced by an increase in female participation in the labor force. See Elsa Chaney and Marianne Schmink, *Women and Development: Access to Tools* (New York: Chaney, 1974); and see their contributions in June Nash and Helen Safa, *Sex and Class in Latin America: Women's Perspectives on Politics, Economics, and the Family in the Third World* (New York: J. F. Bergin Publishers, 1980). Ester Boserup argues that women experience a decline in their relative status within settled agricultural communities in the course of economic development. Boserup called for the inclusion and consideration of the significance of productive women laborers in the development process, leading the way for the recognition of women in the development approach. See Ester Boserup, *Women's Role in Economic Development* (New York: St. Martin's Press, 1970), 53. Her views have been used widely to address inequalities between women and men. (For an analysis of Boserup's work, see Frances Vavrus and Lisa Ann Richey, "Women and Development: Rethinking Policy and Reconceptualizing Practice," *Women's Studies Quarterly* 31, no. 3–4 (Fall-Winter 2003): 6–18. She does so by suggesting that colonialism and development have introduced "a structure and ideology of male domination." See Eleanor Burke Leacock, *Myths of Male Dominance* (New York: Monthly Review Press, 1981); or Brettell and Sargent, *Gender in Cross-Cultural Perspective,* 507.

10. Addressing this simple question in regard to Turkey, Alev Cinar adopts the mode of alternative modernities, contrary modernities, or creative modernities, arguing that both the founding state ideology and its current challenger, "Islamists," are different modes of modernization. See Alev Cinar, *Modernity, Islam, and Secularism in Turkey: Bodies, Places, and Time* (Minneapolis: Univ. of Minnesota Press, 2005), 1–5. My question about Turkey's modernity, whatever it might be, is whether it can be protected without force and military intervention. Eisenstadt suggests the idea of "multiple modernities" to contrast both Francis Fukuyama's "end of history" and Samuel P. Huntington's "clash of civilizations." See S. N. Eisenstadt, "Multiple Modernities in an Age of Globalization," *Canadian Journal of Sociology/Cahiers canadiens de sociologie* 24, no. 2 (Spring 1999): 283–95. Fukuyama's phrase is from the title of his famous book, *The End of History and the Last Man* (New York: Maxwell Macmillan International, 1992), in which he argued that triumphal capitalism is the only remaining legitimate ideology in the world. For information on "authoritarian modernity," see Touraj Atabaki and Erik Zürcher, eds., *Men of Order: Authoritarian Modernization under*

Atatürk and Reza Shah (London: I. B. Tauris, 2004). Finally, the concept of creative modernity might be somewhat redundant. Creativity, or more precisely, innovation, has always been a core concept of modernity since its conception, and it is not solely realized through education, hard work, and precise management.

11. See Reinhart Kössler, "The Modern Nation State and Regimes of Violence: Reflections on the Current Situation," *Ritsumeikan Annual Review of International Studies* 2 (2003): 15–36.

12. See Allan Pred and Michael Watts, *Reworking Modernity: Capitalisms and Symbolic Discontent* (New Brunswick: Rutgers Univ. Press, 1992), xiv. To be sure, the Commission on Growth and Development's 2008 report indicates that the thirteen countries that sustained high growth have emulated a number of important steps and measures in the past several decades, and they all have acknowledged or helped the urbanization of their societies and have had modernized institutions to carry their plans through. See the report at Finfacts Team, Commission on Growth and Development Report, http://www.finfacts.com/irishfinancenews/article_1013683.shtml (May 23, 2008).

13. In regard to the issue of translation, see Faridun Adamiyat, *Andishah-i Taraqi va Qukumat-i Qanun-i Asr-E Sepahsalar* (Tehran: Khvarazmi, 1973), 210–12.

14. There are many other informative works devoted to the definition of modernity. See, for example, Leszek Kolakowski, *Modernity on Endless Trial* (Chicago: Univ. of Chicago Press, 1990); Anthony Giddens, *The Consequences of Modernity* (Stanford, CA: Stanford Univ. Press, 1990); Bryan Turner, *Theories of Modernity and Postmodernity* (London: Sage, 1990); Marshall Berman, *All That Is Solid Melts into Air: The Experience of Modernity* (New York: Viking Penguin, 1982); Anthony J. Cascardi, *The Subject of Modernity* (Cambridge: Cambridge Univ. Press, 1992); Matei Calinescu, *Five Faces of Modernity* (Durham, NC: Duke Univ. Press, 1987); Rita Felski, *The Gender of Modernity* (Cambridge, MA: Harvard Univ. Press, 1995); Jürgen Habermas, *The Philosophical Discourse of Modernity: Twelve Lectures,* trans. Frederick Lawrence (Cambridge, MA: MIT Press, 1987); Stuart Hall, David Held, Don Hubert, and Kenneth Thompson, eds., *Modernity: An Introduction to Modern Societies* (Cambridge, MA: Blackwell, 1996); John Jervis, *Exploring the Modern* (Oxford: Blackwell, 1998); Scott Lash and Jonathan Friedman, eds., *Modernity and Identity* (Oxford: Blackwell, 1992); Stephen Toulmin, *Cosmopolis: The Hidden Agenda of Modernity* (New York: Free Press, 1990); Charles Taylor, *Sources of the Self: The Making of the Modern Identity* (Cambridge, MA: Harvard Univ. Press, 1989).

15. Only in the twenty-first century have Iranian intellectuals (most still contradictorily, arbitrarily, or religiously) started thinking and somewhat discussing the teachings of David Hume (1711–76), John Locke (1632–1704), Thomas Hobbs (1588–1679), John Stuart Mill (1806–1873), and other Enlightenment and early modern thinkers. Only in recent years have they discussed the necessity for a civil society, democracy, pluralism, and elections. Prior to this, intellectual discussions were mostly centered on the applicability of Cuban, Chinese, or Algerian models to Iran.

16. In a sense, the Iranian critique of modernity does not seem to have surpassed the moral, economical, and philosophical criticism of modernity forwarded by Durkheim, Weber, Hegel, Nietzsche, and Marx who share a series of social theories that came into existence in response to the development of modern societies.

17. These contradictions and discontinuities are not limited to the tensions between modern thinking and traditional sexuality. They include many aspects of life, such as urban development, architectural change, industrial expansion, issues related to daily life such as entertainment, appearance, courtship, outing, dating, and so on. This is different from modernity's "constant and reflexive auto-innovative quality." See Barry Smart, *Facing Modernity: Ambivalence, Reflexivity and Morality* (Thousand Oaks, CA: Sage, 1999). There are also a number of informative articles in *On Continuity,* ed. Rosamund Diamond and Wilfried Wang (Cambridge, MA: 9H Publications, 1995). On the issue of architecture, see Cecil Keeling, *Pictures from Persia* (London: R. Hale, 1947), 166.

18. Bruno Latour shows that all these realms are interconnected. Bruno Latour, *We Have Never Been Modern,* trans. Catherine Porter (Cambridge, MA: Harvard Univ. Press, 1993). In the words of Andrew Pickering, "Latour argued that by following scientists and engineers around one could see that science, technology, and society were continually coproduced in a process of the reciprocal tuning of facts, theories, machines, human actors, and social relations. This actor-network analysis flew in the face of technological and social determinist perspectives (technological change causes and determines social change, or vice versa)." See Andrew Pickering, "We Have Never Been Modern," book review in *Modernism/Modernity* 1, no. 3 (1994): 257–58. To these, I should add another point about Christianity. In *The Victory of Reason: How Christianity Led to Freedom, Capitalism, and Western Success,* Rodney Stark argues and shows that elements of the Christian faith resulted in "visions of reason and progress" as well as "the evolution of capitalism." Stark boldly asserts that Christianity is a "forward-looking" religion that offers a "faith in progress," allowing its followers to understand God over time. He writes, "But, if one digs deeper, it becomes clear that the truly fundamental basis not only for capitalism, but for the rise of the West, was an extraordinary faith in *reason.*" See Rodney Stark, *The Victory of Reason: How Christianity Led to Freedom, Capitalism, and Western Success* (New York: Random House, 2005), ix–xvi. See also Rodney Stark, "How Christianity (and Capitalism) Led to Science," *Chronicle of Higher Education* 52, no. 15 (Dec. 2, 2005): B11. In such a way, Stark also rejects the Weberian notion that the roots of capitalism are in the Protestant Reformation; he traces these roots further back to Catholicism of the dark ages. In fact, he locates the roots of democracy in Christianity by arguing that St. Paul's view of all Christians as equal in God's sight was the source for modern notions of equality. Furthermore, he claims that before ideas of individualism were codified in the English Bill of Rights and before the Reformation, the writings of Augustine and Aquinas had helped shape the concept of individual property rights. See Stark, *Victory of Reason,* ix–xvi; and Stark, "How Christianity (and Capitalism) Led to Science," B11. One may not agree with such a radical revision of history, but if there is any truth in some of Stark's notion of Christianity, why should its logic not be considered for adaptation by Muslim theologians? Even if we dismiss Stark's point, Phyllis Trible has successfully challenged the persisting notion that women are a weaker sex in Biblical passages. She does so through a textual and rhetorical analysis showing that the creation of the woman is the climax of the story of Genesis. See Phyllis Trible, *God and the Rhetoric of Sexuality* (Philadelphia: Fortress Press, 1978). Also see Malcolm Bradbury and James McFarlane, *Modernism, 1890–1930* (Harmondsworth: Penguin, 1976).

19. Schiesari and Migiel write, "If the Renaissance once meant the flowering of great works by great men in the expression of a *Geistesgeschichte*, Marxism and feminism have taught us that individual freedom and self-expression were not available to all subjects at the time. And while the Renaissance once meant the advent of the "individual," feminism and psychoanalysis now require that we question how individuality has been predicated on an unspoken hierarchy of differences. Such theoretical and political discourses have recast our understanding of Renaissance culture and civilization in ways that are as irrevocable as they are provocative of further debate." See Marilyn Migiel and Juliana Schiesari, *Refiguring Woman: Perspectives on Gender and the Italian Renaissance* (Ithaca, NY: Cornell Univ. Press, 1991), 2–3. Also, even Japanese society, which has been perceived as a modernization success story that, according to opponents of the "blueprint," did not progress through all of these historical phases of Western modernity, includes these constructs. For information on Japan's modernization, see C. C. Black, *The Dynamics of Modernization: A Study of Comparative History* (New York: Harper and Row, 1966).

20. Faridun Adamiyat, *Andishe-ha-ye Mirza Aqa Khan Kermani* (Tehran: Tuhuri, 1978), 267.

21. Iran baayad zaheran, batenan, jesman, va ruhan farangi ma'aab shaved va bas Sayed Hasan Taqizadeh, "Dore Jadid," *Kaveh* 5, 36 (1920), cited in Mohamad Tavakoli-Targhi, "Tajadod, Tamadon Ariyati, va Enqelabe Ruhaani," *Iran Nameh* 20, no. 2–3 (Spring-Summer 2002).

22. See Berman, *All That Is Solid Melts into Air,* and *The Politics of Authenticity: Radical Individualism and the Emergence of Modern Society* (New York: Atheneum, 1970); see also Mirsepassi's work for an analysis of Berman's theories. The views of Zygmunt Bauman may be categorized along with those of Berman and Habermas, in that they focus on the "negative" aspects of the modernization project outside the Western world; see Bauman, *Modernity and Ambivalence* (Ithaca: Cornell Univ. Press, 1991).

23. Hamid Algar, *Mirza Malkum Khan: A Study in the History of Iranian Modernism* (Berkeley: Univ. of California Press, 1973), 28–34.

24. Ahmad Kasravi, *Khaharan va Dokhtaran-e Ma* (Tehran: Payman, 1945), 5. Kasravi refers to Adalat's humor section in *Sohbat,* which was published in the city of Tabriz.

25. Ibid., 15. He concludes that Europe's understanding of women is similar to that of Iranian religious clerics.

26. Jalal Al-e Ahmad, *Gharbzadigi* [Plagued by the West] (Tehran: Ravaq, 1978).

27. Simin Daneshavar, *Beh Ki Salam Konam* [To whom can I say hello] (Tehran: Kharazmi, 1986), 53–74. For more detailed analysis of this short story, see Talattof, *Politics of Writing in Iran,* chap. 3.

28. To be sure, several Iranian scholars have contemplated the relationship between the question of modernity and gender. Afsaneh Najmabadi has noted the centrality of gender to the conceptualization of beauty, love, homeland, marriage, education, and nationalism, all of these being essential to the formation of a "modern culture and politics," yet Iran remains a patriarchal society. Afsaneh Najmabadi, *Women with Mustaches and Men without Beards: Gender and Sexual Anxieties of Iranian Modernity* (Berkeley: Univ. of California Press, 2005). New conceptualizations of beauty (as divine and religious), love (as sacred), homeland (Islamic), marriage (absolutely medievalist with

polygamy and lowered age limits), education (halted for a decade), and nationalism (again in the opposition) then emerged with the 1979 Revolution, rendering conceptualizations of Qajar modernity obsolete. Camron Amin too has explored the issue of modernity and gender and has identified marriage, motherhood, women's education, and civic participation as the four acceptable categories of women in prerevolutionary Iran. He believes that the availability of just these four categories in the gender debate led to a dichotomy of modern/good/educated woman versus traditional/bad/illiterate woman. Camron Michael Amin, *Making of the Modern Iranian Woman: Gender, State Policy, and Popular Culture, 1865–1946* (Gainesville: Univ. Press of Florida, 2002), 48, 70–72. The Western egalitarian feminist movement included trends that supported gender equality and trends that emphasized issues related to sexuality. See Eliz Sanasarian, *The Women's Rights Movement in Iran: Mutiny, Appeasement, and Repression from 1900 to Khomeini* (New York: Praeger Press, 1982), 79, 75.

29. This has occurred in Arab societies as well. See Ellen Fleischmann, "Nation, Tradition, and Rights: The Indigenous Feminism of the Palestinian Women's Movement, 1929–1948," in Ian Christopher Fletcher, Laura E. Nym Mayhall, and Philippa Levine, eds., *Women's Suffrage in the British Empire: Citizenship, Nation, and Race* (London: Routledge, 2000), 138–54.

30. See Talattof, "Iranian Women's Literature," 531–58.

31. See more below regarding the Nazi's policies.

32. Amy Richlin, *Pornography and Representation in Greece and Rome* (New York: Oxford Univ. Press, 1992).

33. A number of scholars have referred to recent changes in sexual activity in Iran as a sexual revolution. As we will see in the final chapter, the changes seem instead to be leading to sexual chaos with potentially dangerous results. Moreover, the diverse range of sexual and sexual practices and aesthetic exploration of identity in terms of sexuality and gender in the West are best comprehensible when placed in the context of sexual freedom of the post-Kinsey contraceptive methods and pre-AIDS era.

34. In the 1930s, science did not include an open discussion of "orgasm." Reich's work launched the discussion of the function of orgasm and its social role. For more information, see James DeMeo, *On Wilhelm Reich and Orgonomy* (Ashland, OR: Organ Biophysical Research Laboratory, 1993).

35. See, for example, Roy Porter, "Is Foucault Useful for Understanding Eighteenth and Nineteenth Century Sexuality?" in *Debating Gender, Debating Sexuality*, ed. Nikki Keddie (New York: New York Univ. Press, 1996), 247–68.

36. See Hannah Tavares, "Education/Desire," *Theory and Event* 1, no. 2 (1997): 6, 104–5.

37. See Daniel Juan Gil, "Before Intimacy: Modernity and Emotion in the Early Modern Discourse of Sexuality," *ELH* 69, no. 4 (Winter 2002): 861–87.

38. See Jonathan Goldberg, ed., *Queering the Renaissance* (Durham, NC: Duke Univ. Press, 1994), 4.

39. In the West, debates about the female body and sex might still be controversial and divisive when they overlap with the discussion of women's liberation, especially when sexuality is associated with sexual violence. Many feminists believe that Euro-American heterosexuality still emphasizes "male pleasure and female restraint." Rose Weitz, *The Politics of Women's Bodies: Sexuality,*

Appearance, and Behavior (Oxford: Oxford Univ. Press, 2003), x. Western scholars have debated the relations between the female body and the prevalent social practice of sex, pornography, prostitution, escort services, erotic dancing and shows, phone and Internet sex, and so on. On prostitution, see Carole Pateman, *The Sexual Contract* (Stanford, CA: Stanford Univ. Press, 1988); Nils Johan Ringdal, *Love for Sale: A World History of Prostitution* (New York: Grove Press, 2004); and Laurie Shrage, *Moral Dilemmas of Feminism: Prostitution, Adultery, and Abortion* (New York: Routledge, 1994). A plethora of information is now available on these topics and about female sexuality, masturbation, and female-oriented sex as well about politics, power, pleasure, and desire. In other words, "ideas about women's bodies [that] have centrally affected the strictures within which women live" are all under constant scrutiny in the West. See Weitz, *Politics of Women's Bodies*, 10. Yet "Western" modernity has created means and measures for changing these ideas constantly not only through scientific but also through legal processes. For example, sexual crimes and sexual harassment in the West are reported when they occur and are not censored. The reports become the subject of extensive research as well. See Dean D. Knudsen and JoAnn L. Miller, *Abused and Battered: Social and Legal Responses to Family Violence* (New York: A. de Gruyter, 1991). Victims are supported by many institutions and not viewed as culpable or part of the problem like in today's Iran. The media does not differentiate in their exposure of sexual violence, crime, and misconduct; the more powerful the perpetrator, the more relentless the journalists are in their fact-finding. The definitions of the crimes and misconducts and misbehavior are clear. See Clara Bingham and Laura Leedy Gansler, *Class Action: The Story of Lois Jenson and the Landmark Case that Changed Sexual Harassment Law* (New York: Doubleday, 2000). Workplaces publish brochures, guidelines, rules, and written materials on facts about sexual harassment and the law does not discriminate. During the 1960s and 1970s, new generations in many Western countries enjoyed increased access to all sorts of media and responded with attitudes and behaviors that changed their societies; these include the hippie movement, psychedelic shows, *Easy Rider* culture, and Woodstock. In the same period, Iran was supposed to be in a process of modernization or Westernization; however, those Western attitudes and behavior had very little, if any, impact on Iranian society. They were represented only in certain theaters in certain big cities and to certain young men and women who were inspired by the Western forms. Further, the underlying messages and lessons of these Western counter-cultural phenomena and their ramifications were never transferred and presented to their Iranian consumers. In a bizarre way, Iranian intellectuals even took them as representative of Western modernity itself and used them in their argument for a revolution to create a socialist society or at least oppose liberalism. The statement "corrupt Western culture" (*farhang-e monhat-e gharbi*) became a strophic line in the journals published by both leftist and rightist advocates.

40. Ann Rosalind Jones, "Writing the Body: Toward an Understanding of 'L'Ecriture Feminine,'" *Feminist Studies* 7, no. 2 (Summer 1981): 247–63.

41. Jean Walton, *Fair Sex, Savage Dreams: Race, Psychoanalysis, Sexual Difference* (Durham, NC: Duke Univ. Press, 2001).

42. See Barbara K. Gold, Paul Allen Miller, and Charles Platter, eds., *Sex and Gender in Medieval and Renaissance Texts: The Latin Tradition* (Albany: State Univ. of New York Press, 1997).

43. Albrecht Classen, ed., *Eroticism and Love in the Middle Ages,* 5th ed. (New York: Thomson Custom Publishing, 2004).

44. Albrecht Classen, "Women in Martin Luther's Life and Theology," *German Studies Review* 14, no. 2 (May 1991): 231, 232. For further information on the topic of sex and sexuality in medieval Europe, see also Classen, *Eroticism and Love in the Middle Ages.*

45. For an extended analysis of this work, see the writings of Michelle Bolduc, particularly "The *Breviari d'Amor:* Rhetoric and Preaching in Thirteenth-Century Languedoc," *Rhetorica: A Journal of the History of Rhetoric* 24, no. 4 (Autumn 2006): 403–26.

46. Ahman Kasravi, Khaharan va Dokhtaran-e Ma, 26.

47. See IRI Penal Code, articles 109–37. See also Armen Rouzbahani, *From Islamic Penal Codes of Islamic Republic of Iran* (Glendale, CA : New Horizons, 2002). For a rare glimpse into the culture and consequences of polygamy in Iran, see *Four Wives—One Man* (Nahid Persson, dir., Iran, Sweden, 2007). Nahid Persson's outrageous portrait of a number of outspoken people brought together by the act of polygamy is exasperating and revealing. It illustrates the awkwardness, primitiveness, and even brutality of the culture surrounding the concept of polygamy, actively promoted by the regime in the postrevolutionary period. The film is impressive in the sense that it has captured not only the fleeting happiness of the wives and their everlasting victimization, but also the expression of manliness, virility, and masculinity in a confessional, naked, and frank language.

48. Dagmar Herzog, *Sexuality and German Fascism* (New York: Berghahn Books, 2004), 4. In the same volume, Erik Jensen's article is another testimony in the Western connection between sexuality, postwar thoughts of revenge, redemption, and political liberation in Germany. See Erik Jensen, "The Pink Triangle and Political Consciousness: Gays, Lesbians, and the Memory of Nazi Persecution." The article explores the relationships between sexuality, postwar thoughts of revenge, redemption, and political liberation in Germany.

49. This backlash will be explained in detail in chapter 4.

50. The last two chapters present some facts about these segregating policies and the ideologies that justify them.

51. Florence Babb, "Incitements to Desire: Sexual Cultures and Modernizing Projects," *American Ethnologist* 31, no. 2 (2004): 225–30.

52. For more relevant information about historical and Western architecture in Iran, see Jafar Shahri Baf, *Tarikh-e Ejtimai-e Tehran dar Qarn-e Sizdahom: Zindagi, Kasb va Kar* (Tehran: Intesharat-e Ismailiyan, 1988); D. Fairchild Ruggles, *Women, Patronage, and Self-Representation in Islamic Societies* (Albany: State Univ. of New York Press, 2000); and John Elder, *History of the Iran Mission* (Tehran: Literature Committee of the Church Council of Iran, 1960).

53. The architectural paradigmatic response is more chaotic than in some other fields. The response to Western and particularly American high-rise buildings is pursued via the example of Dubai architectural development as well as conditioned by many rules and regulations or the lack of rules and regulations and mere profiteering and rentier cultures dominant in this sector.

54. Diana Robin, "Woman, Space, and Renaissance Discourse," in Gold, Miller, and Platter, *Sex and Gender in Medieval and Renaissance Texts,* 166.

55. Floor, *A Social History of Sexual Relations in Iran*.

56. Sirus Shamisa, *Shahed Bazi dar Adabiyat-e Farsi* (Tehran: Firdaws, 2002).

57. Lester Allen Kirkendall, *Helping Children Understand Sex* (Chicago: Science Research Associates, 1952), trans. Mehdi Jalali as *Amuzish-i Jinsi-i Atfal* (Tehran: Bungah-i Matbuati-e Safi-alishah, 1952). Kirkendall, a sociologist by training, began teaching sex education in 1928 and subsequently wrote profusely, including a draft of the American Humanist Association's "Bill of Sexual Rights and Responsibilities" in 1976. I believe this was his only book translated into Persian.

58. In the 2000s, a few new translations of materials related to sex education have appeared on the book market. See Mahyar Azar, *Bulugh-e Jesmi, Ruhi, va Ravani dar Dokhtaran* [Female physical, emotional, and psychological puberty] (Tehran: Nur-e Danesh, 2003); and *Bulugh-e Jesmi, Ruhi, va Ravani dar Pesaran* (Male physical, emotional, and psychological puberty) (Tehran: Nur-e Danesh, 2003). Foucault's *History of Sexuality* presents the processes through which sexuality entered public discourse since the Enlightenment period.

59. Safdar Sanei, *Ta'alim-e Behdashti-e Islam* (Isfahan: Saqafi, 1960), 100–1.

60. The Persian names for some of these organs such as *chuchuleh* or *baz[dh]ar* (clitoris) are not commonly used in common parlance. Sometimes they are used with negative connotations such as *chuchuleh Baaz*, referring to a womanizer or a whoremonger.

61. See Fahrhang Rayhaneh, *Adab-e Aqad va Arusi* [Ceremony, mores, and celebration of marriage] (Tehran: Kelk-e Azadegan, 2006).

62. Ibid., 311. The book in fact confirms that the common people's notion of sexuality is wrong and that they should seek help from official institutions.

63. "Eshq, Zojha-ye Khoshbakht, va Masael Jensi," *Zan-e Ruz* 264 (Khordad 1949): 14.

64. Paula E. Drew's article "Iran," in *The Continuum Complete International Encyclopedia of Sexuality,* ed. Robert T. Francoeur and R. Noonan (New York: Continuum, 2004). I should mention that although this entry on Iran contains numerous keen, insightful, and interesting observations, it sometimes ignores time and place in its generalization of the issue of sexuality in the country. For example, differences between villages and towns and between the periods before and after the revolution are sometimes blurred.

65. "Enherafat-e Jensi dar Zan: Jazebeh-e Jensi dar Zan va Mard," *Khandaniha* 17, no. 84 (1957): 28.

66. "Aya Mard dar An-e Vahed Asheq-e Chand Zan Mishavad?" *Khandaniha* 3, no. 75 (1947): 28.

67. H. Ramezani, "Mobarezeh Ba Fahshah," in *Sepid o Siyah* 11 (Mehrh 1956): 4.

68. *Tofiq* 8, no. 128 (March 1970): 2.

69. Ibid., 3.

70. Ibid., 10.

71. For more information, see Kamran Talattof, "Nizami's Unlikely Heroines: A Study of The Characterizations of Women in Classical Persian Literature," in *The Poetry of Nizami Ganjavi: Knowledge, Love, and Rhetoric,* ed. Kamran Talattof and Jerome W. Clinton (New York: Palgrave Macmillan, 2000), 51–81.

72. Drew, "Iran." See also Malek Chebel, *Encyclopedie de l'amour en Islam: érotisme, beauté et sexualité dans le monde arabe, en Perse et en Turquie* (Paris: Payot, 1995).

73. Drew, "Iran."

74. "Dokhtar-ha Bekarat-e Khod Ra Az Dast Nadahid," *Khandaniha* 72, no. 276 (1947): 21.

75. Alice Schelegel, "Status, Property, and the Value of Virginity," *American Ethnologist* 18, no. 4 (Nov. 1991): 719–34. Schelegel further states that the cultural value of virginity is based on the marriage transaction and is different in different societies. In the particular case of Iran, see many articles written by Dr. Hamidreza Shirmohammadi and Dr. Mojgan Kahen.

76. See Drew, "Iran."

77. See also note 79 on this topic in chapter 5.

78. *Civil Code of the Islamic Republic of Iran: (Articles 1 to 1335)* (Tehran: Bureau of International Agreements, 2000), chapter 1, 1128.

79. See Mojgan Kahen's articles and daily writings at http://mojgankahen.blogfa.com/cat-1 .aspx.

80. Fatima Mernissi, *Beyond the Veil: Male-Female Dynamics in Modern Muslim Society* (Bloomington: Indiana Univ. Press, 1987).

81. Again, the incidents pages of the dailies provide endless examples. But the government's project called *Gerdab* (with a Web site by the same name) focuses on sexual crimes on the Internet. Other Web sites outside Iran, such as http://7tir.com/, also focus (at least for a period) on such controversial news.

82. Abdelwahab Bouhdiba, *Sexuality in Islam* (London: Routledge and Kegan Paul, 1985), 231.

83. Houchang Chehabi, "Az Tasnif-e Enqelabi ta Sorud-e Vatani," *Iran Nameh* 16, no. 1 (Winter 1998): 69–96. I should mention that even at the time of globalization, according to the Commission on Growth Development, many of the good decisions that helped these thirteen countries (mentioned earlier) sustain high growth were based on some principles of nationalism and national interests.

84. Jean Baudrillard, *Simulations,* trans. Nicola Dufresne (New York: Semiotexte, 1983).

85. For example, see his troubling portrayal and fiddly tone in his book about women's lives. Jalal Al-e Ahmad, *Zan-e Ziadi* [The extra woman] (Tehran: Ravaq, 1952).

86. This genre will be discussed in chapter 4.

87. Photos of Raquel Welch and Brigitte Bardot appeared with discussions about their movies in popular magazines on a regular basis.

88. For much of its publication life, *Ferdowsi Magazine* published a chart every week rating the movies shown in theaters. Iranian movies rarely appeared in the top few spots if they were mentioned at all.

89. For the use of these words in their Iranian context see Najmabadi, *Women with Mustaches and Men without Beards,* a book in which she argues that a cultural transformation occurred in nineteenth-century Iran that involved reconfigurations of gender and sexuality.

90. I have previously defined ideology as a set of structured metaphors that guide the conceptual and perceptual systems within which its advocates think, communicate, and act. Ideology is, in other words, a systematic, inclusive, universal, ontological, and metaphorical construction

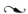

that aims to guide people in their pursuit of happiness and accomplishment. As a metaphorical construction, it creates new semantic systems, new models, and new paradigms. Because they do not exist in a vacuum, ideological paradigms interact with other ideological paradigms and produce various responses. Indeed, in the long term these interactions create new ideologies.

91. Pierre Bourdieu, *Distinction: A Social Critique of the Judgment of Taste,* in *Everyday Theory: A Contemporary Reader,* ed. Becky McLaughlin and Bob Coleman (New York: Pearson/Longman, 2005), 29.

92. Michel Foucault, *Power/Knowledge: Selected Interviews and Other Writings 1972–1977,* ed. Colin Gordon (New York: Pantheon Books, 1980), 100.

93. Referring to the works of Gayatri Chakravorty Spivak, Afsaneh Najmabadi writes, "Let me conclude, then, by reframing the contingency of emergence of gender and sexuality as 'useful categories of analysis,' not as a matter of location and time—good for here and the modern, not so good for elsewhere and other times—but as a contingency of our own historical making, as our recognition of our production of subject effects." See Najmabadi, "Beyond the Americas: Are Gender and Sexuality Useful Categories of Historical Analysis?" *Journal of Women's History* 18, no. 1 (Spring 2006): 11–21. See also Spivak, "Subaltern Studies: Deconstructing Historiography," in *Selected Subaltern Studies,* ed. Ranajit Guha and Gayatri Chakravorty Spivak (Oxford: Oxford Univ. Press, 1988).

3. Iranian Women and Public Space in the Seventies:
Shahrzad, a Woman of Her Time

1. In the West, a nightclub is a place where men and women go to drink, dance, and have fun and entertainment. It includes a dance floor and special lighting and music (which is sometimes live). In the 1970s they were often called discothèques (a French name) in Iran. The cabarets, according to the movies, were places where men (occasionally accompanied by women) would go to eat and drink while watching women (and men) sing and dance or perform other arts, such as magic or comedy, on a stage. In the West too, a cabaret refers to a form of entertainment featuring staged song, dance, and comedy, often also serving food. The significant difference was probably related to the type of audience these establishments drew in Iran versus the West.

2. Shahrzad, introduction to *Ba Teshnegi Pir Mishavim* [Thirsty, we age] (Tehran: Khushah, 1972).

3. "Inast Qeseh-ye Sharzad Zamaneh Ma," *Setareh Cinema* 23 (new series) (17 Azar 1352): 13, 49.

4. She received the offer from Pars Studio after she showed her talent in the movies *Qaysar* (Qaysar, 1969) and *Majera-ye Yek Dozd* (The adventure of a thief, 1971).

5. See Susan Enderwitz, "Shahrazâd Is One of Us: Practical Narrative, Theoretical Discussion, and Feminist Discourse," *Marvels and Tales* 18, no. 2 (2004): 187–200.

6. The first play in which she had a role was most probably titled "Bayn-e Rah" (On the way) in Nasr Theater in the Lalehzar area. Puran Farrokhzad, *Karnameh Zanan Kararaye Iran* (Tehran: Nashr-i Qatrah, 2002), 434.

7. Hashem Askari and S. Majin, "Recent Economic Growth in Iran," *Middle Eastern Studies* 12, no. 3 (1976): 195–23.

8. See Ervand Abrahamian, *Iran Between Two Revolutions* (Princeton, NJ: Princeton Univ. Press, 1982).

9. For more information on these developments, see Eliz Sanasarian, *The Women's Rights Movement in Iran: Mutiny, Appeasement, and Repression from 1900 to Khomeini* (New York: Praeger Press, 1982), 63–65; and Guity Nashat, *Women and Revolution in Iran* (Boulder, CO: Westview Press, 1983), 68–70.

10. I will talk more about these women in chapter 6.

11. See, for example, the king's own book: M. Reza Pahlavi, *Inqilab-i Safid* [The white revolution] (Tehran: Kitabkhanih-i Saltanati, 1967).

12. Sadeq Hedayat and many of his contemporary intellectuals advocated such views. For reading on this topic, see Michael Beard, *Hedayat's "Blind Owl" as a Western Novel* (Princeton, NJ: Princeton Univ. Press, 1990). Even today, some scholars, including the venerable Abbas Milani, believe that Iran has from ancient times contributed to the creation of modernity. See Abbas Milani, *Lost Wisdom: Rethinking Modernity in Iran* (Washington, DC: Mage Publishers, 2004). Some historians, including Mohammad Tavakoli-Targhi, believe that modernity developed first in Asia, Africa, and Latin America. See Tavakoli-Targhi, *Tajadod Bumi va Bazandishi-ye Tarikh*. Much of the findings of these scholars is accurate, but they ignore the question of discontinuity in Iranian culture production, which returned the country to a premodern state after the 1979 Revolution in many aspects of life.

13. Her written reply to my written interview questions consists of two sections. Her handwriting created a big challenge. Using expert help, I transcribed the interviews into Microsoft Word files. The first interview, mostly the rejection of any idea of having an interview, is in a file of 11,679 words. The second set consists of three handwritten books, which after being typed, comprises three files of 98,735, 22,515, and 50,323 words, respectively. From now on, I will refer to these bodies of writing as Letters, volumes 1, 2, 3, and 4.

14. Golestaneh is the same area about which Sepehri wrote a poem with the same title "Dar Golestaneh." Shahrzad once went on a pilgrimage with her mother during which time she heard her talk about her youth (Letters, vol. 2).

15. This is not only different from the one mentioned on her official birth certificate that in fact belonged to an older dead sister but also is also different from the date (December 9, 1950) that is entered on an ID card issued to her in the postrevolutionary period, which belongs to her younger sister. Other information on her birth certificate is erroneous as well. For example, she is mentioned as being born in both Semnan and Garmsar.

16. In her later letters, she mentions that she first attended the traditional school, *maktab-khaneh,* in the Khani Abad area.

17. I draw this conclusion from third-person accounts of her life, her own allusions in works that I concluded were very much autobiographical, her self-portrayal in a sort of short story published in *Ferdowsi Magazine,* and her interviews.

18. Interviews and Letters, vols. 2 and 4.

19. She is perhaps talking about *alak dulak,* which is played with two sticks by two groups of kids. It has other names in other parts of the county including *chub-kelid* (stick and key) in Fars.

20. Letters, vol. 1.

21. *Chub va Falak*: a form of punishment by whipping the feet.

22. Alborz Street was later called Pahlavi Street (monarchist implication) and then became Mosaddeq Street (nationalism) after the revolution, but soon was changed to Vali Asr (religious), a title for the Shiites' hidden thirteenth Imam.

23. Letters, vol. 1.

24. See Shahpur Monsef, "From Dancing the Hips to Moving the Brain: Half Nude Shahrzad of Bars and Cabarets to Today's Intellectual Actress," *Film o Hunar* 429 (30 Farvardin 1352/April 19, 1973), 20, 21, 24.

25. Ibid. And the book she is referring to is Ahmad Reza Ahmadi, *Vaqt-e Khub-e Mosaeb* [A Good Time for Tragedy] (Tehran: Ketabe Zaman, 1968).

26. "Yadi as Shahrzad," in *Ravi Hekayt Baqi,* http://www.parand.se/ra-yadmane-shahrzad .htm.

27. Letters, vol. 4.

28. All references to this incident are vague, undated, and succinct. It could not be verified through any other sources.

29. In fact, many artists suffered the loss of their properties in complete silence for fear of being castigated for their past.

30. Letters, vol. 2.

31. Ibid.

32. For example, she remembers buying the books of Cesare Pavese (1908–50) and William Blake (1757–1827).

33. Ibid.

34. Ibid.

35. Mohammad Emadipur, "Lozum Amuzesh Behdashat dar Qale Shahr e No" [The necessity of teaching hygiene in the Qale Shahr e No] (master's thesis, Tehran Univ., 1976). For some photos of the working women of Shahr-e No, see Kaveh Golestan's work in *Sepid o Siyah* 36, no. 9 (25 Isfand 1979/March 16, 1979).

36. Said Madani, "Enkar-e Ruspigari Shoyu' Anra Kam Nemikonad" [Denying the existence of prostitution does not decrease its spread], *Ruzmareh,* Feb. 2, 2006.

37. See Murtaza Sayfi Fami Tafrishi, *Nazm va nazmiyah dar Dawrah-i Qajariyah* (Tehran: Intisharat-i Yasavuli Farhangsara, 1983); and *Pulis-i Khufyah-i Iran, 1299–1320: Mururi bar Rukhdadha-yi Siyasi va Tarikhchah-i Shahrbani* (Tehran: Ququns, 1989).

38. R. Rudan, "Faheshekhaneh Zahirabad," *Elm va Jameh* 8, reprinted in *Nimeh-ye Digar* 1, no. 6 (Winter 1366/1988).

39. See Setareh Farmanfarmaiyan, *Ruspigari Dar Shahr-e Tehran* (Tehran: Amuzeshgah-e Khadamat-e Ejtemai, 1970). It details the places of prostitution (in addition to Shahr-e No), the background of the workers, the level of their literacy, the reasons and causes of their prostitution, a discussion of sexually transmitted diseases, and other social, cultural, and economic aspects of their lives. Although a number of questions can be raised about their methodology, their definitions, and

the way the data were collected, the work provides a good picture of the prerevolutionary problems of prostitution.

40. For discussion of this article, see Ghulam Riza Salami and Afsaneh Najmabadi, *Nahzate Nesvane Sharq* (Tehran: Shiraze, 2005).

41. Works by Moshfeq Kazemi, Mohammad Hejazi, Mohammad Masud, and Jahangir Jalili are notable.

42. To use the words of Barry Smart, *Facing Modernity*, 1999).

43. In Jeffrey Olick's words, "All utterances take place within unique historical situations while at the same time [they] contain 'memory traces' of earlier usages." Drawing on Bakhtinian dialogic, Olick believes that the images of the past reflect the commemorated event of the present, the contemporary circumstances, and "path-dependent products of earlier commemorations." See Jeffrey K. Olick, "Genre Memories and Memory Genres: A Dialogical Analysis of May 8, 1945 Commemorations in the Federal Republic of Germany," *American Sociological Review* 64, no. 3 (June 1999): 383.

44. These observations are not solely based on mere memory of those days or on the anecdotes repeatedly told during the talks and discussions of the revolution. Writings and publications of the leftist organizations, especially those books written on the tribute to the organizations' martyrs, indicated this point about the conversion from normal to revolutionary. See, for example, Marziyeh Ahmadi Oskui, *Khatirati Az Yak* ([S.l.]: Sazman-i Charik'ha-ye Fadai-e Khalq-e Iran, 1974); Mujahedin, *Az zindagi-i inqilabiyun dars bi-girim* (S.l.: Abu Zar, 1976); or Cherikhaye Fadai, *Yad-e Yaran Yad Bad* (see also http://www.siahkal.com).

45. Shahrzad, "Inast Qese ye Sharzad Zamaneh Ma," 13.

46. Shahrzad, "In Be Estelah Nosetareha," *Setareh Cinema* 27 (Dore Jadid) (15 Day 1352): 16–19.

47. Letters, vol. 2.

48. Naser Zara'ati, *Zendeginameh Behruz Vosughi* (San Francisco: Aran Press, 2004).

49. After the revolution, he married the famous singer Googoosh and helped her organize her first concerts in the United States after twenty-five years of silence.

50. Shahrzad, "Inast Qeseh-ye Shahrzad Zamaneh Ma," 13.

51. *Ferdowsi Magazine* 24, no. 1141 (12 Azar 1973).

52. The title of the entry read, "Shahrzad dar Rome Ba Khiyal-e Kimiya-i Zendegi Mikonad" (Shahrzad lives in Rome with fantasies of Kimiyai). It also states that she intends to publish her biography in Italian. Another article in *Setareh Cinema* (23: 13) is entitled "Shahrzad dar bareh shaye-'e ravabet khod va Mas'ud Kimiyai sokhan miguyad" (Shahrzad talks about the rumor regarding the affairs between her and Mas'ud Kimiyai).

53. Alireza Nurizadeh, "Interview with Shahrzad," *Ferdowsi Magazine*, special issue, Year of the 2500th Kingdom Celebration (Doshanbeh 12 Mehrmah 1971), 12–14, 35.

54. Ibid.

55. Ibid.

56. Ibid.

57. Ibid.

58. Ibid.

59. Ibid.

60. Ibid. In the interview, we read this comment also directly from Shahrzad, who states, "For a long time, I could not afford to purchase *Jean-Christophe* because I did not have money. It cost 100 tomans. Then I realized the paperback, pocket size version of the book was cheaper. I was flabbergasted for a few months after I read the book."

61. Ibid.

62. Ibid.

63. Ibid. The lines of poetry that she read and that accompanied this interview in the journal are translated and discussed later in chapter 5.

64. Letters, vol. 1.

65. Ibid.

66. Monsef, "From Dancing the Hips to Moving the Brain," 20, 21, 24.

67. Ibid.

68. Sarrazin had been born in Algiers in 1937 and been adopted by a French family who then left Algiers to settle in Aix-en-Provence. Her childhood was marked by suffering, humiliation, rape at age ten by a member of her adoptive family, and an ongoing conflict with her parents. She escaped home, fell into prostitution, and went to prison. While escaping from prison in 1957, Albertine broke her ankle. For more information about Albertine Sarrazin, see Jacques Layani, *Albertine Sarrazin: une vie* (Paris: Ecriture, 2001). A passerby, Julien Sarrazin, helped her and then married her two years later. She later wrote many successful books, including one with a reference to her broken ankle entitled *L'Astragale* (Paris: Pauvert, 1965).

69. Monsef, "From Dancing the Hips to Moving the Brain," 20, 21, 24.

70. Ibid.

71. Ibid.

72. Ibid.

73. Ibid.

74. Letters, vol. 2.

75. Zara'ati, *Zendeginameh Behruz Vosuqi,* 241. Such affairs apparently were not rare. The twenty-one-year-old Nuri Kasrai, who also played in revealing FilmFarsi movies, alleges that Vosuqi was involved with Puri Banai and Googoosh. Vosuqi later married Googoosh.

76. I am basing these assertions on her written works, the very few short interviews she gave to some journals, and on the long letters and autobiographical notes I received from her before she took refuge somewhere in the northwestern part of the country in 2002. The letters and autobiographical writings are too ambiguous and often illegible to provide, at this time, any decisive conclusion about her past tendencies.

77. Farrokhzad, *Karnameh Zanan Kararaye Iran,* 434–35.

78. Ebrahim Golestan, "Mehdi Akhvan-Sales," in *Donya-ye Sokhan.* It is also reprinted in Morteza Kahi, *Bagh-e Bi Bargi: Yadnameh Mehdi Akhavan-Salis* (Tehran: Agah, 1991). As we will see in chapter 5, Ebrahim Golestan and Shahrzad had some meetings in 1968–69 after which he

also offered some advice as to how to edit and improve her poems. He eventually commented on her poetry in his most recent interview. He is in all likelihood the person Shahrzad refers to in the introduction of *Thirsty, We Age*. See Parviz Jahed, *Neveshtan Ba Durbin: Ru Dar Ru Ba Ibrahim Golestan* (Tehran: Akhtaran, 2007).

79. Soraya Sullivan, trans., *Stories by Iranian Women Since the Revolution* (Austin: Center for Middle Eastern Studies, Univ. of Texas at Austin, 1991).

80. Ibid.

81. Ibid.

82. *Kayhan*, no. 19172, 12/6/1387, 2.

83. Naser Mohajer, *Ketab-e Zendan* (Berkeley: Nashr-e Noqteh, 1998), 195.

84. Ibid. The term "corrupt on Earth" or *Mofsed fel-al-Arz* was a judgment/allegation of crime easily imposed on the members of the previous regime or the oppositional groups and was punishable by death. "Big mouth" is equivalent to *zaban deraz* (literally, long tongue) and was often used for women.

85. Ibid., 196.

86. Ibid., 197.

87. See Iraj Mesdaghi, *Ghorub-e Sepideh: Na Zistan na Marg* (Sweden: Alfabit Makzima, 2004), 273. Also sometimes allegation of prostitution was added to the list of crimes for women who were arrested for other reasons. See Fariba Sabet, *Yadha-ye Zendan* (Paris: Khavaran, 2004). And, most alarmingly, a former prisoner also nicknamed Shahrzad mentions scenes of rape in prison as well. See Shahrzad, *Dar Inja Dokhtaran Nemimirand* (Paris: Nashr Khavaran, 1997). In "Ravayat-e Zendan, Seda-ye Zanan" (*Negah* 1; http://www.negah1.com), Shahla Shafiq makes a reference to the above author and provides an analysis of the woman's experience in prison.

88. Mesdaqi, *Ghorub-e Sepideh*, 267.

89. Mohajer, *Ketab-e Zendan*.

90. Exceptions include Shahrnush Parsipur, Marina Nemat, or other women who remain political and are still members of political organizations. They discuss their prison time to support their organizations' formal positions on social matters but do so outside Iran.

91. The appearance of the expression "Mitarsam sangi besham" (I fear to be stoned) is an astonishing lexical phenomenon. Also, the word *sangi* is an adjective and is imbued with a completely new meaning here.

92. On my behalf, and as a philanthropist, Parviz Nazari helped with some of these problems in early 2000s.

93. Letters, vol. 1.

94. Ibid.

95. Ibid.

96. William Rowe and Vivian Schelling, *Memory and Modernity: Popular Culture in Latin America* (London: Verso, 1991).

97. Sahebqalam, Gholam Reza, "The Day My Mother Unveiled," *Zan-e Ruz*, Jan. 8, 1936, special issue.

98. Ibid.

99. Hajar Tarbiyat, "The Day My Mother Unveiled," *Zan-e Ruz,* Jan. 8, 1936, special issue.

100. Esmat Safavi, Honarpishe-ha-ye Qadim, Dec. 16, 2005.

101. Mosio Hambarson, "Zan-e 17 Day," *Zan-e Ruz* 98 (24 Day 1345/1966), 17.

102. Ibid.

103. Ibid.

104. Sharia Katuzian, "Shoaer-e Islam Rah-e Anhast," *Zan-e Ruz* 98 (24 Day 1345/1966).

105. Ibid., 72.

106. See reports in *Zan-e Ruz* 98 (24 Day 1345/1966).

107. Mohammed Reza Pahlavi, *Ma'muriyat bara-yi Vatanam* (Tehran: Shirkat-i Sahami-i Kitabha-yi Jibi, 1971); and Muhsin Sadr, *Khatirat-i Sadr al-Ashraf* (Tehran: Intisharat-i Vahid, 1985). Reference to these works is made in Muassasah-e Farhangi-e Qadr-e Valayat, *Hikayat-i Kashf-i Hejab* (Tehran: Qadr-e Vilayat, 1999), a book on the topic of unveiling compiled by an organization affiliated with the IRI (Islamic Republic of Iran).

108. Valayat, *Hikayat-e Kashf-e Hejab,* contains many original documents on the unveiling process.

109. Ibid.

110. Mehri Kar, "Nameless, Disreputable Iranian Women Have Lost Their National Identity Card," *Ferdowsi Magazine* 24, no. 1083 (1971), 1, 4, 39. Again, *Ferdowsi* was considered to be an intellectual and nonreligious journal.

111. Ibid.

112. "Ruspigari dar Filmha-ye Farsi," *Ferdowsi Magazine* 24, no. 1099 (Bahman 2, 1972): 1, 4, 39.

113. Mehrangiz Kar, "Padideh-ie jadid" [A new phenomenon and a disgusting image], *Ferdowsi Magazine* 24, no. 1142 (19 Azar): 10–11.

114. Mehrangiz Kar, "Mojezeh Takhdir-e Afkar," *Ferdowsi Magazine* 25, no. 1130 (24 Shahrivar): 14–15. The author was very determined to work on women's issues after the revolution when she was still residing in Iran.

115. Starting her career in the Lalehzar street cabarets in the 1950s, Mahvash played, danced, and sang in more than ten movies before she died in a car accident. While Mahvash's husband played the piano in her orchestra, in the Lalehzar theaters of the 1950s, groups of rough guys would spend their evenings drinking there and competing, sometimes violently, over her attention. The newspapers of the time sometimes reported those incidents, but Mahvash movies too often included such scenes of fighting among rough groups who lived to fight and perhaps trade drugs. For more information, see Hosayn Mohebbi, *Farhang-e Bazigaran-e Sinema-ye Iran* (Tehran: Nashr-e Rivayat, 1996); and Web sites such as Persian Film, Ghadimiha, and Soureh Ciman.

116. According to all statistics and in comparison to Africa, India, and even Turkey, honor killings were hardly a visible problem in Iran in that period, so the article's reference to such a topic is very curious, given the rise of such crimes only in recent decades in provincial towns and villages

117. Reza Barahani, "Sex: Yeki az Anasor-e Sanzandeh Ejtemai," *Ferdowsi Magazine* 24, no. 1088 (15 Aban 1972).

118. Ibid.

119. See Martha Camallas, *Introduction to Feminist Legal Theory* (New York: Aspen Publishers, 1999); and Andrea Dworkin, *Intercourse* (New York: Free Press, 1987).

120. Shahrzad, "Iren: Ba Omid beh Mojezat-e Emruz, Ba Hastrat va Eftekhar beh Diruz," *Setareh Cinema* 23 (Azar 1352): 19–46.

121. Ibid.

122. Shahrzad, "In Be Estelah Nosetareha" [These so-called new stars], *Setareh Cinema* 27 (Dore Jadid) (15 Dey 1352): 16–19.

123. Ibid.

124. Ibid.

125. Ibid.

126. Shahrzad, "Naderi Kargardan-e Tengsir Nist" [Naderi is not the director of Tangsir], *Setareh Cinema* 28 (Dore Jadid) (22 Dey 1352/Feb. 23, 1974): 2, 3, 40, 41.

127. Ibid.

128. Ibid., 20, 21, 43.

129. Shahrzad, "Do Nasl Dar Barabar e Ham, Va Dar Kenar e Ham," *Setareh Cinema* 33 (4 Esfand 1352/Feb. 24, 1974): 12, 13, 36, 37.

130. Ibid.

131. Ibid., 12.

132. Its original Italian title is *Cosa Avete Fatto a Solange?*

133. Fardin, in interviews with *Setareh Cinema.*

134. See comments by Sepideh who said she stopped playing in Iraj Qaderi's movies because she was tired of being used as a sex object.

4. Seduction, Sin, and Salvation: Spurious Sexuality in Dance and Film

1. She goes on to say that dance's "practice and its scholarship are, with rare exception, marginalized." See Jane Desmond, "Issues in Dance and Cultural Studies," in Celeste Fraser Delgado and José Esteban Munoz, *Everynight Life: Culture and Dance in Latin/o America* (Durham, NC: Duke Univ. Press, 1997), 33.

2. This book only analyzes a particular popular Persian dance. A thorough study should include historiographies, analyses of Iranian dances throughout history, discussions of the effects of foreign invasions and foreign influences on dance, its prohibition under the Islamic rules, and all varieties of Iranian national, ethnic, and mystic versions.

3. Ahdiyeh Badi'i, "An interview with Nima Tamadon" *Majalleh Qadimiha* 2, no. 72 (June 2008); and Badi'i, "Honar Khandan-e man madyun-e taraneh-ha-ye film ast," interview with Radio Farda, 14 Farvardin 1387. Male singers in these movies included Iraj, Aref, Manucher, Daryush, and others.

4. See Monsef, "From Dancing the Hips to Moving the Brain," 20, 21, 24. Such perception is one of the incentives beyond Shariati's book on arts, *Hunar* [Art] (Tehran: Andishmand, 1982)]. His work is similar to the ideas presented in Al-e Ahmad, *Gharbzadigi*. Many of these notions were

collected and reprinted in many other books right after the revolution. See Muhammad Taqi Ja'fari, *Nigahi Bih Falsafah-'i Hunar Az Didgah-i Islami* [A look at art philosophy from the Islamic viewpoint] (Tehran: Intisharat-i Nur, 1982). Similar views are discussed in this chapter.

5. Desmond, "Issues in Dance and Cultural Studies," 35.

6. Helen Thomas, "Focusing on the emergence and development of American modern dance, particularly through the work of Martha Graham," approaches this view in her *Dance, Modernity, and Culture: Explorations in the Sociology of Dance* (London: Routledge, 1995).

7. This is indeed the subject of the documentary *Pretty Things,* a film financed by New York Foundation for the Arts (NYFA) and written, directed, and produced by Liz Goldwyn, which debuted on HBO in July 2005. It focuses on the history of American burlesque as told by its remaining burlesque queens, who reigned in the 1940s through 1960s. See *The Gift,* the newsletter of the New York Foundation for the Arts, fall 2005, 3.

8. See Martha Feldman and Gordon Bonnie, *The Courtesan's Arts: Cross-Cultural Perspectives* (New York: Oxford Univ. Press, 2006); and Liza Dalby, *Geisha* (Berkeley: Univ. of California Press, 1983). Recently, a novel and its film version have brought the subject to the fore. See Arthur Golden, *Memoirs of a Geisha* (New York: Alfred A. Knopf, 1997).

9. Anthony Shay, "Limitations of Iranian Iconographic Sources for the Development of Historical Evidence of Iranian Dancing." Linda J. Tomko, "Speaking of History: Dance Scholarship in the Nineties," Univ. of Minnesota, Minneapolis, June 13–16, 1996 (Riverside: Univ. of California, 1996), Proceedings, 173–85.

10. Information about some of these dancers will be presented in chapter 6.

11. These accepted forms include movements that represent religious events or classical Persian stories. For more information, see interviews with Farzaneh Kaboli at http://www.jadidonline.com/print/373.

12. In Tehran, in the early decades of the twentieth century, most theaters were located in fashionable Lalehzar. In Shiraz, most of the chic theaters were located on Zand Street between Darius Street and Governance Circle. For another description of how these movies and movie theaters played a social role in 1970s, see the introduction in Hamid Dabashi, *Close Up: Iranian Cinema, Past, Present, and Future* (London: Verso, 2001), 1–11.

13. Some people with access to the adjacent Razi High School could see some of the performances from the rooftop. After the revolution, the café was turned into storage room first and later became a newspaper distribution center. According to some colleagues from Shiraz, photos of the dancers were kept on the walls for years afterward.

14. In the 1970s, there were two major pool halls (clubs that offered other games such as jackpot machines, foosball tables, or small bowling lanes) in Shiraz on Darius and Lotfali Khan Zand Streets. Both were frequented by many high school students who stopped there on their way home from school. Most mothers had no idea what a pool table was, but they thought that the games could corrupt their boys morally and disrupt their education.

15. In the West, one does not encounter such a dilemma perhaps because billiards is in all likelihood rooted in a traditional game, most likely the medieval "ground billiards" with which

generations have grown up. "A Croquet-like game is believed to have been played by thirteenth century French peasants who used crudely fashioned mallets to whack wooden balls through hoops made of willow branches. . . . Ground Billiards featured a hoop and a stick, a point being scored for each time your ball was first through the hoop and hit the stick. At some point in the 15th century someone chose to invent an indoor variation of this played on a table which led to billiards and that whole family of games." See the Online Guide to Traditional Games, http://www.tradgames.org.uk/.

16. After many years of prohibition, Iran now has national teams in both billiards and snooker.

17. For most Iranians, dancing is a private, perhaps a family and friendly, activity. The greatest exception is group dancing among ethnic populations. Nevertheless, even folk dancing never gained a prominent position among the performance arts.

18. Karin van Nieuwkerk, *A Trade Like any Other: Female Singers and Dancers in Egypt* (Austin: Univ. of Texas Press, 1995), 43–45.

19. Only a number of attempts were made before the revolution, and these have only been followed by a handful of attempts by women outside Iran after the revolution. These few pioneers who at the time of modernization and Westernization thought of dance as an indication of a modern society were often from the minorities such as the Armenians or of immigrant families, such as Gholam Reza Moradi, whose mother was Russian. Others went to Europe or Russia to learn modern dances. (See related reports on dance at Radio Zamaneh, http://www.radiozamaneh.com, and Jadid Online, http://www.jadidonline.com.) For a memoir and historical text relevant to the topic of dance in 1950s, see Nesta Ramazani, *The Dance of the Rose and the Nightingale* (Syracuse, NY: Syracuse Univ. Press, 2002).

20. Moniru Ravanipur portrays the life of a depressed dancer in the short story "Jeyran." Dancing mainly at weddings and other festive occasions, the dancer is always the entertainer and never the cause for the celebration, that is, the bride. She is aging and her consciousness of this, her loneliness, and her dismal lonely future are in strong contrast with her profession. At the end, her lover leaves her to marry another woman. See Moniru Ravanipur, *Sangha-yi Shaytan* (Tehran: Markaz, 1990), 29–34; trans. and ed. M. R. Ghanoonparvar as *Satan's Stones* (Austin: Univ. of Texas Press).

21. That may explain why women from the religious minorities more frequently made successful careers in music and entertainment; they faced less religious and communal pressure if they joined a music troupe—which, by the way, were often organized by non-Muslim men as well.

22. The relevant issue is that dance and cabarets were mentioned in political writings and ideological exposés only as signs of decadence. They were portrayed as if dancing was exclusive to the bourgeois class and those connected with the Shah's court. As we will see, even the makers of FilmFarsi portrayed dance as sinful while using it to profit in the box office, very much like *Ferdowsi Magazine* printed small pictures of sexy women while writing against sex. For a sample, see "Cinema Dami Baraye Khanandegan," *Itelaat Banavan* 733, no. 23 (Tir 1350/1971): 94–95.

23. See Liz Goldwyn, *Pretty Things: The Last Golden Generation of American Burlesque Queens* (New York: Regan Books, 2006); and also her documentary film *Pretty Things* (see note 7). In an interview about the American burlesque genre with HBO, Goldwyn states, "It was not getting on stage and taking your clothes off. It was a craft that had to be perfected. It involved costume designers

and choreographers and sets. And the orchestra, and it was difficult. It was very difficult. . . . Well for me I guess the hypothesis that I had in the beginning was of these romantic creatures and putting them on a pedestal as these glamorous figures, these glamorous icons of power and female sexuality." See "An Interview with Liz Goldwyn" at http://www.hbo.com/docs/programs.

24. Analytical books, memoirs, museums, documentary films, miniseries, and the screening of the black-and-white (great quality) films of these women performing on stage indicate the role they played in popular arts.

25. Ministry of Culture and Guidance, *Asnadi az Musiqi, Tiatr va Sinima dar Iran (1300–1357 H. Sh.)* [Documents on music, theater and cinema in Iran, 1921–1978] (Tehran: Sazman-e Chap va Intisharat, Vizarat-i Farhang va Irshad-i Islami, 2001), 713. A few institutes have published many documents of the old regime. While one must be somewhat apprehensive about the number of changes that could have been made in these documents before they were published, these particular documents do not support the position of the opponents of the Shah's regime, so it is unlikely that they have been censored or altered. The curious question is why the regime stopped pursuing such restrictive policies.

26. Ibid., 703.

27. Ibid., 717.

28. Ibid., 752.

29. Ibid., 658, 704.

30. Ibid., 730.

31. Ibid., 733.

32. See, for example, the report by the head of the organization of fine arts to the prime minister in 1962. Ibid., 866.

33. Ibid., 1328.

34. Ibid., 1329, 1330. Toward the end of the Shah's regime, a fundamentalist group burned down the Rex Cinema in the southern city of Abadan in August 1978; more than 350 people perished, and the screening of sexy movies halted completely. Oddly, some blamed it on the Shah's secret police. What is clear now is that minor sex scenes, in the absence of natural development of the public presence of manifestations of sexuality, in cinema, art, or life, can so easily translate into tragedy and be used as political tools for ideological purposes.

35. Ibid., 1149. I should mention that a similar occasion arose during the Islamic Republic in late 1997 in relation to a conference held in Berlin in which people were spotted dancing.

36. Farmanfarmaiyan, *Ruspigari Dar Shahr-e Tehran* (see chapter 3, note 39).

37. Mohalel means the man who marries a thrice-divorced woman to dismiss her soon after consummation.

38. Interestingly, a number of filmmakers, writers, directors, and actors of FilmFarsi also condemned sexually explicit scenes even as they were involved in the production of such movies. Shahrzad conducted a number of interviews about sex in cinema, and most of the interviewees believed that that kind of movie was detrimental and dangerous to society. Some of them said that the women who get naked in front of the camera are social terrorists. See Shahrzad, "Bazi az Bazigaran-e

Cinema," "Movafaqiyat va Etebare Filmsazan-e Irani," and "Chera Durbin-e Filmbardari dar Iran Bishtar Tasvir Saze Sahneha-ye Sexi Ast?" in *Setareh Cinema* 27, 28 (1352): 17, 40, 41.

39. See the document in the same book. Ministry of Culture and Guidance, *Asnadi az musiqi, tiatr va sinima dar Iran*, 1048057.

40. Bourdieu, *Distinction*.

41. Ibid.

42. Theodor Adorno, "On Popular Music," *Studies in Philosophy and Social Sciences* 9, no. 1 (1941): 17–18.

43. For information on Iranian cinema and pertinent theoretical issues, see Jamsheed Akrami, *Dreams Betrayed: A Study of Political Cinema in Iran, 1969–1979* (New York: Jamsheed Akrami, 1985); Jamsheed Akrami, *Piramun-i Sakht va Naqsh-i Rasanah'ha: Hamayish-i Shiraz* (Tehran: Surush, 1977); Roy Armes, *Patterns of Realism* (New York: Garland, 1986); Morteza Avini, *Ayineh-e Jadu* (Tehran: Barg, 1991); Hamid Dabashi, *Close Up: Iranian Cinema, Past, Present, and Future* (London: Verso, 2001); Mohammad Ali Issari, *Cinema in Iran, 1900–1979* (Metuchen, NJ: Scarecrow Press, 1989); Claire Johnston, "Women's Cinema as Counter-Cinema," in *Notes on Women's Cinema,* ed. Claire Johnston (London: Society for Education in Film and Television). Reprinted in *Screen* (1991), 24–31; Laura Mulvey, "Visual Pleasure and Narrative Cinema," in *Visual and Other Pleasures* (Basingstoke: Macmillan, 1989), 14–26; Hamid Naficy, "Iranian Writers, the Iranian Cinema, and the Case of Dash Akol," *Iranian Studies* 18, no. 2–4 (1985): 231–51; Naficy, "From the Imperial Family to the Transnational Imaginary: Media Spectatorship in the Age of Globalization," in *Global/Local: Cultural Production and the Transnational Imaginary,* ed. Rob Wilson (Durham, NC: Duke Univ. Press, 1996); Naficy, "Iranian Cinema under the Islamic Republic," in *Images of Enchantment: Visual and Performing Arts of the Middle East,* ed. Sherifa Zuhur (Cairo: American Univ. in Cairo Press, 1998); Naficy, "The Cinema of Displacement: Towards a Politically Motivated Poetics," *Film Criticism* 20, no. 1–2 (Fall 1995–96), 102–13; Farah Nayeri, "Iranian Cinema: What Happened in Between," *Sight and Sound* 3, no. 12 (Dec.1993), 26–28; Ministry of Culture and Guidance, *Asnadi az musiqi, ti'atr va sinima dar Iran, 1300–1357*; Ministry of Culture and Guidance, *Iranian Cinema, 1979–1984* (Tehran: General Department of Cinematographic Research and Relations, Ministry of Islamic Guidance, 1985); Richard Tapper, ed., *The New Iranian Cinema: Politics, Representation and Identity* (London: I. B. Tauris Publishers, 2002); the articles or online works of Agnès Devictor and Piruz Ghafari; and the online works of Farrokh Ghaffari, Ziba Mir-Hosseini, Norma Claire Moruzzi, and Jamal Omid.

44. Michael Marsden, *Movies as Artifacts: Cultural Criticism of Popular Film* (Chicago: Nelson-Hall, 1982), xiv.

45. Shahrzad, "Bazi az Bazigaran-e Cinema," "Movafaqiyat va Etebare Filmsazan-e Irani," and "Chera Durbin-e Filmbardari dar Iran Bishtar Tasvir Saze Sahneha-ye Sexi Ast?" 17, 40, 41.

46. Parviz Ejlali, *Digarguni-e Ejtimai va Film-ha-ye Sinimai dar Iran* (Tehran: Intesharat-e Farhang va Andishe, 2004), 108.

47. Issari, *Cinema in Iran, 1900–1979.*

48. In rural, ethnic, and farming areas, women historically have been able to socialize with men rather more freely than in urban or religious centers.

49. One of the most breathtaking scenes in the movie portrays the protagonist fighting and wrestling with another man while holding the end of a rope that stretches over a cliff. At the other end of the rope hangs a woman, the Lori girl, who with every move the men make goes up and down in imminent danger of falling. Perhaps Claire Johnston's explanation of "Woman" in classical cinema as "no-thing" or "not-man" is applicable here. See Johnston, "Women's Cinema as Counter Cinema," 25.

50. Ministry of Culture and Guidance, *Asnadi az Musiqi, Ti'atr va Sinima dar Iran, 1300–1357; Iranian cinema, 1979–1984.*

51. Some authors discuss a similar historical problem in the West by showing how women's place in society there at one point was reduced to the virgin/whore binary, a condition legitimized by God's words. See, for example, Mary Daly, *Gyn/Ecology: The Metaethics of Radical Feminism* (with her "New Intergalactic Introduction") (Boston: Beacon Press, 1990). Moreover, the dances were often of the type that Anthony Shay categorizes as "out of control" as opposed to "normative" or "transgressive." See Anthony Shay, *Choreophobia: Solo Improvised Dance in the Iranian World* (Costa Mesa, CA: Mazda, 1999), 13, 116–18. In the former type, all moves, including eye contact, are sexual. Women were often portrayed as either prostitute or angel, as if no women of any other type could exist.

52. Mulvey, "Visual Pleasure and Narrative Cinema."

53. For more information on FilmFarsi, see Hamid Naficy, "Iranian Cinema," in *Companion Encyclopedia of Middle Eastern and North African Film,* ed. Oliver Leaman (London: Routledge, 2001), 130–222; and Naficy, "Veiled Visions/Powerful Presences: Women in Postrevolutionary Iranian Cinema," *Life and Art: The New Iranian Cinema,* ed. Rose Isa and Sheila Whitaker (London: National Film Theatre, 1999), 43–65.

54. In many of them Foruzan (Parvin Kheirbakhsh, b. 1936) and Jamileh (Iran Sadeqi, b. 1946), two important dancer/actresses, had the lead female role in films, while Shahrzad most often had a peripheral role.

55. For more information on Iranian cinema, see Naficy, "Iranian Cinema," 130–222; Naficy, "Veiled Visions/Powerful Presences," 43–65; Dabashi, *Close Up*; and Tapper, *New Iranian Cinema.* See also the works of Ziba Mir-Hosseini, Nasrin Rahimieh, and Agnès Devictor.

56. For more information about numerous other women artists who contributed to cinema and music, see chapter 6.

57. We have recently witnessed the promotion of some more of these schizophrenic characters into high offices.

58. Farmanfarmaiyan, *Ruspigari Dar Shahr-e Tehran,* 39.

59. See Sue Thornham, ed., *Feminist Film Theory: A Reader* (Edinburgh: Edinburgh Univ. Press, 1999); and Diane Carson, Janice R. Welsch, and Linda Dittmar, eds., *Multiple Voices in Feminist Film Criticism* (Minneapolis: Univ. of Minnesota Press, 1994).

60. Ross Murfin, "What Is Feminist Criticism?" in *Henry James' the Turn of the Screw,* ed. Peter G. Beidler (New York: Bedford Books of St. Martin's Press, 1992), 248. In her *The Disruption of the Feminine in Henry James,* Priscilla Walton suggests that the "male gaze . . . serves as a marker

of sexuality and control" insofar as it allows a person to be a "spectator" and not a "spectacle." She focuses on the governess's fantasy that she is the object of her master's gaze as well as on her tragic, subsequent construction of a "fictive male gaze" of her own. See Priscilla Walton, *The Disruption of the Feminine in Henry James* (Toronto: Univ. of Toronto Press, 1992), 3–12.

61. The movie *Ki Daste Gol be Aab Dadeh?* (Who has been naughty? 1973), in which a husband is accused of having a baby outside of his marriage, provides many excuses for both traditional and Western dancing. The movie *Naqs Fanni* (Mechanical defect, 1976) portrays a man who is experiencing temporary impotence. Shy and embarrassed about his problem, he tries to seek help from his friends and then doctors in Tehran and Paris. These conversations and occasions provide opportunities for talking about sex, albeit in a symbolic language, or showing sex, albeit with a sense of how we should not really do it.

62. In an interview, Vahdat states that when he and his friends performed in their newly established Sepahan Theater in Isfahan, the members of the Marxist Tudeh Party attacked them. He also states that he eventually became the Lando Buzzanca of Iran. Many of Lando Buzzanca's movies were dubbed into Persian. The Italian actor often played the role of a provincial and naïve man with a strong sexual drive and a tendency of being mischievous and detrimental.

63. Puri Banai played the role of a German woman in this movie.

64. Even today, the clip has a viewing record on YouTube at http://www.youtube.com/watch?v=oi82pS8fRfk&mode=related&search=.

65. See Mojgan Kahen, "Masael Jensi dar Kotob-e Kohan-e Farsi," at http://mojgankahen.blogfa.com/post-3.aspx.

66. *Navab*, directed by Javad Taheri. This director made a few more movies until 1975, and then in 1983, he made a movie about the Iran-Iraq war, entitled *Passing Through Landmines*.

67. For more information on the works of Kimiyai, see Zaven Qukasian, *Mas'ud Kimiyai: Az Khat-e Qermez ta Faryad* (Tehran: Didar, 1999).

68. See Desmond, "Issues in Dance and Cultural Studies," 33.

69. Mary Catherine Bateson, *At Home in Iran* (Tehran: St. Paul's Church, 1965), 24.

70. This characterization of northern Tehran has lasted through the postrevolutionary years. However, in recent years, things may have changed, and the dichotomy of northern Tehran (rich, educated, Westernized) versus southern Tehran (poor, religious, anti-Western) no longer stands. Many surveys and opinion polls, which have been done in both areas over the past ten years, do not support a clear-cut geographical division. For example, in the past ten years, religious fundamentalists often received only around 15 percent of the votes in major elections. University students who are often in opposition to the fundamentalist rule come from all economic backgrounds and perhaps more from the lower middle class. Many of the southerners who have been affiliated with government have become rich and have moved north. Hundreds of religious families known for their support of an Islamic state have purchased good houses in good neighborhoods in good Western cities and travel back and forth to Iran (Vancouver is a prime example), and I am not sure if they can be characterized as anti-Westerner any longer.

71. Letters, vol. 1.

72. Shahrzad, "Nagozarid Ghahramanan e Napadid Shavand," *Setareh Cinema* 30 (Dore Jadid) (6 Bahman 1352/1974): 20, 21, 43.

73. In these films, the actors did not actually sing; the voices of famous singers were dubbed in. However, directors rarely arranged for others to sing for Shahrzad.

74. In a brief and rare interview Shahrzad had with *Ferdowsi Magazine,* she expresses pride about her role in this movie and laments that not all her movies were as artistic. She insinuates that Behruz Vosughi, the lead male actor, is her favorite actor. Vosughi was born in 1937 and played in many hits in the 1960s and 1970s, especially those directed by Mas'ud Kimiyai. He is the actor mentioned above who paid for the publication of one of her books, and in its preface, Shahrzad expresses her appreciation for his help and support.

75. The movie received honorable mention and best actor prize at the Tashkent Film Festival in 1972; best film, best cinematography, and best supporting actor prizes at the Fourth Iranian National Film Festival in 1972; and screenings at the Tehran International Film Festival and the Cairo International Film Festival.

76. *Toqi* was directed by Ali Hatami. There is an old saying in Persian, "If you catch a *Toqi,* keeping it will bring bad omens to the members of the family." And that is what happens to a very close knit family. A well-respected uncle, Mostafa, plans to marry a young woman who lives in a distant town. He asks his young nephew, Morteza, to bring the fiancée to him. On the way back, Morteza and the girl fall in love, get married, and return home. When the uncle finds out, he embarks on bloody revenge. Shahrzad is first seen sitting around a big room singing and dancing in front of other women who are "preparing" the bride for her marriage. Toward the end she is once again seen, being abused by a man who believes she knows of the whereabouts of the runaway bride.

77. *Pol* is about love gained and love lost due to lies and misinformation. Mojtaba and his companion Abdullah are train conductors who happen to pull into a certain town on their various trips. Upon entering the town, Mojtaba sees a woman, Tala, who sells eggs to passengers and whom everyone thinks has lost her mind. After a few brief encounters, Mojtaba and Tala fall in love. Shahrzad's role in this movie is that of a waitress and entertainer in the train station's teahouse. But soon, she runs off with a truck driver and is never heard from again.

78. *Baluch* is about a village husband becoming a vigilante after learning that his wife had been raped by two men from Tehran. He learns that the two men who had entered his village are now successful businessmen and cabaret owners. As he is planning the killing of the rapists, he meets a wealthy widow who dates him and agrees that if he serves as her bodyguard and lover she will help him find the persons he is looking for. Shahrzad is seen mainly in the beginning parts of the movie as the leader of the money launderers.

79. Jamal Omid, *Farhang-e Sinema-ye Iran* (Tehran: Negah, 1998), 261. The *Encyclopedia of Iranian Cinema, Sinemay-e Iran* (Tehran: Ariana, 1990), http://www.irancinema.ir, lists several more movies in which Shahrzad appeared, but I could not verify those titles.

80. Omid, *Farhang-e Sinema-ye Iran.*

81. Jamileh Nedai, "Mosahebeh ba Basir Nasibi," *Pandora2,* June 4, 2006.

82. Armes, *Patterns of Realism,* 191.

83. The story was based on a policeman's capture of a guerilla fighter who belonged to the OFPI (Fadaians). The protagonist is wounded during a bank robbery (presumably to support his revolutionary organization). Distressed, he seeks refuge in the house of his childhood friend who is now addicted and earns his money by working in a Lalehzar theater.

84. The lyrics of these songs include such famous lines as Farha's "On Fridays, it rains blood," Daryush's "The smell of wheat is mine, what I cultivate is yours", Vafai's "Oh God, you took all my belongings," and Shamlu's poem "Cry, oh, you fairies," again by Daryush.

85. These filmmakers were occasionally in trouble with the secret police over their products. Kimiyai was questioned for *Gavaznha*.

86. Moazezinia, *FilmFarsi Chist*, 22.

87. Examples of these include Makhmalbaf's *Ta Esteghaseh* and *Do Cheshm-e Bisu* and F. Salahshur's *Ayub-e Payambar*. Morteza Avini was one of the first writers who tried to defend and define this cinematic concept in Iran, mostly based on religious and political convictions. Morteza Avini, *Ayineh-e Jadu* (Tehran: Barg, 1991).

88. For a discussion of this topic and for more examples of the treatment of hejab in the movies, see Norma Claire Moruzzi, "Women's Space/Cinema Space: Representations of Public and Private in Iranian Films," *Middle East Report* 212 (Autumn 1999), 52–55.

89. As has been the case with literary movements, cinematic communities have also always been able to shape the way their consumers interpret their filmic products. The dominant mode of film reception in Iranian society also has changed every time a new movement or a new mode of expression appears. Each movement encourages its own way of reception. The elements that constitute this discursive relationship between the filmmakers and their audience include cinematic techniques, sarcastic language, symbolism, and metaphor all being worked in the context of the relationship between the regime's dominant ideological discourse, censorship, and the country's desire for change, progress, and simply functionality. By encouraging an understanding of the nuances of the plots, filmmakers also promote a subjective reception. Through all this, they shape the viewers' tastes and teach them to place the importance of political or sexual meaning over any symbolic, cinematic, entertaining scene. The response to successful movies like these is sometimes long lines at the box office, praise and positive reviews in cinematic weblogs, or banning and punishment of the filmmakers.

90. For example, Dariush Mehrjui, who made the political and psychological *Gav* before the revolution, has since made many movies that deal with gender issues. Indeed, several of his films bear female names as titles.

5. Shahrzad as a Writer: The Question of Literary Modernity

1. Her published works include *Ba Teshnegi Pir Mishavim* [Thirsty, we age]; *Salam, Aqa: Majmueh Shi'r* [Hello, sir: A collection of poetry] (Tehran: Dunya-yi Kitab, 1978); and *Tuba* (Tehran: n.p., 1977). In addition, she has written other works, including a screenplay, which have not been published.

2. Shahrzad, "Harfe Avval," in *Ba Teshnegi Pir Mishavim*, 6, 21–23. All translations of her poetry and prose are mine.

3. Sohrab Sepehrai, "Seday-e Pa-ye Ab" [The sound of water's steps], in *Hasht Ketab* (Tehran: Kitabkhanah-'i Tahuri, 1979).

4. Sepehri, "The Surah of Observation" [The verse on observation], in *Hasht Ketab*.

5. Sepehri, "Qayeqi Khaham Sakht" [I'll make a boat], in *Hasht Ketab*.

6. Ahmad Abidi, *Ashnayi ba Bihar al-Anwar* (Tehran: Dabirkhanah-i Hamayish-i Buzurgda-sht-i 'Allamah Majlisi, 1999).

7. Shahrzad, "Cheshmeh beh Fathe Darya," in *Salam, Aqa,* 49–51.

8. Sepehrai, "Marg-e Rang" [The death of color], in *Hasht Ketab*.

9. Sepehrai, "Roshan Shab" [The bright night], in *Hasht Ketab*.

10. Sepehrai, "Sarab" [Mirage], in *Hasht Ketab*.

11. Sepehrai, "Sedaye Paye Ab."

12. Forugh Farrokhzad, "Tavalod-i Digar," the title poem in *Tavalod-i Digar* (Tehran: Mor-varid, 1963).

13. Iraj Gorgin, *Chahar Musahibih Ba Furugh Farrukhzad* [Four interviews with Forugh Far-rokhzad] (Tehran: Intisharat-i Radio Iran, 1964).

14. For information on women's poetry and on the life and works of Forugh Farrokhzad, see Farzaneh Milani, *Veils and Words: The Emerging Voices of Iranian Women Writers* (Syracuse, NY: Syracuse Univ. Press, 1992); Michael C. Hillmann, *A Lonely Woman: Forugh Farrokhzad and Her Poetry* (Washington, DC: Mage, Three Continents Press, 1987).

15. Shahrzad, "You Are the Guest of my Eyes," in *Salam, Aqa*.

16. Shahrzad, "Zan Budam," in *Salam, Aqa,* 139.

17. Shahrzad, "Salam, Aqa," in *Salam, Aqa,* 102–11.

18. Forugh Farrokhzad, *Bride of Acacias: Selected Poems of Forugh Farrokhzad,* trans. Jascha Kessler, with Amin Banani (Delmar, NY: Caravan Books, 1982), 22.

19. Shahrzad, "Beh Sokhan Biya," from *Salam, Aqa,* 73–75.

20. Shahrzad, "The Fifth Season," in *Salam, Aqa*.

21. Shahrzad, "Harfe Aval," 6, 22–23.

22. Shahrzad, "The Fifth Season." In this work, she also uses the word "barren" to describe her woman character.

23. Shahrzad, "The Heights of the Cypress," in *Tuba*.

24. Shahrzad, "Harf-e Dovom," in *Ba Teshnegi Pir Mishavim,* 7–8, 24.

25. Shahrzad, "Safar-e Sevom," in *Ba Teshnegi Pir Mishavim,* 36–39.

26. Shahrzad, "Adam Cheqadr Dir Bozorg Mishavad, Adam Cheqadr Zud Pir Mishavad," in *Tuba,* 48–50.

27. From the section "We Can Walk the City," in *Tuba*.

28. From the section "Knowing the Fire," in *Tuba*.

29. Ibid.

30. Letters, vol. 3.

31. Letters, vol. 4.

32. These interviews were published as Shahrzad, "Inast Qeseh-ye Shahrzad Zamaneh Ma," 13.

33. Ibid.

34. Shahrzad, "Fasele Panjom," in *Salam, Aqa,* 85–91.

35. These interviews were published as Shahrzad, "Inast Qeseh-ye Shahrzad Zamaneh Ma," 13.

36. Alireza Nurizadeh published his interview with Shahrzad in *Ferdowsi Magazine* (Doshanbeh 12 Mehrmah 1971).

37. Ibid.

38. See Shahrnush Parsipur, *Touba and the Meaning of Night,* trans. Havva Houshmand and Kamran Talattof (New York: Feminist Press, 2006), 335.

39. See the introduction by Kamran Talattof and the afterword by Hura Yavari and Persis Karim in ibid. See also Kamran Talattof, "Breaking Taboos in Iranian Women's Literature: The Work of Shahrnush Parsipur," *World Literature Today,* Sept.-Dec. 2004, 43–46.

40. David Loma, *The Haunted Self: Surrealism, Psychoanalysis, Subjectivity* (New Haven, CT: Yale Univ. Press, 2000), 1, 3, 10, 120–21.

41. Ibid., 5–7.

42. See Arthur Rimbaud, "Sensation" in *Collected Poems* (Baltimore: Penguin Books, 1962); "I Embraced the Summer Dawn," in *Illuminations* (New York: J. Laughlin, 1957); and Paul Eluard, *Ombres et soleil/Shadows and Sun: Selected Writings of 1913–1952* (Durham, NC: Oyster River Press, 1995).

43. Shahrzad, "Pishgoftar: Ba U Beh Derza Keshideh Ast Shab," *Salam, Aqa,* 3–8.

44. The committed literary movement contributed heavily to the formation of the leftist discourse and to the movement that led to popular uprisings at the end of the decade. A group of poets, authors, intellectuals, and activists shaped a strong desire for political change. Among them, Ahmad Shamlu was prolific, and his poems promoted political activism. Mehdi Akhavan Sales, despite the rumor that he smoked opium, promoted a militant approach to society's problems. Ismail Khoi was the emblem of resistance. Hamid Mossadeq's poems became our slogans of resistance. Nader Naderpur wrote exciting poems that exposed other social problems. Nosrat Rahmin's work was controversial, although I did not understand why. Siyavush Kasrai wrote a poem that we memorized and recited when we hiked Tehran's northern mountains as intellectuals. Fiction by Mahmud Dowlatabadi, Hushang Golshiri, Ahmad Mahmud, and Bahram Sadeqi guided us in our defense of the deprived classes in our society and in our quest for political change. The political plays of Golam Hossein Saedi seemed appealing. Akbar Radi, Mohammad Ali Sepanlu, and Abd Ali Dastghaybe taught us a leftist/Marxist literary analysis; Jalal Al-e Ahmad managed to confuse many of us with his militaristic Persian prose against everything and nothing. Through the works and translations of Mohamad Reza Zamani, Daryush Ashuri, Sadr Aldin Elahi, Hamid Enayat, Sadr Haj Sayyed Javadi, Mahmud Etemadzadeh, and especially Mostafa Rahimi, we became partially familiar with social criticism, with some world literature (mostly Russian), and with the ideas of Sartre and Hegel and other German philosophers such as Marx and Engels whose names were not spoken out loud. Books by Khosrow Golsorkhi and Said Soltanpur would get readers in trouble if found by the police. Likewise, the books of Samad Behrangi and Ali Ashraf Darvishian were forbidden, although they were for children. We even tried to assign political significance to the few nonpolitical poems of Fraidun

Moshri, Fradun Tavaloli, Shafi Kadkani, Yadollah Royai, and the delicate poems of Sohrab Sepehri. Many contemporary poets had a nickname or a pen name to escape censorship and prosecution and simply to go with the trend: Ahmad Shamlu called himself A. Bamdad, Shafi Kadkani called himself M. Sereshk, Mahmud Etemadzadeh was M. A. Behazin, and so on. Many only learned many years later that M. Azad was indeed Mahmud Moshref Azad Tehrani. Many authors and poets went to prison and were interrogated by the SAVAK, the regimes' secret police. Authors such as Hushang Ebtehaj, Ismail Shahrudi, Amad Reza Ahmadi, Mansur Oji, Rasul Parvizi, Mohamad Kalantari, Asghar Vaqedi, Manuchehr Atashi, Farokh Tamimi, Ali Akbar Kasmai, Reza Barahani, Zayn al-Abedin Rahnama, and Manuchehr Niyestani were either too old or too young, and so were less influential, or lesser known. And readers cared little about the works of the traditional and old style authors and poets such as Shahriyar, Mahjub, Ali Dashti, and Moshfeq Kashani.

45. Shahrzad, "Pishgoftar," 3–8.

46. Jacques Lacan, *Ecrits* (New York: Norton, 1977).

47. Letters, vol. 2.

48. See Foucault, *History of Sexuality,* vol. 1, 3–49; and Foucault, *The Order of Things: An Archaeology of the Human Sciences* (New York: Vintage, 1973), ix–xxiii.

49. The reason it is mentioned here is because Shahrzad in her letters frequently refers to him at the times she is mentioning other men who have had different interactions with her. She remains respectful to Golestan, however. She also mentions that in 1968 or 1969, she took a green booklet containing her poetry to Golestan for his feedback.

50. See the introduction to *Ba Teshnegi Pir Mishavim.*

51. Monsef, "From Dancing the Hips to Moving the Brain," 20, 21, 24.

52. Annette Kolodny says that we miss the "richness and variety of women's writing" if we see it only as "feminine mode" or "style." Nevertheless, Kolodny also points out that women have had their own style, which is reflexive constructions with recurring themes such as clothing and self-fashioning. See Annette Kolodny, "Dancing Through the Minefield: Some Observations on the Theory, Practice, and Politics of a Feminist Literary Criticism," in *The New Feminist Criticism: Essays on Women, Literature, and Theory,* ed. Elaine Showalter (New York: Pantheon, 1985).

53. Sandra Gilbert and Susan Gubar, "Infection in the Sentence: The Woman Writer and the Anxiety of Authorship," in *The Madwoman in the Attic: The Woman Writer and the Nineteenth-Century Literary Imagination* (New Haven, CT: Yale Univ. Press, 1979), 45–93.

54. Ebrahim Golestan, "Si Sal Bishtar Ba Akhavan," *Majaleh-e Donya-ye Sokhan* 35 (1989): 4.

55. Alireza Nurizadeh published his interview with Shahrzad in *Ferdowsi Magazine* (Doshanbeh 12 Mehrmah 1971). On other occasions, she had stated that she is well read and that she has studied classical Persian literature as well.

56. See Benjamin Péret, "Hello," in *Surrealist Love Poems* (Chicago: Univ. of Chicago Press, 2005), 100.

57. Ibid.

58. Pithamber Polsani has noted that Dali's paranoiac method is not a random grouping of disparate images but a system in itself. He shows how each of the elements of "Dali's paranoiac-critical

activity" is related to Jacques Lacan's "reading of paranoiac delirium, as well as how Dalí achieves his goal of creating systematic confusion in reality." See Polsani, "The Image in a Fatal Kiss: Dalí, Lacan and the Paranoic Representation," in *Lorca, Buñuel, Dalí: Art and Theory*, ed. Manuel Delgado and Alicia Poust (Lewisburg, PA: Bucknell Univ. Press, 2001).

59. Shahrzad, "Ay Cheshmane Siahe To Abi," in *Salam, Aqa*, 23–26.

60. Both Nezami Ganjavi, in *Haft Paykar* [Seven beauties], ed. H. Vahid Dastgirdi (Tehran: Ibn-i Sina, 1955); and Abd al-Rahman Jami, in *Masnavi Haft Awrang* [Jami's seven thrones], ed. Mudarris Gilani (Tehran: Sa'di, 1958), especially employ this image in their poetry. For example, in Nezami's *Haft Paykar* (233), in the story told by the Slavic princess, we read "gah rokh buseh dad u gah labash/gah narash gazid o gah rotabash" (Now he kissed her cheek, at times her lips; sometimes he tasted/her pomegranates [her breasts], and sometimes her dates [her lips]).

61. Shahrzad, "Safare Aval," in *Ba Teshnegi Pir Mishavim*, 29–33.

62. Shahrzad, "Zananeha 9," in *Ba Teshnegi Pir Mishavim*, 80–82.

63. Shahrzad, *Salam, Aqa*, 102–11.

64. Letters, vol. 4.

65. Shahrzad, "Man va Khaharam," *Ferdowsi Magazine* 23, no. 1034 (19 Mehr 1971).

66. Nurizadeh, "Interview with Shahrzad."

67. Shahrzad, "Me . . . Want . . . Candy," in Sullivan, *Stories by Iranian Women Since the Revolution*, 80–87. The original work is Shahrzad, "Ah, Baba, Qiqam," *Ketab-e Jomeh* 1, no. 27 (2 Isfand 1980): 33–36.

68. Ibid.

69. Gilbert and Gubar, "Infection in the Sentence," 45–93.

70. This interview was published in *Ferdowsi Magazine*, and it was accompanied by a photo from a dancing scene from the movie *Majaray-e yek dozd* (The adventures of a thief) in which Shahrzad wears a miniskirt.

71. Women's works frequently in the past have been dismissed as the works of a man close to her, a father, a brother, or a friend.

72. Shahrzad, "Man va Khaharam."

73. I have provided an analyses of these issues in "Personal Rebellion and Social Revolt in the works of Forugh Farrokhzād: Challenging the Assumptions," in an edited volume on Farrokhzad. See Kamran Talattof, "Personal Rebellion and Social Revolt in the Works of Forugh Farrokhzād: Challenging the Assumptions," in *Forugh Farrokhzad, Poet of Modern Iran*, ed. Nasrin Rahimieh and Dominic Brookshaw (London: I. B. Tauris, forthcoming). The essay also disputes the notion that Farrokhzad's poetry represented a feminist discourse, as expressed by a number of critics in recent years. Finally, the article questions the repeated notion that Farrokhzad faced extraordinary obstacles, criticism, and suffering in her poetic career because she was a woman.

74. Letters, vol. 2.

75. Ibid.

76. Ibid.

77. See Daniel Juan Gil, "Before Intimacy: Modernity and Emotion in the Early Modern Discourse of Sexuality," *ELH* 69, no. 4 (Winter 2002): 861–87. For discussion of literary modernity in Iran, see Karimi-Hakkak, Thomas M. Ricks, and Majid Nafisi's works on Nima, including Nafisi's article, "Tazegi va Dirinegi dar Shi'r-e Behbahani," *Negah-e No* 44 (2000): 126–43. I particularly concur with Ahmad Karimi-Hakkak, who explains the nature of the poetic changes in the nineteenth and twentieth centuries as a complex process of borrowings and adaptations. See Ahmad Karimi-Hakkak, *Recasting Persian Poetry: Scenarios of Poetic Modernity in Iran* (Salt Lake City: Univ. of Utah Press, 1995).

78. For example, the works of Ezzat O-Sadat Gushegir, Reza Qasemi, or Shahrnush Parsipur, but these works are recent and all written outside Iran.

79. In addition to *Tehran-e Makhuf* (1923) by Moshfeq Kazemi, *Tafrihat-e Shab* (1932) by Mohammad Masud, and *Ba Man Be Shahr-e No Biya* (1932) by Hedayat Hakimolahi, the list include *Ziba* (1930) by Mohammad Hejazi, *Man Ham Garyeh Kardam* (1932) by Jahangir Jalili, *Adam Forushan-e Qarn-e Bistom* (1941) by Rabi' Ansari, and Fahesheh (1953) by Javad Fazel.

80. Earlier I mentioned Ezzat o Sadat Gushegir, Reza Qasemi, and Shahrnush Parsipur who write literary works that are distinguished from the porn stories that proliferate on the Internet. The latter genre might actually be mostly translation.

81. See Talattof, *Politics of Writing in Iran,* chap. 2.

82. Letters, vols. 1 and 2.

83. For a discussion of the issue of the self and the rise of feminist literary discourse, see Talattof, "Iranian Women's Literature," 531–58.

84. See Hamid Shawkat, *Tarikh-e Bist Salah-e Konfederasiyun-e Jahani-e Muhasselin va Daneshjuyan-e Irani* (Germany: Nashr-i Baztab, 1994); and Mehdi Khanbaba Tehrani and Hamid Shawkat, *Negahi az Darun beh Junbesh-e Chap-e Iran* (Saarbrücken: Baztab Verlag, 1989).

85. Even the title of the short piece on Shahrzad in *Ferdowsi Magazine* was suggestive. See "A Woman who Comes From the Darkness," *Ferdowsi Magazine* 1033 (1971): 12–14.

86. Letters, vol. 2.

87. Ibid.

88. This is not in contradiction with my argument in *The Politics of Writing in Iran* that, according to the notion of episodic literary movement, major works in each movement comply with the dominant ideological paradigm. The book provides numerous examples of the works that contribute to carry on the dominant discourse. Shahrzad's work does not fit into the committed literary movement but her marginalization and indeed her exclusion prove the validity of that analytical mode. The model affirms that authors who do not comply with the dominant discourse are not fully accepted into the literary community.

89. Letters, vol. 2.

90. Shahrzad, "Second Word," in *Ba Teshnegi Pir Mishavim.*

91. Sigmund Freud, *The Interpretation of Dreams,* trans. A. A. Brill (1913; New York: Macmillan, 1991), 32.

92. In condemning her, radical fundamentalist newspapers referred to the passage in which two women, Munes and Faizeh, have a discussion about the hymen before their journey to a "promised" garden begins. When Parsipur first came to the United State to give a talk, she was often incapable of functioning socially. It took her permanent residency and years of treatment to regain her normal life to some extent.

93. Letters, vol. 2.

94. This is not to negate the great outcome and product of postrevolutionary literary discourse. For an explanation and the effect of this literary movement, see Talattof "Iranian Women's Literature," 531–58.

95. Paul Sprachman, *Suppressed Persian* (Costa Mesa, CA: Mazda, 1995), viii.

96. In *Haft Paykar* [Seven beauties], he refers to women's genitals as *ganj* (treasure), *ganj-e dor* (treasure of pearl[s]), *ganj-e gohar* (treasure of gem[s]), *khazineh* (treasury), *ganj-e qand* (treasury of sugar), and *dorj-e qand* (jewel box of sugar). He also refers to the hymen and virginity as the *kan-e la'l* (mine of rubies), *dar-e ganjkhaneh* (treasure house door), *qufl-e zarrin* (golden lock), *mohr-e gohar* (jewel seal), and *mohr* (seal). For a discussion of Nezami's view of women, see Kamran Talattof, "Nizami's Unlikely Heroines," 51–81. See also Arjang Maddi, "Bar rasi-i suvar-i khiyal dar haft paykar," *Farhang* 10 (Fall 1992), 331–408.

97. See Albrecht Classen, "Sexuality in the Middle Ages: An Exploration of Mental History on the Basis of Literary Evidence," *Neohelicon* 22, no. 2 (Sept. 1995): 9–51. My information is also derived from presentations at a seminar that the author organized entitled "International Symposium on the History of Sexuality in the Middle Ages and the Renaissance," held at the Univ. of Arizona on May 3–6, 2007. See http://www.gened.arizona.edu/aclassen.

98. Parsipur, *Touba and the Meaning of Night,* 320.

6. Social Change in Iran and the Transforming Lives of Women Artists

1. See Houchang Chehabi, "Voices Unveiled: Women Singers in Iran," in *Iran and Beyond: Essays in Honor of Nikki R. Keddie,* ed. Rudi Matthee and Beth Baron (Costa Mesa, CA: Mazda, 2000), 164.

2. Bruno Nettle, "Attitude towards Persian Music in Tehran," *Musical Quarterly* 56, no. 2 (1970). BBC Persian featured the story of the early and last days of Lalehzar. See Masud Behnud, "Ta'til-e Teatre Pars: Payan-e Lalehzar," *BBC Persian* (14 Dec. 2004).

3. Respectively, in *Tehran Mosavar* 148 (23 Farvardin 1946): 5; *Tehran Mosavar* 151 (12 Farvardin 1947): 8.

4. Deirdre Lashgari, Violence, Silence and Anger: Women's Writing as Transgression (Charlottesville: Univ. Press of Virginia, 1995), 2, 11.

5. Ibid., 33.

6. See Taqi Binesh, *Tarikh-e Mokhtasar-e Musiqi-e Iran* (Tehran: Nashr-i Arvin, 1995); and *Hamshahri Online* at http://www.hamshahrionline.ir/News/?id=16499.

7. Many oppositional publications right after the revolution documented the rise of the rough neighborhood young men into power through their participation in the revolutionary committees (Komiteh-ha-ye Enqelab).

8. Of course at the time, these groups accused the Shah's regime of the massacre and many at the time believed the accusation.

9. Letters, vol. 2.

10. Ibid.

11. See Talattof, "Nizami's Unlikely Heroines," 51–81.

12. For more information on women in Islam, see Amina Wadud, *Qur'an and Woman: Rereading the Sacred Text From a Woman's Perspective* (New York: Oxford Univ. Press, 1999); Anwar Hekmat, *Women and the Koran: The Status of Women in Islam* (Amherst, NY: Prometheus Books, 1997); Haideh Moghissi, *Feminism and Islamic Fundamentalism: The Limits of Postmodern Analysis* (London: Zed Books, 1999); Fatima Mernissi, *Women and Islam: An Historical and Theological Enquiry*, trans. Mary Jo Lakeland (Oxford: Basil Blackwell, 1991); and M. E. Combs-Schilling, *Sacred Performances: Islam, Sexuality, and Sacrifice* (New York: Columbia Univ. Press, 1989). Muslim scholars like Ibn Hisham, Ibn Hajar, Ibn Sad, and Tabari presented a radically different portrayal of women; see Mernissi, *Women and Islam*, viii, 126, 128.

13. For further information, see Abbas Amanat, *Resurrection and Renewal: The Making of the Babi Movement in Iran, 1844–1850* (Ithaca: Cornell Univ. Press, 1989); Denis MacEoin, *The Sources for Early Babi Doctrine and History* (Leiden: Brill, 1992); Moojan Momen, ed. *Selections from the Writings of E. G. Browne on the Babi and Bahá'í Religions* (Oxford: George Ronal, 1987). See also Farzaneh Milani, *Veils and Words: The Emerging Voices of Iranian Women Writers* (Syracuse, NY: Syracuse Univ. Press 1992) on the poetry of Tahereh.

14. See Moojan Momen, "Usuli, Akhbari, Shaykhi, Babi: The Tribulations of a Qazvin Family," *Iranian Studies* 36, no. 3 (2003): 317–37.

15. See Abbas Amanat, *Resurrection and Renewal: The Making of the Babi Movement in Iran 1844–1850* (Ithaca, NY: Cornell Univ. Press, 1989).

16. For the story of Googoosh's song, see Chris Hedges, "Beloved Infidel," *New York Times*, July 4, 1993. I should add that Googoosh's song "Aqa Jun" was believed to refer to the leader of the revolution, but some, including Sadeq Nojuki, the writer of the lyrics, deny this rumor. See Mohiyadin Alampur, *Eshq Faryad Konad* (Dushanbe, Tajikistan: Vezarat-e Farhang-e Tajikistan, 1995), 22.

17. See the chapters on women's literary work in Talattof, *Politics of Writing*. See also Talattof, "Gender, Feminism, and Revolution: Shifts in Iranian Women's Literature" in *Gozaar*, http://www.gozaar.org/template1_en.php?id=459, April 2007; Talattof, "I Will Rebuild You, Oh My Country": Simin Behbahani's Work and Sociopolitical Discourse," *Journal of Iranian Studies* 41, no. 1 (2008): 19–36; and Talattof, "Personal Rebellion and Social Revolt." See also the introductions and afterwords in *Touba and the Meaning of Night* and *Women Without Men: A Novel of Modern Iran*, trans. Kamran Talattof and Jocelyn Sharlet (New York: Syracuse Univ. Press, 1998). Kamran Talattof, "Translating Women's Experience: A Note on Rendering the Novel," in Parsipur, *Touba and the Meaning of Night*, vii–xv; Houra Yavari, afterword, in Parsipur, *Touba and the Meaning of Night*; and Persis Karim, "Biography," in Parsipur, *Touba and the Meaning of Night*. The works of Farzaneh Milani, Persis Karim, and Nasrin Rahimieh, to name a few examples, shed light on women's literary works.

18. See Chehabi, "Voices Unveiled"; PersianMovies.com, Ghadimiha.biogfa.com, and http://forum.p30world.com; Alampur, *Eshq Faryad Konad*.

19. Tuka [Tooka] Maleki, *Zanan-e Musiqi-e Iran* (Tehran: Ketab-e Khorshid, 2001).

20. For information about this movie, see chapter 4.

21. For a historical analysis of women's dancing and singing, see Chehabi, "Voices Unveiled," 151–66.

22. Quoted in the banned book by Tuka Maleki, who also provides some additional information about Ruhangiz's life during the postrevolutionary period. See Maleki, *Zanan-e Musiqi-e Iran,* 224–27.

23. Ejlali, *Digarguni-i Ejtimai va Film-ha-ye Sinimai dar Iran,* 110–11. He quotes Mohammad Tahaminejad's report in *Majalleh Vizhe Sinema va Teatre* 1, no. 3, 123.

24. Parvin Ghafari, *Ta Siahi* (Tehran: Sokhan, 1997).

25. Ibid., 107.

26. Ibid., 113.

27. A plethora of such memoirs have been written in or translated into Persian, and many of them in one way or another refer to the sex life of the royal family. See, for example, Farideh Diba, *Dokhtaram Farah: Khatirat-i Banu Faridah Diba, Madar-i Farah Pahlavi* [*My Daughter Farah: Memoir of Farideh Diba*], trans. Elahe Raisfiruz (Tehran: Behafariin, 2000), 338; Taj al-Moluk Pahlavi, *Khatirat-e MalEkah-e Pahlavi* (Tehran: Behafarin, 2001); Assadollah Alam, *Guftgu'ha-yi Man ba Shah: Khatirat-e Mahramanah-i Amir Asadollah Alam* (Tehran: Tarh-e No, 1992); and Vezarat-e Etelaat, *Zanan-i darbar bih Ravayat-i Asnad Savak* (Tehran: Markaz-e Barrasi-e Asnad-e Tarikhi, 2002).

28. Ghafari, *Ta Siahi,* 5–7.

29. It included Shahrokh Golestan's interview with Delkash and was distributed by BBC Persian. For more information on her life and work, see Erik Nakjavani, "Delkhash," *Encyclopaedia Iranica,* October 28, 2005.

30. For information and analysis of Qamar al-Moluk Vaziri, see Chehabi, "Voices Unveiled."

31. For information about the way in which she began her official work as a singer, see Maleki, *Zanan-e Musiqi-e Iran,* 268–73.

32. For a short article about Elahe's life, see Farid Dehzadi, "Elahe Beh Afsaneh Payvast," *Mahnahmeh Takhososi Musiqi* 1, no. 67 (2007): 60–63. For information on *Golha* programs, see Jane Lewisohn, "Flowers of Persian Song and Music: Davud Pirnia and the Genesis of the Golha Programs," *Journal of Persianate Studies* 1, no. 1 (2008): 79–101. The author has collected 1,400 programs. Many females are among the names of the poets whose poems were used for the songs.

33. I believe it was *Lady Windermere's Fan.*

34. "An Interview with Foruzan," *Itilaat-e Haftegi* 1617 (1972).

35. Jon Pareles, "Googoosh," in *Current Biography Yearbook* (New York: H. W. Wilson, 2001), 219–21. See also Chris Hedges, "Beloved Infidel," *New York Times,* July 4, 1993.

36. For more information about her life and career, see Chehabi, "Voices Unveiled."

37. See Alampur, *Eshq Faryad Konad,* 14–15.

38. See her interview in Alampur, *Eshq Faryad Konad*. I tried to interview Forouhar. However, my attempts to discuss the pre- or postrevolutionary situation of the artist in Iran and United States did not lead to any meaningful conversation.

39. See Ashraf Baqeri and Nasrin Safavi, *Gole Goldune Man: Simin Ghanem Az Aghaz ta Emruz* [The flower of my vase: Simin Ghanem from beginning until today] (Tehran: Nashr-e Sales, 2004). The title of this book is derived from one of Simin Ghanem's popular songs. The two authors interviewed Ghanem about her life and her work on television prior to the revolution. During the reform period in 1999, she gave two concerts for all-female audiences.

40. Many of the women singers and artists who manage to exist in Iran today have their own Web sites. A few Web sites are also dedicated to old pop music (in addition to several with classical music) and films.

41. There is some scattered information about all these stories on the Internet on the artists' Web sites.

42. Many details are known about Susan's life because of my research done for a forthcoming entry in *Encyclopaedia Iranica*.

43. Apparently, it was possible for children to sing in these nightclubs, because doing so was a stepping-stone in the life of Googoosh and others who later became celebrities.

44. For information about her life, see Golam Haydari, *Filmshinakht-i Iran* (Tehran: Daftar-e Pazhuhesh Farhangi, 1992); M. Mojteba, "Honarpishe-haye Qadim and Khanandegan Irani" [Old days actors and Iranian singers], http://filmghadimi.blogfa.com/post-488.aspx; and Ravi, "Ba Cheragh-e Taraneh dar Kuche Bagh-e Khatereh" [Under the light of songs in the orchard alleys of memoirs], http://www.parand.se/t-yadmane-sousan.htm.

45. Mansur Owji, *In Susan Ast keh Mikhanad* (Tehran: Daricheh, 1970), 143–45.

46. Ibid.

47. For more information, see Haydari, *Filmshinakht-i Iran*; Mojteba, "Honarpishe-haye Qadim and Khanandegan Iraniat"; Ravi, "Ba Cheragh-e Taraneh dar Kuche Bagh-e Khatereh"; and Owji, *In Susan Ast keh Mikhanad*.

48. Shahrnush Parsipur, *Khaterat-e Zendan* (Spanga, Sweden: Baran, 1996).

49. Parsipur's novels translated into English are *Touba and the Meaning of Night* and *Women Without Men: A Novel of Modern Iran*.

50. According to Maleki, some also died because of their addictions. See Maleki, *Zanan-e Musiqi-e Iran*.

51. The title of the movie was *Duzakhiha* (Hellraisers, 1982). For more information and a discussion of this movie, see Hamid Reza Sadr, *Iranian Cinema: A Political History* (London: I. B. Tauris, 2006), 178–79.

52. ISNA News Agency, "Aqa-ye Bazigar-e Cinema-ye Iran 83 Saleh Shod," June 20, 2007.

53. "We Women Are All Unchaste," *Khandaniha* 493, no. 80 (4 Mordad 1949): 17–18.

54. Ali Akbar Kasmai, "Az in Zanan Beparhizid," *Taraqi* 7, series 3, no. 336 (30 Khordad 1949): 7.

55. Ibid.

56. "Mode jadid adam koshi," *Tehran Mosavar* 922 (14 Ordibehesht; 1950): 41.

57. See "Az Manazer-e Zanandeh," *Sepid o Siyah* 4, no. 6 (Shahrivar 1956).

58. See, for example, the special issue celebrating the journal's fortieth anniversary on March 10, 1971. Almost every page includes a sexual joke or a somewhat nude photo or cartoon all making fun of contemporary women.

59. See, for example, the interview of Farzaneh Taidi in *Zan-e Ruz* (27 Aban 1351). The interviewer's first question is "How possible is it that you finally take off your clothes in a movie?"

60. Editorial in *Khandaniha*, "Enherafat-e Jensi," *Khandaniha* 17, no. 84 (Tir 1967): 28.

61. Ali Akbar Kasmai, "Zan-e Irani Por Modea-tarin Zan-e Jahan Ast," *Taraqi* 52, no. 489 (Khorda 1952): 11.

62. Jahangir Afghami, "Dokhtar-ha Bekarat-e Khod Ra Az Dast Nadahid," *Khandaniha* 7, series 72, no. 276 (Ordibehesh 1947): 21.

63. Mahvash is reported to have authored or co-authored a book entitled *Raz-e Kamyabi-ye Jensi* (Secrets of sexual satisfaction). For more information about Mahvash and several sources about her life, see Chehabi, "Voices Unveiled."

64. See the archive of M. Mojteba, "Honarpishe-haye Qadim va Khanandegan Irani" [Old days actors and Iranian singers] at http://www.filmghadimi.blogfa.com/post-107.aspx.

65. Newspapers of the time frequently reported such fights and cases of people being roughed up. *Tehran Mosavar,* a popular magazine published in Tehran, routinely published the news of Mahvash's activities, including her arrest for the publication of the book about sex. The intellectual journal *Kaveh,* published in Germany, reported her well-attended funeral in a brief entry.

66. M. Kiyamehr, "FilmFarsi, Bi Farhang, Bi Hoviyat, and Biganeh: Chera FilmFarsi Misazand?" *Khandaniha,* Azar 1974, 24–27.

67. The situation of women during and after the 1979 Revolution is not the main subject of this chapter. Indeed, there have been numerous studies about the situation of women in postrevolutionary Iran. See, for example, the work of Halah Isfandiyari, *Reconstructed Lives: Women and Iran's Islamic Revolution* (Washington, DC: Woodrow Wilson Center Press, 1997), who depicts the lives of some women from different backgrounds who suffered because they did not want to submit to the mandatory dress codes (109–22). See also Jane Bayes and Nayyirah Tawhidi, *Globalization, Gender, and Religion* (New York: Palgrave, 2001); and Asghar Fathi, *Iranian Refugees and Exiles Since Khomeini* (Costa Mesa, CA: Mazda, 1991). These works shed light on the status of women in Islam generally as well or offer studies related to the economic and legal challenges that women have been facing since 1979.

68. These are evident in the writing of the Marxist, leftist, and nationalist groups as well as in the writing of critics such as Al-e Ahmad, Shariati, Rahimi, and Zamani. Socialist and Marxist groups believed that only a socialist republic system would allow an Iranian identity to be fully formed.

69. These accounts are not complete and do not include the tragic situation of many women artists. Each story requires a complete project of its own to be completely told and understood.

70. See the interviews with artists' wives in Hannanih, *Pusht-i Darichah-h,* translated and discussed in Talatoff, *Politics of Writing in Iran.*

71. In fact, the Tajikistan Ministry of Culture published a book in her honor that discusses her work and life. The author states, "Googoosh is still extremely popular in Tajikistan. People in that country frequently asked Mohammad Reza Shajarian, one of the most prominent singers of classical Persian music, who was visiting different Tajik cities in early 1990s about Googoosh, her work, and her whereabouts." See Alampur, *Eshq Faryad Konad,* 5. The book contains information about Googoosh's work that has been collected in old journals or during interviews with different people. It offers an interesting account of Googoosh's winning the first prize and golden record at the Cannes Festival in 1971 (18). It is not an exaggeration to say that the book has promoted the Iranian singer to the level of a cultural messenger, an artistic icon, and a national legend.

72. I have witnessed some of these signs firsthand and have heard some of the reports personally. The "Farhang va Hunar" page on the Persian BBC on the Internet has been doing great work bringing some of these cultural nuances to the surface. See http://www.bbc.co.uk/persian/arts/.

73. Baqeri and Safavi, *Gole Goldune Man.*

74. For her story, see Marc Bonel and Danielle Bonel, *Edith Piaf, le temps d'une vie* (Paris: Editions de Fallois, 1993); and Simone Berteaut, *Piaf: A Biography* (New York: Harper and Row, 1972).

75. *The Notorious Bettie Page* is a biographical film about pinup and bondage model Bettie Page, directed by Mary Harron, written by Guinevere Turner, and with Gretchen Mol (released in April 2006, Canada). For more information on Page, see Richard Foster, *The Real Bettie Page: The Truth About the Queen of the Pin-ups* (New York: Citadel Press, 1997).

7. Ideology, Sexuality, and Sexual Agency: An Afterword

1. As a sign of women's empowerment, we must note that Iranian women's expressions and choice of words have significantly changed; a feminist discourse informs their writings, and gender issues have gained central significance. They are now active in many fields, including the reinterpretation of their religion. Filmmakers who devoted their entire energy to criticizing poverty today make movies about women, in which they subtly and indirectly and in a very primitive form deal with gender and sexuality.

2. "Sarnevesht-e Ebrat Amuz-e Bazigar-e Maruf-e Cinema-ye Ebtezal: Gozaresh-e Vizheh," in *Kayhan,* no. 19172, 12/6/1387, 2.

3. Mansur Owji, "Shiraz," in *Sokhan: Majaleh Adabiyat va Danesh, va Honar-e Emruz* 20, no. 9–10 (Esfand 1970), 877. For the analysis of the prerevolutionary committed literature, see Talattof, *The Politics of Writing in Iran,* chapter 3.

4. For the views of these contemporary Muslim philosophers, see Reza Davari, *Vaze kununi-ye tafakkur dar Iran* [The present state of thought in Iran] (Tehran: Surush, 1978); Morteza Motahari, "Osul falsafeh va ravesh-e realism" [The principles and methodology of realism], in *Majmueh asar* [Collected works] (Tehran: Sadra, 1992); and Muhammad Husayn Tabatabai, *Shiite Islam* (Albany: State Univ. of New York Press, 1975).

5. Valentine Moghadam argues that women's lives are shaped not only by Islam and culture but also by factors such as state, class, and politics. Valentine Moghadam, *Modernizing Women: Gender and Social Change in the Middle East* (Boulder, CO: L. Rienner, 1993). Nayereh Tohidi has shown that global processes also play a role in shaping of Middle Eastern women's lives. Herbert Bodman and Nayereh Tohidi, *Women in Muslim Societies: Diversity Within Unity* (Boulder, CO: L. Rienner Publishers, 1998). All these point out that Islam may not be seen as the sole factor in the explanation of Iranian women's current conditions. However, it is also undeniable that the economy, local politics, and international relations in Iran were influenced by Islamic culture, or presented through an Islamic cultural filter, and are now, more than ever before, shaped by that official discourse.

6. Despite Rodney Stark's assertion, the relationship between Catholicism and sexuality does not support the former as the early source of modernity. To be sure, one can even look at the state of democracy in mainly Protestant European countries as opposed to the Catholic European countries in the twentieth century.

7. Imam Abu Hamed Mohammad Ghazali [Ghazali], *Kimiya-e Sa'adat* [The alchemy of happiness] (Tehran: Intesharat-e Tulu va Intisharat-e Zarin, 1982), 301. For more information on this topic, see Ghazali, *Marriage and Sexuality in Islam: A Translation of al-Ghazali's Book on the Etiquette of Marriage from the LIhya 'Ulum al-Din*, trans. Madelain Farah (Salt Lake City, Utah: Univ. of Utah Press, 1984).

8. Of course such a view of sex relationships may go back to a branch of thinking in ancient Greek philosophies. However, in contemporary Iran, the leftist secular revolutionaries also adopted it, making it further difficult for women activists to discuss issues of self, womanhood, and women's concerns.

9. On the discussion of women in Islam, see, for example, the works of Fatima Mernissi, Nawal El Saadawi, Valentine Moghadam, and Nayereh Tohidi. The book co-edited by Bodman and Tohidi in particular provides a forum for the studies of women in Muslim countries and a variety of ways in which they live and think, pointing to dynamic definitions of Muslim women and their social roles. See Bodman and Tohidi, *Women in Muslim Societies*.

10. Some scholars believe that the issues of gender inequality become the focus of the clerical establishment after the revolution. For example, Ziba Mir-Hosseini writes, "Once in power, the clerical establishment could no longer evade the issue of gender inequality as it had done before." See his "Women's Rights and Clerical Discourses: The Legacy of Allameh Tabatabai," in *Intellectual Trends in Twentieth-Century Iran: A Critical Survey*, ed. Negin Nabavi (Gainesville: Univ. Press of Florida, 2003), 193. As we will see, the clerical establishment did not evade the question of women and gender inequality before the revolution. They indeed reinforced it. After the revolution, these questions became more urgent for the dominant state ideology.

11. Murteza Mutahhari [Morteza Motahari], *On the Islamic Hijab*, trans. Laleh Bakhtiar (Tehran: Islamic Propagation Organization, 1987), 47–64.

12. Ibid.

13. Morteza Motahari, *Akhlaq-e Jensi dar Islam va Gharb* (Qom: Sadra, 1980), 19–20. In this work, the author considers sexual ethics to be the most important type of ethics. And he explains

its elements as being women's coyness with men, men's sexual honor, women's chastity and loyalty to husbands, covering sexual organs, covering women's bodies, forbidding sex outside marriage, forbidding visual and sensual joy of women not legally married, forbidding incest, forbidding sex during women's menstruation, banning pornography, and forbidding the praise of single life.

14. Imam Ruhullah Khomeini, *Islam and Revolution: Writings and Declarations of Imam Khomeini,* trans. and annot. Hamid Algar (Berkeley, CA: Mizan Press, 1981), 181–88.

15. Ali Shariati, "Modern Calamities," in *Marxism and Other Western Fallacies: An Islamic Critique,* trans. R. Campbell (Berkeley, CA: Mizan Press, 1980), 32–40, 91–96.

16. See, for example, Morteza Motahari, *Nizam-i Huquq-i Zan dar Islam* (Tehran: Intisharat-i Sadra, 1978); Motahari, *Masalah-i Hijab* (Tehran: Anjuman-i islami-yi pizhishkan, 1969); Ali Shariati, *Fatemeh Fatemeh Ast* (Tehran: Husayniyah Irshad, 1971); and Muhammad Husayn Tabatabai, *Ravabit-i Ejtemai dar Islam* (Tehran: Intisharat-i Azadi, 1981). See also several examples in Ahmad Sadeqi Ardestani, *Islam va Masael-e Jensi va Zanashui* (Tehran: Muassaseh-ye Matbu'ate-e Khazar, 1971), 197, 292.

17. No wonder in the decades after the revolution, ideas presented in such books as *Alfiyah wa Shalh, Kashf al-Zunun,* and *Miftah* facilitated a return to temporary marriage and polygamy and a number of other medieval beliefs and practices. Such ideas and concepts are collected in a volume by Mohammad Ebrahim Avazeh [Razavi] entitled *Qanun-e Qoveh Bah: Adab-e Zanashui,* 3rd ed. (Qom: Intesharat-e Selseleh, 2003). It should be mentioned that some Muslim thinkers such as Karim Sorush and Mohsen Kadivar have offered some religious counterarguments.

18. See, for example, the works by Sadeqi Ardestani and in particular his *Islam va Masael-e Jensi va Zanashui.* This book was reprinted a few times after the revolution. His other works also gained new importance in the 1980s. The book goes as far as quoting one religious leader telling another where and on what days of the month not to have sex with wives (208, 218).

19. Afzular Rahman, *Role of Muslim Women in Society* (London: Seerah Foundation, 1986), 359–61.

20. Ibid.

21. Allamah Sayyid Zeeshan Haider Jawadi, *Women and Shari'at (Divine Law): Complete Rules Regarding Women, in Islam* (Mumbai: Idarah Islam Shinasi, 1999), 10–12.

22. For a discussion of this topic, see Chehabi, "Voices Unveiled."

23. Avazeh, *Qanun-e Qoveh Ba'h.* The information provided by the book indicates that the author is a researcher, an Islamic physician, and a member of the Hejab Institute in Qom, where the book became a best seller upon the publication of its first edition. One of the sayings quoted actually refers to a woman as an "instrument of joy" (22).

24. Rahman, *Role of Muslim Women in Society,* 359–61, 385–86.

25. Ibid.

26. Ayatollah Khomeini, "Sokhanrani dar Behesht-e Zahra" [Speech in Behesht-e Zahra,] Feb. 1, 1979, published in *Kayhan,* no. 10628, Feb. 3, 1979.

27. Badr ol-Moluk Bamdad, *From Darkness Into Light: Women's Emanicipation in Iran* (New York: Exposition Press, 1977), 16–19.

28. Ibid.

29. A few examples of the expressions of women's artists married to male artists are presented later in this chapter. For a more detailed discussion of the topic, see Shahin Hannanih, *Pusht-i Darichah-ha: Guft Gu Ba Hamsaran-i Hunarmandan* [Behind the windows: A conversation with artists' spouses] (Tehran: Dunya-yi Madar, 1992).

30. See Baqeri and Safavi, *Gole Goldune Man.*

31. Some the most popular books written by these authors include Ali Asghar Haj Sayyed Javadi, *Arzyabi Shitabzadeh* (Mashhad: Intesharat Tus, 1970); Mostafa Rahimi, *Nim Negah* (Tehran: Zaman, 1977); and Mostafa Zamani, *Islam va Tamaddun-i Jadid* (Tehran: Ketabkhane Sadr, 1970).

32. In the West, Ernest Gellner and particularly Robert Wuthnow demonstrate that secularism began during the religious revolution of the sixteenth century and was led by Martin Luther and John Calvin. See Gellner, *Nationalism* (London: Weidenfeld and Nicholson, 1997); and Wuthnow, introduction to *Communities of Discourse: Ideology and Social Structure in the Reformations, the Enlightenment, and European Socialism* (Cambridge, MA: Harvard Univ. Press, 1989).

33. Talattof, "Comrade Akbar," 634–49.

34. Talattof, *The Politics of Writing in Iran,* 11.

35. Amin, *Making of the Modern Iranian Woman.*

36. Oriana Fallaci, *Interview with History* (New York: Liveright Publishing, 1976), 270–71.

37. For a discussion of the notion of gender in these ideologies, see also Haideh Moghissi, *Populism and Feminism in Iran: Women's Struggle in a Male-Defined Revolutionary Movement* (New York: St. Martin's Press, 1994), 58.

38. See interviews with Farzaneh Taidi at http://www.filmghadimi.blogfa.com/post-456.aspx.

39. Bamdad, *From Darkness Into Light,* 16, 17.

40. The constitution itself banned women, along with criminals and beggars, from voting.

41. Al-e Ahmad, *Gharbzadigi.*

42. Ruth Roded, *Women in Islam and the Middle East* (New York: I. B. Tauris, 1999), 255–57.

43. For a more elaborate analysis, see Talattof, "Comrade Akbar," 634–49.

44. Geraldine Brooks, *Nine Parts of Desire* (New York: Doubleday, 1995), 237–38.

45. Kolakowski, *Modernity on Endless Trial,* 1990.

46. Hans Blumenberg, *The Legitimacy of the Modern Age,* trans. Robert M. Wallace (Cambridge, MA: MIT Press, 1983), 69. Blumenberg also believes that modernity cannot be understood except as the "second overcoming of Gnosticism." See Blumenberg, *The Genesis of the Copernican World,* trans. Robert M. Wallace (Cambridge, MA: MIT Press, 1987), 126.

47. Article 44 is to implement guidelines of the Twenty-Year Vision Plan to help privatization and to minimize the government's role in the economy. The guidelines were set out in May 2005.

48. Again, to understand how different the process of the normalization of sexuality has been in the West and in nonmodern societies, a nineteen-century book by P. L. Jacob offers many insights into medieval Western sexuality. For example, he writes, "Whatever opinion may be formed of chivalry, it is impossible to deny the influence which this institution exercised on private life in the Middle Ages. It considerably modified custom, by bringing the stronger sex to respect and defend the weaker. These

warriors, who were both simple and externally rough and coarse, required association and intercourse with women to soften them. . . . In taking women and helpless widows under their protection, they were necessarily more and more thrown in contact with them. A deep feeling of veneration for women, inspired by Christianity, and, above all, by the worship of the Virgin Mary, ran throughout the songs of the troubadours, and produced a sort of sentimental reverence for the gentle sex, which culminated in the authority which women had in the courts of love." P. L. Jacob, *Manners, Customs, and Dress During the Middle Ages and During the Renaissance Period* (London: Chapman and Hall, 1876).

49. Judith Lorber, "Believing Is Seeing: Biology as Ideology," in *The Politics of Women's Bodies: Sexuality, Appearance, and Behavior,* ed. Rose Weitz (Oxford: Oxford Univ. Press, 2003), 12–13.

50. Ibid.

51. Ibid.

52. The document in its first 1992 edition refers to gay intercourse as *lavat* and to lesbian sex as *mosaheqeh*. The penal code includes two types of offenses and corresponding punishments. The first type includes offenses such as adultery, alcohol consumption, burglary or petty theft, rebellions against Islamic authority, apostasia, and homosexual intercourse, and they are punishable with *Hudud* (fixed punishments) including death by stoning, decapitation, amputation, or flagellation (punishments may be carried out in public). The other type regards private crimes such as murder or rape that are subject of *Qissas* (retribution) or *Diya* (blood money as in an eye for an eye). Iranian Penal Code, *NATLEX* (a database by the International Labor Organization at http://www.ilo.org, consulted Feb. 2, 2006).

53. Atefh Rajabi was sixteen years old when she was executed for acts "incompatible with chastity" (*amal-e manafi-ye efat*) including seduction (*eghva*). Amnesty International furiously condemned the death penalty on August 23, 2004.

54. Jean Baudrillard, *Seduction,* trans. Brian Singer (Basingstoke: Macmillan Education, 1990).

55. See Jürgen Habermas, *The Structural Transformation of the Public Sphere: An Inquiry into a Category of Bourgeois Society,* trans. Thomas Burger with the assistance of Frederick Lawrence (Cambridge, MA: MIT Press, 1998), 2–5.

56. Ibid.

57. It might be more productive to study these issues from a transnational point of view. An observation of the globalization process strongly suggests that the constant flow of people, information, and culture across borders has played a factor in the formation of Iran's contemporary history since the mid–twentieth century, when transnational flow accelerated significantly.

58. This goes back to in the late 1990s. The rise of a fundamentalist faction to power in 2005 seems to indicate a new approach to the re-reinforcement of the old revolutionary dress codes.

59. Authorities have thus far made several unsuccessful attempts to prevent the exchange of jokes through text messaging.

60. See Mansoor Moaddel, "The Iranian Revolution and Its Nemesis: The Rise of Liberal Values among Iranians," *Comparative Studies of South Asia, Africa and the Middle East* 29, no. 1, 2009), 126–36. See also Abdolmohammad Kazemipur and Ali Rezaei, "Religious Life under Theocracy: The Case of Iran" *AFF News Briefs* 2, no. 6 (2003).

61. For information on Persian rap music, see Sholeh Johnston, "Persian Rap: The Voice of Modern Iran's Youth," *Journal of Persianate Studies* 1, no. 1 (2008), 102–19.

62. To name a few, Iranians have access to the Internet and Persian satellite television networks operated by Iranians in California and elsewhere or by major international broadcasting networks in the United States and Europe. Iranian women are also inspired by NGO ideas and activities that find their way to the country.

63. See http://web.iranamerica.com/forum/archive/index.php/t-6659.html. The site actually also mentions the source as http://www.entekhabnews.com/portal/index.php?news=4842 (accessed 5/20/2009). To combat Internet pornography, the government has formed special forces, and their activities are reported on a special Web site entitled Gerdab (whirlpool): http://www.gerdab .ir. Gerdab reports that one of the porn activists who has been identified from the city of Gorgan has worked with such sites as Avizoon, Sexiran, Biaclip, Icebazi, and so on. He has provided Avizoon alone about four hundred sex clips that have been downloaded 3.2 million times. It is impractical to verify all this. However, it is interesting that in the comments section and in response to a reader's objection for not publishing his views, the site editors state that most of the comments and feedback they receive contains sexual language and are thus not publishable. *CEKAF* is discontinued.

64. This is evident in the argument of a female member of the Iranian parliament who once rejected polygamy, stating that no ordinary man can be as just toward more than one wife as the prophet, who once recommended the practice. Moreover, many women in the interesting documentary entitled *Mrs. President: Women and Political Leadership in Iran* (dir. Shahla Haeri, 2001), which includes interviews with women candidates for the president, based their arguments about women's rights to run for the office based on the most traditional anecdote of the early years of Islam in order to avoid the accusation of Americanization.

65. For statistics and discussion of sex crimes, see Abd al-Amir Maneshhadvi, *Qatl-i Namusi* (Tehran: Afarineh, 2000); and Parvin Bakhtiyarnejad, *Faje'e Khamush Qatlhaye Namusi* (an online publication by Bakhtiyarnejad, Jan. 6, 2010).

66. Payam Fazalinejad, "Zanan-e Feminist, Tarh-e Khavarmiyan-e Bozorg, va Enqelab-e Makhmali" [Feminist women, the great Middle East project, and the velvet revolution]. This lecture by a *Kayhan* employee was later reprinted on several Web sites including http://www.dw-world.de.

67. A number of other scholars have referred to sexual changes in terms of rebellion, backfire, or revolution. See Elaine Sciolino in her *Persian Mirrors: The Elusive Face of Iran* (New York: Free Press, 2000); Pardis Mahdavi, *Passionate Uprisings: The Intersection Between Sexuality and Politics in Post-Revolutionary Iran* (Ph.D. dissertation, Columbia Univ., 2006); and Moaveni, "Sex in the Time of Mullahs," 54.

The following items explain the above assertions further. After the Iran-Iraq war, then-Iranian President Hashemi Rafsanjani helped promote temporary marriage, allegedly to ensure that the widows of the soldiers who were killed in the war were cared for by other men. He also mentioned that he wanted to ease sexual segregation that had frustrated people's sexual urges. A short story by Moniru Ravanipur entitled "Three Pictures" offers a glimpse into these women's harsh lives and their situation as prey. For the English translation of this story, see Ravanipur, *Satan's Stones*. For more information, see Sciolino, *Persian Mirrors,* 128, who also states, "Despite the legality of *sigheh*

in the Islamic Republic, it is unpopular among young people and that is not likely to change . . . for *sigheh* is a public advertisement that a woman is not a virgin. . . . Even illicit sex is considered better than *sigheh*—as long as the sex is kept secret" (129). See also Shahla Haeri, *Law of Desire: Temporary Marriage in Shi'i Iran* (Syracuse, NY: Syracuse Univ. Press, 1989). Also for further discussion of the issue of abuse, see Nushin Ahmadi Khorasani and Parvin Ardalan, eds., *Fasl-e Zanan: Majmueh Ara va Didgahaye Feministi* (Tehran: Tosaeh, 2001). To add to the list, a colossal discrepancy has emerged between people's public and private lives. Roxanne Varzi also believes that despite the regime's pretension that everything is normal and Islamic, drugs, prostitution, AIDS, crime, unwanted pregnancies, and suicides are on the rise. Roxanne Varzi, *Warring Souls: Youth, Media, and Martyrdom in Post-Revolution Iran* (Durham, NC: Duke Univ. Press, 2006), 172. The state's response to all of this is more suppression of sexuality, connecting it with power in the sense that Foucault once described. Foucault, *History of Sexuality.* Is Socrates right in saying that all wrongdoing stems from ignorance, or does ideology blind its advocates so that they do not see the results of their wrongdoings? Finally, Roxanne Varzi discusses the double life lived by upper middle-class secular youth that results from having one value system at home and another one (promoted by the state) outside. While the youth follow fashion in private, they keep Islamic appearance outside home to escape the moral police. This inconsistency, Varzi believes, leads ultimately "to a situation of social crisis." See Varzi, *Warring Souls,* 140.

And this is not new. Rudi Matthee shows that such contradictions existed regarding nonprofessional women as well as dancers, courtesans, and prostitutes during the Safavid period. Rudi Matthee, "Courtesans, Prostitutes and Dancing Girls: Women Entertainers in Safavid Iran," in *Iran and Beyond: Essays in Honor of Nikki R. Keddie,* ed. Rudi Matthee and Beth Baron (Costa Mesa, CA: Mazda, 2000), 121–50.

68. Zayn al-Abedin Maraghe-i, *Siyahat-name-ye Ebrahim Beg* (Tehran, 1965, 1978, 1983, 1985).

69. Ibid., vol. 1, 43, 142.

70. On this topic, see for example the writings of M. Ghaed, such as Mohammad Qaed, *Daftarcheh-e Khaterat va Faramushi va Maqalat-e Digar* (Tehran: Tarh-e No, 2001.

71. Taj al-Saltaneh promotes reforms and modern ideas in her memoirs *Khaterat Taj Saltaneh* as she criticizes many aspects of life and the social situation in Iran at her time. For information on this memoir, see Abbas Amanat, *Crowning Anguish: Memoirs of a Persian Princess from the Harem to Modernity, 1884–1914* (Washington, DC: Mage Publishers, 1993).

72. It is not practical to list all these titles here. However, many of them are mentioned in a few bibliographical works on the topic. See, for example, Sazman-e Tablighat-e Islami, *Ketabnameh-e Hejab va Lebas* (Qom: Sazman-e Tablighat-e Islam, 1991) and "Ketabnameh Hejab" in *Payam-e Zan,* no. 8 (Daftar-e Tablighat-e Islami, 1997). For information on the hejab and chastity software, see the report by the Koran News Agency on *Narmafzar Hejab va Efaf* by Moaseseh Kosar.

73. In 2007, a couple of months after the broad assault on "bad veiling" or "misveiling" started, the Deputy Commander of the Islamic Republic Police Forces announced that thus far, "We have given notice to more than 527,255 people. About 20,363 have been [arrested] and released on bail. And 2,265 have been sent to courts." See http://www.isna.ir, June 25, 2007. Often such news items

and briefings include other numbers about sex offenders, prostitutes, and harassers, all sex related and in nature negative. According to a report by *Fars News* on August 30, 2007, about 171,151 women have received notice just by the airport police, a number of whom were prevented from traveling.

74. In Shahrnush Parsipur's novel, *Touba and the Meaning of the Night,* the role of the protagonist, Touba, can be explained by the concept of literary agency. Traditionally, men had the main role and women simply followed the norms of society in fictional works. However, Touba is given the ability to act. The word "act" is what makes the agency real. However, the scope of agency and acting are both relative; the author, Parsipur, is aware of the fact that in a traditional society, there is a limit to what a woman can do or achieve. The author has shown this relativity more explicitly in her other novel where female characters trying to take up a quite true sexual agency seem to do so only under fantastic or surreal conditions.

75. Carl Jung, *Synchronicity: An Acausal Connecting Principle* (London: Routledge and Kegan Paul, 1972).

Bibliography

Abidi, Ahmad. *Ashnayi ba Bihar al-Anwar*. Tehran: Dabirkhanah-i Hamayish-i Buzurg-dasht-i 'Allamah Majlisi, 1999.

Abrahamian, Ervand. *Iran Between Two Revolutions*. Princeton, NJ: Princeton Univ. Press, 1982.

Adamiyat, Faridun. *Andishah-i Taraqi va Qukumat-i Qanun-i Asr-E Sepahsalar*. Tehran: Khvarazmi, 1973.

———. *Andishe-ha-ye Mirza Aqa Khan Kermani*. Tehran: Tuhuri, 1978.

———. *Andishe-ye Taraqqi va Hokumat-e Qanun* [The idea of modernity and the rule of law]. Tehran: Kharazmi, 1972.

———. *Fekr-e Azadi va Moqaddamat-e Nehzat-e Mashruteh* [The idea of liberty and the beginning of the Iranian Constitutional Movement]. Tehran: n.p.: 1961.

———. *Ideolojhi-ye Nehzat-e Mashrutiyat-e Iran* [The ideology of the Iranian Constitutional Movement]. Tehran: Payam, 1976.

Adelkhah, Fariba. *Being Modern in Iran*. New York: Columbia Univ. Press, 2000.

Adorno, Theodor. "On Popular Music." *Studies in Philosophy and Social Sciences* 9, no. 1 (1941): 17–18.

Afary, Janet. "Gozar az Mian-e Sakhreh va Gerdab: Degarguni Naqsh-e Zan va Mard dar Iran-e Qarn-e Bistom." *Iran Nemeh* 15, no. 3 (Summer 1997): 365–87.

———. *Sexual Politics in Modern Iran*. Cambridge: Cambridge Univ. Press, 2009.

Afghami, Jahangir. "Dokhtar-ha Bekarat-e Khod Ra Az Dast Nadahid." *Khandaniha* 7, series 72, no. 276 (Ordibehesh 1947): 21.

Ahmadi, Ahmad Reza. *Vaqt-e Khub-e Mosaeb*. Tehran: Ketabe Zaman, 1968.

Akrami, Jamsheed. *Dreams Betrayed: A Study of Political Cinema in Iran, 1969–1979*. New York: Jamsheed Akrami, 1985.

———. *Piramun-i Sakht va Naqsh-i Rasanah'ha: Hamayish-i Shiraz*. Tehran: Surush, 1977.

Alam, Assadollah. *Guftgu'ha-yi Man ba Shah: Khatirat-e Mahramanah-i Amir Asadollah Alam*. Tehran: Tarh-e No, 1992.

Alamdari, Kazim. *Why the Middle East Lagged Behind: The Case of Iran.* Lanham, MD: Univ. Press of America, 2005.

Alampur, Mohiyadin. *Eshq Faryad Konad.* Dushanbe, Tajikistan: Vezarat-e Farhang-e Tajikistan, 1995.

Alavi, Nasrin. *We Are Iran.* New York: Soft Skull Press, 2005.

Al-e Ahmad, Jalal. *Gharbzadigi* [Plagued by the West]. Tehran: Ravaq, 1978.

———. *Zan-e Ziadi* [The extra woman]. Tehran: Ravaq, 1952.

Algar, Hamid. *Mirza Malkum Khan: A Study in the History of Iranian Modernism.* Berkeley: Univ. of California Press, 1973.

Amanat, Abbas. *Crowning Anguish: Memoirs of a Persian Princess from the Harem to Modernity, 1884–1914 (Taj al-Saltanah).* Washington, DC: Mage, 1993.

———. *Resurrection and Renewal: The Making of the Babi Movement in Iran 1844–1850.* Ithaca, NY: Cornell Univ. Press, 1989.

Amin, Camron Michael. *The Making of the Modern Iranian Woman: Gender, State Policy and Popular Culture, 1865–1946.* Gainesville: Univ. Press of Florida, 2002.

Ansari, Ali. *Modern Iran Since 1921: The Pahlavis and After.* 2nd ed. London: Longman, 2007. Originally published 2003.

Armes, Roy. *Patterns of Realism.* New York: Garland, 1986.

Ashraf, Ahmad. "State and Agrarian Relations Before and After the Iranian Revolution, 1960–1990." In *Peasants and Politics in the Modern Middle East,* edited by F. Kazemi and J. Waterbury. Miami: Florida International Univ. Press, 1991.

Askari, Hashem, and S. Majin. "Recent Economic Growth in Iran." *Middle Eastern Studies* 12, no. 3 (1976): 105–23.

Atabaki, Touraj, and Erik Zürcher, eds. *Men of Order: Authoritarian Modernization under Atatürk and Reza Shah.* London: I. B. Tauris, 2004.

Avazeh [Razavi], Mohammad Ebrahim. *Qanun-e Qoveh Bah: Adab-e Zanashui.* 3rd ed. Qom: Intesharat-e Selseleh, 2003.

Avini, Morteza. *Ayineh-e Jadu.* Tehran: Barg, 1991.

Azar, Mahyar. *Bulugh-e Jesmi, Ruhi, va Ravani dar Dokhtaran* [Female physical, emotional, and psychological puberty]. Tehran: Nur-e Danesh, 2003.

———. *Bulugh-e Jesmi, Ruhi, va Ravani dar Pesaran* [Male physical, emotional, and psychological puberty]. Tehran: Nur-e Danesh, 2003.

Babb, Florence. "Incitements to Desire: Sexual Cultures and Modernizing Projects." *American Ethnologist* 31, no. 2 (2004): 225–30.

———. "Honar Khandan-e man madyun-e taraneh-ha-ye film ast." Interview with Radio Farda, 14 Farvardin 1387.

Badi'i, Ahdiyeh. "An Interview with Nima Tamadon." *Majalleh Qadimiha* 2, no. 72 (June 2008).

Bakhash, Shaul. *The Reign of the Ayatollah: Iran and the Islamic Revolution.* New York: Basic Books, 1984.

Bakhtiyarnejad, Parvin. *Faje'e Khamush Qatlhaye Namusi.* Online publication, Jan. 6, 2010.

Bamdad, Badr ol-Moluk. *From Darkness Into Light: Women's Emancipation In Iran.* New York: Exposition Press, 1977.

Baqeri, Ashraf, and Nasrin Safavi. *Gole Goldune Man: Simin Ghanem Az Aghaz ta Emruz* [The flower of my vase: Simin Ghanem from beginning until today]. Tehran: Nashr-e Sales, 2001/2004.

Barahani, Reza. "Sex: Yeki az Anasor-e Sanzandeh Ejtemai." *Ferdowsi Magazine* 24, no. 1088 (Aban 15 1972).

Bateson, Mary Catherine. *At Home in Iran.* Tehran: St. Paul's Church, 1965.

Baudrillard, Jean. *Seduction,* translated by Brian Singer. Basingstoke: Macmillan Education, 1990.

———. *Simulations,* translated by Nicola Dufresne. New York: Semiotexte, 1983.

Bauerlein, Mark. "Henry James, William James, and the Metaphysics of American Thinking." In *America's Modernisms: Revaluing the Canon. Essays in Honor of Joseph N. Riddel,* edited by Kathryne V. Lindberg and Joseph G. Kronick, 54–76. Baton Rouge: Louisiana State Univ. Press, 1996.

Bauman, Zygmunt. *Modernity and Ambivalence.* Ithaca: Cornell Univ. Press, 1991.

Bayes, Jane, and Nayyirah Tawhidi. *Globalization, Gender, and Religion.* New York: Palgrave, 2001.

Beard, Michael. *Hedayat's "Blind Owl" as a Western Novel.* Princeton, NJ: Princeton Univ. Press, 1990.

Berman, Marshall. *All That Is Solid Melts into Air: The Experience of Modernity.* New York: Viking Penguin, 1982.

———. *The Politics of Authenticity: Radical Individualism and the Emergence of Modern Society.* New York: Atheneum, 1970.

Berteaut, Simone. *Piaf: A Biography.* New York: Harper and Row, 1972.

Binesh, Taqi. *Tarikh-e Mokhtasar-e Musiqi-e Iran.* Tehran: Nashr-i Arvin, 1995.

Bingham, Clara, and Laura Leedy Gansler. *Class Action: The Story of Lois Jenson and the Landmark Case that Changed Sexual Harassment Law.* New York: Doubleday, 2000.

Black, C. C. *The Dynamics of Modernization: A Study of Comparative History.* New York: Harper and Row, 1966.

Blumenberg, Hans. *The Genesis of the Copernican World,* translated by Robert M. Wallace. Cambridge, MA: MIT Press, 1987.

———. *The Legitimacy of the Modern Age,* translated by Robert M. Wallace. Cambridge, MA: MIT Press, 1983.

Bodman, Herbert L., and Nayereh Tohidi. *Women in Muslim Societies: Diversity Within Unity.* Boulder, CO: L. Rienner Publishers, 1998.

Bolduc, Michelle. "The *Breviari d'Amor*: Rhetoric and Preaching in Thirteenth-Century Languedoc." *Rhetorica: A Journal of the History of Rhetoric* 24, no. 4 (Autumn 2006): 403–26.

Bonel, Marc, and Danielle Bonel. *Edith Piaf, le temps d'une vie.* Paris: Editions de Fallois, 1993.

Boroujerdi, Mehrzad. "The Ambivalent Modernity of Iranian Intellectuals." In *Intellectuals and the State in Iran: Politics, Discourse, and the Dilemma of Authenticity,* edited by Negin Nabavi. Gainesville: Univ. Press of Florida, 2003.

———. "Faraz va Nashib-haye Modern Garai Ameraneh." *Iran Nameh* 20, no. 4 (Fall 2002): 475–88.

———. *Iranian Intellectuals and the West: The Tormented Triumph of Nativism.* Syracuse, NY: Syracuse Univ. Press, 1996.

———. "Iranian Islam and the Faustian Bargain of Western Modernity." *Journal of Peace Research* 34, no. 1 (Feb. 1997): 1–5.

Boserup, Ester. *Women's Role in Economic Development.* New York: St. Martin's Press, 1970.

Bouhdiba, Abdelwahab. *Sexuality in Islam.* London: Routledge and Kegan Paul, 1985.

Bourdieu, Pierre. *Distinction: A Social Critique of the Judgment of Taste.* In *Everyday Theory: A Contemporary Reader,* edited by Becky McLaughlin and Bob Coleman. New York: Pearson/Longman, 2005.

Bradbury, Malcolm, and James McFarlane. *Modernism, 1890–1930.* Harmondsworth: Penguin, 1976.

Brettell, Caroline, and Carolyn Fishel Sargent. *Gender in Cross-Cultural Perspective.* Upper Saddle River, NJ: Prentice Hall, 1997.

Brooks, Geraldine. *Nine Parts of Desire.* New York: Doubleday, 1995.

Calinescu, Matei. *Five Faces of Modernity.* Durham, NC: Duke Univ. Press, 1987.

Camallas, Martha. *Introduction to Feminist Legal Theory.* New York: Aspen, 1999.

Carson, Diane, Janice R. Welsch, and Linda Dittmar, eds. *Multiple Voices in Feminist Film Criticism.* Minneapolis: Univ. of Minnesota Press, 1994.

Cascardi, Anthony J. *The Subject of Modernity.* Cambridge: Cambridge Univ. Press, 1992.

Chaney, Elsa, and Marianne Schmink. *Women and Development: Access to Tools.* New York: Chaney, 1974.

Chebel, Malek. *Encyclopedie de l'amour en Islam: érotisme, beauté et sexualité dans le monde arabe, en Perse et en Turquie.* Paris: Payot, 1995.

Chehabi, Houchang. "Az Tasnif-e Enqelabi ta Sorud-e Vatani." *Iran Nameh* 16, no. 1 (Winter 1998): 69–96.

————. *Iranian Politics and Religious Modernism: The Liberation Movement of Iran Under the Shah and Khomeini.* Ithaca, NY: Cornell Univ. Press, 1990.

————. "The Need to Spread the Perimeter of One's Curiosity Beyond One's Own Borders." In *Playing with Modernity,* edited by Ramin Jahanbegloo, 285–92. Tehran: Cultural Research Bureau, 2004.

————. "Sport." In *Esther's Children: A Portrait of Iranian Jews,* edited by Houman Sarshar, 373–78. Beverly Hills: Center for Iranian Jewish Oral History, 2002.

————. "Voices Unveiled: Women Singers in Modern Iran." In *Iran and Beyond: Essays in Middle Eastern History in Honor of Nikki R. Keddie,* edited by Rudi Matthee and Beth Baron, 151–66. Costa Mesa, CA: Mazda, 2000.

Chelkowski, Peter, and Hamid Dabashi. *Staging a Revolution: The Art of Persuasion in the Islamic Republic of Iran.* New York: New York Univ. Press, 1999.

Cinar, Alev. *Modernity, Islam, and Secularism in Turkey: Bodies, Places, and Time.* Minneapolis: Univ. of Minnesota Press, 2005.

Civil Code of the Islamic Republic of Iran: (Articles 1 to 1335), chap. 1, 1128. Tehran: Bureau of International Agreements, 2000.

Classen, Albrecht, ed. *Eroticism and Love in the Middle Ages.* 5th ed. New York: Thomson Custom Publishing, 2004.

————. "Sexuality in the Middle Ages: An Exploration of Mental History on the Basis of Literary Evidence." *Neohelicon* 22, no. 2 (Sept. 1995): 9–51.

————. "Women in Martin Luther's Life and Theology." *German Studies Review* 14, no. 2 (May 1991): 231–60.

Combs-Schilling, M. E. *Sacred Performances: Islam, Sexuality, and Sacrifice.* New York: Columbia Univ. Press, 1989.

Corbin, Alain. Women for Hire: *Prostitution and Sexuality in France after 1850,* translated by Alan Sheridan. Cambridge, MA: Harvard Univ. Press, 1990.

Dabashi, Hamid. *Close Up: Iranian Cinema, Past, Present, and Future.* London: Verso, 2001.

Dalby, Liza. *Geisha.* Berkeley: Univ. of California Press, 1983.

Daly, Mary. *Gyn/Ecology: The Metaethics of Radical Feminism.* With the "New Intergalactic Introduction" by the author. Boston: Beacon Press, 1990.

Daneshavar, Simin. *Beh Ki Salam Konam* [To whom can I say hello]. Tehran: Kharazmi, 1986.

Davari, Reza. *Vaze kununi-ye tafakkur dar Iran* [The present state of thought in Iran]. Tehran: Surush, 1978.

Debray, Regis. *Revolution in the Revolution? Armed Struggle and Political Struggle in Latin America.* New York: Grove Press, 1967.

Dehzadi, Farid. "Elahe Beh Afsaneh Payvast." *Mahnahmeh Takhososi Musiqi* 1, no. 67 (2007): 60–63.

DeMeo, James. *On Wilhelm Reich and Orgonomy.* Ashland: Orgone Biophysical Research Laboratory, 1993.

Desmond, Jane. "Issues in Dance and Cultural Studies." In *Everynight Life: Culture and Dance in Latin/o America,* edited by Celeste Fraser Delgado and José Esteban Munoz. Durham, NC: Duke Univ. Press, 1997.

Diamond, Rosamund, and Wilfried Wang, eds. *On Continuity.* Cambridge, MA: 9H Publications, 1995.

Dolatabadi, Mahmud. *Kalidar.* Tehran: Farhang Muasir, 1989.

Drew, Paula E. "Iran." In *The Continuum Complete International Encyclopedia of Sexuality,* edited by Robert T. Francoeur and R. Noonan. New York: Continuum, 2004.

Dworkin, Andrea. *Intercourse.* New York: Free Press, 1987.

Eisenstadt, S. N. "Multiple Modernities in an Age of Globalization." *Canadian Journal of Sociology/Cahiers canadiens de sociologie* 24, no. 2 (Spring 1999), 283–95.

Ejlali, Parviz. *Digarguni-e Ejtimai va Film-ha-ye Sinimai dar Iran.* Tehran: Intesharat-e Farhang va Andishe, 2004.

Elder, John. *History of the Iran Mission.* Tehran: Literature Committee of the Church Council of Iran, 1960.

Eluard, Paul. *Ombres et soleil/Shadows and Sun: Selected Writings of 1913–1952.* Durham, NC: Oyster River Press, 1995.

Emadipur, Mohammad. "Lozum Amuzesh Behdashat dar Qale Shahr e No" [The necessity of teaching hygiene in the Qale Shahr e No]. Master's thesis, Tehran Univ., 1976.

Enayat, Mahmud. *Enqelab va Roshanfekran.* Los Angeles: Sarnevesh, 1971.

Enderwitz, Susan. "Shahrazâd Is One of Us: Practical Narrative, Theoretical Discussion, and Feminist Discourse." *Marvels and Tales* 18, no. 2 (2004): 187–200.

Etelaat, Vezarat-e. *Zanan-i darbar bih Ravayat-i Asnad Savak.* Tehran: Markaz-e Barrasi-e Asnad-e Tarikhi, 2002.

Fallaci, Oriana. *Interview with History.* New York: Liveright Publishing, 1976.

Farmanfarmaiyan, Setareh. *Ruspigari Dar Shahr-e Tehran.* Tehran: Amuzeshgah-e Khadamat-e Ejtemai, 1970.

Farrokhzad, Forugh. *Bride of Acacias: Selected Poems of Forugh Farrokhzad,* translated by Jascha Kessler, with Amin Banani. Delmar, NY: Caravan Books, 1982.

———. *Tavalod-i Digar.* Tehran: Morvarid, 1963.

Farrokhzad, Puran. *Karnameh Zanan Kararaye Iran.* Tehran: Nashr-i Qatrah, 2002.

Fathi, Asghar. *Iranian Refugees and Exiles Since Khomeini.* Costa Mesa, CA: Mazda, 1991.

Featherstone, Mike. "In Pursuit of the Post-Modern." *Theory, Culture, and Society* 5 (1988).

Feldman, Martha, and Gordon Bonnie. *The Courtesan's Arts: Cross-Cultural Perspectives.* New York: Oxford Univ. Press, 2006.

Felski, Rita. *The Gender of Modernity.* Cambridge, MA: Harvard Univ. Press, 1995.

Ferdowsi Magazine. "Ruspigari dar Filmha-ye Farsi." 24, no. 1099 (2 Bahman 1972): 1, 4, 39.

Finfacts Team. Commission on Growth and Development Report. May 23, 2008. http://www.finfacts.com/irishfinancenews/article_1013683.shtml.

Fleischmann, Ellen. "Nation, Tradition, and Rights: The Indigenous Feminism of the Palestinian Women's Movement, 1929–1948." In *Women's Suffrage in the British Empire: Citizenship, Nation, and Race,* edited by Ian Christopher Fletcher, Laura E. Nym Mayhall, and Philippa Levine, 138–54. London: Routledge, 2000.

Floor, Willem. *A Social History of Sexual Relations in Iran.* Washington, DC: Mage, 2008.

Foster, Richard. *The Real Bettie Page: The Truth About the Queen of the Pin-ups.* New York: Citadel Press, 1997.

Foucault, Michel. *The History of Sexuality,* translated by Robert Hurley. New York: Pantheon Books, 1978.

———. *The Order of Things: An Archaeology of the Human Sciences.* New York: Vintage, 1973.

———. *Power/Knowledge: Selected Interviews and Other Writings 1972–1977,* edited by Colin Gordon. New York: Pantheon Books, 1980.

Frazer, Elizabeth, and Nicola Lacey. *The Politics of Community: A Feminist Critique of the Liberal-Communitarian Debate.* New York: Harvester Wheatsheaf, 1993.

Freud, Sigmund. *The Interpretation of Dreams,* translated by A. A. Brill. 1913. New York: Macmillan, 1991.

Fukuyama, Francis. *The End of History and the Last Man.* New York: Maxwell Macmillan International, 1992.

Ganjavi, Nezami. *Haft Paykar* [Seven beauties], edited by H. Vahid Dastgirdi. Tehran: Ibn-i Sina, 1955.

Ganji, Akbar. *Alijenabe sorkhpush va alijenabe khakestari* [The red eminence and the gray eminences]. Tehran: Tarhe No, 2000.

Gellner, Ernest. *Nationalism.* London: Weidenfeld and Nicholson, 1997.

Ghafari, Parvin. *Ta Siahi.* Tehran: Sokhan, 1997.

Ghazali, Imam Abu Hamed Mohammad [Ghazzali]. *Kimiya-ye Sa'adat* [The alchemy of happiness]. Tehran: Intisharat-i Tulu va Intisharat-i Zarrin, 1982.

———. *Marriage and Sexuality in Islam: A Translation of al-Ghazali's Book on the Etiquette of Marriage from the LIhya 'Ulum al-Din,* translated by Madelain Farah. Salt Lake City: Univ. of Utah Press, 1984.

Giddens, Anthony. *The Consequences of Modernity.* Stanford, CA: Stanford Univ. Press, 1990.

Gil, Daniel Juan. "Before Intimacy: Modernity and Emotion in the Early Modern Discourse of Sexuality." *ELH* 69, no. 4 (Winter 2002): 861–87.

Gilbert, Sandra, and Susan Gubar. "Infection in the Sentence: The Woman Writer and the Anxiety of Authorship." In *The Madwoman in the Attic: The Woman Writer and the Nineteenth-Century Literary Imagination.* New Haven: Yale Univ. Press, 1979.

Gold, Barbara K., Paul Allen Miller, and Charles Platter. *Sex and Gender in Medieval and Renaissance Texts: The Latin Tradition.* Albany: State Univ. of New York Press, 1997.

Goldberg, Jonathan, ed. *Queering the Renaissance.* Durham, NC: Duke Univ. Press, 1994.

Golden, Arthur. *Memoirs of a Geisha.* New York: Alfred A. Knopf, 1997.

Goldwyn, Liz. *Pretty Things: The Last Golden Generation of American Burlesque Queens.* New York: Regan Books, 2006.

Golestan, Ebrahim. "Si Sal Bishtar Ba Akhavan." *Majaleh-e Donya-ye Sokhan* 35 (1989): 4.

Gorgin, Iraj. *Chahar Musahibih Ba Furugh Farrukhzad* [Four interviews with Forugh Farrokhzad]. Tehran: Intisharat-i Radio Iran, 1964.

Habermas, Jürgen. *The Philosophical Discourse of Modernity: Twelve Lectures,* translated by Frederick Lawrence. Cambridge, MA: MIT Press, 1987.

———. *The Structural Transformation of the Public Sphere: An Inquiry into a Category of Bourgeois Society,* translated by Thomas Burger with the assistance of Frederick Lawrence. Cambridge, MA: MIT Press, 1998.

Haddad, Yvonne Yazbeck, and John L. Esposito. *Islam, Gender, and Social Change.* New York: Oxford Univ. Press, 1998.

Haeri, Shahla. *Law of Desire: Temporary Marriage in Shi'i Iran.* Syracuse, NY: Syracuse Univ. Press, 1989.

Hairi, Ali. *Zehniyat va Zaviyah-i Did Dar naqd va Naqd-i Adabiyat-i Dastani: Naqdi bar, Sad Sal-i Dastan Nevisi* [Mentality and perspectives: A critique of *One Hundred Years of Persian Fiction*]. Tehran: Kubah, 1990.

Hajj Sayyid Javadi, Ali Asghar. *Arzyabi Shitabzadeh.* Mashhad: Entesharat Tus, 1970.

Hall, Stuart, David Held, Don Hubert, and Kenneth Thompson, eds. *Modernity: An Introduction to Modern Societies.* Cambridge, MA: Blackwell, 1996.

Halperin, David M. *How to Do the History of Homosexuality*. Chicago: Univ. of Chicago Press, 2002.

Hambarson, Mosio. "Zan-e 17 Day." *Zan-e Ruz* 98 (24 Day 1345/1966): 17.

Hannanih, Shahin. *Pusht-i Darichah-ha: Guft Gu Ba Hamsaran-i Hunarmandan* [Behind the windows: A conversation with artists' spouses]. Tehran: Dunya-yi Madar, 1992.

Harsin, Jill. *Policing Prostitution in Nineteenth-Century Paris*. Princeton, NJ: Princeton Univ. Press, 1985.

Haydari, Golam. *Filmshinakht-i Iran*. Tehran: Daftar-e Pazheshe Farjangi, 1992.

Hekmat, Anwar. *Women and the Koran: The Status of Women in Islam*. Amherst, NY: Prometheus Books, 1997.

Herzog, Dagmar. *Sexuality and German Fascism*. New York: Berghahn Books, 2004.

Hillmann, Michael C. *A Lonely Woman: Forugh Farrokhzad and Her Poetry*. Washington, DC: Mage Publishers and Three Continents Press, 1987.

Hojat, Mohammadreza, Reza Shapurian, Habib Nayerahmadi, Mitra Farzaneh, Danesh Foroughi, Mohin Parsi, and Maryam Azizi. "Premarital Sexual, Child Rearing, and Family Attitudes of Iranian Men and Women in the United States and in Iran." *Journal of Psychology* 133, no. 1 (Jan. 1999): 19.

Homayoun, Dariush. "Paykar-e Iran ba Tajadod." *Iran Nameh* 19, no. 3 (Summer 2001): 349–58.

Hoxha, Enver. *Selected Works*. Tirana: Nentori Publishing House, 1974.

———. *With Stalin: Memoirs*. Tirana: Nentori Publishing House, 1979.

Isa, Rose, and Whitaker, Sheila, eds. *Life and Art: The New Iranian Cinema*. London: National Film Theatre, 1999.

Isfandiyari, Halah. *Reconstructed Lives: Women and Iran's Islamic Revolution*. Washington, DC: Woodrow Wilson Center Press, 1997.

Islamic Students Association in North America. *Band-e Jim*. Albany, CA: ISANA, 1981.

Issari, Mohammad Ali. *Cinema in Iran, 1900–1979*. Metuchen, NJ: Scarecrow Press, 1989.

Itelaat Banavan. "Cinema Dami Baraye Khanandegan," 733, no. 23 (Tir 1350/1971): 94–95.

Jacob, P. L. *Manners, Customs, and Dress During the Middle Ages and During the Renaissance Period*. London: Chapman and Hall, 1876.

Ja'fari, Muhammad Taqi. *Nigahi Bih Falsafah-'i Hunar Az Didgah-i Islami* [A look at art philosophy from the Islamic viewpoint]. Tehran: Intisharat-i Nur, 1982.

Jahanbegloo, Ramin, ed. *Iran between Tradition and Modernity*. Washington: Lexington, 2004.

———. *Iran va Modernite: Goftgu hai ba Pazhuheshgaran-e Irani va Khareji dar Zamineh Ruyarui Iran ba Dastavard haye Jahan-e Modern*. Tehran: Goftar, 2000.

———. *Lost Wisdom: Rethinking Persian Modernity in Iran.* Washington, DC: Mage Publishers, 2004.

Jahed, Parviz. *Neveshtan Ba Durbin: Ru Dar Ru Ba Ibrahim Golestan.* Tehran: Akhtaran, 2007.

Jalai, Mehdi. *Amuzish-i Jinsi-i Atfal.* Tehran: Bungah-i Matbuati-e Safialishah, 1952.

Jami, Abd al-Rahman. *Masnavi Haft Awrang* [Jami's seven thrones], edited by Mudarris Gilani. Tehran: Sa'di, 1958.

Jawadi, Allamah Sayyid Zeeshan Haider. *Women and Shari'at (Divine Law): Complete Rules Regarding Women, in Islam.* Mumbai: Idarah Islam Shinasi, 1999.

Jensen, Erik. "The Pink Triangle and Political Consciousness: Gays, Lesbians, and the Memory of Nazi Persecution." In *Sexuality and German Fascism,* edited by Dagmar Herzog. New York: Berghahn Books, 2004.

Jervis, John. *Exploring the Modern.* Oxford: Blackwell, 1998.

Johnston, Claire. "Women's Cinema as Counter-Cinema." In *Notes on Women's Cinema,* edited by Claire Johnston. London: Society for Education in Film and Television. Reprinted in *Screen* (1991), 24–31.

Johnston, Sholeh. "Persian Rap: The Voice of Modern Iran's Youth." *Journal of Persianate Studies* 1, no. 1 (2008): 102–19.

Jones, Ann Rosalind. "Writing the Body: Toward an Understanding of 'L'Ecriture Feminine.'" *Feminist Studies* 7, no. 2 (Summer 1981): 247–63.

Jung, Carl. *Synchronicity: An Acausal Connecting Principle.* London: Routledge and Kegan Paul, 1972.

Kahi, Morteza. *Bagh-e Bi Bargi: Yadnameh Mehdi Akhavan-Salis.* Tehran: Agah, 1991.

Kar, Mehrangiz. "Mojezeh Takhdir-e Afkar." *Ferdowsi Magazine* 25, no. 1130 (Shahrivar 24): 14–15.

———. "Padideh-i Jadid va" [A new phenomenon and a disgusting image]. *Ferdowsi Magazine* 24, no. 1142 (19 Azar): 10–11.

Kar, Mehri [Mehrangiz Kar]. "Nameless, Disreputable Iranian Women Have Lost Their National Identity Card." *Ferdowsi Magazine* 24, no. 1083 (1971): 1, 4, 39.

Karimi-Hakkak, Ahmad. *Recasting Persian Poetry: Scenarios of Poetic Modernity in Iran.* Salt Lake City: Univ. of Utah Press, 1995.

Kasmai, Ali Akbar. "Az in Zanan Beparhizid." *Taraqi Haftegi* 7, series 3, no. 336 (30 Khordad 1949): 7.

———. "Zan-e Irani Por Modea-tarin Zan-e Jahan Ast." *Taraqi* 52, no. 489 (Khorda 1952): 11.

Kasravi, Ahmad. *Khaharan va Dokhtaran-e Ma.* Tehran: Payman, 1945.

Katouzain, Homa. *The Persians, Ancient, Medieval and Modern Iran.* New Haven, CT: Yale Univ. Press, 2009.

———. *State and Society in Iran: The Eclipse of the Qajars and the Rise of the Pahlavis.* London: I. B. Tauris, 2006.

Katuzian, Sharia. "Shoaer-e Islam Rah-e Anhast." *Zan-e Ruz* 98 (24 Day 1345/1966).

Kazemipur, Abdolmohammad, and Ali Rezaei. "Religious Life under Theocracy: The Case of Iran." *AFF News Briefs* 2, no. 6 (2003).

Keeling, Cecil. *Pictures from Persia.* London: R. Hale, 1947.

Keshavarz, Fatemeh. *Recite in the Name of the Red Rose: Poetic Sacred Making in Twentieth-Century Iran.* Columbia: Univ. of South Carolina Press, 2006.

Khanbaba Tehrani, Mehdi, and Hamid Shawkat. *Negahi az Darun beh Junbesh-e Chap-e Iran.* Saarbrücken: Baztab Verlag, 1989.

Khomeini, Imam Ruhullah. *Islam and Revolution: Writings and Declarations of Imam Khomeini,* translated and annotated by Hamid Algar. Berkeley, CA: Mizan Press, 1981.

Khorasani, Nushin Ahmadi, and Parvin Ardalan, eds. *Fasl-e Zanan: Majmueh Ara va Didgahaye Feministi.* Tehran: Tosaeh, 2001.

Kirkendall, Lester Allen. *Helping Children Understand Sex.* Chicago: Science Research Associates, 1952.

Kiyameh, M. "FilmFarsi, Bi Farhang, Bi Hoviyat, and Biganeh: Chera FilmFarsi Misazand?" *Khandaniha,* Azar 1974, 24–27.

Klebnikov, Paul. "Millionaire Mullahs." *Forbes* 21 (July 2003).

Knudsen, Dean D., and JoAnn L. Miller. *Abused and Battered: Social and Legal Responses to Family Violence.* New York: A. de Gruyter, 1991.

Kolakowski, Leszek. *Modernity on Endless Trial.* Chicago: Univ. of Chicago Press, 1990.

Kolodny, Annette. "Dancing Through the Minefield: Some Observations on the Theory, Practice, and Politics of a Feminist Literary Criticism." In *The New Feminist Criticism: Essays on Women, Literature, and Theory,* edited by Elaine Showalter. New York: Pantheon, 1985.

Kössler, Reinhart. "The Modern Nation State and Regimes of Violence: Reflections on the Current Situation." *Ritsumeikan Annual Review of International Studies* 2 (2003): 15–36.

Kurzman, Charles, ed. *Liberal Islam.* New York: Oxford Univ. Press, 1998.

Lacan, Jacques. *Ecrits.* New York: Norton, 1977.

Lash, Scott, and Jonathan Friedman, eds. *Modernity and Identity.* Oxford: Blackwell, 1992.

Lashgari, Deirdre. *Violence, Silence and Anger: Women's Writing as Transgression.* Charlottesville: Univ. Press of Virginia, 1995.

Latour, Bruno. *We Have Never Been Modern,* translated by Catherine Porter. Cambridge, MA: Harvard Univ. Press, 1993.

Layani, Jacques. *Albertine Sarrazin: une vie.* Paris: Ecriture, 2001.

Leacock, Eleanor Burke. *Myths of Male Dominance.* New York: Monthly Review Press, 1981.

Lefebvre, Henri. *Everyday Life in the Modern World.* New York: Harper and Row, 1971.

Lenin, V. I. *Collected Works.* English ed., 10:48–49. Moscow: Foreign Languages Publishing House, 1962.

Lewis, Bernard. *The Shaping of the Modern Middle East.* Oxford: Oxford Univ. Press, 1994.

Lewisohn, Jane. "Flowers of Persian Song and Music: Davud Pirnia and the Genesis of the Goha Programs." *Journal of Persianate Studies* 1, no. 1 (2008): 79–101.

Loma, David. *The Haunted Self: Surrealism, Psychoanalysis, Subjectivity.* New Haven: Yale Univ. Press, 2000.

Lorber, Judith. "Believing Is Seeing: Biology as Ideology." In *The Politics of Women's Bodies: Sexuality, Appearance, and Behavior,* edited by Rose Weitz, 12–13. Oxford: Oxford Univ. Press, 2003.

MacEoin, Denis. *The Sources for Early Babi Doctrine and History.* Leiden: Brill, 1992.

Madani, H. "Enkar-e Ruspigari Shoyu' Anra Kam Nemikonad" [Denying the existence of prostitution does not decrease its spread]. *Ruzmareh,* Feb. 2, 2006.

Maddi, Arjang. "Bar rasi-i suvar-i khiyal dar haft paykar." *Farhang* 10 (Fall 1992): 331–408.

Mahdavi, Pardis. *Passionate Uprisings: The Intersection between Sexuality and Politics in Post-Revolutionary Iran.* Ph.D. dissertation, Columbia Univ., 2006.

———. *Passionate Uprisings: Iran's Sexual Revolution.* Stanford: Stanford Univ. Press, 2009.

Mahruyan, Hushang. *Mudirnitah va Buhran-i Ma: Payan-i Mitafizk ya Shurish 'Alayh-i 'Aql.* Tehran: Nashr-i Akhtaran, 2004.

Maleki, Tuka [Tooka]. *Zanan-e Musiqi-e Iran.* Tehran: Ketab-e Khorshid, 2001.

Maneshhadvi, Abd al-Amir. *Qatl-i Namusi.* Tehran: Afarineh, 2000.

Marlowe, Christopher. *The Tragical History of Doctor Faustus.* Canberra, Australia: National Univ. Press, 1982.

Marsden, Michael. *Movies as Artifacts: Cultural Criticism of Popular Film.* Chicago: Nelson-Hall, 1982.

Matthee, Rudi. "Courtesans, Prostitutes and Dancing Girls: Women Entertainers in Safavid Iran." In *Iran and Beyond: Essays in Honor of Nikki R. Keddie,* edited by Rudi Matthee and Beth Baron, 121–50. Costa Mesa, CA: Mazda, 2000.

Mernissi, Fatima. *Beyond the Veil: Male-Female Dynamics in Modern Muslim Society.* Bloomington: Indiana Univ. Press, 1987.

———. *Women and Islam: An Historical and Theological Enquiry,* translated by Mary Jo Lakeland. Oxford: Basil Blackwell, 1991.

Mesdaghi, Iraj. *Ghorub-e Sepideh: Na Zistan na Marg.* Sweden: Alfabit Makzima, 2004.

Migiel, Marilyn, and Juliana Schiesari. *Refiguring Woman: Perspectives on Gender and the Italian Renaissance.* Ithaca, NY: Cornell Univ. Press, 1991.

Milani, Abbas. *Lost Wisdom: Rethinking Modernity in Iran.* Washington, DC: Mage Publishers, 2004.

Milani, Farzaneh. *Veils and Words: The Emerging Voices of Iranian Women Writers.* Syracuse, NY: Syracuse Univ. Press, 1992.

Miller, Nancy K. *Getting Personal: Feminist Occasions and Other Autobiographical Acts.* New York: Routledge, 1991.

Ministry of Culture and Guidance. *Asnadi az Musiqi, Tiatr va Sinima dar Iran (1300–1357 H. Sh.)* [Documents on music, theater and cinema in Iran, 1921–1978]. Tehran: Sazman-e Chap va Intisharat, Vizarat-i Farhang va Irshad-i Islami, 2001.

———. *Iranian Cinema, 1979–1984.* Tehran: General Department of Cinematographic Research and Relations, Ministry of Islamic Guidance, 1985.

Mir-Hosseini, Ziba. "Women's Rights and Clerical Discourses: The Legacy of Allameh Tabatabai." In *Intellectual Trends in Twentieth-Century Iran: A Critical Survey,* edited by Negin Nabavi. Gainesville: Univ. Press of Florida, 2003.

Mirsepassi, Ali. *Intellectual Discourse and the Politics of Modernization: Negotiating Modernity in Iran.* Cambridge: Cambridge Univ. Press, 2000.

Mishler, Paul C. "Communism for Kids." In *Defining Print Culture for Youth,* edited by Anne Lundin and Wayne A. Wiegand. Westport, CT: Greenwood, 2003.

Mitchell, Timothy. *The Questions of Modernity.* Minneapolis: Univ. of Minnesota Press, 2000.

———. *Rule of Experts: Egypt, Techno-Politics, Modernity.* Berkeley: Univ. of California Press, 2002.

Moaddel, Mansoor. "The Iranian Revolution and Its Nemesis: The Rise of Liberal Values among Iranians." *Comparative Studies of South Asia, Africa and the Middle East* 29, no. 1 (2009): 126–36.

Moaddel, Mansoor, and Kamran Talattof. *Contemporary Debates in Islam: An Anthology of Modernist and Fundamentalist Thought.* New York: St. Martin's Press, 2000.

Moaveni, Azadeh. "Sex in the Time of Mullahs." In *My Sister, Guard Your Veil; My Brother, Guard Your Eyes: Uncensored Iranian Voices,* edited by Lila Zanganeh, 55–61. Boston: Beacon Press, 2006.

Moazezinia, Hossein. *FilmFarsi Chist.* Tehran: Nashr-e Sharq, 1999.

Moghadam, Valentine. *Modernizing Women: Gender and Social Change in the Middle East.* Boulder, CO: L. Rienner, 1993.

Moghissi, Haideh. *Feminism and Islamic Fundamentalism: The Limits of Postmodern Analysis.* London: Zed Books, 1999.

———. *Populism and Feminism in Iran: Women's Struggle in a Male-Defined Revolutionary Movement.* New York: St. Martin's Press, 1994.

Mohajer, Naser. *Ketab-e Zendan.* Berkeley: Nashr-e Noqteh, 1998.

Mohebbi, Hosayn. *Farhang-e Bazigaran-e Sinema-ye Iran.* Tehran: Nashr-e Rivayat, 1996.

Momen, Moojan. "Usuli, Akhbari, Shaykhi, Babi: The Tribulations of a Qazvin Family." *Iranian Studies* 36, no. 3 (2003): 317–37.

———, ed. *Selections from the Writings of E. G. Browne on the Babi and Bahá'í Religions.* Oxford: George Ronal, 1987.

Monsef, Shahpur. "From Dancing the Hips to Moving the Brain: Half Nude Shahrzad of Bars and Cabarets to Today's Intellectual Actress." *Film o Hunar* 429 (30 Farvardin 1352/April 19, 1973): 20, 21, 24.

Moruzzi, Norma Claire. "Women's Space/Cinema Space: Representations of Public and Private in Iranian Films." *Middle East Report* 212 (Autumn 1999): 52–55.

Motahari, Morteza. *Akhlaq-e Jensi dar Islam va Gharb.* Qom: Sadra, 1980.

———. *Masalah-i Hijab.* Tehran: Anjuman-i islami-yi pizhishkan, 1969.

———. *Nizam-i Huquq-i Zan dar Islam.* Tehran: Intisharat-i Sadra, 1978.

——— [Murteza Mutahhari]. *On the Islamic Hijab,* translated by Laleh Bakhtiar. Tehran: Islamic Propagation Organization, 1987.

———. "Osul falsafeh va ravesh-e realism" [The principles and methodology of realism]. In *Majmueh Asar* [Collected works]. Tehran: Sadra, 1992.

Muassasah-e Farhangi-e Qadr-e Valayat. *Hikayat-i Kashf-i Hejab.* Tehran: Qadr-e Vilayat, 1378.

Mulvey, Laura. "Visual Pleasure and Narrative Cinema." In *Visual and Other Pleasures,* 14–26. London: Macmillan, 1989.

Murfin, Ross. "What Is Feminist Criticism?" In *Henry James' The Turn of the Screw,* edited by Peter G. Beidler, 242–53. New York: Bedford Books of St. Martin's Press, 1992.

Nabavi, Negin. *Intellectuals and the State in Iran: Politics, Discourse, and the Dilemma of Authenticity.* Gainesville: Univ. Press of Florida, 2003.

Naficy, Hamid. "The Cinema of Displacement: Towards a Politically Motivated Poetics." *Film Criticism* 20, no. 1–2 (1995–96).

———. "From the Imperial Family to the Transnational Imaginary: Media Spectatorship in the Age of Globalization." In *Global/Local: Cultural Production and the*

Transnational Imaginary, edited by Rob Wilson. Durham, NC: Duke Univ. Press, 1996.

———. "Iranian Cinema." In *Companion Encyclopedia of Middle Eastern and North African Film,* edited by Oliver Leaman, 130–222. London: Routledge, 2001.

———. "Iranian Cinema under the Islamic Republic." In *Images of Enchantment: Visual and Performing Arts of the Middle East,* edited by Sherifa Zuhur. Cairo: American Univ. in Cairo Press, 1998.

———. "Iranian Writers, the Iranian Cinema, and the Case of Dash Akol." *Iranian Studies* 18, no. 2–4 (1985): 231–51.

———. "Veiled Visions/Powerful Presences: Women in Postrevolutionary Iranian Cinema." In *Life and Art: The New Iranian Cinema,* edited by Rose Isa and Sheila Whitaker, 43–65. London: National Film Theatre, 1999.

Nafisi, Majid. "Tazegi va Dirinegi dar Shi'r-e Behbahani." *Negah-e No* 44 (2000): 126–43.

Najmabadi, Afsaneh. "Beyond the Americas: Are Gender and Sexuality Useful Categories of Historical Analysis?" *Journal of Women's History* 18, no. 1 (Spring 2006): 11–21.

———. "Iran's Turn to Islam: From Modernism to a Moral Order." *Middle East Journal* 41, no. 2 (Spring 1987): 205–7.

———. *Women with Mustaches and Men without Beards: Gender and Sexual Anxieties of Iranian Modernity.* Berkeley: Univ. of California Press, 2005.

Nakjavani, Erik. "Delkhash." *Encyclopedia Iranica,* Oct. 28, 2005.

Nashat, Guity. *Women and Revolution in Iran.* Boulder, CO: Westview Press, 1983.

Nayeri, Farah. "Iranian Cinema: What Happened in Between." *Sight and Sound* 3, no. 12 (Dec. 1993): 26–28.

Nedai, Jamileh. "Mosahebeh ba Basir Nasibi." *Pandora2,* June 4, 2006.

Nettle, Bruno. "Attitude towards Persian Music in Tehran." *Musical Quarterly* 56, no. 2 (1970).

Nieuwkerk, Karin van. *A Trade Like any Other: Female Singers and Dancers in Egypt.* Austin: Univ. of Texas Press, 1995.

Nurizadeh, Alireza. "Interview with Shahrzad." *Ferdowsi Magazine.* Year of the 2500th Kingdom Celebration. Doshanbeh 12 Mehrmah, 1971, 12–14, 35.

Olick, Jeffrey K. "Genre Memories and Memory Genres: A Dialogical Analysis of May 8, 1945 Commemorations in the Federal Republic of Germany." *American Sociological Review* 64, no. 3 (June 1999): 381–402.

Omid, Jamal. *Farhang-e Sinema-ye Iran.* Tehran: Negah, 1998.

Organization of Iranian People's Fedai Guerillas. *Islahat-i arzi va natayij-i mustaqim-i an* [Land reform and its direct impact]. Tehran: OIPFG, 1974.

Ortner, Sherry, and Harriet Whitehead. *Sexual Meanings: The Cultural Construction of Gender and Sexuality.* Cambridge: Cambridge Univ. Press, 1981.

Owji, Mansur. *In Susan Ast keh Mikhanad.* Tehran: Daricheh, 1970.

Pahlavi, Mohammed Reza. *Inqilab-i Safid* [The white revolution]. Tehran: Kitabkhanih-i Saltanati, 1967.

———. *Ma'muriyat bara-yi Vatanam.* Tehran: Shirkat-i Sahami-i Kitabha-yi Jibi, 1971.

Pahlavi, Taj al-Moluk. *Khatirat-e MalEkah-e Pahlavi.* Tehran: Behafarin, 2001.

Paidar, Parvin. *Women and the Political Process in Twentieth-Century Iran.* Cambridge: Cambridge Univ. Press, 1995.

Pareles, Jon. "Googoosh." In *Current Biography Yearbook.* New York: H. W. Wilson, 2001.

Parsipur, Shahrnush. *Khaterate Zendan.* Spanga, Sweden: Baran, 1996.

———. *Touba and the Meaning of Night,* translated by Havva Houshmand and Kamran Talattof. New York: Feminist Press, 2006. Originally published as *Touba va Manaye Shab.* Tehran: Esparak, 1999.

———. *Women Without Men: A Novel of Modern Iran.* Introduction by Kamran Talattof, translated by Kamran Talattof and Jocelyn Sharlet. New York: Syracuse Univ. Press, 1998.

Pateman, Carole. *The Sexual Contract.* Stanford, CA: Stanford Univ. Press, 1988.

Peret, Benjamin. "Hello." In *Surrealist Love Poems.* Chicago: Univ. of Chicago Press, 2005.

Persson, Nahid. *Four Wives—One Man.* Iran, Sweden, 2007.

Pickering, Andrew. "We Have Never Been Modern." Book review in *Modernism/Modernity* 1, no. 3 (1994): 257–58.

Polsani, Pithamber. "The Image in a Fatal Kiss: Dalí, Lacan and the Paranoic Representation." In *Lorca, Buñuel, Dalí: Art and Theory,* edited by Manuel Delgado and Alicia Poust. Lewisburg: Bucknell Univ. Press, 2001.

Porter, Roy. "Is Foucault Useful for Understanding Eighteenth and Nineteenth Century Sexuality?" In *Debating Gender, Debating Sexuality,* edited by Nikki Keddie, 247–68. New York: New York Univ. Press, 1996.

Pred, Allan, and Michael Watts. *Reworking Modernity: Capitalisms and Symbolic Discontent.* New Brunswick: Rutgers Univ. Press, 1992.

Probyn, Elspeth. *Sexing the Self: Gendered Positions in Cultural Studies.* London: Routledge, 1993.

Rahimi, Mustafa. *Nim Negah.* Tehran: Zaman, 1977.

Rahman, Afzular. *Role of Muslim Woman in Society.* London: Seerah Foundation, 1986.

Ramazani, Nesta. *The Dance of the Rose and the Nightingale.* Syracuse, NY: Syracuse Univ. Press, 2002.

Ramezani, H. "Mobarezeh Ba Fahshah." *Sepid o Siyah* 11 (Mehrh 1956): 4.

Ravanipur, Moniru. *Sangha-yi Shaytan*. Tehran: Markaz, 1990. Edited and translated by M. R. Ghanoonparvar as *Satan's Stones*. Austin: Univ. of Texas Press, 1996.

Rayhaneh, Fahrhang. *Adab-e Aqad va Arusi* [Ceremony, mores, and celebration of marriage]. Tehran: Kelk-e Azadegan, 2006.

Ribner, Irving, ed. *Christopher Marlowe's Doctor Faustus: Text and Major Criticism*. New York: Odyssey Press, 1966.

Richlin, Amy. *Pornography and Representation in Greece and Rome*. New York: Oxford Univ. Press, 1992.

Rimbaud, Arthur. "I Embraced the Summer Dawn." In *Illuminations*. New York: J. Laughlin, 1957.

———. "Sensation." In *Collected Poems*. Baltimore: Penguin Books, 1962.

Ringdal, Nils Johan. *Love for Sale: A World History of Prostitution*. New York: Grove Press, 2004.

Robin, Diana. "Woman, Space, and Renaissance Discourse." In *Sex and Gender in Medieval and Renaissance Texts*, edited by Barbara K. Gold, Paul Allen Miller, and Charles Platter. Albany: State Univ. of New York Press, 1997.

Roded, Ruth. *Women in Islam and the Middle East*. New York: I. B. Tauris, 1999.

Rouzbahani, Armen. *From Islamic Penal Codes of Islamic Republic of Iran*. Glendale, CA: New Horizons, 2002.

Rowe, William, and Vivian Schelling. *Memory and Modernity: Popular Culture in Latin America*. London: Verso, 1991.

Rudan, R. "Faheshekhaneh Zahirabad." *Elm va Jameh,* 8. Reprinted in *Nimeh-ye Digar* 1, no. 6 (Winter 1366/1988).

Ruggles, D. Fairchild. *Women, Patronage, and Self-Representation in Islamic Societies*. Albany: State Univ. of New York Press, 2000.

Sabet, Fariba. *Yadha-ye Zendan*. Paris: Khavaran, 2004.

Sadeghi, Fatemeh. *Jinsiyat, Nasiyunalism va Tajaddud dar Iran: Dureh Pahlavi Aval*. Tehran: Qasideh Sara, 2006.

Sadeqi Ardestani, Ahmad. *Islam va Masael-e Jensi va Zanashui*. Tehran: Khazar, 1971.

Sadr, Muhsin. *Khatirat-i Sadr al-Ashraf*. Tehran: Intisharat-i Vahid, 1985.

Sahebqalam, Gholam Reza. "The Day My Mother Unveiled." *Zan-e Ruz*, Jan. 8, 1936. Special issue.

Saidi, Kobra. *See* Shahrzad.

Salami, Ghulam Reza, and Afsaneh Najmabadi. *Nahzate Nesvane Sharq*. Tehran: Shiraze, 2005.

al-Saltaneh, Taj. *Khatirat-i Taj al-Saltanah: Dukhtar-i Nasir al-Din Shah-e Qajar,* edited by Naser Zera'ati. Sweden: Khaneh Honar va Adabiyat, 2008.

Sanasarian, Eliz. *The Women's Rights Movement in Iran: Mutiny, Appeasement, and Repression from 1900 to Khomeini*. New York: Praeger Press, 1982.

Sanei, Safdar. *Taalim-e Behdashti-e Islam*. Isfahan: Saqafi, 1960.

Sarrazin, Albertine. *L'Astragale*. Paris: Pauvert, 1965.

Scarparo, Susanna. *Elusive Subjects: Biography as Gendered Metafiction*. Leicester: Troubador, 2005.

Schelegel, Alice. "Status, Property, and the Value of Virginity." *American Ethnologist* 18, no. 4 (Nov. 1991).

Schirazi, Asghar. *The Problem of Land Reform in the Islamic Republic of Iran*. Berlin: Verlag Das Arabische Buch, 1987.

Sciolino, Elaine. *Persian Mirrors: The Elusive Face of Iran*. New York: Free Press, 2000.

Sepehrai, Sohrab. "Marg-e Rang" [The death of color]. In *Hasht Ketab*. Tehran: Ketabkhanah-'e Tahuri, 1979.

———. "Qayeqi Khaham Sakht" [I'll make a boat]. In *Hasht Ketab*. Tehran: Kitabkhanah-'i Tahuri, 1979.

———. "Roshan Shab" [The bright night]. In *Hasht Ketab*. Tehran: Kitabkhanah-'i Tahuri, 1979.

———. "Sarab" [Mirage]. In *Hasht Ketab*. Tehran: Kitabkhanah-'i Tahuri, 1979.

———. "Seday-e Pa-ye Ab" [The sound of water's steps]. In *Hasht Ketab*. Tehran: Kitabkhanah-'i Tahuri, 1979.

———. "The Surah of Observation" [The verse on observation]. In *Hasht Ketab*. Tehran: Kitabkhanah-'i Tahuri, 1979.

Shafiq, Shahla. "Ravayat-e Zendan, Seda-ye Zanan." *Negah* 1. http://www.negah1.com.

Shahidian, Hammed. "The Iranian Left and the 'Woman Question' in the Revolution of 1978–79." *International Journal of Middle East Studies* 26, no. 2 (May 1994): 225.

Shahri Baf, Jafar. *Tarikh-e Ejtimai-e Tehran dar Qarn-e Sizdahom: Zindagi, Kasb va Kar*. Tehran: Muassasah-i Khadamat-i Farhangi-e Rasa, Intisharat-i Ismailiyan, 1988.

Shahrzad [M. Shahrzad, Kobra Saidi]. "Adam Cheqadr Dir Bozorg Mishavad, Adam Cheqadr Zud Pir Mishavad." In Shahrzad, *Tuba*, 48–50.

———. "Ah, Baba, Qiqam." *Ketab-e Jomeh* 1, no. 27 (2 Isfand 1980): 33–36.

———. "Ay Cheshmane Siahe To Abi." In Shahrzad, *Salam, Aqa*, 23–26.

———. *Ba Teshnegi Pir Mishavim* [Thirsty, we age]. Tehran: Khushah, 1972.

———. "Bazi az Bazigaran-e Cinema." *Setareh Cinema* 27, 28 (1352): 17, 40, 41.

———. "Chera Durbin-e Filmbardari dar Iran Bishtar Tasvir Saze Sahneha-ye Sexi Ast?" *Setareh Cinema* 27, 28 (1352): 17, 40, 41.

———. "Cheshmeh beh Fathe Darya." In Shahrzad, *Salam, Aqa*, 49–51.

———. "Do Nasl Dar Barabar-e Ham, Va Dar Kenar-e Ham." *Setareh Cinema* 33 (4 Esfand 1352/Feb. 24, 1974): 12, 13, 36, 37.

———. "Harfe Avval." In *Ba Teshnegi Pir Mishavim,* 6, 21–23. Tehran: Khushah, 1972.

———. "Inast Qeseh-ye Shahrzad Zamaneh Ma." *Setareh Cinema* 23 (17 Azar 1352): 13.

———. "In Be Estelah Nosetareha." *Setareh Cinema* 27 (15 Day 1352): 16–19.

———. "Iren: Ba Omid beh Mojezat-e Emruz, Ba Hastrat va Eftekhar beh Diruz." *Setareh Cinema* 23 (Azar 1352): 19–46.

———. "Man va Khaharam." *Ferdowsi Magazine* 23, no. 1034 (19 Mehr 1971).

———. "Movafaqiyat va Etebare Filmsazan-e Irani." *Setareh Cinema* 27, 28 (1352): 17, 40, 41.

———. "Naderi Kargardan-e Tengsir Nist." *Setareh Cinema* 28 (22 Dey 1352/Feb. 23, 1974): 2, 3, 40, 41.

———. "Nagozarid." *Setareh Cinema* 30 (6 Bahman 1352/Jan. 26, 1974): 20, 21, 43.

———. "Nagozarid Ghahramanan e Napadid Shavand." *Setareh Cinema* 30 (6 Bahman 1974): 20, 21, 43.

———. "Pishgoftar: Ba U Beh Derza Keshideh Ast Shab." In Shahrzad, *Salam, Aqa,* 3–8.

———. *Salam, Aqa [Aqha]: Majmueh Shi'r* [Hello, sir: A collection of poetry]. Tehran: Dunya-ye Ketab, 1978.

———. *Tuba.* Tehran: n.p., 1977.

Shahrzad [unrelated to author above]. *Dar Inja Dokhtaran Nemimirand.* Paris: Nashr Khavaran, 1997.

Shamisa, Sirus. *Shahed Bazi dar Adabiyat-e Farsi.* Tehran: Firdaws, 2002.

Shariati, Ali. *Fatemeh Fatemeh Ast.* Tehran: Husayniyah Irshad, 1971.

———. *Hunar* [Art]. Tehran: Andishmand, 1982.

———. "Modern Calamities." In *Marxism and Other Western Fallacies: An Islamic Critique,* translated by R. Campbell, 32–40, 91–96. Berkeley, CA: Mizan Press, 1980.

Shawkat, Hamid. *Tarikh-e Bist Salah-e Konfederasiyun-e Jahani-e Muhasselin va Daneshjuyan-e Irani.* Germany: Nashr-i Baztab, 1994.

Shay, Anthony. *Choreophobia: Solo Improvised Dance in the Iranian World.* Costa Mesa, CA: Mazda, 1999.

Shrage, Laurie. *Moral Dilemmas of Feminism: Prostitution, Adultery, and Abortion.* New York: Routledge, 1994.

Smart, Barry. *Facing Modernity: Ambivalence, Reflexivity and Morality.* Thousand Oaks, CA: Sage, 1999.

Spivak, Gayatri Chakravorty. "Subaltern Studies: Deconstructing Historiography." In *Selected Subaltern Studies,* edited by Ranajit Guha and Gayatri Chakravorty Spivak. Oxford: Oxford Univ. Press, 1988.

Sprachman, Paul. *Suppressed Persian.* Costa Mesa, CA: Mazda, 1995.

Stark, Rodney. "How Christianity (and Capitalism) Led to Science." *Chronicle of Higher Education* 52, no. 15 (Dec. 2, 2005): B11.

———. *The Victory of Reason: How Christianity Led to Freedom, Capitalism, and Western Success.* New York: Random House, 2005.

Stoler, Ann. *Race and the Education of Desire: Foucault's "History of Sexuality" and the Colonial Order of Things.* Durham, NC: Duke Univ. Press, 1995.

Sullivan, Soraya, trans. *Stories by Iranian Women Since the Revolution.* Austin: Center for Middle Eastern Studies, Univ. of Texas at Austin, 1991.

Sullivan, Zohreh T. "Eluding the Feminist, Overthrowing the Modern? Transformations in Twentieth-Century Iran." In *Remaking Women: Feminism and Modernity in the Middle East,* edited by Lila Abu-Lughod, 215–42. Princeton: Princeton Univ. Press, 1998.

Tabatabai, Muhammad Husayn. *Ravabit-i Ejtemai dar Islam.* Tehran: Intisharat-i Azadi, 1981.

———. *Shiite Islam.* Albany: State Univ. of New York Press, 1975.

Tafrishi, Murtaza Sayfi Fami. *Nazm va nazmiyah dar Dawrah-i Qajariyah.* Tehran: Intisharat-i Yasavuli Farhangsara, 1983.

———. *Pulis-i Khufyah-i Iran, 1299–1320: Mururi bar Rukhdadha-yi Siyasi va Tarikhchah-i Shahrbani.* Tehran: Ququnus, 1989.

Talattof, Kamran. "Breaking Taboos in Iranian Women's Literature: The Work of Shahrnush Parsipur." *World Literature Today,* Sept.-Dec. 2004, 43–46.

———. "Comrade Akbar: Islam, Marxism, and Modernity." *Comparative Studies of South Asia, Africa and the Middle East* 25, no. 3 (Nov. 4, 2005): 634–49.

———. "Gender, Feminism, and Revolution: Shifts in Iranian Women's Literature." *Gozaar.* http://www.gozaar.org/template1_en.php?id=459. April 2007.

———. "Iranian Women's Literature: From Pre-revolutionary Social Discourse to Post-revolutionary Feminism." *International Journal of Middle East Studies* 29, no. 4 (Nov. 1997): 531–58.

———. "I Will Rebuild You, Oh My Country": Simin Behbahani's Work and Sociopolitical Discourse." *Journal of Iranian Studies* 41, no. 1 (2008): 19–36.

———. "Nizami's Unlikely Heroines: A Study of The Characterizations of Women in Classical Persian Literature." In *The Poetry of Nizami Ganjavi: Knowledge, Love, and Rhetoric,* edited by Kamran Talattof and Jerome W. Clinton, 51–81. New York: Palgrave Macmillan, 2000.

———. "Personal Rebellion and Social Revolt in the Works of Forugh Farrokhzād: Challenging the Assumptions." In *Forugh Farrokhzad, Poet of Modern Iran,* edited by Nasrin Rahimieh and Dominic Brookshaw. London: I. B. Tauris, forthcoming.

———. *The Politics of Writing in Iran: A History of Modern Persian Literature.* Syracuse, NY: Syracuse Univ. Press, 2000.

Tanenbaum, Leora. *Slut! Growing Up Female With a Bad Reputation.* New York: Seven Stories Press, 1999.

Tapper, Richard, ed. *The New Iranian Cinema: Politics, Representation and Identity.* London: I. B. Tauris, 2002.

Taqizadeh, Sayed Hasan. "Dore Jadid." *Kaaveh* 5, no. 36 (1920).

Tarbiyat, Hajar. "The Day My Mother Unveiled." *Zan-e Ruz,* Jan. 8, 1936. Special issue.

Tavakoli-Targhi, Mohamad. *Refashioning Iran: Orientalism, Occidentalism, and Historiography.* New York: Palgrave, 2001.

———. *Tajadod Bumi va Bazandishi-ye Tarikh.* Tehran: Nashr-e Tarikh-e Iran, 2002.

———. "Tajadod, Tamadon Ariyati, va Enqelabe Ruhaani." *Iran Nameh* 20, no. 2–3 (Spring-Summer 2002).

Tavares, Hannah. "Education/Desire," *Theory and Event* 1, no. 2 (1997): 6, 104–5.

Taylor, Charles. *Sources of the Self: The Making of the Modern Identity.* Cambridge, MA: Harvard Univ. Press, 1989.

Thomas, Helen. *Dance, Modernity, and Culture: Explorations in the Sociology of Dance.* London: Routledge, 1995.

Thornham, Sue, ed. *Feminist Film Theory: A Reader.* Edinburgh: Edinburgh Univ. Press, 1999.

Tohidi, Nayereh. "Islamic Feminism: Perils and Promises." *Association for Middle East Women's Studies Review* 16, no. 3-4 (Fall 2001/Winter 2002): 27.

Toulmin, Stephen. *Cosmopolis: The Hidden Agenda of Modernity.* New York: Free Press, 1990.

Trible, Phyllis. *God and the Rhetoric of Sexuality.* Philadelphia: Fortress Press, 1978.

Tse-tung, Mao. *Talks at the Yenoan Forum on Literature and Art.* Peking: Peking Foreign Languages Press, 1967.

Turner, Bryan. *Theories of Modernity and Postmodernity.* London: Sage, 1990.

Vahdat, Farzin. *God and Juggernaut: Iran's Intellectual Encounter with Modernity.* Syracuse, NY: Syracuse Univ. Press, 2002.

Varzi, Roxanne. *Warring Souls: Youth, Media, and Martyrdom in Post-Revolution Iran.* Durham, NC: Duke Univ. Press, 2006.

Vavrus, Frances, and Lisa Ann Richey. "Women and Development: Rethinking Policy and Reconceptualizing Practice." *Women's Studies Quarterly* 31, no. 3-4 (Fall-Winter 2003): 6–18.

Wadud, Amina. *Qur'an and Woman: Rereading the Sacred Text From a Woman's Perspective.* New York: Oxford Univ. Press, 1999.

Walton, Jean. *Fair Sex, Savage Dreams: Race, Psychoanalysis, Sexual Difference*. Durham, NC: Duke Univ. Press, 2001.

Walton, Priscilla. *The Disruption of the Feminine in Henry James*. Toronto: Univ. of Toronto Press, 1992.

Weber, Max. *The Protestant Ethic and the Spirit of Capitalism*. New York: Scribner, 1958.

Weitz, Rose. *The Politics of Women's Bodies: Sexuality, Appearance, and Behavior*. Oxford: Oxford Univ. Press, 2003.

Woolf, Virginia, and Rachel Bowlby. *Orlando: A Biography*. Oxford: Oxford Univ. Press, 1992.

Wuthnow, Robert. *Communities of Discourse: Ideology and Social Structure in the Reformations, the Enlightenment, and European Socialism*. Cambridge, MA: Harvard Univ. Press, 1989.

Zamani, Mustafa. *Islam va Tamaddun-i Jaded*. Tehran: Ketabkhane Sadr, 1970.

Zan-e Ruz. 98 (24 Day 1345) (1966).

Zara'ati, Naser. *Zendeginameh Behruz Vosoqi*. San Francisco: Aran Press, 2005.

Zayn-al 'Abedin Maragha-i. *Sivahat-name-ve Ebrahim Beg*. Tehran: 1965, 1978, 1983, 1985.

Index

Gellner, Ernest, 282n32

Germany: Daryabaygi in, 91; Federal Republic of, 256n43; Iranian Students Confederation in, 104; *Kaveh* published in, 287n65; political liberation in, 250n48; Sharzad's travel to, 61, 75, 77, 207

Ghafari, Parvin, 18, 183–84

Ghafari, Piruz, 264n43

Ghafari, Simin, 204

Ghaffari, Farrokh, 264n43

Ghanem, Simin (singer), 188, 215; first performance after revolution, 202; interview with, 277n39

Ghanoonparvar, M. R., 240n25, 262n20

Ghazzali, Imam Abu Hamed Mohammad, 280n7

Gholamhosayni, Bahar. *See* Elahe

Gil, Daniel Juan, 28, 168

globalization, 23, 31, 252n83, 264n43, 278n67, 283n57

Gold, Barbara K., 29

Goldberg, Jonathan, 28, 245n14, 248n38

golduzi, 226

Golestan, Ibrahim, 74, 158, 159, 167, 257–58n78, 271n49

Golestan, Kaveh (photographer), 255n35

Golestan, Shahrokh, 276n29

Googoosh/Gugush (Faeqeh Atashin) (singer), 4, 18, 50, 93, 102, 181, 182, 187–88, 191, 202, 204, 206, 228, 256n49, 257n75, 275n16, 276n35, 277n43, 279n71

Graham, Martha, 261n6

Guevara, Che, 61

Habermas, Juergen, 223, 242n4, 245n14, 247n22, 283n55

Haider, Zeeshan, 212, 281n21

Hajjarian, Said, 22

Hakimi, Mayam, 170

Hakimolahi, Hedayat, 38, 273n79

Haleh, 203

Hambarson, Mosio, 82

Hananeh, Shahin, 170

Harron, Mary, 203, 279n75

Hatami, Ali, 190, 195, 267n76

Hatami, Leila, 177

Hayward, Susan, 202

Hedayat, Sadeq, 3, 13, 15, 67, 122, 254n12

Hefner, Hugh, 28

Hegel, 22, 242n4, 245n16, 270n44

Hejazi, Mohammad, 38, 256n41, 273n79

Hengameh (actress), 203

high arts, 39–40, 238n12

high culture, 2, 20, 40, 80, 94, 125, 177, 221; and elite culture, 238n12

Hillman, Michael, 240n25, 269n14

Hollywood, 130, 131, 194, 201

Homayra (singer), 93, 177

homosexuality, 30, 33, 39, 228, 239n16, 240n21

honor killing/honor-based violence, 85, 114, 116, 227, 259n116

human rights, 78, 219–20, 231

Huntington, Samuel P., 242n4, 243n7, 244n10

hymen, 36–37, 174–75, 225–26, 274n92, 274n96

ideology: definition of, 216, 221–22, 252n90; function of, 44–45; of fundamentalism on women,176–204; in Iran, 205–36; paradigm and, 16; production of, 16; resistance to, 224–26

inconsistency/discontinuity (cultural and literary), 14, 32, 40, 44, 51, 101, 106, 156, 158, 174, 221, 246n17, 254n12, 285n67

Indian cinema, 57, 105, 107, 111, 182

intellectual (definition), 238n8

intercourse, 34–37, 87, 145, 146, 198, 223, 227, 230, 283n48, 283n52